Film, Art, New Media

Also by Angela Dalle Vacche

THE BODY IN THE MIRROR: Shapes of History in Italian Cinema

CINEMA AND PAINTING: How Art is Used in Film

DIVA: Defiance and Passion in Early Italian Cinema

Film, Art, New Media

Museum Without Walls?

Edited by

Angela Dalle Vacche
Professor of Film Studies, Georgia Institute of Technology, USA

First published 2012 by
PALGRAVE MACMILLAN

Palgrave Macmillan in the UK is an imprint of Macmillan Publishers Limited,
registered in England, company number 785998, of Houndmills, Basingstoke,
Hampshire RG21 6XS.

Palgrave Macmillan in the US is a division of St Martin's Press LLC,
175 Fifth Avenue, New York, NY 10010.

Palgrave Macmillan is the global academic imprint of the above companies
and has companies and representatives throughout the world.

Palgrave® and Macmillan® are registered trademarks in the United States,
the United Kingdom, Europe and other countries.

ISBN 978-0-230-27292-7

This book is printed on paper suitable for recycling and made from fully
managed and sustained forest sources. Logging, pulping and manufacturing
processes are expected to conform to the environmental regulations of the
country of origin.

A catalogue record for this book is available from the British Library.
A catalog record for this book is available from the Library of Congress.

10 9 8 7 6 5 4 3 2 1
21 20 19 18 17 16 15 14 13 12

Printed and bound in Great Britain by
CPI Antony Rowe, Chippenham and Eastbourne

Contents

List of Figures

Foreword

The New Museum: Spectatorship and Installation

With the museum as its backdrop, this anthology offers the rea ler a collection of perspectives on intermedial relations. Discussions of pho-tography, painting, and cinema (Dudley Andrew, Dalle Vacche) find their place next to those that discriminate between the analog and the digital (Dalle Vacche, Hogben), and those that focus on o jects (Christie, Dalle Vacche, Steimatsky). Here painters learn from the cin-ema (Felleman, Dudley Andrew), filmmakers cite and borrow fro the visual arts (Lundemo, MacKay), and films about painters take un sual forms (Dixon, Nead, Shafto). Situated with respect to painting, film also finds its place in the context of the other arts—of dance and arc itec-ture (Nell Andrew, Penz, Pucci). In acts of accommodation, perha s of appropriation, today's intermedial landscape produces museum and galleries with expanded functions: museums stage exhibits ar und films (Penz, Christie) even as they commission films about painter and their works (Shafto, Dalle Vacche, Szaniawski, Penz). And then th re is the narrative organization of museal space (Penz). Filmmakers (rate exhibitions, and museums exhibit both feature films and installa ions with digital images (Christie, Hogben, Penz, Szaniawski). Move ent enters the museum, and stillness invades the moving image. Art tself has changed (Hogben), and so has its spectator.

If we were asked to name one visual artist who experiments in ll of these modes, Peter Greenaway would probably spring to mind. Tr ined as a painter, he still occasionally exhibits his work. But he is prin arily a curator of exhibitions, an installation artist, a filmmaker whose ilms exhibit paintings; feature painters as well as writers; juxtapose me-based arts with spatial arts and analog with digital images; and (eate intermedial palimpsests that layer painting, literature, photogr phy, architecture, landscape architecture, and dance. It's an exhat ting repertoire, one that cannot be tackled here. But by way of a r cent installation, *Leonardo's Last Supper: A Vision by Peter Greenaway*, I'll ffer suggestions about the spectator of Greenaway's installations, gest ring towards the visual and experiential pleasure they afford.

Greenaway's films often figure spectatorial space as contir ous with the space of representation—not a surprising strategy for a sual

artis with an abiding interest in creating "a dialogue between the visu l literacies of cinema and the visual literacies of painting."[1] In fore rounding the place of the spectator within the text, Greenaway's film figure one condition of spectatorship in installations, especiall those that exhibit painting. Greenaway embraces this form with the commissioned installation surrounding Rembrandt's *Night Wat 1* (2006), the first of his projects in the *Classic Paintings Revisited* serie , of which the more recent *Leonardo's Last Supper* (2008) is the seco d. In the latter installation especially the spectatorial body is contain d—literally—within a space of representation, and its position, its mov ment through space, and its views are both guided and free; now focu ed, now distracted. But how is perceptual and aesthetic experience shap d for the spectator? And what kind of spectatorial pleasure do such practices produce?

I xperienced Greenaway's vision of *Leonardo's Last Supper* in New York's Park Avenue Armory in January 2011, but it was originally exhi ited in Milan. In New York the installation consisted of two very larg screens as well as a number of smaller screens on each side of a cent al space, scrims layered over one another, all suspended from the ceili g. A three-dimensional version of a refectory table—set with goblets, lates, knives, and loaves of bread—was located in the middle of the ace (Leonardo's painting was made especially for the refectory of the onastery Santa Maria delle Grazie). The two large screens at either end eld vastly enlarged and identical digitally scanned replicas of Leor rdo's painting, onto which Greenaway projected a light show that fused his cinematic and museum exhibition practices. Blending cine atic, painterly, and museal space, the installation constructed an expe ience in which each spectator was a perceptual center. To say that the pectator entered the space of a painting—or a film—would not tell he whole story. In this installation, the spectators inhabited an aestl eticized space between multiple versions of the same performance. But was also a space in which other screens, other projected images, and a three-dimensional sculpture co-existed, and in which sound play d an important part.

At times the smaller screens held the same image, underscoring their digit lly reproduced nature. Here, for instance, there were variations on i lages of Leonardo's *Vitruvian Man*, a pen and ink study of proportion rom Vitruvius's *De Architectura*—just to add another art or two to the lix. At times each screen contained only details of the *Last Supper*, deta s so enlarged as to be abstract, products of an extreme act of decc istruction. These and other digitized images were of photographs

as well as of paintings and drawings, and banners suspended from the ceiling served to reinforce the three-dimensionality of the space and of the aesthetic experience at the same time. Whether mobile or standing still, attentive to stereophonic music or to the primarily disembodied voice of Greenaway as "audio-guide," the spectator was contained within a space of projections, objects, and sounds that promoted multi-sensory perception. The sculptural refectory table holding semi-abstracted plates and goblets added tactility to spectatorship, even as its diffuse and changing lighting effects reinforced the experience of time in the "show" that Greenaway called his "vision." In this installation, then, there was the palimpsest-like layering of representational systems characteristic of Greenaway's work: the three-dimensional table was sculptural with interior kinetic light effects, yet its bleached color and still-life composition called to mind the still-life paintings of Giorgio Morandi, particularly his *Natura Morta* (1956) recently on view at the Metropolitan Museum of Art. (Is this the auratic work of art, satirized? If so, this inclusion entailed a measure of self-mockery as well.) Painting and sculpture, movement and stasis, multiple screens and moving images, a voice-over narrative—all motivated spectators who moved freely and arbitrarily between the sometimes contemplative, sometimes distracted looking of the typical museum-goer. A disembodied gaze would not have been possible.

While the spectator had the choice of looking at one image or another, at objects as well as images, for a long or a short period of time, the temporality of Greenaway's *son et lumière* was circumscribed, of course, although it included repetitions that impinged on the temporality of perceived experience and gave the show the semblance of a loop. Lighting effects projected on the large-screen versions of *The Last Supper* introduced a constant motion onto—seemingly almost *into*—these exact reproductions. Light was made to "shine through" the three windows in the background of the painting; light isolated different groups of the Apostles; its beams sometimes played over the whole, but it also lit the Apostles' and Christ's hands and feet (with the interesting *addition* of Christ's feet, in actuality cut from the painting in 1654 when a new door was installed in the refectory, and borrowed by Greenaway from a contemporary copy of the painting now in Antwerp). At times light streamed auratically from the body of Christ; and a cross of light was occasionally superimposed on the reproduction's surface. Typically for Greenaway, numbers and writing also inscribed the *Last Supper* and, at times, groups of Apostles were set off by red outlining, producing a paint-by-numbers effect.

And then there were the moments in Greenaway's vision of *Leonardo's Last Supper* when the grid depicted on the painting's ceiling—the grid that anchors the *Last Supper* within a perspectival system—was "set free" from that place, was tilted and rotated, and allowed to play over the surface of the reproductions in an arc now originating from their right side, now from their left side. Interestingly, these grids appeared as shadows on the reproduction, shadows that served to reinforce the grids' space-producing function. Projected onto the reproduction, no doubt the grids liberated from their fixed position in the actual painting served to suggest that the Albertian model of spectatorship had been "dissolved," as Norman Bryson puts it, "into computative space,"[2] but they by no means promoted immersion in the spectator. They remained images on a screen, images that *figured* three-dimensionality, but could no more literally take us up into their space than a painting can. They remained mere *allusions* to another kind of space, constituents of the hypermediatic landscape represented here. The spectator of Greenaway's installation was contained within an aesthetic space by virtue of the installation as a *whole*—not by means of the screens alone.

The spectatorial effects promoted by the *Last Supper* installation bore a striking similarity to those of the aestheticized garden such as we find in Greenaway's *The Draughtsman's Contract* (1982)—acts of framing, games with two and three dimensions, and the like. And in fact, within the space of Greenaway's installation there was another projection, one that derived from the landscape garden and used the floor as a screen: images of a brook rippling over stones flowed across the Armory floor, and it was amusing to see several people move into the stream of images, as though to take a quick dip. (Here the performative aspect of spectatorship came into play). Not a pleasure to be enjoyed very long by an adult, perhaps, but among the spectators that day there was a child, a little boy of perhaps three or four, who promptly sat down in the projected images of water, moved around in them, and didn't get up from the floor until the images had stopped at the end of the show. It was here that immersion was played out—metaphorically, not literally—in a space even the child recognized as a liminal space between image and reality. But *that* was no doubt the fun of it, not just for the ambulatory spectators of the landscape garden before 1750, but also for the twenty-first-century spectator: it is specifically one's presence within illusion that is the attraction of such effects. Theorists of spectatorship have tended to ignore the spectatorial pleasure that participation in theatrical spectacles such as installations enables. I suggest that prominent among them is the pleasure we take in *aesthetic play*. Not only do

we apprehend such effects intellectually, but we experience enjoyment, pleasure—like the child's—in the juxtaposition of real bodies and real objects with represented ones.[3] To come full circle and to conclude: we, the installation's spectators, were filmed throughout Greenaway's "show" by camera people clearly hired for the purpose, producing images no doubt to be used in a film that will grow out of this installation, a film that will surely—as so often in Greenaway—contain images of spectators.

Brigitte Peucker,
Yale University,
August 2011

Notes

1. Quoted from a lecture at UC Berkeley, November 2010.
2. N. Bryson, "The Gaze and the Glance," *Vision and Painting: The Logic of the Gaze* (New Haven, CT: Yale University Press, 1983), 112.
3. See B. Peucker, *The Material Image: Art and the Real in Film* (Palo Alto, CA: Stanford University Press, 2007), 1–15.

Acknowledgments

The development of this anthology dates back to my days on a Leverhulme Distinguished Professorship in the History of Art Department at Birkbeck College, University of London, during the spring of 2007. By the end of that year, Brigitte Peucker invited me to her symposium on "The Human Figure in Painting, Film, and Photography" at Yale University. This event gave me a chance to meet new and old colleagues interested in film and the arts. By then, I had already contacted the Sterling and Francine Clark Art Institute in Williamstown, Massachusetts, and proposed a two-day event on the dialogue between art history and film studies. Michael Ann Holly, Starr Director of the Research and Academic Program, and Mark Ledbury, then Associate Director of the Research and Academic Program, accepted my proposal, and on March 13–14, 2009, the symposium "Image and Movement" took place in Williamstown.

Before and after March 2009, additional situations propelled me towards the execution of this anthology based on the Clark symposium, the first ever about cinema. In 2008, with my colleagues in film studies, Jennifer Wild at the University of Chicago and Karl Schoonover at Michigan State University, I founded a scholarly interest group called Cinemarts, within the Society for Cinema & Media Studies, focusing on the relationship between film and the visual arts.

In 2009, in conjunction with the 25th anniversary of FESPACO (Pan-African Film Festival of Ouagadougou) in Burkina Faso, with filmmaker Gaston Kaboré, film scholars Dudley Andrew and Aboubakar Sanogo, and Egyptologist Yoporeka Somet, I organized a small symposium on "African Film, African Art," at Imagine, Kaboré's documentary filmmaking school. This event was also attended by Cecilia Cenciarelli from the Cineteca di Bologna and the World Cinema Foundation.

Then in March 2010, I served as a juror for the Festival International du Film sur l'Art (FIFA) in Montreal, a prestigious event launched in 1981 and which annually presents several hundred documentaries on the arts.

In January 2011, the Institut national d'histoire de l'art in Paris invited me to present a paper on "Le cinéma au musée." They also published my remarks on Alexander Sokurov's film *Russian Ark* (2002) in their journal *Perspective*.

Furthermore, during the spring of 2011, I had the honor to present my work on Paul Cézanne and early cinema at the Metropolitan Museum of Art in New York for a public program called "Sunday at the Met". And in July 2011, I was the keynote speaker at "Cinema and the Museum," an international conference organized by Cambridge University in England.

Usually the Clark Institute publishes the proceedings of its symposia, but, in these times of economic recession, this solution was not possible. Thus I turned to the publisher Palgrave Macmillan, whose interest in the project sustained me through months of revisions across essays written by speakers educated in different languages. After learning from Palgrave Macmillan that they would publish this volume, my friend Jaime Wolf helped me finalize my contract.

Throughout this multilingual challenge, Nadine Covert, a consultant and specialist in visual arts media, patiently collaborated with me. This anthology is dedicated to her to acknowledge her long career dealing with this particular area of study. From 1984 to 1998 Ms Covert worked with the Program for Art on Film, a joint venture of the J. Paul Getty Trust and the Metropolitan Museum of Art, where she developed and managed the Art on Screen Database and organized several conferences on the arts and media. Since 1996, she has served as the New York delegate to the Montreal International Festival of Films on Art (FIFA). She is also the editor of several directories of film/video, including *Architecture on Screen* (G.K. Hall, 1994) and *Art on Screen* (G.K. Hall, 1992).

I am, of course, deeply indebted to my contributors who have tolerated my e-mails, deadlines, and comments in the margins asking them to rewrite or to send pictures with permissions and captions. Our dialogue during the organization of this anthology was as productive and as intellectually stimulating as during the unfolding of the symposium itself. I must say that publishing the proceedings, thanks to Palgrave Macmillan, has actually made me think through every chapter and their overall interconnections in a much more serious way, so that I can only hope that my contributors will be pleasantly surprised when they receive the final book product. Of course, I take full responsibility for any oversight or mistake or misunderstanding which I failed to correct or prevent in this collection.

There is still much more to do and learn about the interdisciplinary connections between moving-image media and the visual arts, so it is likely that more and more books in this direction will emerge in the

near future. I, for one, hope some day to produce a group of essays on African film and African art, a topic that has never before been explored in film studies.

Angela Dalle Vacche
New York,
August 2011

Notes on Contributors

Dudley Andrew is the R. Selden Rose Professor of Film and Compa itive Literature at Yale. Before moving to Yale in 2000, he taught for 30 'ears at the University of Iowa directing the dissertations of many illus ious film scholars. He began his career with three books commentir ; on film theory, including the biography of André Bazin, whose thoug t he continues to explore in the recent *What Cinema Is!* (2010) and the (lited volume, *Opening Bazin* (2011). His interest in aesthetics and hermen(itics led to *Film in the Aura of Art* (1984), and his fascination with Frencl film and culture resulted in *Mists of Regret* (1995) and *Popular Front* 'aris (2005). He is currently completing *Encountering World Cinema*.

Nell Andrew is Assistant Professor of Art History at the Univers y of Georgia, where she teaches modern art, dance history, and early ilm. She is completing a book on the contributions of dance and cine1 a to the formation of European abstract art. Her writing has appeared i Art Journal* and in exhibition catalogues from the Smart Museum o Art, Chicago, and the Weston Art Gallery, Cincinnati. She took her doc1 rate from the University of Chicago after working for the curatorial d()art-ments of the National Museum of Women in the Arts, Washington DC, and the Art Institute of Chicago.

Ian Christie is a film historian, curator, broadcaster, and consu ant. He has written and edited books on Powell and Pressburger, Rt sian cinema, Scorsese, and Gilliam; and contributed to exhibitions ra1 ging from *Film as Film* (Hayward, 1979) to *Modernism: Designing a New 'orld* (V&A, 2006). Since the 1980s he has presented many Russian filn sea-sons and events, interviewing Tarkovsky at the National Film Th atre, London, in 1981, and Sokurov on many occasions. In 2006 he was lade Professor of Fine Art at Cambridge University, with a series of le(ures titled "The Cinema Has Not Yet Been Invented." A Fellow of the E tish Academy, he is Professor of Film and Media History at Birkbeck C(ege, director of the London Screen Study Collection, and vice-pres lent of Europa-Cinemas, of which he was a co-founder. Recent pu lica-tions include *Stories We Tell Ourselves: the Cultural Impact of Britisl Film 1946–2006* (co-author, for UK Film Council, 2009) and *The Art of 'ilm: John Box and Production Design* (2009), and articles on Méliès and P rick Keiller. www.ianchristie.org

Angela Dalle Vacche is Professor of Film Studies at the Georgia Institute of Technology. She is the author of *The Body in the Mirror: Shapes of History in Italian Cinema* (1992); *Cinema and Painting: How Art is Used in Film* (1996); *Diva: Defiance and Passion in Early Italian Cinema* (2008); she has also edited *The Visual Turn: Classical Film Theory and Art History* (2003); and co-edited, with Brian Price, *Color: The Film Reader* (2006). She is currently working on a book called *André Bazin: Art, Cinema, Science*.

Simon Dixon teaches film, literature, and critical studies in the Honors Program at Montana State University. He is currently at work on a monograph, *The Hollywood Image*, which examines strategies of depiction in classical Hollywood film.

Susan Felleman is Associate Professor of Cinema Studies in the Department of Cinema and Photography and of Women's Studies at Southern Illinois University Carbondale. She is the author of *Botticelli in Hollywood: The Films of Albert Lewin* (1997), *Art in the Cinematic Imagination* (2006), and numerous other writings on art and film, including in the collections *Sayles Talk: New Perspectives on Independent Filmmaker John Sayles* (2005) and *Cinephilia in the Age of Digital Reproduction: Film, Pleasure, and Digital Culture II* (2012); and in the journals *Camera Obscura*, *Iris*, *Film Quarterly*, and *Jump Cut*. She is currently working on two book projects: *Real Objects in Unreal Situations: Modern Art in Fiction Films*, and with Steven Jacobs on a hand guide to an imaginary museum of cinematic art.

Gavin Hogben is a working architect and researcher in digital media who has taught, practiced, and published extensively on both sides of the Atlantic. He has taught on the architectural faculties of Princeton, Yale, and Cambridge, and as a visiting professor at Harvard and Rice. His most recent teaching has been in the Digital Media Department of the Rhode Island School of Design. A co-founder of the Cambridge University program for Architecture and the Moving Image, and a consultant to the UK National Film and Television School, his work has focused on the application of New Media and established screen languages to the design of buildings, cities, environments, and events. His current research is focused on the development of handheld devices for museum and quasi-museum environments.

Trond Lundemo is Associate Professor in the Department of Cinema Studies at Stockholm University. He has been a visiting professor and visiting scholar at the Seijo University of Tokyo on a number of occasions. He is co-directing the Stockholm University Graduate School of

Aesthetics and is co-editor of the book series "Film Theory in Media History" at Amsterdam University Press. He is also affiliated with the research project "Time, Memory and Representation" at Södertörns University College, Sweden, and "The Archive in Motion" research project at Oslo University. His research and publications engage in questions of technology, aesthetics, and intermediality as well as the theory of the archive. His English-language publications include "Archival Shadows," in *The Archive in Motion* (2010); "Jean Epstein's Writings on Technics and Subjectivity," in *Jean Epstein* (2012); "Archive Theory as Film Theory," in *At the Very Beginning – at the Very End* (2010); "In the Kingdom of Shadows," in *The YouTube Reader* (2009); "The Colour of Haptic Space," in *Color; a Reader*(2006); "The Arrival of King Haakon VII in Christiania," in *The Cinema of Scandinavia* (2005); and "The Dissected Image," in *Allegories of Communication* (2005).

John MacKay is Professor of Slavic Languages and Literatures and Film Studies and chair of the Film Studies Program at Yale University. He is the author of *Inscription and Modernity: From Wordsworth to Mandelstam* (2006), *Four Russian Serf Narratives* (2009), and articles on Soviet film, film theory, and biography. He is currently completing two books, *Dziga Vertov: Life and Work* and *True Songs of Freedom: The Russo-Soviet Reception of Uncle Tom's Cabin*.

Lynda Nead is Pevsner Professor of History of Art at Birkbeck College, University of London. She has published widely on various aspects of the history of visual culture and her recent publications include *Victorian Babylon: People, Streets and Images in Nineteenth-Century London* (2005) and *The Haunted Gallery: Painting, Photography, Film c.1900* (2007). She is currently working on a book about British visual culture in the 1950s called *Modernity Through a Mist*.

François Penz, an architect by training, teaches in the Faculty of Architecture and History of Art at the University of Cambridge. He co-founded Cambridge University Moving Image Studio (CUMIS, 1998–2005) and currently heads the Digital Studio for Research in Design, Visualisation and Communication where he runs the research and PhD program. He also contributes to the interdisciplinary university-wide MPhil in Screen Media and Cultures. François's work on the history of the relationship between architecture and the cinema informs his research in spatiality in synthetic imaging, computer augmented space, and creative digital media, with particular emphasis on the body in space in the context of architecture, and the narrative organization of space. In particular he

focuses on new forms of digital moving-image narratives and techniques with a view to visualize and communicate architecture and the city. He has written widely on the history of the relationship between cinema and architecture and the city, and most recently co-edited *Urban Cinematics* (2011). He was the principal investigator of an Arts and Humanities Research Council (AHRC)-funded pilot project, "Discursive Formations— Place, Narrative and Digitality in the Museum of the Future" (2007) and co-investigator of an AHRC network "MIST—Museum Interfaces, Spaces, Technologies" in 2010. François also co-organized an international conference on "Moving Image and Institution: Cinema and the Museum in the 21st Century," which took place in Cambridge in 2011.

Brigitte Peucker is the Elias Leavenworth Professor of German and a Professor of Film Studies at Yale University. She is currently at work on *Aesthetic Spaces: The Place of Art in Film*. Earlier books include *The Material Image: Art and the Real in Film* (2007), *Incorporating Images: Film and the Rival Arts* (1995), and *Lyric Descent in the German Romantic Tradition* (1987). She is the author of many essays on questions of representation in film and literature, and serves as director of graduate studies for the Combined Program in Film at Yale.

Lara Pucci is Lecturer in Art History at the University of Nottingham, where she teaches twentieth-century European visual culture. After completing a PhD at the Courtauld Institute of Art in 2007, she was British Academy Postdoctoral Fellow in Italian Studies at the University of Manchester (2007–10). The chapter in this volume is one of the outcomes of that postdoctoral project. Her research is concerned with intersections between political and visual cultures in Fascist and postwar Italy, most recently focusing on relationships between fascism and landscape. Her essays and reviews have appeared in *Immediations*, *Italian Studies*, the *Journal of the Warburg and Courtauld Institutes*, and the *Oxford Art Journal*.

Sally Shafto teaches film at Ibn Zohr University in its Polydisciplinary Faculty in Ouarzazate, Morocco. Her original training is in art history and she worked for several years at the Williams College Museum of Art in Williamstown, Massachusetts. She is a specialist of Jean-Luc Godard, the French New Wave, and international art cinema. Her interdisciplinary scholarship on Godard examines his films in the context of several major 20th-century artists such as Nicolas de Staël, Gerhard Richter, Robert Morris, and Marcel Duchamp. In Paris where she lived for ten years, she taught at the Institut International de l'Image et du Son and translated for *Cahiers du Cinéma*. In January 2010, she taught

a winter-term class on "Masterpieces of French" at Williams College. In 2006–7, she directed the 29th edition of the Big Muddy Film Festival at Southern Illinois University Carbondale. Her research on a group of French avant-garde films made in the aftermath of May 1968, called the Zanzibar Films, was published in 2007 in a bilingual edition by Paris Expérimental. She has presented these films at FIDMarseille, the Centre Pompidou, the ICA London, Anthology Film Archives (New York), and Facets Multimedia (Chicago). Her writings on film, in French and English, have appeared in a wide variety of journals including *Cinémathèque*, *CinémAction*, *Framework*, *Gastronomica*, *1895*, *Kinok*, and *Artforum*. She serves on the editorial board of *Framework*. Currently, she is working on Moroccan and Maghrebin film. Her festival reviews of Maghrebin film have appeared in the online journal *Senses of Cinema* where she has regularly contributed since 2006. Her article on the representation of the Algerian War in film is forthcoming in the French review *Migrance*. In 2011, she invited the well-known Moroccan filmmaker Daoud Aoulad-Syad to guest-lecture at the Polydiscplinary Faculty in Ouarzazate.

Noa Steimatsky is Associate Professor in the Department of Cinema and Media Studies at the University of Chicago. She was previously faculty member in the Department of the History of Art at Yale University. She is the recipient of several honors, among which the Fulbright Award, the Getty Research Grant, and the National Endowment for the Humanities Rome Prize. Steimatsky's first book, *Italian Locations: Reinhabiting the Past in Postwar Cinema* was published in 2008 by the University of Minnesota Press. Her new book, provisionally titled *On the Face of Film*, will be published by Oxford University Press. Her groundbreaking project on the use of the Cinecittà studios as a refugee camp in the postwar era, is being expanded into a book to be published by Donzelli Editore (Rome), and is also the source for a documentary film on the topic.

Jeremi Szaniawski is a doctoral candidate at Yale University. His dissertation deals with the cinema of Alexander Sokurov. His publications on Sokurov include an interview with the Russian director, published in *Critical Inquiry*. Other publications cover a wide range of topics including horror cinema, post-feminism, Ingmar Bergman, André Bazin, and Belgian cinema. During his years at Yale, Jeremi has shared his love of cinema not only by teaching numerous classes; co-organizing the inaugural Yale Film Studies graduate conference; co-founding and chairing The Cinema at the Whitney, Yale's 35mm film society; curating the Slavic Film Colloquium; but also by directing short films in collaboration with his students.

1
Introduction: A Cosmology of Contingency

Angela Dalle Vacche

Originally conceived as an international symposium at the Clark Institute in Williamstown, Massachusetts, during the month of March 2009, the purpose of this anthology is to look at the relation of film studies and art history and to ask: what do these two fields have to offer each other and why? Historically, movement has been both problematic and fascinating for artists and art historians who, in the plastic arts, produce and study mostly static objects. To be sure, the nineteenth-century invention of photography, a medium unconcerned with the human hand, paradoxically both deepened and bridged the gulf between the fine arts and popular media, thanks to the spreading of mechanical reproduction. By adding movement, the turn-of-the-century invention of the cinema combined illusion with the impression of reality, frail shadows with the speed of modern life. As a form of mummified change, or embalmed duration,[1] the cinema and the museum have respectively specialized in the perception of time passing and in the display of past traces. The widespread use of digital media in the twenty-first century has brought down the walls of the museum by opening up this eighteenth-century institution to marginalized areas of society. It is perhaps to slow down this new concept of the museum as a database of images accessible anywhere and anytime, that major institutions such as the Louvre, the Hermitage, and the Musée d'Orsay have started producing feature films, asking prominent directors to develop their own views about the space and the mission of the museum.

The topic of the museum in film can be invoked by pointing to some of its architectural features. For instance, the museum is a space of silent objects, guided tours, and red velvet ropes keeping the public away from precious pieces. There are also major differences between the cinema and the museum: the former is about voyeurism, while

1

the latter depends on exhibition. Yet this contrast does not prevent a beneficial exchange between two new partners. By siding with the art museum, mainstream cinema gains status and legitimacy, and by siding with fictional cinema, the museum becomes intriguing thanks to the unique vision of a strong director. Whereas the museum requires an ambulatory situation and encourages a mixture of distraction and concentration, the cinema still means sitting down in the darkness and paying attention to only one big luminous screen, with no educational labels on the side. In comparison to recent digital applications, such as cell-phone cinema or DVDs watched on small computer screens, the museum auditorium guarantees a cinema of atmosphere, ritual, and careful programming. With small movie theaters awash in financial difficulties, the museum is the new temple of cinephilia.

Ironically, the medium of the ephemeral and the fugitive moment, the cinema, has now become convenient for the museum in order to retrain its public to a certain degree of steady attention and respectful expectation. On one hand, the museum is keen on new media as a tool to penetrate into the deepest recesses of the public sphere; on the other, it also seems that the museum has been turning to talented directors—such as Alexander Sokurov for *Russian Ark* (2002), Olivier Assayas for *Summer Hours* (2008), and Hou Hsiao-Hsien for *Flight of the Red Balloon* (2008)—in order to explore death and memory, the storytelling power of objects, and the shaping force of human creativity. Indeed, editing and camera-work in these directors' fictional narratives enable the museum to break free from a pedantic and elitist reputation, while the filmic image soars to new heights of complexity. All of a sudden, knowledge and meaning handed from the top down surrender in front of a new perceptual approach where everything is in process. This sense of wonder involves Hou Hsiao-Hsien's child seeing his red balloon as art for the first time, Assayas's hesitant adults wondering about the life of objects, and Sokurov's invisible visitor questioning the odd authority of a French guide in a Russian museum.

Despite their diverse intellectual sensibilities, the film specialists and the art historians featured in this anthology share a common agenda: to explore the intricate and overlapping relations among photography, film, and new media; to question the opposition between the old-fashioned art documentary and the international art cinema of the postwar period; to interrogate theories of art and the history of film theory from the early days to the present in regard to Sergei Eisenstein's and André Bazin's oppositional paradigms of montage and the long take.

To guide the reader, I have structured the contents of the volume into sections which are updated and adapted from the original panels for the Clark Symposium. Although the topic of cinema and the museum was included, I have enlarged it in such a way to make it even more central in the title of the anthology itself, which is based on the English translation of Malraux's "imaginary museum"—where the French word *imaginaire* is not directly about the elimination of walls. In this regard, Dudley Andrew's essay on the "cultural aesthetics" of André Malraux, Walter Benjamin, and André Bazin can be considered the centerpiece of the anthology as a whole. In fact, Andrew does not only discuss Malraux and the museum in comparison to Bazin and Benjamin on art and photography, but he also argues that the cinema moves beyond its roots in art, popular culture, and technology. Thus, the cinema becomes a cosmology of contingency, as I shall explain at the end of this introduction by looking at *Summer Hours*.

Dudley Andrew writes:

> By taking unto themselves the flesh and blood of earthly existence, these inventions released painting to pursue its loftier spiritual mission. Bazin leapt past the more traditional Malraux, for whom art was a voice from beyond the earth. In place of the voice, Bazin believed in the trace, the remnants of something real recorded by photography and cinema. Fruit of science and popular culture, these technologies affect art certainly, and may be used in artistic creation, but their uses go well *beyond* it, or, if you prefer, slip *beneath* it.[2]

Despite their different sensibilities, Malraux, Benjamin, and Bazin shared a democratizing vision of culture which they developed from the early 1930s to the late 60s. It is puzzling to note that their hopes and ambitions for an intelligent and responsible mass culture regrettably remain unfulfilled even to this day. This goes to show that technological changes alone are not enough to develop solutions, because a popular education in the guise of an audiovisual literacy of different kinds of moving images is still in the making and is urgently necessary.

This anthology includes 15 original contributions and is divided into five sections. The first two sections are grafted on key areas in film studies: such as early cinema; Soviet film theory; and the phenomenological approach put forth by André Bazin from 1945 onward. The third section of the anthology deals with two case studies involving the tropes of landscape and the face in art history, visual studies, and film. Here I am using the term *visual studies* because Noa Steimatsky brings

autistic perception to her discussion about the reticence of the face in the cinema of Robert Bresson. Steimatsky's turn to neurology is no biographical argument about the French director. On the contrary, by reading autistic perception in Bresson's image, the author was inspired by the successful alliance between Roman Jakobson's study of aphasia and the disjunctive features of postwar, modernist filmmaking.

The fourth section of the anthology is structured around two seminal figures: Paul Cézanne and Francis Bacon, not to mention all the subsequent literary, biographical, and filmic exploration that these two painters have triggered beyond their own efforts. The reader may wonder about the absence of Andy Warhol, or Jean-Luc Godard's *Histoire du Cinéma*—not to mention the exclusion of video art. While these are certainly regretful lacunae, I am ready to put all the blame on myself and my decade-long obsession with Paul Cézanne in comparison to any other topic. Likewise Susan Felleman had a long-standing interest in Francis Bacon, so the make-up of this anthology is genuine enough to reflect the contributors' intellectual passions. There is also a completely different way in which the key topics in the title of this anthology could have been organized and presented. I am thinking, here, of Peter Greenaway's multimedia installations and films. Indeed, Greenaway's work explores stillness as much as movement, while it neither isolates nor fuses different media. As Brigitte Peucker explains in her Foreword, Greenaway seems to invite us to explore a new kind of constantly changing theatrical space where the viewers become actors of a more eccentric history of images, because each visitor can develop a unique sensorial experience which is no longer public and institutional but exploratory and playful.

Finally, the last section of the anthology is about cinema and the museum. And, despite my own optimistic reaction to a recent crop of fictional films about specific museums, my contributors' balance sheet is by far more cautious. There seems to be a general consensus that whenever the image is moving, there is still a big problem for neither the museum nor the history of art can fully endorse it. The recent acceptance of more live performance art inside and outside the museum walls may be one of the ways in which the museum is rethinking its own curatorial categories and aesthetic priorities. Indeed, one wonders whether the flourishing of more and more live performance art is related in any way to the increasing frequency of digital art in the world of art galleries. There, multimedia installations, many of them about the history of the cinema, have been highly successful through this second turn-of-the-century. Unfortunately, although digital art is at

home in the less canonical space of the gallery, the art museum tends to confine new media to the education department, perhaps prudently waiting for these new technologies to unravel their full potential and find their own vocation.

Image and movement

The first group of essays is devoted to the early period because the turn-of-the-century marks the birth of art history as an academic discipline, together with the technological invention of the cinema.[3] This is not to say that the aesthetic systems of art history always fit the problems of the cinema. Sometimes they do, sometimes they do not. In my essay on Alberti, Kepler, and the cinema, titled "Cinema and Art History: Film has Two Eyes" (2008,) I offer an example of an integrated approach between the two fields.[4] On the other hand, the phenomenon of color, which is already subjective and incredibly complicated, works in different ways in art and in film. And, of course, movement, which means staging as well as randomness, is missing. And yet, the analysis of the face, landscape, and objects in film benefits from readings about portraiture, landscape painting, and still-life. Art history, as a practice of bringing images to life, can help film specialists to look at intangible details and describe visual situations based on atmosphere. Conversely, film studies has been broadening art historians' grasp of modernity and modernism, since the cinema bypasses what art is about. At any rate, Brigitte Peucker's metaphor in the title of her book *Incorporating Images* (1995)[5] offers a good description of what cinema does with images from other media, in comparison to the incarnation process based on the indexical and contingent relation triggered by natural light between photographic imprint and its object referent.

Nell Andrew's essay is an invitation to think of dance as one of the sources of cinema and as one of the fundamental, yet neglected media of modernity which is so much about motion. For critics Clement Greenberg and Michael Fried, Modernist abstract art is about spatial, motionless, and self-absorbed or framed objects. By contrast, Nell Andrew argues that there was an alternative development of Modernist abstraction, one that included time and motion and whose agenda was not the separation of painting and dance, but rather the prolonging of vision in relation to an ever-changing and, therefore, temporally based way of seeing.

In line with Nell Andrew's call for a more integrated history, Dalle Vacche's comparison between the Lumière Brothers' short film *Partie*

d'Écarté (1896) and Cézanne's *The Card Players* (1890–96) is a re-reading of the origins of modernity. She discusses Cézanne's role in taking on a contradictory stance, split between painting and photography, image and movement, subjectivity in space and objectivity in time.

Some of Dalle Vacche's points in her essay on Cézanne and the Lumières resonate in Sally Shafto's theme of a special "encounter" between Danièle Huillet and Jean-Marie Straub with the famous painter. Shafto's method of analysis is quite unique, focusing on the exact temporal length of shots within a "carefully juxtaposed" parataxis of ten paintings, three film clips, three photographs of the painter—always outdoors—and several filmed images of contemporary rural and urban locations in Provence and in Paris. After noting that the first painting, in a series of ten, fills the first half hour of the film, Shafto informs us, later on, that the two filmmakers treat us to a generous "two-minute shot" in relation to another element of their parataxis. By specifying for how many minutes different shots go on, Shafto invokes the days of early cinema when the duration of a single, static view matched the length of filmstrip available inside a heavy and not easily movable apparatus that was used for both shooting and projecting.

The tension between the stable pictorial image and the movement of cinema is the topic of Lynda Nead's essay, which examines the trope of "the artist in his studio." By dividing her essay in two parts, one on Clouzot's innovative art documentary *The Mystery of Picasso* (1956) and the other on Robert W. Paul's early silent-era films, Nead demonstrates how the cinema belittles the painter's skills, parodies the myth of artistic creativity, and even claims to be superior to painting by virtue of its ability to set in motion static images. This continues to be the case in Clouzot's film, which does not explain the artist's secret technique but plainly displays Picasso's creativity as if his hand were comparable to a self-moving force tracing the contours of ever-changing figures.

In my view, by making the painter's hand invisible behind a special screen which can only register visual traces, Clouzot makes a film about the impact of an autonomous and automatic force. The sexualized body of the famous artist remains so much behind the screen that painting begins to look like an uncanny process imprinting itself on a white, flat surface. Put another way, movement itself steals the show, because Picasso's art looks like the nonhuman tracing of a *photographic recording* set in motion by the sheer energy of mysteriously self-propelled lines and patches of color.

Nead's dichotomy of high art and low culture in early cinema is all the more useful as soon as it is set in stark opposition to the same

problem in Soviet film theory, where it quickly disappears for the sake of a new social structure without class differences. After the Bolshevik Revolution of 1917, the key challenge for artists and filmmakers alike was to find a scientific way to implement revolutionary ideals. With great attention to the interplay between individual personalities and collective aspirations, John MacKay charts Alexander Rodchenko's modular solutions in designing objects, while he also comments on Dziga Vertov's contradictory stance in regard to propaganda.

Sergei Eisenstein's ways of handling both words and images on the printed page and on the filmic screen are as worthy of examination as Dziga Vertov's passion for nonfiction and political cinema. By examining the tension between the art-historical image and filmic movement in the light of the problem of quotation from the screen of cinema to the page of a book, Trond Lundemo revisits a topic first explored by Raymond Bellour.

For Eisenstein, intellectual montage is the last stage of an art-historical tendency moving toward the cinema, while his favorite method for quotation is the static shot of a work of art in close-up or a frame enlargement of a book page. For Vertov, instead, there is no difference between the movements inside the shot and the movements between the frames. Thus, his way of quoting is neither visual nor analogical, but can be, instead, strictly numerical. This is the case because Vertov is not interested in iconography, but only in the number of running frames for each shot in order to accurately quantify the variations in length which are the intervals between two shots.

On one hand, Lundemo dwells on some similarities between Vertov's use of numerical charts or tables, and the computational mentality of today's digital surveillance systems based on automated, numerical recognition patterns. On the other hand, Lundemo argues that Vertov's goal is the dispersion of film's energy into the social sphere, as if cinema could spin its own movement into some kind of gas-like entity generating enthusiasm, productivity, and cohesion among citizens for the sake of a new, socialist utopia.

Whereas, in Lundemo's essay, Eisenstein's kind of cinema emerges as more conservative in comparison to Vertov's, nevertheless Eisenstein—the brilliant inventor of intellectual montage—turns out to be a crucial influence in the work of Francis Bacon, as examined by Susan Felleman. She charts the influence of Buñuel's and Dalí's Surrealism on the British painter, so that the open mouths and the desperate screams of the victims in Eisenstein's Odessa steps travel into Bacon's deformed and highly emotional portraits.

In ways comparable to Sally Shafto's attention to clusters of filmic, pictorial, and literary texts at the heart of Straub and Huillet's method, Felleman is not only interested in Bacon and the cinema, but in how this powerful and controversial artist has unleashed a creative impulse involving such provocative figures as Kenneth Anger and David Lynch.

If Cézanne shifted the history of art from a focus on optical perception to bodily sensations, Bacon continued to move in the same visceral direction, but with an increased sense of physical pain and mental anguish. Abjection, nightmare, masochism, and horror are pervasive, while Bacon's interest in sensation is still pertinent today in response to the numbing overload of synthetic images in our digital society.

To be sure, the face and landscape are not only crucial art historical tropes, but key areas of inquiry among film theorists. The Hungarian writer/critic Béla Balázs argued that the face is a sort of microscopic landscape, while, in the writings of French philosopher Gilles Deleuze, the neologism "faciality" is the symptom of an increasing interest in surface and materiality. By taking an approach completely different from Béla Balázs's interest in the intensity of the face, Noa Steimatsky's essay discusses Bresson's de-facing filmic technique or "work in the negative," through which she proposes an alternative model of subject/object relations based on child autism.

The reader may wonder how autistic withdrawal and confusion in perceiving the mother's face would compare to Felleman's Surrealist equivalence among mouth, anus, and other corporeal openings in her essay on Bacon. By citing from Bresson's *Notes on Cinematography*, Steimatsky suggests that the use of the face in Bresson's cinema, and especially in *Au Hasard Balthazar* (1966), veers away from address, consciousness, and agency, while it taps into a primal and opaque overlap between the animal and the human spheres.

The allure of a primitive, a-historical subtext can also be detected in Alessandro Blasetti's *Terra Madre* (1931), a fascist film advocating rural and timeless values against the city, industrialization, and foreign influences. Lara Pucci's research tracks all the pictorial sources and artistic discourses presiding over the transformation of the landscape into an ideological and historical palimpsest, so layered and mediated that its artifice is suffocating. She pays a special degree of attention to the work of caricaturist Mino Maccari, in charge of *Il Selvaggio* (*The Wild One*)—a journal of the ruralist *Strapaese* movement. *Il Selvaggio* was in competition with *Novecento* (1900s), founded by Massimo Bontempelli, the official spokesperson for the *Stracittà* side of the Fascist cultural industry in favor of urban values.

Steimatsky's autistic model finds an echo in Simon Dixon's reference to neurologist Oliver Sacks's *The Man Who Mistook His Wife for a Hat* in his essay on Victor Erice's unconventional art documentary about painting a tree in real time. In Sacks' case study, Dixon explains, a patient was asked to paint a tree. The patient reached out to cover the object itself with paint. By contrast, Victor Erice rejects the unknowingly aesthetic solution proposed by Sacks' patient, because the Spanish artist limits himself to marking the leaves and the quinces of his own tree with a minimum of white paint to track change in real time. These modest markings make even more explicit the temporal discrepancy between Erice as an artist and his competitor, namely nature as the artist.

Cinema and museum

In his essay on Victor Erice's *El Sol del Membrillo/Dream of Light* (1992), Simon Dixon unpacks the Spanish title of the film, by addressing the issue of temporal disjuncture between an object in the world and its representation on canvas:

> [Victor Erice] wants to do more than capture an instant; he wants to capture a particular time of year, called in Spain "the sun of the quince tree" ... a time of seasonal change for trees, but metaphorically a time of reflection for those entering life's autumn.[6]

This metaphorical expression from the Spanish language finds an equivalent in the title of Olivier Assayas' recent film for the Musée d'Orsay on the relation between cinema and the museum and titled in French *L'Heure d'été* (*Summer Hours*, 2008). This French idiom refers to the longer summer days when the sun rises earlier and sets later, so that there is a lot more room for an active life in daylight. But the astronomical interpretation of the title is not enough. In fact, the lengthening of the day is comparable to the afterlife of objects in the museum.

Despite all the recent collaborations between the cinema and the museum, Ian Christie does not settle on the museum's good faith toward the cinema. For the British scholar, the only relative exception is the Museum of Modern Art in New York, which opened its first department of film in the 1930s. Although MoMA's film department was never fully integrated with the curatorial branches of the rest of the museum, it constitutes a rare acknowledgment of cinema as the major protagonist of the twentieth century.

Furthermore, Christie's assessment of Alexander Sokurov's *Russian Ark* as an elegy to a traditional notion of high art echoes Jeremi Szaniawski's similar conclusion in his essay on the same topic. Floating on the waves of history and inside the Hermitage museum, Sokurov's dreamy long take unravels layers of Russian history. Notwithstanding the lyrical quality of many episodes in *Russian Ark*, Christie and Szaniawski disapprove of its monumental and nostalgic stance.

In contrast to Christie's sense that the screening of a film is likely to be a disturbing presence inside a museum exhibition, Gavin Hogben at first sight may seem optimistic about digitalization throwing down the museum walls. He celebrates how these new media can engage the fugitive moment inside and outside the no-longer solid and monumental art museum.

As Hogben explains, the exemplary narrative of this liberating process seems to be the subject of an art documentary titled *Exit Through the Gift Shop* (2010), which brings together Thierry Guetta, a French-born compulsive filmmaker from Los Angeles, and Banksy, an elusive and poised British performance artist whose public interventions hover among the surreal apparition, the humorous prank, and guerrilla tactics.

It turns out that Thierry can shoot but cannot edit, whereas Banksy, after staging an amazing art opening, is eager to step behind the camera and shoot Thierry's very first and personal art opening. This swapping of positions in front and behind the camera, however, does not evolve into a new way of thinking about the cinema or in an innovative approach to art-making. Instead of a true reversal and exchange in power relations, the flip-flop between Thierry's inexhaustible image production and Banksy's hooded, secretive authorial persona turns out to be one more consumer-oriented manifestation of the culture industry. Thus Hogben decries the return of walls brought about by the arrival of the cinema in the museum, where the auditorium is now used as the new movie theater:

> Museums have film series these days, so it is likely that *Exit Through the Gift Shop* will make an appearance within their walls. But when this happens, and notwithstanding the panel discussion that will likely be tied into the event, will the museum have become just one more cinema—with Banksy's name on the marquee?[7]

Hogben's concern about the acceptance of the cinema displacing the celebration of the digital inside the museum, is very well founded, and this pecking order is probably due to the fact that the cinema is an older

medium than the digital, which is still mired in issues of piracy, privacy, security, and integrity.

At the same time, the ending of François Penz's essay suggests that the fall of the museum walls need not be an architectural and literal debunking, but it can also take place through innovative curatorial practices, and through the alliance of art and science by blurring the boundaries between the art museum and the natural history museum. Penz describes his visit to the new natural history or ethnographic museum of Paris, the Musée du Quai Branly, where architect Jean Nouvel's transformation of this museum-space into a cinema-like site brings to fruition Malraux's dream of the imaginary museum as a place of experimentation, rather than just a site of preservation and celebration of canonized objects and timeless values out of touch with competing histories and lived experience.

Photographic parthenogenesis, contingency, the long take

At the very end of this introduction about essays dealing with film, art, and new media, something must be said about the difference between a photographic and a digital image in light of the contrast between natural, biological and artificial or electronic reproduction. As Lev Manovich explains in *The Language of New Media*,[8] digital images are spatial, haptic, and, I would add, comparable to clones. This is the case because they are based on binary codes made of ones and zeros in computers programmed with algorithms inside these images' pixels. This means that the digital image is a synthetic product of numbers whose visual appearance is referential whenever it looks like its origin, but it does not spontaneously constitute itself through a living source, because it relies on microprocessors and scanning devices. By contrast, photographs are natural, automatic, physio-chemical phenomena triggered by the light hitting a sensitive surface, and autonomously taking place between energy and matter. Neither digital images nor photographs tell the truth, but with photography, regardless of how we interpret what we see, we can be sure of at least one thing: something staged or random ought to have been there at a particular moment in time and space, otherwise the light has nothing to contour and cannot leave its imprint. Highly malleable, digital images raise ethical issues in regard to whom or what was there, which become especially prominent in relation to history, memory, and, of course, the museum.

A good example of how digital aesthetics give way to historical ethics is the Israeli animation *Waltz with Bashir* (2008). This film narrates

the amnesia of two soldiers, as they come to terms with the haunting aftermath of a genocide. Significantly, this digital animation ends with the photographic shot of a massacre. In contrast to the black-and-white animation, the final image of mangled bodies is so blurry that it can hardly be interpreted or read, but it is there, at the very end of the film, simply to call attention to the *de facto* documentary status of photography, in comparison to prototype-based drawings from the rest of the film. In *Waltz with Bashir*, water can be shown only as a thick black line and there is no fluid play of natural light and shade.

How does the encounter between cinema and the museum in recent films comment on the ethics of visual culture and art, since both photography and the museum are devoted to the preservation of memory after death? Unlike air and water, nothing is volatile or evaporates in the museum, where each object is solid and has its place in a temperature-controlled narrative that guarantees reassuring connections across idealistic categories of art, truth, beauty, and authenticity.

In his famous essay written between 1943 and 1945, "The Ontology of the Photographic Image," André Bazin remarks: "photography actually contributes something to the order of natural creation *instead* of providing a substitute for it."[9] With this sentence, Bazin is telling us that photographic reproduction is about a natural performing act triggered by randomness, with no involvement of the human hand. Light involves chance, so that its photo-writing has no intentional design and can range from a few dead leaves to some seeds scattered on the ground. Molded on these accidental objects, a photographic impression is born as something new each time, in the moment, out of energy bouncing off matter. Performance is appropriate here, because photography involves contingency. By bearing witness to something that was indeed there in the past, photography is also about a birthing process into the new and as such it is a natural image that exists inside a sort of future anterior.[10] Were we to look for a comparison in nonhuman biology, photography comes close to a form of self-reproduction called *parthenogenesis*. The word parthenogenesis comes from the Greek *Parthenon* or "virgin," because no male is involved.

Parthenogenesis was a topic dear to Jean Rostand, a prominent French scientist whose research was explored by the writer and documentary filmmaker Nicole Védrès in her films *Life Begins Tomorrow* (1952) and *At the Frontiers of Man* (1953). Likewise parthenogenesis was discussed in Jean Painlevé's scientific surrealist documentaries about minuscule organisms living under 10 mm of water. Painlevé was also in charge of the film and science section in the newly opened Palais

de la Découverte during the 1937 International Paris Exposition. At this point in time, André Bazin was about to finish his training at the École Normale d'Instituteurs in La Rochelle, France, before returning for more coursework in Paris. By 1943, after a solid education in science and mathematics, literature, philosophy, and the arts, Bazin was well aware of the role played by contingency in photography, and he greatly admired Painlevé's films from the 1920s onward. To be sure, Painlevé's paper archive includes several references to parthenogenesis, but also to chance in relation to genetics.[11] In 1947 André Bazin wrote a famous review of Painlevé's cinema entitled "Science Film: Accidental Beauty," where in a sort of surrealist way, randomness breeds aesthetics. In order to celebrate the cinema as a technology and a popular medium in dialogue, but also separately from the other arts all linked to a human element, Bazin was especially keen on how parthenogenesis or photographic self-birth can refer to an anti-anthropocentric and scientific kind of creativity.[12]

In Roland Barthes' words, photography is a message without a code, namely the automatic incarnation[13] of invisible time in clear antithesis with the digital image, which is all about measuring space, design, control. Just as with any natural event, every single photograph is new and different since every single moment accounts for this difference, or virginal quality. Unlike the media of engraving and lithography, which are comparable to printing and devoted to the diffusion in black-and-white of handmade images, photography is not an additional expanded stage of these techniques, but a radical rupture in the history of mechanical reproduction across the centuries.[14] However, photographic parthenogenesis alone is not enough to account for the cinema as a medium. The reproductive cycle leading to the public, mass institution of the cinema is not over yet because it requires the development and circulation of photographic shots as copies; it is only at this later stage that all the different photographic shots as copies and all the different photographic prints are equal among themselves. This final stage of mechanical reproduction corresponds to the mummy-like statuettes mentioned by Bazin in "The Ontology of the Photographic Image" (p. 9), when he discusses the possibility of thieves accessing the pyramid and stealing the real mummy or original negative.

Just as in parthenogenesis with no male involved, photography is a virginal fleshing-out of energy, characterized by the complete absence of the human hand. This absence of the hand is in clear contrast with what happens during the execution of a painting, a drawing, or a digital animation. In these anthropocentric manual and computational media,

the artist/designer *incorporates* or matches the mental image of a previous sign. Photography, by contrast, *incarnates* a nonhuman, contingent source of light through the tracing of an object.[15] The digital designer is closer to a traditional artist than to photographic parthenogenesis.

Finally, were we to translate Bazin's biological subtext in his own words, photography is, by definition, pointing to "the natural image of a world that we neither know nor can see."[16] This unknowable world is the real, the flow of natural time, or the spatiotemporal continuum that we are made of, namely death. Within this context, only the continuous camera movement of the long take, in contrast to montage, can tune us into an illusory and temporary material duration, a "being-in-time." Through this particular way of filming, not only are we free to try out relationships among all the elements contained in a mobile frame with penetrable borders, but corrosive time itself turns into a volumetric cross-section of uncharted experience whose facets in space are as rich as our own sense of living interiority and competing moral choices.[17] In the wake of Dudley Andrew's essay which underlines how cinema slips "beyond" and "beneath" art, I would argue that the long take is an open-ended stylistic choice meant to suggest intricate webs of self-delusion, free will, and chance in the lives of Assayas's characters.

It is this heuristic definition of the cinema that subtends Assayas's use of long takes at the beginning and at the end of his film about the museum, *Summer Hours*. Briefly, the plot: an elderly mother, Hélène Berthier (Edith Scob), asks Frédéric (Charles Berling), her eldest son, to supervise the transmission of her art collection to the Musée d'Orsay. The family country house with the collection is very special to Hélène because it represents the memories of her life with Paul Berthier, a reasonably well-known artist. More specifically, Berthier has left behind two paintings by Corot, one Art Deco armoire, one Art Nouveau writing desk, two large panels by Odilon Redon, and many sketchbooks. In antithesis to his carefully assembled art pieces, Berthier's own paintings are scattered across many individuals and places. Thus, we begin to understand that there are two sets of children living side-by-side in this film: the object-children and the human children. As long as Hélène is alive, the art objects are all in one place: the family country home; on the contrary, just like Paul's own paintings, Edith's three adult children have all flown the nest to disperse themselves in different countries and professions.

Within the category of the object-children, there are also some art pieces whose official historical value is a small thing in comparison to strong personal and family memories. For instance, an airplane toy hides

inside a precious Art Deco armoire; at the bottom of a wooden and glass display cabinet, there is a grocery bag containing the pieces of a statuette by Degas which Hélène's two sons broke by accident. Besides art objects, the film sets up additional categories that have to do with aesthetically valueless, but utilitarian or emotionally charged objects due to generational difference, personal attachment, or conflict in lifestyle. Assayas' exploration of the cinema and the museum through objects points back to Bazin's photographic ontology as "objectivity in time,"[18] where the word "objectivity" has nothing to do with the truth.

For the French theorist, the recording camera-eye, unlike the human eye imbued with subjective biases, is an indifferent one. Thus, it levels all things in favor of either a fresh perception or unexpected parallels questioning worn-out value judgments. The camera-eye expands the photographic way of seeing into the virginal stance of parthenogenesis, so that the world viewed through the cinema offers a sense of anti-anthropocentric and indifferent being there, without a pre-set utilitarian aim.

This world viewed through the cinema is so aloof and self-sufficient that it puts into crisis our trust in knowledge over perception. For Maurice Merleau-Ponty, perception of things as they appear during their immediate manifestation has primacy over analytical knowledge of what is really going on.[19] Although indebted to Merleau-Ponty's for his phenomenology in the present tense, where the act of seeing always happens anew or for the first time, the French film critic and the philosopher also differ. On one hand, by embodying his subject, Merleau-Ponty went against Descartes' body-less thinking self with no sensations. On the other, by embracing Bergson's duration and life as constant motion, Bazin could not accept any longer the classical humanist subject depicted by Leonardo with his Vitruvian man. In fact, eager to develop a new kind of humanism open to the Other, Bazin's view of the cinema is rooted in an anti-anthropocentric, kinetic outlook that relies on an automatic image of the world or on an image that needs no human hand to take place and come into being.

The point of this de-centering of the subject through cinema's movement, is to make us understand how previous knowledge can prevent us from seeing things in a new way. For Bazin, this is the great promise of cinema: the possibility to see according to human perception, but in a nonhuman way through the fresh eye of the camera. Through the close-up where the very far and very small can look like the very near and the very large, film's technology reminds us of its ancestors in the telescope and the microscope, two instruments through

which the human eye can look at both stars and bacteria. Yet, with Bazin, these two nonhuman ways of seeing never become superhuman or godlike, because, despite his de-centering of the subject, Bazin still believes in man's fundamental ability to learn, change, and relate to that which is different or new. Whenever this anti-anthropocentric way of seeing takes place, cinema enables us to give birth to a new inner self out of a parthenogenesis based on the contingency of an encounter with something profoundly other whose difference is possible to love.

The purpose of this rebirth of the inner self is a shared duality, or Merleau-Ponty's "chiasmus" between mind and body, the human and the nonhuman, us and the world that contains us. Within this anti-anthropocentric framework, the long take is a crucial stylistic strategy to position us in a broader world that shapes itself according to material spatial coordinates that we can experience and interrogate, but, according to Bazin, not alter or reconfigure for the sake of an intellectual agenda or a particular thesis that would rule out uncharted possibilities of encounter within that very same space.

Interestingly enough, the décor of *Summer Hours* is without family photographs, except for one picture depicting Hélène and Paul Berthier eating with friends and family *en plein air*. This very same picture belongs to an illustrated book, which is a museum catalogue for a traveling exhibition about Paul Berthier. In addition to this glimpse of private life, there is another quick hint about photography. This second, but absolutely crucial photographic reference is placed at the very beginning of the film and picked up again at the very end. It involves Frédéric's oldest daughter who remains marginal in *Summer Hours'* narrative. And the young woman's peripheral placement until the end of the film, is comparable to the way photography has truly shifted to the periphery of visual culture in our digital age. Regardless of this apparent marginalization of youth and photography, *Summer Hours* opens and closes with two extended long takes of young people running freely through the landscape. And photography is always a new-born, natural event.

Photography first comes up at the beginning of the film. This is when the Berthier children are involved in a treasure hunt among the trees, but their map leading to the riches looks like a white page. The map-drawing has been done in invisible ink. Just like the traces of a photographic negative, this chemical substance needs the heat of a flame to surface on the page in order to become visible. There is also a second long take that stylistically and thematically rhymes with the first one. At the end of *Summer Hours*, Hélène's grand-daughter, Sylvie (Alice

de Lencquesaing), shares with her boyfriend her memories of a painting of a young Hélène picking cherries by Berthier which the family no longer owns. The problem is that, due to the absence of both painting and photographs in regard to this episode, granddaughter Sylvie cannot remember the position of the old house in relation to Hélène. Yet this blind spot points to the limited strength of personal knowledge. And it is precisely within these areas of amnesia or loss where the museum strives to play a role.

Assayas' film is soft-spoken and profound, a quasi-documentary essay about legal, financial, fiscal, and funeral arrangements, and a fiction that involves the actual specialists and administrators of the Musée d'Orsay. In *Summer Hours*, the museum appears only at the end, when Frédéric and his wife Lisa (Dominique Reymond) look at their family collection in a new context, next to unknown objects and gazed upon by anonymous tourists. The result is an uncanny sense of displacement. By now, their old family country house has become a mummy-like body without organs. On the contrary, the museum has all its restored objects in place, but there is no flame to warm up with love its highly control-led public space and to kindle new perceptions of people and things. Frédéric feels that Hélène's objects sit inside an invisible cage, but it is also true that the museum restoration specialists have repaired the Degas statuette he and his brother damaged during their childhood.

It would be too one-sided to say that Assayas proposes a negative view of the museum, but it is also true that in his film, art restoration is comparable to plastic surgery over an already dead patient for the sake of good appearances. The only object from Hélène's country home that goes on living is a green vase the family housekeeper takes to her own modest home. Ironically, this vase is not the same one Hélène thought her housekeeper would have liked to have. On one hand, this discrep-ancy calls attention to how anecdotes from daily life are subjective, and therefore, eloquent about misperceptions. On the other, we do not even need to see the green vase in its new setting, the housekeeper's personal home. Although this very same green vase could be lost or broken in the future, we are already sure that this object will be alive and loved more than anything else in the museum. By contrast, its companion-objects in the museum experience a less personal kind of love, even though they are so safely guarded, labeled, and accurately displayed.

Something vital is missing in Assayas' Musée d'Orsay, while Frédéric does indulge in negative nostalgia. Yet his wife, Lisa, reminds him of the weekend party that their children, Sylvie and Pierre, have organized in their old country home now on sale. She persuades her husband that

their youthful presence alone will bring the old place back to life. As they reminisce about their own young romance through an affectionate laughter of complicity, they know that new loves will be born during this new gathering in Hélène's home. If the museum represents the public scene in contrast to a private family scenario, Sylvie's and Pierre's generation of iPods, laptops, multicultural ties, and freewheeling experimentation is a third scene well outside the constraints of personal history and official culture, family duties, and museum rules alike. Sylvie and Pierre are the most recent generation, one that neither goes to the cinema nor to the museum, because their access to everything is totally digital, anywhere anytime. The break with the previous media, however, is not so extreme that amnesia or indifference has settled in. There are still powerful linking memories across relationships and technologies which Assayas unravels through his final long take, by following Sylvie and Pierre into the open countryside. Like her grand-mother Hélène, Sylvie knows how to bring people together and foster a whole culture of leisure, art-making, and self-interrogation. Together with her boyfriend, the young woman jumps over a brick wall, so that the two leave the past behind and disappear into a thick forest nearby. Meanwhile their two figures look microscopic, inside an enveloping countryside shown from above through an aerial shot continuously developed out of an ongoing long take.

Why do Sylvie and Pierre disappear into nature? Is Assayas' film in favor of art-historical tradition or of the digital future? The digital thrives next to the pictorial in *Summer Hours* because they are both anthropo-centric media in opposition to the anti-anthropocentric filmic element. The latter is steeped in the nonhuman realm of contingency and in an outward-bound force that has to do with the constant changes going on outside the museum, either in the street or in nature. During the final museum sequence of Assayas' film, one anonymous young character answers his cell phone: he plans to go to the movies after the guided tour around Hélène's and Paul's art objects. The links between these objects and their former owners are forever lost, while a new centrifugal spin begins by taking one person inside the museum away from the history of art back to the cinema. In the end, the museum saves objects, but erases personal stories about relationships. By contrast, the cinema is always about beginnings and outward-bound spins of energy originat-ing from absent objects, but forming new bonds.

Institutionally, the digital is not the enemy of photographic cinema, but only another medium and another phase with ethical consequences for the twenty-first century that are still unknown. Indeed, there are

unavoidable ontological differences between these two technologies. Along with the leisure culture of Impressionist painting and early cinema, small hints about photography loom large in *Summer Hours*. Unlike previous and future media, cinema is quite unique because—with its mixture of stillness and movement, illusion and tracing, absence and presence—it can take us in and out of atmospheres and rhythms which are so profound and yet ephemeral that both art and science would be at a loss in producing them with the same intensity or explaining them with equal clarity. André Bazin was the first theorist to fully understand the ethical and aesthetic implications of this definition of the cinema as a cosmology of contingency rooted in daily life and in human perception. Considering the analogy between the photographic phenomenon and parthenogenesis in the natural world, one wonders whether new directions for the traditional art museum might be found in dialogues with the natural history museum, the curiosity cabinet, and the philosophy of science. In my view, it would be desirable to see digital imaging and new media of all kinds take the lead in bridging the gap between art and science through the cinema. Yet, considering that photography as a natural image is unique and is always new, it is unlikely that we shall stop studying it, especially because it is a special lens through which to look at the twentieth century on film. And what a century it was: the century of the cinema!

Notes

1. On cinema and the museum, the best book is P. Rosen, *Change Mummified: Cinema, Historicity, Theory* (Minneapolis, MN: University of Minnesota Press, 2001).
2. D. Andrew, see Chapter 7, p. 126, this volume.
3. On these two overlapping fields, see my edited collection: *The Visual Turn: Classical Film Theory and Art History* (New Brunswick, NJ: Rutgers University Press, 2003).
4. A. Dalle Vacche, "Cinema and Art History: Film Has Two Eyes," in *The SAGE Handbook of Film Studies*, ed. J. Donald and M. Renov (London; Thousand Oaks, Calif.: Sage, 2008, pp. 180–98).
5. B. Peucker, *Incorporating Images: Film and the Rival Arts* (Princeton, NJ: Princeton University Press, 1995).
6. S. Dixon, see Chapter 8, p. 144, this volume.
7. G. Hogben, see Chapter 16, p. 315, this volume.
8. L. Manovich, *The Language of New Media* (Cambridge, MA: MIT Press, 2002).
9. A. Bazin, "The Ontology of the Photographic Image," *What is Cinema?* trans. H. Gray (Berkeley, CA: University of California Press, 1967, vol. 1, p. 15).

10. For this concept of time, I am indebted to D. Torlasco, *The Time of Crime: Phenomenology, Psychoanalysis, Italian Film* (Palo Alto, CA: Stanford University Press, 2008).
11. I wish to thank Brigitte Berg for sharing her personal archive about Jean Painlevé with me. I am also grateful to Fox Harrell, Massachusetts Institute of Technology, for his comments on the difference between the digital and the photographic.
12. On the theme of an anti-anthropocentric scientific creativity, see my "The Difference of Cinema in the System of the Arts," in *Opening Bazin: Postwar Film Theory and Its Afterlife*, eds D. Andrew and H. Joubert-Laurencin (New York: Oxford University Press, 2011, pp. 142–52).
13. R. Barthes, *Image, Music, Text*, trans. S. Heath (New York: Hill and Wang, 1977).
14. In regard to lithography and engraving, see W. Benjamin, "The Work of Art in the Age of Mechanical Reproduction" (1936), *Illuminations*, trans. H. Zohn (New York: Schocken Books, 1968, p. 219).
15. On photography and incarnation, see D. Andrew, *What Cinema Is! Bazin's Quest and Its Charge* (Malden, MA: Wiley-Blackwell, 2010); M.-J. Mondzain, *Image, Icon, Economy: The Byzantine Origins of the Contemporary Imaginary*, trans. R. Franses (Stanford, CA: Stanford University Press, 2005).
16. A. Bazin, "The Ontology of the Photographic Image," p. 15.
17. H. Bergson, *Time and Free Will: An Essay on the Immediate Data of Consciousness* (New York: Macmillan, 1910).
18. A. Bazin, "The Ontology of the Photographic Image," p. 14: "Viewed in this perspective, the cinema is objectivity in time."
19. M. Merleau-Ponty, *The Phenomenology of Perception* (1945) (New York: Routledge, 2011).

Part I
Early Cinema

2
The Artist's Studio: The Affair of Art and Film

Lynda Nead

> Hair o' the head, burnt clouts, chalk, merds, and clay,
> Powder of bones, scalings of iron, glass,
> And worlds of other strange ingredients,
> Would burst a man to name
>
> Ben Jonson, *The Alchemist*, 1612

Jonson's list of ingredients evokes the weird and marvelous world of the alchemist: the magician who could take these macabre and banal materials and through his knowledge and power turn them into gold. The enduring image of the alchemist's laboratory, where this transmutation takes place, has become a metaphor for other forms of mysterious creativity and is, one suspects, behind prevailing myths of artistic creativity and our ongoing fascination with the artist's studio as the alchemic site of artistic transformation. Alchemy was a heady mixture of philosophy, art, and science, the precursor of modern chemistry, and the stuff of the creative imagination. It dealt with illusions, with things not being what they seemed, and with sight's fallibility in comprehending the true nature of objects. The ultimate goal of the alchemist was the transmutation of matter, of base materials, to gold, and it was this process of transformation and its questioning of the physical universe through formal experimentation that made alchemy an art as much as a science.

Like the seventeenth-century alchemists, artists take the base forms of pigment, oil, canvas, stone, or clay and turn them into the exceptional and priceless images of art. The processes involved in these acts of artistic creation have become as much of a mystery or mythology as the metaphysical experiments of alchemy. In alchemy and in art, the additional elements that are added to base substances and that create value are the reputation and identity of the alchemist/artist as they are enacted in the

space of the laboratory/studio. Artistic identity, it could be said, is the philosopher's stone that drives the history of Western art.

From its first years as a medium of public entertainment, film adopted the theme of the artist in his studio as a subject for comedies, romances, tragedies, and nonfiction. Indeed filmmakers seem to have had an ongoing fascination with the processes of art, images of the artist, and the setting of the studio. Film both perpetuates and parodies the myth of artistic creativity. In a relationship reminiscent of a sexual affair, the history of film's representation of artistic production embraces fascination and longing; envy and attraction; admiration and deference. At times the sole purpose of film seems to be to ridicule the figure of the artist and to demythologize the processes of artistic creativity; in other instances, film appears committed to capturing and sustaining the alchemic myth, revealing and concealing the processes of artistic genius. In order to elaborate these ideas, this essay takes two case studies in the long affair of art and film: the first is a group of films made in the early 1900s, and the second is the making of Henri-Georges Clouzot's Le Mystère Picasso (1956).

There are a striking number of films made in the 1890s and early 1900s that take as their subject the artist's studio, and that tell us a great deal about how filmmakers regarded fine artists in this critical period of cultural transformation. In these films, the artist's studio is the setting for film to perform its astonishing visual tricks. Makers of trick or transformation films used all the available techniques of filmed illusion, such as stop-motion effects, multiple exposure, and dissolves, to create spectacular visions of the artist's studio in which paintings are made in the blink of an eye, pictures come to life and taunt the bemused artist, and devils appear from thin air and wreak artistic havoc. Artists are invariably made to look like fools and their attempts at artistic creativity are ridiculed, in the end typically the artist is abandoned to his unrequited desire and inadequate creative powers. Although fine art had much greater cultural value and status in the 1890s than the emergent, popular medium of cinema, these films can be seen as the way in which the first filmmakers asserted their technological superiority and illusionistic skills. If a painting could imitate reality, film could go one better and actually *animate* the picture and transform it into a living form. The artist's studio became a battleground for a fascinating and frequently comic cultural struggle between the creative powers of art and film.

In Robert Paul's film *The Devil in the Studio* (1901), the artist is subjected to a series of humiliating transformations when Mephisto materializes

from a tube of paint in the studio where the artist is painting a model. Paul's trade catalogue of 1900–01 describes the ensuing play with visual images:

> The painter is astonished to see work done without effort, and shakes his head dubiously at his own portrait filling the canvas The canvas is once more blank, and, as the artist stands ... he perceives, to his great amazement, that the model is slowly fading from her platform, and at the same time is gradually appearing on the canvas like a developing photograph ... the artist, in a transport of delight at the production of a painting in a few minutes, rushes from the studio and quickly returns with a dealer Just as they turn to look at the picture, it immediately changes to a comic caricature making fun of them.
>
> (Paul, 1900–01, 4)

Driven wild with frustration at the demon's tricks, the artist finally wrecks his own canvas and smashes up the studio. In the face of the sequence of transformations, the artist is a helpless victim and even the art dealer turns out to be Mephisto. As his creative powers are progressively stripped away, the artist can do nothing but destroy his own means of picture-making.

Artists in these films are a pretty sorry bunch. Either sleeping or in a state of waking amazement, they are rarely at work and are always outdone by the film's magic effects or their demonic personification. It can often seem that the central purpose of these films of enchanted painting set in the artist's studio is to undermine the long-established mythology of artistic creativity. Trick effects are used to flaunt the ease with which film can simulate the making and unmaking of art and impart life to the lifeless image. In the face of this technical ease, the artists in these films are often left in a state of helpless rage, or resigned sleep!

Film played with the *time* of painting. If masterpieces took a long time to create, then magic films could make them in an instant; and when the painting was finally complete, film would transform the still image into a living human being. Thomas Edison's 1901 film *The Artist's Dilemma* begins with the familiar scene of the artist asleep in his studio. As he sleeps, the door of a carved grandfather clock opens and out steps a female figure in a dancer's costume (Figure 2.1). She wakes the artist who takes her to a raised platform and indicates that he wishes to paint her portrait. Placing her in a conventional pose, reclining against a pedestal and holding a bouquet of flowers (indeed,

Figure 2.1 Thomas Edison, *The Artist's Dilemma*, 1901. Film stills. Courtesy: Library of Congress, Motion Picture, Broadcasting and Recorded Sound Division

the very conventionality of the pose signifies the painterly status of the proposed image), he takes up his palette, brushes, and mahl stick. As he begins work on his canvas another figure emerges from the clock: half clown, half demon, this mysterious figure is the *genius technologi*, or the spirit of film, who will unravel all the artist's attempts to paint a likeness of the model.

The clown shows his admiration for the model and begins to disrupt the artist's work, suggesting that he can do better. Rejecting the painter's palette and brushes, he reaches into the clock to grab a large bucket of paint and a huge paintbrush. With a few strokes he covers the canvas and, to the distress and amazement of the artist, a perfect likeness of the model is produced. As film historian Mary Ann Doane has shown, this section of the film was achieved by reverse motion, so that a sequence in which the demon actually painted a rough coat of black paint over a finished portrait of the model was run backwards to look as though a few strokes had produced the finished picture (Doane, 2002, 109). The clown's erasure of the painted portrait simultaneously produces his own magical image. But there is more. The clown goes over to his painting and brings the painted woman to life; clown and model then taunt and ridicule the artist who is finally left alone, with a blank canvas.

Through the figure of the demon/clown, film usurps all the illusionistic functions of art. It can make and unmake a painting in a moment, and it can animate the lifeless image. The artist is the dupe; turned upon by both his model and his living image; humiliated both as a maker of images and as a man. There can be no artistic genius or masterpiece in this bizarre film world, just the defeated painter and the agonizing, impotent blankness of the empty canvas.

When pictures come to life, they do not become part of the ordinary, everyday world but enter a kind of dream time, haunted by visions and mischief-makers. This is the space created by magic films, with their

relentless mockery of still images and traditional media. In order to demonstrate its own mastery, however, film had to keep returning to the still image—the basic component of its own modern life—and show its power to transform stasis to motion. In the trick films of Edison, Paul, Méliès, and Pathé, the art image and the film image can be said to be in an aesthetic dialogue, jockeying for position and influence in the new world of early twentieth-century media.

The relationship between art and film continues to be a contested one, but the exhilarating images of film's early years show us the first moments of this ongoing cultural affair. The studio is a place of magic art, of alchemical transformations and enchanted paintings. But if the films of the 1900s can be said to have been involved in a process of demystification of high art, then more recent films pay more respect to the artist and his studio. As film directors assumed the personal creative vision and cultural status of artists in the second half of the nineteenth century, it was not surprising that films made in the context of this shift were more reverent in their representations of artistic creativity and paid homage to the magic of great art.

In 1955, Picasso agreed to be the subject of a documentary by the French director Henri-Georges Clouzot, in which he would be filmed in the act of drawing and painting. The film premiered at the 1956 Cannes Film Festival where it was awarded the Prix du Jury and hailed as a major innovation in the representation of the artist at work. By the mid-1950s Picasso was reaching the peak of his artistic reputation—in his late middle age he embodied the myth of male artistic creativity. As Alexander Liberman wrote about him in 1960:

> The penetration of his body is prodigious. His body, old but strongly muscled, is the body of a prehistoric man. His neck is short and bull-like, his skull deep and large He seems incessantly hunting to fix his visual prey, as the cave artist fixed his prey on the walls of Altamira.
>
> (Liberman, 1988, 104)

Here we have a kind of atavistic masculinity; a crude physicality expressing an essential, predatory sexuality. But the metaphorical register shifts; Liberman continues directly:

> His eyes are constantly searching form, dimension and movement. All of his gestures are precise and incisive. A pencil in his hand becomes a scalpel ready to cut the space before him.

Here I simply want to stress the centrality of the artist's body to the formation of artistic identity; but it does not end there. As well as *embodiment*, there is also a gradually staged movement away from the body of the artist, as the aura of artistic presence is displaced onto substitute objects. In a photograph of the cast of Picasso's hand by Brassaï, Picasso's corporeal intensity is passed on to the image of his hand: "a monument to a sovereign power and balance, a fleshy palm, a prominent, sensual Mount of Venus" (Brassaï, 1982, 172). The associative pathway continues to inanimate objects; for example, his studio. Brassaï made a number of photographic studies of Picasso's studio; carefully staged and lit still lifes, strategically ordered disorder. As one of the contributors to the catalogue of the 1987 exhibition *Picasso vu par Brassaï*, put it: "The most beautiful 'portraits' of Picasso are without doubt those of his studios ... for Picasso these sites of creation ... are like a second 'skin'" (Bernaduc, 1987, 13). The studio becomes the corporeal extension of the artist and traces of the body are detected at all turns.

This process of displacement of the artist's body onto the objects of art reaches its apogee in the image of the blank canvas or paper. There are a surprising number of images of Picasso in front of blank or empty surfaces in which the untouched paper or canvas is countered by the physical presence of Picasso (Figure 2.2). But whereas the image of the blank canvas could be read as a sign of artistic impotence in the trick films of the early 1900s, here a different meaning can be drawn, in which the untouched surface is an indication of the sublimity of the artist's creative genius, something that is so unique and ephemeral that it is beyond pictorial representation. The blankness of the untouched surface—or screen—can itself bear the corporeal connotations of the artist's body. It is a sign of vast potentiality, empty and full of meaning at the same time. In this context, the representation of the artist at work, in the act of creativity, reveals the very moment when artistic identity and a precarious masculinity are inscribed.

There are powerful structural links between phallic metaphors, male sexuality, and the making of art. In *Spurs: Nietzsche's Styles*, Jacques Derrida examines the concept of style in philosophical and critical writing and the metaphors that embody the concept. Starting from the buried reference to the *stylus*, Derrida argues that style is usually conceived of as a pointed, sharp, spurred projective. This idea is part of an opposition between the pointed, the punctual, and the hostile material that surrounds it and that it resists or perforates:

In the question of style there is always the weight or *examen* of some pointed object. At times this object might be only a quill or a stylus.

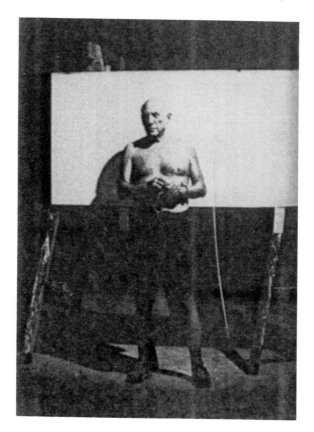

Figure 2.2 Edward Quinn, portrait of Picasso taken during the filming of *Le Myst e Picasso*, from E. Quinn, *Picasso: Photographs from 1951–1972* (New York: Barr 's, 1980), fig. 66

B t it could just as easily be a stiletto, or even a rapier. Such objects n ght be used in a vicious attack against what philosophy appeals t in the name of matter or matrix, an attack whose thrust could n t but leave its mark, could not but inscribe there some imprint o form ... it seems, style also uses its spur (*éperon*) as a means of p)tection against the terrifying, blinding mortal threat [of that] w ich *presents* itself into view.

(Derrida, 1979, 37, 39)

Styl is figured as masculinized, phallic power and the medium that it resis 5, which may be imagined as paper, canvas, or screen, is woman. The are two main elements in Derrida's analysis of the gendering of

style: the phallic, marking instrument of style and the awaiting surface which is both receptive and also a terrifying and unknown force. Both of these figures are played out with remarkable insistence in representations of Picasso. This is, surely, the framework for understanding those images of the artist standing before his blank canvas/paper. The artist's silhouette becomes a phallic substitute for the "stylus" and the surface represents those indeterminate layers of resistant matter. Clearly, there has been a significant shift in photography's imagining of the artist, from the comedic oaf of early film to the reverent representations of Picasso.

The title of Clouzot's film, *Le Mystère Picasso*, hints at secrets of creativity that may be revealed by seeing the great artist at work. This promise of initiation into hidden mysteries recalls the magic of the alchemist and the transformation of base matter into gold. For Clouzot, the moving image is able to reveal these secrets better than any other medium. Rejecting most films on art, particularly those that attempt to analyze an artist's work by guiding the spectator's gaze from one detail to the next, Clouzot developed a new way of filming that was intended to integrate the artist, the work, and the creative process. Clouzot's aim was to portray the chronological development of artistic activity rather than the already finite expression of the finished object. The changes, the breaks, the choices, and the decisions of the artist were seen as a revelation of the artist's mental process and thus the truest representation of the actual mechanisms of creativity.

The technical gimmick that enabled this revelation was the use of a new type of colored ink that when put on paper soaks through and makes the surface transparent. The paper was stretched upright, with the artist on one side of the screen and the camera on the other, so that Picasso's picture-making could be filmed with the marks appearing spontaneously on the screen without the artist himself being visible. The images thus appear as if by magic, without any apparent physical manipulation or mediation by the artist. The method suggests that creativity is the transposition of imagination to image, with little or no intervention from the artist's body. It was this aspect of the filming that most impressed critics. Roland Penrose applauded how the camera tracked the progression of the image: "without the hand of the artist getting in the way" (Penrose in Quinn, 1965, n.p.). This fascination is reminiscent of reaction to a series of comedy cartoons from the 1900s, called "The Hand of the Artist," made by Charles Urban and other filmmakers. Advertising his latest addition to the series in 1904, Urban's catalogue described how: "Illusion follows illusion, mystery succeeds mystery in this most

attractive subject, until the spectators are lost in amazement and delight" (Urban, 1904–5, n.p.). How nice to see an historical continuity between the supposedly naïve first audiences of film and the sophisticated viewers of *Nouvelle Vague!* André Bazin went further, admiring how the picture was born before our eyes without even seeing "the shadow of the hand of the painter" (Bazin, 1956). Of course, this insistence on the physical *absence* of the artist also works in the opposite direction, invoking the *presence* of that body that has been effaced.

During the first half of the film, Picasso executes a number of drawings with this method. There is no camera movement and, at first, no editing of takes; the entire screen is filled by the stretched translucent paper. His first drawing is made only with the accompanying sound of the scratching of pen on paper, which guarantees, in part, that we are witnessing unedited real time; it conveys both a meditative silence and reminds us of the surface/paper/screen that is being inscribed or incised, recalling the sexualized metaphors of artistic production. The *sound* of the mark-making is as important in suggesting the connotations of artistic process as the *sight* of the colors and lines themselves appearing.

The gimmickry of the filming is finally revealed when a second camera, placed at right angles to the stretched paper, reveals the drawing being removed and the familiar physical form of Picasso (Figure 2.3). This move re-enacts the rhythm of embodiment and disembodiment discussed above. While the filmed drawing technique quite literally renders the artist invisible, disembodied, the physicality of the artist is then reinstated by the revelation of the second camera. The last moments of the film also ultimately defer to the corporeality of the mythic Picasso. The artist is shown approaching a large, blank canvas and signing his name in charcoal across the whole of its surface. The camera then follows him as he moves slowly into the shadows of the film set. It is as if the film cannot sustain the invisibility of the man and finally capitulates to the potency of the image of his body and the sign *Picasso*.

The two worlds of Clouzot's film, the world of the artist's studio within the film studio and the world of Picasso's images, are differentiated through the use of black and white and color film. The sequences in which Picasso actually appears are shot in black and white, with the film studio cast in deep shadow, whereas color stock is used in the sequences in which the pictures fill the screen. In this way the world of art (the artist's imagination) is shown to exceed the world of reality; the vision of Picasso's images bursts onto the screen,

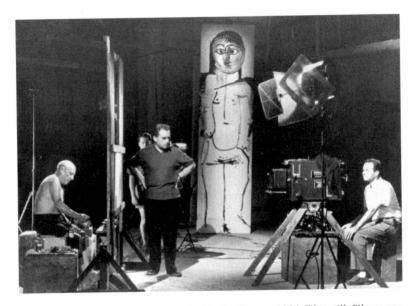

Figure 2.3 Henri-Georges Clouzot, *Le Mystère Picasso*, 1956. Film still. Filmsonor.
Photo courtesy: BFI stills

surpassing the monochrome technological world of the studio. Film
technology is thus curiously debased by Clouzot; although it enables
the representation of Picasso's creativity, its facility and mimicry
must then be denied in order to maintain art's superior creative
status. Cinema at this point defers to painting in a striking reversal
of its original humiliation of the artist in the films of Edison, Paul,
and others.

 Le Mystère Picasso is one particularly vivid element within the discur-
sive formation of the myth of Picasso. He has become the paradigm
of the artist in the age of mechanical reproduction. The speed of his
working process seems to complement the duration of the film—it is a
method awaiting representation by the camera. The director is captured
warning Picasso that he is running out of film; that he has very little
time left. Picasso continues working on a drawing and the film moves
between shots of the stretched paper and the film gauge on the camera;
meters of film tick away as Picasso's drawing reaches its completion.
Clouzot counts down the final seconds and the work of art is finished
just as the film runs out and the shot is cut. The time of the film
turns the process of artistic production into narrative; picture-making
becomes melodrama.

Le Mystère Picasso is a film about time that exploits different kinds of temporality. If the trick films of the 1900s had played with the time taken to make a work of art and its undoing in film, then Clouzot's film marks a return to film's exploration of the evolution of a painting. "Abstract values could not be put into words," said Clouzot. "The analysis of the drawings and pictures is gradual and progressive—you might call it chronological" (National Film Theatre, 1994, n.p.). The chronology of the Picasso mystery is animated by long shots and a fascination with the evolution and changes in the production of the work of art that require the audience to engage in a more contemplative style of viewing. There can be no shortcuts or accelerations; to observe the temporality of Picasso's picture-making is to witness and perhaps to comprehend the time of genius. André Bazin identified the element of time as the particular dimension that cinema could bring to painting. Reviewing Clouzot's film, he sees the future relationship of art and film as one that exploits duration, the passing of time, and creative development in the work of art. Bazin also presents the relationship in terms of a model of depth. In his essay "Painting and Cinema," he argues that the spatial and temporal models of the two media are quite distinct and almost contradictory. The sequence of a film gives it a unity in time that is horizontal or geographical, across the surface of the work; whereas time in a painting develops geologically and in depth. Furthermore, the orientation of space within the two media is antithetical:

> The outer edges of the screen are not, as the technical jargon would seem to imply, the frame of the film image. They are edges of a piece of masking that shows only a portion of reality. The picture frame polarizes space inwards. On the contrary, what the screen shows us seems to be a part of something prolonged indefinitely into the universe If we show a section of a painting on a screen, the space of the painting loses its orientation and its limits ... [it] takes on the spatial properties of cinema.
>
> (Bazin, 1967, 166)

The only way, therefore, that cinema can represent painting without compromising art's temporal and spatial model is by showing the *development* of the work, the creative process rather than the finished object. This replaces a horizontal cinematic movement across the surface of the finished painting that chops up and fragments the work into details, with a voluminous frontality in which the progressive layers of the image are charted. For Bazin, the physical and

metaphorical surface of the picture has a layered depth that contains the stages of the creative process.

The film of a painting being made should be an aesthetic symbiosis of screen and painting. This idea of the dialogue between camera and brush reiterates the way in which the artist's relationship to the canvas has been imagined. In a text written by the eminent British critic Roland Penrose, Picasso's artistic process is described as an intense interaction between the maker and his progeny:

> Picasso, particularly when he begins to draw on a virgin surface, seems to trace the outline of a vision which is already there but visible only to him. For a time he continues with complete conviction but as the drawing materializes a second phase begins which is like a dialogue between him and the image to which he has given birth. The image has already been given a personality of its own which can provoke surprises that demand to be taken into account. Picasso "the finder" can now interpret the impatient demands of his offspring and with a parent's insight he guides his child as it grows in stature or rescues it if it stumbles. The artist and his creation during this time are inseparably linked; they reciprocate, and rise or fall together. He is the product of his own work ... [these are] passionate dialogues between Picasso and his own creation.
>
> (Penrose in Quinn, 1965, n.p.)

Penrose moves through a familiar register of metaphors to evoke the mysterious and transcendent nature of artistic creativity. With recollections of Derrida's account of the sexualized gendering of style, the canvas is initially imagined as "a virgin surface" awaiting inscription, and as the marks are made, they appear to be an unmediated transcription of Picasso's imagination, with the hand tracing lines directly from the mind. As the image is born and develops, the method shifts to a creative give and take between Picasso and his picture; a relationship that Penrose describes in terms of that of a parent and its child. Following this act of autogenesis, Picasso nurtures his art-child; the image has a will of its own but also surrenders to the desires of its maker, and they succeed or fail together. These metaphors of birth and creation are familiar within Western discourses on artistic identity (Battersby, 1989; Nead, 1992) and are active in the assumptions and objectives of *Le Mystère Picasso*, in which subject and technique serve to make visible the emergence of "the creator's ideas" (Clouzot as cited in National Film Theatre, 1994, n.p.).

At times, however, Picasso can be a destructive and vengeful father, and in the final section of the film Clouzot sets out to document Picasso's work on a large-scale canvas, *The Beach at La Garoupe*. Here the format of the film shifts, with the camera on the same side of the easel as Picasso and offering a more prolonged coverage of his working process. This sequence introduces the main narrative drama of the film. As the image develops, Picasso becomes dissatisfied and wipes out, with turps and a paintbrush, practically the whole painting. The scene shifts to the film studio and Clouzot is shown asking Picasso why he has erased his picture. Picasso replies: "You wanted some drama; now you have it."

The erasure of the first version sets the scene for the final reiteration of Picasso's creative genius. He is shown working, with unfaltering certainty, on a second, simplified version of the picture. The drama of the first version was necessary it seems, for this aesthetic resolution to be arrived at. Although the camera *shows* the changes and revisions involved in Picasso's creative method, the process itself appears to lack principle or system. It becomes, in the end, a matter of intuition, something which cannot be fully mastered or understood but to which the artist must submit. Is it a coincidence that both Edison's *The Artist's Dilemma* and Clouzot's *Le Mystére Picasso* hinge on the erasure and remaking of works of art? The act of painting out the image is an act of iconoclasm, a gesture of willful aesthetic rejection; we need only think here of Robert Rauschenberg's erasure in 1953 of a drawing by the master of Abstract Expressionism Willem de Kooning. Described by Barbara Hess as a gesture of identification and rejection, Rauschenberg negated the older artist's work and marked his own aesthetic ascendancy over its surface (Hess, 2004, 7). When the demon-clown paints out the artist's portrait of the dancer in *The Artist's Dilemma*, we know that the traces of the former image must remain as the support for the new magical technique of image-making. Like the relationship of Rauschenberg and de Kooning, film is the bold new cultural pretender using the forms of an earlier generation to stake its claim, and perhaps it might also be said that in the same way that de Kooning willingly gave his drawing to Rauschenberg to be erased, so art is complicit in enabling film to assume the mantle of the new popular culture. This is not the meaning of Picasso's act of erasure, however. Picasso wipes out his *own work* in order to demonstrate his courage and self-mastery and to add drama to the mystery of his creativity.

So many images—so much mystery; as Roland Penrose writes in the introduction to Edward Quinn's photographic study *Picasso at*

Work: "although cameras have recorded thousands, perhaps millions of pictures of him, there remains a desire to know more, a desire which is based on our lack of understanding of how the mind of an artist functions" (Penrose in Quinn, 1980, 4). This gap between representation and understanding is essential. In spite of this mass of imagery, Picasso's mystery exceeds visibility and knowledge; it surpasses any attempt at demystification. Since genius is partly defined as that which is unknowable and unmasterable, the project of revealing Picasso's mystery *must* fail; more than that, the film must demonstrate its failure or risk unsettling one of the most potent mythologies within Western art.

In films of the artist at work, the "aura" of art, in Walter Benjamin's terms, has shifted from the presence of the original finished painting to the process of the artist making the work (Benjamin, 1973). For Brassaï, as we have seen, his photographic studies of Picasso's studio were the most authentic and beautiful portraits of the artist, an extension of the body of the artist and imprinted with the act of creation. Picasso once suggested to Brassaï that he should pose for a photographic parody of the professional artist in his studio (Kleinfelder, 1993, 30–1). He bought a large gilt-framed painting from an antiques dealer, showing a highly conventional reclining nude, and with the assistance of a model, he poked fun at the traditional image of the artist in his studio. Perhaps this parodic figure is the type of poor dupe who is outwitted in *The Artist's Dilemma*, with Picasso assuming the character of the demon-clown in order to demonstrate his distance from this conservative image of artistic creativity.

There is a doubling in both films of the artist's studio and the film studio. In Edison's film the studio, with its easel and model's platform, is a simple box set that extends the space of the film studio; in *Le Mystère Picasso*, however, the art studio and the film studio are the same space, with the painter and the director at times facing each other across the stretched canvas. As we have seen, the image of the artist's studio is a space that has come to resonate with cultural meanings. The special site of creativity, half temple, half laboratory, it is where the artist conducts his alchemical work. But the philosopher's stone, the secret of the artist's ingenious transformation of matter into gold, is unknown, and so we search the studio for signs and clues. The studio and the artist thus collaborate in a reciprocal reinforcement of the mythology of the artist/genius and the enigma of the artistic process. In Clouzot's film the art/film studio is not represented as an open space flooded with natural light, but as dark and cavernous, illuminated only

in a few isolated places. The doubling of the painting studio and the
film studio is made visually explicit in *Le Mystère Picasso*. The cinema
audience initially sees Picasso working in a studio context, but then the
camera shows us that this is not an artist's studio but a film studio and
that we are, by implication, witnessing two kinds of artistry: Picasso's
and that of the film director Clouzot and his cameraman Claude Renoir
(grandson of the Impressionist painter Auguste Renoir). We are surely,
moreover, intended to make this identification. In its early stages,
when the film reveals the gimmickry of the artistic technique that has
enabled its filming, it is not just Picasso but also Clouzot and Renoir
who are shown to the cinema audience. Moreover, *Le Mystère Picasso*
is a highly documented film; Edward Quinn made a photographic
account of its making and Pierre Cabanne also witnessed and recorded
the process in his book *Le siècle de Picasso: la gloire et la solitude* (1975).
Undoubtedly, then, the figure of the artist and the homage to artistic
creativity can be used to suggest a cross-identification between painter
and auteur filmmaker.

What begins to be suggested by these two landmark films in the long
history of film's representation of the artist and artistic creativity is
that painting and cinema have been engaged in an ongoing process of
rejection and identification, of the kind symbolized in Rauschenberg's
erasure of de Kooning. Whereas in the first years of film, filmmakers
parodied the artist and his creative abilities as a means of dispelling the
magic of the old medium and asserting the transformational powers
of moving images, more recently directors have turned to the artist's
studio as a way of identifying with its cultural value and of distancing
themselves from television, video, and digital imagery.

I referred in my title to the relationship between art and film as an
affair, characterized by attraction and rejection and brought about
because of a compelling synergy between the two media: between the
screen/canvas; the duration of the creative process; and the claims to
authorial status. It would be easy to see Edison's film as an instance
of demythologizing and Clouzot's as an example of remystification of
the artist and artistic production. But, of course, it is more uncertain,
more dialectical, than that. At the heart of this history of images is
a fascination between the two media and a longing for both absorp-
tion and distance, repudiation and emulation. The digital culture of
the twenty-first century may mark the end of the affair, or at least the
intrusion of a third party that will prove fatal to the dialogue between
the two old lovers.

References

C. Battersby, *Gender and Genius: Towards a Feminist Aesthetics* (London: Women's Press; Bloomington, IN: Indiana University Press, 1989).

A. Bazin, *"Le Mystère Picasso," L'Education Nationale* (May 1956). As cited in P. Pilard, *Henri-Georges Clouzot* (Paris: Editions Seghers, 1969) (p. 154).

A. Bazin, "Painting and Cinema," in *What is Cinema?*, trans. H. Gray (Berkeley, CA: University of California Press, 1967).

W. Benjamin, "The Work of Art in the Age of Mechanical Reproduction," in *Illuminations*, ed. H. Arendt (1973), Introduction by H. Arendt (Suffolk: Fontana/Collins; New York: Harcourt, Brace & World, 1968). (pp. 219–253).

M. -L. Bernaduc, "Picasso et Brassaï: à la Recherche de la Resemblance," in *Picasso vu par Brassaï*, Exh. cat. Musée Picasso, Paris, 17 June–28 September 1987 (Paris: Ministère de la Culture et de la Communication: Editions de la Réunion des Musées Nationaux, 1987) (pp. 10–19).

Brassaï, *The Artists of My Life*, trans. R. Miller (London: Thames and Hudson; New York: Viking Press, 1982).

P. Cabanne, *Le siècle de Picasso*, 2 vols (Paris: Denoel, 1975).

J. Derrida, *Spurs: Nietzsche's Styles*, trans. B. Harlow (Chicago, IL/London: University of Chicago Press, 1979).

M. A. Doane, *The Emergence of Cinematic Time: Modernity, Contingency and the Archive* (Cambridge, MA/London: Harvard University Press, 2002).

B. Hess, *Willem de Kooning*, trans. J. Gabriel (Cologne/Los Angeles, CA: Taschen, 2004).

K. L. Kleinfelder, *The Artist, His Model, Her Image, His Gaze: Picasso's Pursuit of the Model* (Chicago, IL/London: University of Chicago Press, 1993).

A. Liberman, *The Artist in His Studio* (1960) (London: Thames and Hudson; New York: Random House, 1988).

National Film Theatre, *"Le Mystère Picasso*, Painting in Film," Film notes (London, 1994).

L. Nead, *The Female Nude: Art, Obscenity and Sexuality* (London/New York: Routledge, 1992).

R. W. Paul, *Catalogue of Paul's animatographs and films* (London: R. W. Paul, 1901).

E. Quinn, *Picasso at Work: An Intimate Photographic Study by Edward Quinn*, Introduction and text by R. Penrose (London: W.H. Allen, 1965).

E. Quinn, *Picasso: Photographs from 1951–1972* (Woodbury, N.Y.: Barron's, 1980).

C. Urban, *Urban and Eclipse Films* (London: Charles Urban Trading Co. Ltd, 1904–5).

3
Cézanne and the Lumière Brothers

Angela Dalle Vacche

> *Three men, seated at a table playing cards. Their faces are tense, their hands move swiftly. … It seems as if these people have died and their shadows have been condemned to play cards in silence unto eternity. …*
> —Maxim Gorky, 1896 (as cited in *The Art of Moving Shadows*, eds. A. Michelson, D. Gomery, P. Loughney (Washington, DC: National Gallery of Art, 1989), p. 15.)

In the history of art, the standard narrative about the invention of photography in 1839 and the advent of cinema in 1895 is that painting turned to abstraction, while photography and cinema took on the legacy of figuration and realism.[1] This split becomes much more nuanced as soon as we examine two thematically interrelated works: the first is Cézanne's one and only genre painting, and the second is a short film by Louis Lumière. By setting up a dialogue between these two works, I will focus on how Cézanne's *The Card Players* (1890–96) (Figure 3.1) comments on the crisis of painting[2] and on how the Lumières' *Partie d'Écarté* (1896) (Figure 3.2) calls attention to the economic and artistic uncertainties surrounding the new-born cinema.[3] My overall argument will be that this enigmatic painting is about the turning of bodies into shadows. By the end, I will show how the invention of the cinema, regardless of the painter's intentions, occupies, in visual culture, a position adjacent enough to painting, so that it can function as an appropriate term of reference for Cézanne's work.[4]

Cézanne's painting and Louis Lumière's short film are linked by invocations of a familiar iconography of card-playing, fortune-telling, alcohol abuse, cheating, conviviality, greed, chance and fate, young dupes, and shrewd operators. The most famous examples of this

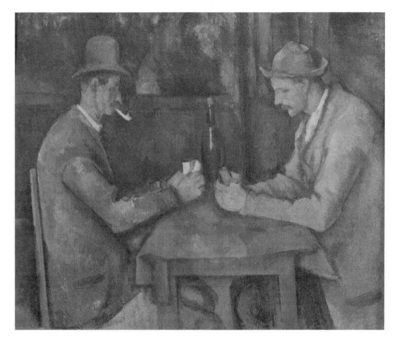

Figure 3.1 Paul Cézanne, *The Card Players*, 1890–95. Musée d'Orsay, Paris. Photo credit: Erich Lessing/Art Resource, New York

iconography are: Caravaggio's *The Fortune Teller* (1594–5), Georges de La Tour's *Cheat with the Ace of Clubs* (1636–8), and Jean-Baptiste Simeon Chardin's *House of Cards* (1737). There is also the lesser known *Soldiers Playing Cards* by Mathieu Le Nain (1607–77), which Cézanne might have seen at the Musée Granet in his town of Aix-en-Provence. Yet, as soon as we consider *The Card Players'* serious atmosphere, it becomes evident that these players are quiet, and there are no signs of cheating. In this particular case, the iconography of card-playing expands into a game of life and death. Cinema was only one year old by the winter of 1896 when Louis staged his card game for a home movie, while, by then, Cézanne had already acquired fame thanks to his new dealer, Ambroise Vollard, who organized his first successful solo exhibition in Rue Laffitte in 1895.[5]

The Card Players was hardly ever exhibited, hence it is likely that the Lumières never saw Cézanne's version of this pervasive pictorial trope. Nor shall we ever be able to establish whether Cézanne ever walked by a cinematographic exhibition in Paris or in Provence. However, posters on public walls[6] announcing the Lumieres' cinematograph,

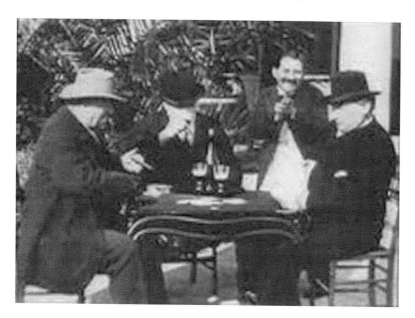

Figure 3.2 Partie d'écarté (Cat. Lumière N°73). Louis Lumière, France – La Ciotat, 1896. Left to right: Antoine Lumière, Félicien Trewey, Antoine Féraud, Alphonse Winckler. © Association frères Lumière

were visible in the capital as well as in the provinces. What is for sure is that Cézanne died on October 23, 1906, and that is only 11 years after the cinema had been most officially presented to a paying audience in the Salon Indien of the Grand Café on the Boulevard des Capucines in the heart of Paris.[7] The point here is that the theme of card-playing during the days of early cinema was not only a way to talk about social rules, but also an opportunity for the inventors and art lovers in the Lumière family to quote realist painting. In filming *Partie d'Écarté* with Antoine Lumière on the left, Louis—son of Antoine and the director of *Partie d'Écarté*—was perfectly aware of one crucial fact: he was showcasing the family painter and patriarch of their household's fortune in photography.

After learning carpentry as an adolescent, Antoine Lumière (1842–1911) had formally studied painting in Paris and pursued his artistic vocation during his early married life in Besançon.[8] There he also started his first photographic studio. Besides joining a Masonic lodge where he met other artists, Antoine specialized in portraiture and landscapes, two genres based on realistic detail and reproducible thanks to photography. Antoine's choices were compatible with the two sides of

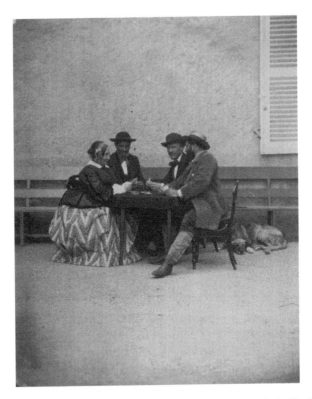

Figure 3.3 Olympe Aguado de las Marismas, *Card Players, c.* 1860. The Museum of Modern Art, New York, Suzanne Winsberg Collection. Gift of Suzanne Winsberg. Photo credit: Digital Image © The Museum of Modern Art/Licensed by SCALA/Art Resource, New York

his life split between art and business. Oddly enough, my searches for nineteenth-century photographs of card-playing have led me to only one example: Olympe Aguado de las Marismas' *Card Players* (1860) (Figure 3.3). Photographs of people sitting quietly as they concentrate on playing checkers or chess are much easier to find. It seems that still photographs of table games usually taken from a certain distance did not go well with the situation of playing a game of cards. This was perhaps due to the fact that card-playing in genre paintings involved cheating and rowdy scenes, unpredictable or secret movements, so that all this kinetic energy might have been difficult to represent with early photography and its long motionless exposure times.

It was only after the birth of Auguste and Louis in Besançon that Antoine's family moved to Lyon. Despite its popular success, photography was still the humble medium of mechanical reproduction, which meant lack of originality and the loss of uniqueness—as with clichés or stereotypes in printing. The printing term *cliché* refers to the printing plate cast from movable type. This was also called *stereotype*. Within this framework of industrial manufacturing and mass consumption, any moving image in 1896 was also comparable to the humble wood signs from the city of Épinal, produced in the Vosges region of northeastern France.[9] In a society with illiterate masses of people, the *image d'Épinal* was supposed to be a combination of lettering and/or pictures anyone could figure out. Often hanging outside the front door of a shop or a public place, the *images d'Épinal* slowly became the visual alphabet of uneducated adults and schoolchildren. In fact, these images had to do with storybook characters and folktales, while they also surveyed Napoleonic episodes and military history (BL).

Not far from the tradition of the *image d'Épinal*, the manufacturing of playing cards existed between a simplified realist style for genre vignettes and a quasi-abstract flat version of stock characters and suit patterns. But the playing card was also used as a metaphor in artistic circles. According to art historian Kurt Badt, everybody knew of the "playing-card versus billiard-ball joke." The joke went like this: realist Courbet said that modernist Manet relied on such an extreme two-dimensional style that his Olympia looked as flat as a playing card, namely the Queen of Spades. Manet answered that all Courbet could paint was a bunch of billiard balls, because his style had become so emphatically three-dimensional to underline the roundness of plump female bodies.[10] Thinking about this episode retrospectively, the joke was clearly about the battle between Manet's modern, quasi-abstracting approach, influenced by Japanese woodblock prints, and Courbet's three-dimensional realism with non-conventional topics from daily life. This latter trend was also involved with modernity, because it replaced the academic mode of allegorical picture-making with scenes from mythology or religion still dominating in the conservative world of art salons and juries.

The Manet versus Courbet joke underlines how male-dominated the Parisian art world was in those days. Yet the stylistic competition between the flat, but svelte Olympia by Manet and Courbet's realist, but rotund females spells out an uncertainty about the human figure and its potential for either animation or dismemberment, figuration or effacement. Indeed, the point of a comparison between Cézanne's *Card Players* with two figures and the Lumières' family vignette on film, is to discuss

what happens to the body within a climate of business rivalries among inventors and of competing artistic styles, not only between Manet and Courbet, but also between Jean-Léon Gérôme and Paul Delaroche.

To begin with, by 1872 in the wake of motion studies carried out by Eadweard Muybridge (thanks to California mogul Leland Stanford), even Gérôme, a famous academic French painter, had begun to go realist, if not scientific, to the point of calculating his shadows in *Pollice Verso* (1872) according to a precise time of the day. Thanks to Muybridge, it became possible for painters to visualize the so-called unsupported transit moment of galloping horses with all four hooves lifted from the ground.[11] Muybridge visited Paris in 1881 and gave two lectures on motion studies, held respectively in the laboratory of his colleague Jules-Étienne Marey and in the studio of the painter Jean Louis Ernest Meissonier. Through these two events—attended by Gérôme, a friend of Meissonier—the marriage of photography and painting became official.[12] As Helen Gardner explains, this use of scientific precision in art will make Gérôme's colleague, the academic painter Paul Delaroche, exclaim: "Painting is Dead!" In fact, Gardner compares, briefly, *Pollice Verso* with Delaroche's *The Death of the Duke de Guise* (1835):

> With Delaroche, the figures are un-centered within the frame, leaving a void in the middle. The frame controls the figures so as to give the whole the appearance of a stage upon which actors are playing a scene. This makes the viewer feel like the member of an audience sitting in front of a play. What we see is play-acting and not a real murder. Gérôme, on the other hand, relies on a comparable off-centered placement of figures for *Pollice Verso*, yet he makes us viewers of the painting become spectators at a "real" event, because we have the impression of witnessing it from within the framed space of the action. Gérôme brings us onto the stage, while with Delaroche we are still outside and in front of it.[13]

With Gérôme, we feel as if we were sitting in the Roman amphitheater and what we are looking at, is really going on, in all its violence, blood, and cruelty. The sensation of horror joins the activity of perception. On the contrary, with Delaroche, we know that we are only looking at a performance, so that perception remains separate from sensation. We identify with the spectators of a play at the theater, while an invisible fourth wall separating stage from life, stands in front of us. Neither of these approaches applies to *The Card Players* who are absorbed into themselves, although theatrically displayed by Cézanne.[14] Busy in thinking about their cards, these two enigmatic figures are indifferent

to the presence of potential viewers nearby. Even if they are peasants posing for the painter, they are so inexpressive that they become as important as the table or the bottle between them.

Gardner's comparison between Gérôme and Delaroche suggests that the increased realism spurred by animal motion studies sets in place an optical mode based on seeing things as if they are "really there," to the extent of being tangible or touchable. Besides the impact of Muybridge's galloping horses on Gérôme's realism, a cross-Atlantic business race among inventors was going on: in 1891 the American Thomas A. Edison patented the peep show or "cinescope" using Eastman Kodak film.[15] In contrast to the Lumières' hosting of a group viewing in 1895, Edison's nickelodeon allowed only one single viewer at a time. But Edison was not the one and only rival of the Lumières. In attendance at the Salon Indien of the Grand Café during the Lumières' famous evening was also Georges Méliès, a man of the theater and a magician, trained originally as an academic painter at the Ecole des Beaux Arts.[16] Méliès immediately offered 10,000 francs to the Lumières with the intention of buying the cinematograph, but Antoine, who had planned the whole event, refused. It seems that Antoine told Méliès: "Young man, you are lucky I am not selling you my invention because it is only a scientific curiosity and any commercial profit in the future is so unlikely that you would go bankrupt."[17]

Thus, Méliès purchased another kind of gadget, called a "bioscope," from William Paul in London and, in 1896, he started making his first film imitating the Lumières' home-movie, outdoor documentary-like approach, with *Une Partie de Cartes*.[18] For this production, Méliès cast his brother Gaston and a couple of friends. The use of the newspaper during this vignette of heavy smoking, drinking, and leisure time reminds the viewer that cinema is not only about entertainment and consumption, but it also deals in randomness and contingency. For this reason, the cinema is comparable to news reports which are so sensational for a day, and so forgotten a day later. Méliès' title in French corresponds word for word to the English translation: "a game of cards". But this is not the case with the Lumières' linguistic pun in their title: *Partie d'Écarté*. In fact, they are staging an old French card game called *Écarté*. Most importantly, the French verb *écarter* means "to separate", so this game of cards might indeed be about something else rather than just playing for fun.

In contrast to Antoine's pessimistic forecast, Méliès' fantastic cinema became a powerful rival of the Lumières' documentary-like approach. This competition of magic with daily life did not prevent the Lumière brothers from befriending another magician, Félicien Trewey, who sits opposite Antoine in *Partie d'Écarté*.[19] Trewey's inclusion in Louis' short film, can be linked to the theme of alcoholic hallucination in the

iconography of card-playing and also to the bottle and glasses brought in by Antoine Féraud, the Lumières' waiter. Alcohol, by contrast, does not seem to play much of a role in Cézanne's *Card Players*, where there are no glasses next to a lonely bottle. To be sure, the waiter's movement from background to foreground enables Louis Lumière to underline spatial depth according to the realist approach of Renaissance perspective. Later on, Méliès will further differentiate himself from the Lumières' style, and will specialize in much flatter backgrounds.[20] He will underline the magical appearance and disappearance of the human figure. Or, he will play with the body's fragmentation into separate pieces, or their grotesque re-assemblies, which, for art historian Natasha Staller, anticipate Picasso's disjointed Cubist images.[21] In 1897 Méliès will build a very expensive theater on his property in Montreuil and, in this new context, he will shoot *The Living Playing Cards* (1904), a spoof based on magic tricks or special effects for the sake of animation.

The fact that Gérôme became interested in Muybridge's photographic findings about horses is no isolated encounter between art and mechanical reproduction. Cézanne, for example, used photography as a mnemonic aid for his work in the studio. In her chronology, Isabelle Cahn reports that in 1905 some visitors noticed a photograph of Poussin's *Arcadian Shepherds* on Cézanne's wall.[22] Despite this expedient approach, Cézanne subscribed to the widely held view that photographs looked cold and phantom-like. According to Ricciotto Canudo, an Italian film critic based in Paris, Cézanne spoke with disdain of the photographic eye as something nonhuman.[23] Well aware that the relations between viewing subject and viewed objects were changing, the painter became famous for asking his models to sit still like apples on a table, while in his still-lifes objects look as if they were about to fall off the table and acquire motion. But there is more about Cézanne's contradictory relationship to photography that has to do with his interest in physical sensations, as if optical perception alone was not enough to penetrate the secrets of the natural landscape.[24] From Jonathan Crary's *Suspensions of Perception*, we learn that Cézanne used his own body in the outdoors as if it were a sensitive photographic plate. After spending hours and hours in the countryside, the painter would return to his studio. There, he was so filled with a sort of corporeal resonance from the sun, the leaves, the grass, the water, and the trees, that his hand alone could automatically paint what he had felt and stored through his body by underplaying the analytical side of perception.[25]

The everlasting power of *The Card Players* depends on how Cézanne depicts human figures with no feet.[26] This is exactly what shadows look

like, by doubling their sources so well that they can move without walking, or better, they do walk but without using their own feet. Cézanne's corporeal shadows are only one stage away from the ephemeral shadows of early photography, thus they become the missing link between the crisis painting and the rise of early cinema. Yet, at the same time, the painter is taking a crucial step in his journey from genre painting, a human still-life, toward his favorite elements for abstraction: the cube, the sphere, the cone, and the cylinder, with the *CardPlayers'* massive bodily shapes looking somewhat cylindrical and slightly disjointed in the same way the limbs of Cézanne's bathers appear to be one on top of the other within an odd anatomical geometry.

The earliest experiments with photography amounted to temporary traces left by the light modeling an object, to the point that the latter's contours would linger on a receptive surface only for a limited amount of time.[27] It is this awareness that time is passing and things are changing that Cézanne builds into *The Card Players*. He endows his peasants with the transient appearance of the fourth dimension. Finally, since time is invisible and therefore abstract, he also simplifies their bodies into two cylinders of concentration on the game at hand. Shadows are also about loss. Still recognizable and well between the human shape and the geometrical form, the peasants echo an historical transition. Put another way, by painting two peasants playing cards, Cézanne decries the loss of regional crafts such as the local printing and coloring of cards in Provence. Likewise, he was annoyed by too much industrialization altering the terrain around his beloved Mont Sainte-Victoire.[28]

Besides looking like two giant figures made of wood and cloth, Cézanne's peasants look alike. The invention of photography and the cinema brought about a blurring of boundaries between the organic and the inorganic, self and other. The moving image also raised questions about the difference between the fleeting moment and the enduring duplicate. To make things even worse, with the cinema, the dimension of the copy or of the double could simultaneously refer to the moving shadows on the screen and/or to the living viewers in the audience. No wonder the age of photography and the cinema is highlighted by some famous literary and proto-psychoanalytic doubles, all of them, involved in narratives about death: for instance, Edgar Allan Poe's short story *William Wilson* (1839) and Otto Rank's *Der Doppelganger* (The Double) (1914). By 1937, at the height of the surrealist period, in *L'Amour Fou*, André Breton stated that Cézanne was the artist of death.[29] To make his point, Breton cites *The House of the Hanged Man* (1873), *The Murder* (1868), and, of course, *The Card Players*. Cézanne's

two male figures flaunt an Egyptianate, mummy-like monumentality. Photographs, shadows, and mummies remind us of our longing for and fear of our own double, and, according to French film theorist André Bazin, photography is about embalming time.[30]

To follow up on this theme of death and playing cards, each of Cézanne's *Card Players* is immersed in deep thought. Hence Cézanne's figures seem to engage in a confrontation that goes beyond the casual card game. The eventful atmosphere, the use of colors and objects suggest that any element is about to turn into its opposite. To be sure, the whole painting is about life and death in the same way in which photographs, shadows, and mummies remind us of our desires and fears of doubles. But if Cézanne held photography in contempt, how is it possible for his peasants, so attached to tradition, to look like modern images circulating through mechanical reproduction? Is Cézanne painting the past, the present, or the future? Although painting is usually considered an art of space, Cézanne was painting the corrosive power of time through the changing body, the human form secretly and subtly dissolving itself into death. And photography, of course, the medium of realism in contrast to painting, is all about death and absence. While preserving memory through an absent presence, photography requires an irrational belief in a present absence. Cézanne's concern with time and change at the level of appearances challenged the idea of a time-less, stable, and exclusively mental vision. In order to insert the fourth dimension of temporality into a static space, Cézanne had to attach a transient body to a rational eye.

But how does the theme of temporality play itself out in the Lumières' *Partie d'Écarté*? This little home movie was shot at La Ciotat, a small village in Provence where the family owned a luxurious mansion near Clos-de-Plages. The film consists of no more than one long static shot. Clearly the atmosphere of this game is much more relaxed and enjoyable than the one in Cézanne's somber painting. *Partie d'Écarté*, however, is not only leisure time, but it is also a gathering of businessmen. In 1896, Félicien Trewey was able to bring the Lumière brothers to the Egyptian Hall in London for a presentation of their cinematograph. Trewey made his reputation as a skillful performer with a shadow play made of hands, renamed the *shadowgraph* (Figure 3.4). By arranging his five fingers, he produced different faces of people and animals, always in profile. Trewey's tricks, with the hand replacing the face, threatened the tradi-tional subordination of touch to sight in optical perception. Through his shadowgraph, Trewey was playing with the dialectic of seeing and touching, producing little faces in profile that were not faces at all but only fingers touching each other. The public praised Trewey's shadow-like

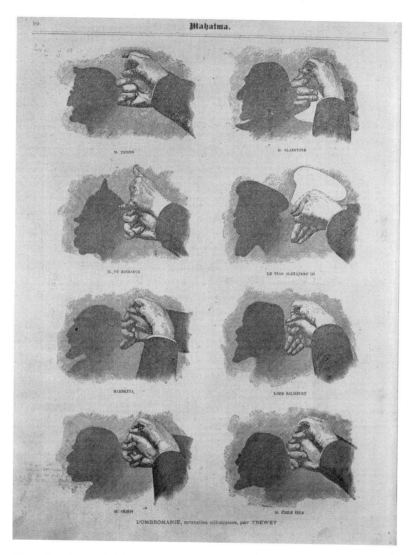

Figure 3.4 Page of eight shadow silhouette hand portraits by Trewey: Thiers, Gladstone, Bismarck, Alexander III, Gambretta, Salisbury, Crispi, and Zola, 1895. Photo courtesy Library of Congress

profiles by saying that they looked as if they had been made "by nature." The three separate categories of the natural, the mechanical, and the real were quickly becoming intertwined and interchangeable thanks to optical toys, fairground shows, and new forms of entertainment such as the cinema with all its ancestors in the worlds of magicians and scientists.

Before explaining further why the Lumières included Trewey in *Partie d'Écarté*, I want to explore a bit more the relationship between Trewey's proto-cinematic shadowgraph and Cézanne's *Card Players*. A sort of situational intimacy, interlaced with the anonymity of a public space, characterizes Cézanne's two card players. They sit facing each other with the same combination of togetherness and indifference, isolation of interest and promiscuity of exchange typical of the dark movie theater. And it is precisely this double network of relations between audience and screen, spectator next to spectator, which film viewers like to experience over and over again. Such a comparison between Cézanne's two figures and the activity of film viewing finds support in the way the boundary between public leisure and mental privacy was well on its way to becoming blurred. Cézanne couldn't care less about the cinema; yet his card players do have a proto-cinematic quality, because the mental exchange between the two figures is analogous to the situation of a filmic audience looking at a duplicate world go by on the screen as if nobody was there watching.

As it became apparent through Antoine's answer to Georges Méliès, the Lumières feared going bankrupt by making a mistake with the cinema. The two brothers were hungry for success, but cautious too. Their ambiguous stance about the hallucinatory yet realistic nature of the cinema comes through in more details about the casting, accidental or otherwise, of their card players for *Partie d'Écarté*. In the middle, we see the Lumières' father-in-law, Alphonse Winkler, the owner of a prosperous beer-making business and a very rich, jovial, powerful fellow.[31] By 1895, Winkler's daughters Marguerite and Rose were already married to Auguste and Louis respectively. As if this first round of double marriage was not enough between the two families, Antoine Lumière's daughters, Juliette and France, married Jules and Charles Winkler, the sons of the beer mogul. As a result, the whole set up of *Partie d'Écarté* seems to include magic, beer, cinema; or family dynasties, business, and a financial gamble with the future.

But again, if Cézanne conveyed a loss of individuality in mass society through his card players, how did the Lumières handle the problem of the human figure in their film? In *Partie d'Écarté*, the identities of the three card players signal themselves through the choice of hats.[32] Sitting in the middle, Alphonse Winkler, just like Félicien Trewey on the right, sports business-like attire, thanks to his bowler hat. On the contrary, Antoine Lumière, on the left, wears a wide-brimmed hat mostly suited for the sunny countryside and his activities as a painter of the outdoors.

The emphasis on prosperity in the Lumières' film strikes a note of contrast with the low-class, gloomy environment of Cézanne's tavern. Just like the Lumières, Cézanne too relies on hats to endow each player with a residue of individuality. Perhaps to compensate for a weakening sense of the self, the painter also differentiated the posture and the size of each player. The man on the left wears a more rigid hat than the man on the right, whose shirt has also a bigger collar than that of his companion. The latter, in turn, is smoking a pipe and his face is smaller and bonier. Both hats do not cover the ear, perhaps because each player is silently listening to his opponent's thoughts. It is difficult to imagine these two players exchanging a look across the table, but they are clearly taking their game most seriously, despite the fact that they seem to be drooping a bit on their respective hands of cards.

Regardless of Cézanne's contradictory stance about photography and, most likely, total indifference to the cinema, one could say that *The Card Players* stands out for its juxtaposition of hats, and it is ready to dissolve into the proto-filmic shadow play practiced by Félicien Trewey and called *chapeaugraphie*, a more specialized development of the *shadowgraph*. Indeed the connection between the use of hats and the importance of black silhouettes in profile with hats is relevant to the history of early photography. Silhouettes and photographs share a similar origin in the cast shadow.[33] And Trewey's *chapeaugraphie* worked with cast, rather than projected, shadows. Before cinema, tracing a person's shadow created a silhouette portrait that served as an enduring reminder of a fleeting presence. *Chapeaugraphie* refers to an obscure kind of performance art transported into shadow play. The result would be that the fairground crowds would recognize famous historical characters or social types thanks to the different hats they were wearing.

As a specialist of *chapeaugraphie*, Trewey shaped little pieces of felt into different kinds of hats for famous historical characters. The hat is about identifying someone and being recognized. Thus the hat involves perception and the idea of the self. Again, there is absolutely no evidence of any contact or mutual awareness between Trewey and Cézanne or between Cézanne and the Lumières; but painters, mountebanks, and engineers at this point in time, perhaps unknowingly, all had one thing in common: they were all asking questions about technological changes impacting perception, producing new sensations, and questioning the human figure.

It is well known that Cézanne's father was a hat maker whose business became so prosperous that, between 1825 and 1828, he was able to become a successful banker in Aix-en-Provence. Apparently Cézanne

had a very difficult relationship with his father for many years, so that one wonders whether hats and paternal origins might be considered in contrast to the absent feet of shadows stretching into an unknown future. In her book *Cézanne and Provence*, Nina Athanassoglou-Kallmyer documents the painter's obsession with hats. She links a few portraits and self-portraits by Cézanne to a whole chart of different hats.[34] From an illustrated magazine of the period, a typological grid of hats looks only a few steps away from Trewey's silhouetted portraiture of historical characters in his *chapeaugraphie*. More specifically, in the Lumières' *Partie d'Écarté*, the hat becomes also the equivalent of the playing card or *image d'Épinal* itself as the simultaneous replacement of portraiture and stereotype, high painting and low-level illustration, photograph and shadow. As an element of fashion in daily life, the hat is a like a glyph or a marker that anyone can figure out—as with shop signs and with playing cards. By decrying the loss of portraiture and by individualizing the stereotype, in *chapeaugraphie*, the hat is like an abbreviation spelling out a famous name, a social type, a profession, or an historical period.

To summarize, the seminal confusion of faces, pieces of felt and fingers at the heart of Trewey's *chapeaugraphie* is also part of a larger confusion between card players and family relations, between the financial calculations of businessmen, the reveries of drinking buddies, not to mention the ambiguities between family relations and professional colleagues in *Partie d'Écarté*. Even the title of the Lumières film underlines the struggle to keep things separate, to tell the forest from the trees. With their strange title, the Lumières tell the viewer that their game is based on discarding cards from a deck on the table between the two players.

To make the links among early cinema, photography, magic, alcohol, business, and painting richer, and in consideration of André Breton's interest in Cézanne and death, it is also worth pointing out the possibility of proto-surrealist language play in the Lumières' title. The linguistic pun of the title is about trying to separate what is impossible to sort out, that is, the business from the family. Yet this proto-surrealist joke is not so much about an old generation unable to predict the choices and the actions of future descendants. Indeed *Partie d'Écarté* is the Lumières' self-conscious admission that, even though they are advocating the cinema, they are also unable to fully control how this medium will develop in the future. Although *écarter* means "to separate," the cautious Lumières and their supporters knew that the opposite is true: some of these options may merge together and others may disappear.

In 1 95, everyone would agree it was too early to know The rest is hist ·y.

In he meantime, genre painting dissolves itself into shadows, whereas cine 1a begins with little clichés based on hats. Through this intermedial mic)-history, the standard version which links painting to abstraction and)hotography to realism expands into a study of visual culture. In fact, ifter the Lumieres, the cinema will grow up and, over a few decades, it w l show how rigid clichés can transform themselves into complex and 1oughtful figures, while generating different points of view among the iewers. Should we then conclude that Cézanne's *Card Players* is a m nento mori? I think so, but Louis Lumière's short film is both a fam y business card and a home movie about the unknown future, so that he cinema, as a whole, is a combination of shadows reinventing ther selves into our own most unpredictable others.

No1 s

1. Galassi, *Before Photography: Painting and the Invention of Photography* lew York: Museum of Modern Art, 1981).
2. . Ireson and B. Wright, eds., *Cézanne's Card Players* (London: The Courtauld allery and Paul Holberton Publishing, 2010).
3. 1is unique genre painting by Cézanne is so famous and mysterious that 1ilippe Sollers wrote a short monograph about it: *Le Paradis de Cézanne* aris: Gallimard, 1995).
4. *Suspensions of Perception*, Crary writes: "Of course, there is no historical 1k between Cézanne and the cinema, but their historical adjacency stands a far more important problem than, for example, his relation to cubism." . 344). On the origins of the cinema in relation to optical toys and stereos- py, see also: J. Crary, *Techniques of the Observer: On Vision and Modernity in* e *Nineteenth Century* (Cambridge, MA: MIT Press, 1990).
5. Cahn, "Chronology," *Paul Cézanne: A Life in Art* (London: Cassell, 1995; 1iladelphia: Philadelphia Museum of Art, 1996, pp. 528–69).
6. n Cézanne and the Lumières, see H. Dilly, *Ging Cézanne Ins Kino?*)stfildern: Edition Tertium, 1996). I am grateful to Trond Lundemo for iving brought this book to my attention. Dilly argues for the impossibility establishing any influence or intentionality between the Lumières and ézanne.
7. Mannoni, "Part 4: The labourers of the eleventh hour," in *The Great Art: rcheology of the Cinema*, trans. and ed. R. Crangle. Introduction by Tom unning and Preface by David Robinson (Exeter: The University of Exeter ess, 2000, p. 315). In *Les Frères Lumière* (Paris: Librarie Plon, 1938, p. 41), enri Kubnick argues that *Partie d'Écarté* was shown at the Salon Indien number seven of various shorts. This is the only source I found where is argument is put forth. The Salon Indien screening was unprecedented cause the 33 people in attendance paid to have a seat. For a detailed count of all the various projection evenings organized by the Lumières in

La Ciotat, Lyon, Paris, and Brussels, see M. Sicard, "Mille huit cent quatre-vingt-quinze ou les bascules du regard," in *Le Cinéma et la Science*, edited by Alexis Martinet (Paris: CNRS Editions, 1994, p. 30).

8. B. Chardère with G. Borgé and M. Borgé, *I Lumière: L'Invenzione del Cinema* (Venice: Marsilio, 1986, p. 28).

9. The British Library in London has some fine examples of *images d'Épinal*. See, for instance, H. George, *La Belle Histoire des Images d'Épinal*, Preface by Philippe Séguin, Collection "Documents" (Paris: Cherche Midi, 1996).

10. K. Badt, *The Art of Cézanne*, translated by Sheila Ann Ogilvie (Berkeley, CA: University of California Press, 1965, p. 115).

11. C. Musser, "A Cornucopia of Images: Comparison and Judgement across Theater, Film, and the Visual Arts during the Late Nineteenth Century," in *Moving Pictures: American Art and Early Film 1880–1910*, eds N. M. Mathews with C. Musser (Manchester, VT: Hudson Hills Press, 2005, pp. 5–37).

12. Musée Goupil, *Gérôme and Goupil: Art et Entreprise* (Paris: Réunion des Musées Nationaux, 1999).

13. H. Gardner, *Gardner's Art through the Ages*, revised by H. de la Croix and R. G. Tansey (New York: Harcourt, Brace, Jovanovich, 1980, 7th edn, p. 748).

14. Art historians feel that Chardin's *House of Cards* is the most important influence on Cézanne's intense atmosphere of concentration for *The Card Players*. On this combination of an inward-bound state of mind and a sense of unintentional display, see M. Fried, *Absorption and Theatricality: Painting and Beholder in the Age of Diderot* (1980) (Chicago, IL: University of Chicago Press, 1980).

15. For a fictional sense of Edison's competitive and entrepreneurial personality, see A. V. de L'Isle-Adam, *Eve of the Future Eden: L'Eve future*, trans. M. G. Rose (Lawrence, KS: Coronado Press, 1981).

16. E. Ezra, *Georges Méliès: The Birth of the Auteur* (Manchester: Manchester University Press; New York: St Martin's Press, 2000); M. Bessy, G. M. Lo Duca, G. Méliès, *Mage: Mes Mémoires par Georges Méliès* (Paris: Jean-Jacques Pauvert, 1961) (pp. 79–80); J. Malthête, *L'Oeuvre de Georges Méliès* (Paris: Éditions de la Martinière, 2008) (p. 89); and L. Chiavarelli, ed. *La Belle Epoque* (Rome: Gherardo Casini, 1966) (p. 328).

17. B. Chardère, pp. 138–48, op. cit.

18. M. Bessy and G. M. Lo Duca, pp. 79–80.

19. E. Barnouw, *The Magician and the Cinema* (New York: Oxford University Press, 1981).

20. R. Schiff, "Cézanne's Physicality and the Politics of Touch," in *The Language of Art History*, ed. S. Kenal and I. Gaskell (Cambridge/New York: Cambridge University Press, 1991, pp. 129–80). The term "haptic" is from A. Riegl, *Late Roman Art Industry* (1901), trans. from the original Viennese edition by R. Winkes (Rome: G. Bretschneider, 1985). On hapticality and the cinema of Georges Méliès, a useful essay is: A. Lant, "Haptical Cinema", *October* 74 (1995), 45–73. For an overview of Riegl's categories in the dialogue between classical film theory and art history, see A. Dalle Vacche, ed., *The Visual Turn: Classical Film Theory and Art History* (New Brunswick, NJ: Rutgers University Press, 2003). On Cézanne and temporality, see G. H. Hamilton, "Cézanne, Bergson, and the Image of Time," *College Art Journal* 16 (Fall 1956), 2–12. On Bergson, Cézanne, and time, see also L. Venturi, *Cézanne*, Preface by

G. C. Argan (New York: Rizzoli, 1978) (pp. 115–19). In contrast to George Heard Hamilton, Meyer Schapiro refutes all connections between Cézanne and philosophy. On this point, see "Cézanne and the Philosophers," in *Worldview in Painting: Art and Society*, by M. Schapiro (New York: George Braziller, 1999); also "*The Card Players*," in *Paul Cézanne*, by M. Schapiro (New York: Harry N. Abrams, 1952, p. 88).

21. N. Staller, "Méliès' Fantastic Cinema and the Origins of Cubism," *Art History* 12: 2 (June 1989), 202–32; S. Z. Levine, "Monet, Lumière, and Cinematic Time," *Journal of Aesthetics and Art Criticism* 36:4 (Summer 1978), 441–7.

22. I. Cahn, 561.

23. On Canudo and Cézanne, see A. Dalle Vacche, *Diva: Defiance and Passion in Early Italian Cinema* (Austin, TX: University of Texas Press, 2008) (pp. 97–8).

24. On Maurice Merleau-Ponty and Cézanne, see W. Forrest, "Cézanne and French Phenomenology," *Journal of Aesthetics and Art Criticism* 12:4 (1954), 481–92.

25. In *Suspensions of Perception: Attention, Spectacle and Modern Culture* (Cambridge, MA: MIT Press, 1999), Crary explains: "Cézanne's work could not have been more removed from the hodgepodge of effects associated with early cinema, which he likely never saw or thought about (except to excoriate it as a 'hideous' sign of 'progress' like the electric lights on the waterfront at L'Estaque, which so appalled him in 1902." (p. 343).

26. V. I. Stoichita, *A Short History of the Shadow*, trans. A.-M. Glasheen (London: Reaktion Books, 1999). For my use of the term "Egyptianate", see É. Faure, *Cézanne* (Paris: Braun & Co., 1936) (p. 8).

27. D. Auzel, *Georges Rouquier: de "Farrebique" à "Biquefarre,"* Preface by J.-C. Carrière (Paris: Cahiers du Cinéma, 2002): "Cézanne, peintre pur, compose sur une surface. Rouquier, cinéaste, voit dans l'espace. Ayant à peindre des personnages autour d'une table dans *Les Joueurs de cartes*, Cézanne les voit à la ligne d'horizon, Rouquier en panoramique: tous deux prennent la bouteille comme génératrice de leur composition, mais chez le peintre, elle est un axe de symétrie, tandis que chez le cinéaste elle est un pivot de rotation." (pp. 177–8).

28. J. Crary, *Suspensions of Perception* (Cambridge, MA: The MIT Press) (pp. 343–4).

29. A. Breton, *Mad Love (L'Amour Fou)*, trans. M. A. Caws (Lincoln, NB: University of Nebraska Press, 1987).

30. On the mummy complex in the plastic arts, see A. Bazin, "The Ontology of the Photographic Image," in *What is Cinema? vol. 1* (Berkeley, CA: University of California Press, 2004, p. 9).

31. For all this crucial information about *Partie d'Écarté*, I am indebted to Bertrand Tavernier's voice-over narration for the DVD compilation titled *The Lumière Brothers' First Films: Landmarks of Early Film* (New York: Kino International, 1996, vol. 1).

32. M. Vanni, ed., *Identità e Diversità: Il Cappello e La Creatività* (Poggibonsi: Carlo Cambi, 2004).

33. V. Stoichita, *A Short History of the Shadow* (London: Reaktion Books, 1997); L. M. Zotti, ed., *Il Rigore del Nero: Silhouettes e Teatri d'Ombra* (Porcari: Matteoni, 2007).

34. J.-L. Comolli, "Historical Fiction: A Body Too Much," *Screen* 19:2 (Summer 1978), 41–54. N. Athanassoglou-Kallmyer, *Cézanne and Provence: The Painter and His Culture* (Chicago, IL: University of Chicago, 2003, p. 207). For more on Cézanne and French film, see P. L. Doebler, "Going beyond Cézanne: The Development of Robert Bresson's Film Style in Response to the Painting of Paul Cézanne," http://www.sensesofcinema.com/2007/43/bresson-cezanne/

4
The Medium is a Muscle: Abstraction in Early Film, Dance, Painting

Nell Andrew

The early twentieth-century histories of cinema and modern dance happen to coincide with the European avant-garde's development of abstraction in painting. But even as film studies, new media, and body based arts become more present in art history departments around the world, the more or less official story that students are taught about abstraction's origins has changed little from the medium-specific, formalist paradigms put forth by Clement Greenberg, and continued by later structuralist revisions: that Modernist abstraction resulted from a century of autonomous and self-reflexive change within the mediums of painting and sculpture.

To be fair, the moving image in film and dance is difficult to pin down as an object of aesthetic contemplation. In the terms given to us by Greenberg and later by Michael Fried, for example, the meaning of the Modernist abstract image lies in its unalterable physical materials and its internal formal relations; this creates a work said to exist outside real time, in a state of absorbed presentness, irrespective of the beholder.[1] Under these terms, the fleeting image of even the most avant-garde film and dance will not only subvert its own materiality, but will remain always anthropomorphizing and time-beholden. At first glance, therefore, film and dance appear definitively theatrical, to borrow the term from Fried—that is, working in a vein other than Modern art by drawing attention to meanings outside the borders of their mediums.

Of course Fried's concerns emerged during the 1960s shift from medium-specific Modernist painting and sculpture to the so-called *post*modern hybrid forms of Minimalism and Pop. However, contemporary multimedia, cross-media, and performance arts are not so cleanly a development of the *post*-Modern era. Rather, if we use art history's frameworks to look at early twentieth-century dance and film, we

encounter a pre-history for media mixing that broadens art history's understanding of the historical avant-garde. This essay presents two examples through which film and dance are put in conversation with painting, and makes a case that the arts of motion are crucial to a more complete story of the development of abstraction in the plastic arts.

It is not news to say that the historical avant-garde was involved in and inspired by both dance and film. From its first moments, the medium of cinema would be linked to dance as a moving, living art. Georges Méliès, one of film's earliest directors, in fact used the metaphor of a dance to describe his reaction to the newly invented cinematograph: "I came home, my head ablaze, haunted by these images that still danced before my eyes."[2] From the other side of the divide, the Ballets Russes choreographer Serge Lifar would show admiration for cinema, saying in an interview: "Cinema and dance should join forces. Dance is awaiting cinema to free it from reality, from the weight of exertion."[3]

My interest in the intersection of abstraction with motion grew out of just such medium-confusion between dance, cinema, and art history. Among the first films ever made, one sees a certain skirt dance appear again and again, displaying an image of a woman's head surrounded by twirling veils centered within the frame. Between 1894 and 1910, the years of cinema's self-discovery, filmmakers Thomas Edison, the Lumières, Méliès, Pathé Frères, and others from France, Germany, England, Italy, and the United States would make more than 30 films showing variations of the serpentine dance which had been made famous on Paris' largest stages by the American dancer Loie Fuller. To watch these serpentine films—stripped down though they are from the spectacular effects of Fuller's performance—the dance nonetheless seems to show off the very ontology of the new medium of film. It demonstrates the essential shifts between two and three dimensions, motion and stillness, fragment and continuity, abstraction and figuration.

Later in film's history, when one encounters the abstract films of Dada artist Hans Richter of the 1920s—with an understanding that he and fellow avant-garde filmmakers often expressed a motivation to return cinema to the spirit of its first manifestations—Richter's animated white and gray rectangular masses paradoxically mimic the perceptual experience of the earlier, more realist serpentine dance films. Richter seems to be replaying early cinema's pure joy in the visual qualities of movement—and in particular the serpentine films' confusion of flatness and depth, of objectivity and ephemerality. The question to be answered, then, is how can the human form in the sensory and bodily

art of dance create a similar perceptual effect to the abstract movement of light and geometry in Richter's plastic art of film?

The common thread seems to me an overt attempt to invoke in the beholder the kinesthetic, that is, a bodily, even muscular, perception of movement be that through dance, film, or static art. This may not be surprising in the case of the moving arts of dance and film, but it might be surprising to claim that plastic artists, taking part in the development of abstraction, sought meaning beyond the material and formal picture in the viewers' individual, temporal, and sensorial responses. I will begin and end this essay with the objects of my initial question. The films and performances of Loie Fuller's serpentine dance in the 1890s will be linked to kindred goals within Symbolist painting's first steps toward abstraction. Then, through Hans Richter and the abstract films of the 1920s, a moment of more complete abstraction in both cinema and painting will be shown to coincide aesthetically with the work of the Belgian dancer Akarova. In each case, the films, dance, and paintings invoke the viewer's kinesthetic sensation of movement, thereby revealing a play for spectatorial engagement—despite a seemingly contradictory abstract mandate.

Prolonging vision

Tom Gunning has previously written that the dance of Loie Fuller spoke to early cinema's fascination with hypnotic rhythms, and that she expressed that joy of motion that we can see in many of the earliest films ever made.[4] As with the elusive, floating fabrics of Fuller's serpentine dance, early film repeatedly sought to record the previously immaterial or ephemeral. In the very first films by the Lumières, for example, we see a showcase of smoke rising from the train arriving at La Ciotat, water spraying from a gardener's hose, and wind billowing a tablecloth at lunch. The most breathtaking aspect of the 1895 Lumière film *Feeding the Baby* is not the foreground figures enacting the title, but the sparkling ripple of leaves rustling behind them, which gives a permanent and physical presence to the shifting atmosphere of light and breeze.

In fact, at century's end, offering the sensation of the elusive *captured* seems to be an aim shared not only by film, but by dance and painting as well. The fin-de-siècle French painter Jan Verkade remembered how "a battle cry rang from one studio to another, 'No more easel pictures! ... Painting must not claim a freedom that isolates it from the other arts! ... There are no more paintings, there is only decoration!'"[5]

Verkade was a painter in the group of mystical Symbolist artists now known as the Nabis, and refers to a brief two decades in art history when decoration was called forth from the domain of the so-called minor arts to become the challenge of the avant-garde. Decoration led the Nabis to experiment in a new language of art that would emphasize abstract qualities such as flatness, patterning, and absorbingly large-scale formats.[6] In an 1892 article in *Le Voltaire*, art critic Roger would articulate the interest and potential of the new decorative art. With particular praise for Nabis painter Edouard Vuillard, Marx wrote that decorative art would go far because it understood the "rhythm of a line, the quality of an arabesque, the alternations of calm and movement, void and solid."[7] For Marx the new decorative painting was striving toward the ability, despite its material existence, to move between contradictory forces of stillness and motion, materiality and immateriality.

Indeed the Nabis decorators were consciously following the Symbolist poet Stéphane Mallarmé who solicited a more ambiguous process of communicating the art object. Avoiding the literalness of metaphor or realism, Mallarmé pushed for a slower unfolding of meaning through suggestion and allusion. By staving off the readiness of literary meaning, he hoped to synthesize the concrete aspects of the work of art with an abstract and metaphysical ideal. In the years to come, however, both Nabis mentors Marx and Mallarmé would write that the aims of painting and poetry had been fully realized in yet a third art form: dance.

Just weeks after the publication of Marx's essay on Nabis decoration, dancer Loie Fuller débuted her serpentine dance at Paris' Folies-Bergère. In Fuller's art, Marx would claim a synthesizing ambiguity similar to, if not greater than, the Nabis: "Announcing the soul's beauty through the rhythm of movements, [Fuller] has achieved the ideal performance that Stéphane Mallarmé once dreamed of: a silent performance that escapes definitions of space as well as time."[8] Fuller paradoxically use the human body to rouse an experience in the critic that seemed outside her own physical realm. Marx was not the only Nabis art critic writing about Fuller in this way. What is so significant in these writings is that they signal an historical link between dance and painting that resides in a kind of abstraction of time and space, and help to explain the fascination Fuller's dance held for the pioneers of the new plastic art of film.

Traditionally in art history, the Nabis's early gestures toward abstract representation—flattening arabesques and pattern, large planes of color and so on—have been assigned the Modernist reading of articulating formal-material concerns. As early as 1890, Nabis painter Maurice Denis would

his famous adage prefiguring Modernist abstraction: "Remember that picture, before being a war horse, a nude woman, or some anecdote, is essentially a flat surface covered with colors and assembled in a certain order."[9] However, paying attention to the reception of performances and films of Loie Fuller's dance during their time, suggests that the urge to abstraction may have also come from a shared goal of suspending or prolonging vision.[10]

In performance reviews of Fuller, Mallarmé and others describe the beauty of her dance through its strain on one's perception. In the serpentine dance, the dancer is dressed in a floor-length, high-necked gown of white silk. The costume's extra folds along each side conceal the dancer's arms which hold long sticks or canes, slightly rounded at the ends to control the flowing drapes. Fuller would maneuver her arms under the drapes in various patterns—limpid ripples, swelling waves, hypnotizing figure-eights—that were carefully choreographed to music so that her fabrics could move around an otherwise-stable body in undulating rhythms, alternately covering and uncovering her face or feet. There were no steps to be learned by the feet, which acted primarily to rotate or move the body across the stage. Lighting techniques of her own design were used to illuminate her figure from many different angles and in multiple combinations of colors. As she moved, the fabric would seemingly take over, often completely engulfing her body in waves of silk (Figure 4.1).

The large silk's continuous repetitive movements created a mesmerizing formal image, spotted with colored lights, in which flashes of woman would tantalizingly appear and disappear within the fabric. A number of Fuller's contemporary Symbolist writers noted this phenomenon in one way or another. Georges Rodenbach found Fuller "delights by being unattainable Such a miracle of constant metamorphoses!"[11] Jean Lorrain wrote, "one could just barely see her, and one wanted to see it again."[12] Paul Adam agreed that "the great seduction emanating from this luminous dance derives foremost from the thrill of seeing a human being decorporealize herself, extinguish herself, become a kind of rhythm melted within movement"[13] Art critic Arsène Alexandre would ask, "Was it dance? Dancers would have told you no [...] Was it color? Painters would have told you with a bit of envy —but loyal and admiring envy—that it was something more that they could neither analyze nor pin down."[14] But it is Mallarmé who most clearly described his sense of hovering in a state of desire to grasp the art in front of him, a state he explains as vision prolonged: "the suspense of the dance, a contradictory fear or desire to see too much and not enough, demands a transparent prolonging."[15]

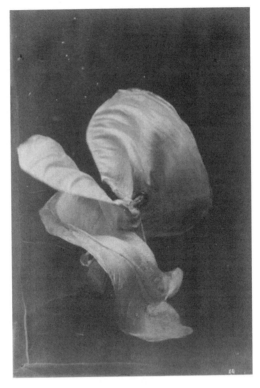

Figure 4.1 Isaiah West Taber, Photograph of Loie Fuller. Musée d'Orsay, Paris.
Image © Réunion des Musées Nationaux/Art Resource, New York

Not one of the many serpentine dance films document Loie Fuller herself, but show rather less-adept dancers in imitation costumes; however, these scaled-down examples of her dance do demonstrate Mallarmé's dilemma. In the serpentine film, we may notice a head and see a woman dancing, but then the flat shapes of the silk take foreground again and the woman disappears. We can perceive one or the other in a glance—the flat almost slow-motion forms, or the dancing body—but we are continually denied the visual completion of a traversable, theatrical space in the films. Instead, the dance form becomes a visual abstraction (Figure 4.2).

Fin-de-siècle avant-garde painters, since Impressionism, had been keen to bring structure and longevity back to the fleeting and contingent experience of modernity, and in kind, Mallarmé pushed Symbolism toward a slower unfolding of meaning through suggestion and allusion.

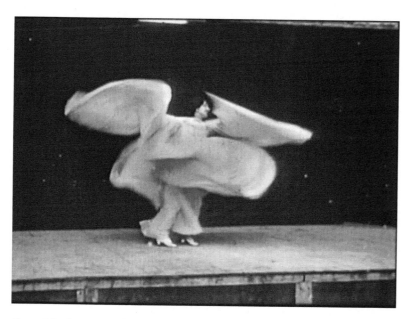

Figure 4.2 Auguste and Louis Lumière, *Danse Serpentine (Serpentine Dance)*, 1896.
Film Still

In his theater essays, "Crayonné au Théâtre," Mallarmé would claim that "Dance alone [is] capable, in its summary writing, of translating the fleeting and the sudden all the way to the Idea."[16] This "Idea"—whether it be a platonic Ideal, a work of art's cerebral inspiration, or an immaterial essence of an essentially material art—articulates Mallarmé's end goal as *an abstraction*. Though painting is not naturally a temporal art as is poetry or dance, the painters who followed Mallarmé can be seen slowing down vision through abstraction to allow for a longer grasp of the sensation of viewing. A look at specific works by the Nabis decorators from the beginning of Loie Fuller's Parisian rise offers striking visual evidence of a palpable kinship between the decorations, the dancer, and their shared desire for an art of suggestive abstraction that might prolong vision.[17]

Unhinging time and space

Maurice Denis's 1892 work *April*, created for a child's bedroom, exemplifies Nabis decorative painting techniques by taking our sight irregularly through the durational rhythms of repeated arabesque line, and across

a spatiotemporal continuum of rhythmically placed forms.[18] Formatted horizontally, and painted in flat sections of matte pastel and earth colors, the painting contains six female figures in white placed along the edges of a serpentine path. Each figure seems a reflection of the next, but with a slightly altered viewpoint, angle, or height, so that they appear as if a sequence gracefully flowing from edge to edge of the work in a diagonal made malleable by three alternately bended figures. As these lit, draped forms cross the picture, echoes of their serpentine motion are also suggested in the surroundings: in the lower left corner, rounded swirls of sable contoured with black loop their way through a green mass to abstractly indicate a briar; in the middle ground, a turquoise river snakes in a diagonal through Roman arches in the distance; in the upper landscape a billow of white smoke rises from a farmyard to create a formal correspondence with the women's white dresses. Because of the painting's composition, the viewer's eyes circulate in repetitive but irregular motions, neither able to complete their course, nor to gel the picture into solid form. Such a composition, continually renewing itself, would suit a work that was to be lived with and relived daily in a domestic environment—in this case, a bedroom. Seen in this way, the techniques of early Symbolist abstraction such as in *April* can be said to stem not from form and material, but through a spatiotemporal unhinging of the picture.

Edouard Vuillard's painting *The Album*, produced as part of a decorative series for Thadée Natanson in 1895 (Figure 4.3) goes even further to suspend our eye again and again upon its matte distemper paint. More than two meters long, the narrative scene of seven women in a parlor—chatting, reading, arranging flowers—is muted, uneven, and difficult to make out amid a cacophony of patterns. The women's dresses, wallpaper, upholstery, and table linens compete for clarity. The patterns of these fabrics show little description of the human bodies and surfaces they clothe; as figures bend or tilt, the pattern remains impossibly flat. The bold fabric on the sleeve of the figure second from left almost suffocates the muted figure below her. Yet, as this woman's head and the other ghostly faces come into view across the canvas, the surrounding patterns must fade out. Vuillard's figures appear and disappear within their surroundings, separated from the continuity of the image in a collage like effect, while arabesque patterning keeps our eye moving from edge to edge. Holding the image together are full white spots of dahlia or peony flowers that flash clearly in their darker greenery, regularly deposited across the canvas. Yet the cloudier images of women and their patterned fabric cannot be held in the same glance

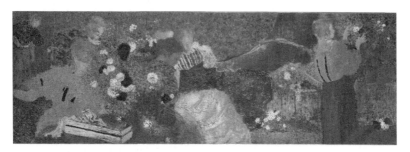

Figure 4.3 Édouard Vuillard, *The Album*, 1895. The Metropolitan Museum of Art, New York, Walter H. and Leonore Annenberg Collection, partial gift of Walter H. and Leonore Annenberg, 2000 (2000.93.2). Artwork © 2010 Artists Rights Society (ARS), New York/ADAGP, Paris. Image © The Metropolitan Museum of Art, New York/Art Resource, New York

as those continuous white patches. We are denied the perception of a whole. Like many of Nabis decorative paintings, *The Album*'s continuous or prolonged viewing is the result of a deliberate absence of stable composition that prevents the beholder from grasping the work as a fixed, pre-organized, and discrete body. It is not a traversable space fixed in time, but instead seems to mimic the phenomenological effects of movement *through* space and time.

Returning to the dance, we can see how Loie Fuller's moving image could perform these painter-decorators' ideal of an enduring, living image. Never locking into a single form, the serpentine imagery is in constant flux and renewal, but it is the repeated forms that create a taut continuum and allow the viewer to sense time or duration. The mesmerizing movements of Fuller's sticks are imprinted like retinal traces on our eye and linger in our imagination. Working like Vuillard's patterning and repeated spots of faces across his canvas, Fuller's taut formal repetition casts a transparent net over the whole that enables us prolong our grasp of the fleeting sensation of her movement.[19]

One of many artists to craft Fuller's image, Henri de Toulouse-Lautrec produced a series of 60 color lithographs entitled *Miss Loie Fuller* in 1893.[20] Although she performed in many of the same variety halls as Lautrec's better-known subjects of cancan dancers, Fuller drew an entirely new expression out of the artist. These prints not only represent the most abstract images ever produced by the artist, but as a regularized series of framed images, they prefigure the cinematic vision of the dancer in the following years. Lautrec's lithograph image consists of an irregular, cottony shape that stretches from center to the upper right of

the print. From the title, we search for a female form, which allows us to recognize in the image two fragile ankles beneath the body's cloud-like mass and a few facial features above that indicate a head tilted back and to the side. The only suggestion of space comes from the dark neck of a contrabass that cuts across a diagonal line at the base of the image for the slightest illusion of an orchestra pit and stage ramp. Lautrec varied each of the 60 prints, using five blocks for color and adding gold or silver dust by hand. Each image shimmers with shifting embellishments, almost certainly inspired by Fuller's performances in which colored lighting skimmed the surface of her skirts. Apart from his images of Fuller, Lautrec remained tied to figurative, even narrative images throughout his life, so that this series demonstrates how Fuller's performances liberated traditional conceptions of time, movement, and form.

The new more abstract techniques developed by Lautrec's shimmering variations atop a repeated lithographic template and the Nabis alternation between focused and confused areas of paint in effect build up a visual and material web in which motion (whether narrative, pictorial, or ocular) is sensed as caught or slowed. These works of art speak to the same suspense found in Fuller's dance, and likewise appeal to that visceral desire to prolong the physical sensation of a fleeting vision. Paul Valéry in fact wrote of dance's particular ability to engage our desire to find stable form within the fleeting sensations of time. In Valéry's 1921 trialogue, *L'Ame et la Danse*, the voice of Phaedrus describes a dancer bearing a resemblance to Fuller in her *Fire Dance*: "Look, but look! ... She makes the instant visible ... she flings her gestures like scintillations ... she filches impossible attitudes, even under the eye of Time! ... She is divine within the unstable, and gives [the instant] to our gazes like a gift!"[21] In dance the unstable seems held and the instant feels longer.

From the many incarnations of the serpentine films, it is clear that filmmakers of her time likewise noted the special quality of Fuller's dance over and against other music-hall dance performance. While there are a few early films documenting the more popular peek-a-boo skirt dance, as in the Edison company's "Annabelle Butterfly Dance" films of 1894–95, the vast majority of dance filmed in this first decade used imitators of Fuller, with the dancer's longer drapes fully covering her body and the fabric's movement at center stage. It seems likely that the first filmmakers used Fuller's serpentine dance to show off the cinema's ability to physically harness vision better than painting or even dance. Fuller's motion and the noted effect of her drapes was an ideal demonstration of the controlled temporality that characterized

the new medium of film. When the serpentine dances are flattened onto a filmic image, the fabric swirls spread from edge to edge, enclosed within a frame and, in Edison's case, viewed individually through the peephole of a Kinetoscope box. Fuller's choreography is thereby removed from its ephemeral performance and set within a plastic visual art where its ephemeral aspect of time might be grasped. Laurent Guido has pointed out the fetishist aspect of watching the continuous loops of early film experiments and cites, even from a scientific standpoint, that the chronophotographer Georges Demenÿ was interested in the possibility of film to slow down movement "according to our desire."[22] More literally in the case of the serpentine films, cinema embeds the fleeting dance frame by frame within the medium, thereby halting the once "unattainable" interior movements of the dancer and imposing cinema's exterior rhythmic control upon them.

Moving the beholder

The visual effects that Fuller created through motion engaged her viewers with a new experience of vision. I've suggested that the kind of viewing required by her dance offers us insight into the motives of her contemporary painters who took figurative painting toward abstraction thereby capturing similar temporal visual effects; it also provides an explanation for her repeated imitation on film in its early years. Yet, the fin-de-siècle painting and films I've described still work through figuration and the female body in particular. I would now like to turn to a similar kind of kinship among the arts of painting, film, and dance that took place even after the plastic arts had reached a so-called total abstraction, removing all figurative illusion from the work of art. By the second decade of the twentieth century, film had already become attached to narrative storylines and big production houses, yet we also see avant-garde artists and writers in the teens and 20s returning to a discussion of cinema's possibilities, as if it were a newly available medium.

In the case of Symbolism, Fuller's dance represented for the avant-garde a more palpable viewing experience. By the 1920s, we can see film requiring even more emphatic engagement of the viewing body. For the avant-garde of this period, film was more than simply "art in motion"; it carried an expectation about viewership and could make a direct connection to the spectator's subjectivity by reproducing point of view. In 1924, following the opening of Dada films like René Clair's *Entr'Acte* (1924) and Fernand Léger's *Ballet Mécanique*, a young Georges

Charensol was delighted to see the artistic shift in French cinema to a non-narrative, visual mode, "made to be seen, not recounted."[23] At this same moment, visual artists Hans Richter and Viking Eggeling, and others, were producing completely abstract or absolute films through animation. Both of these kinds of avant-garde film in the 1920s—Dada-Surrealist abstraction and abstract animations—return to the early ciné-genre of "noncontinuity" in which we are denied any ability to follow a story.[24] The effect is to force the viewer's engagement with the visual and temporal rhythm produced by the film apparatus, so that we actively feel ourselves seeing. Again, Tom Gunning has established that a relationship to the spectator and his or her sense of vision was the defining aspect of cinema in its earliest incarnations. Naming the films of this early period the "Cinema of Attractions," he has emphasized the importance of the spectator's desire and seeing presence. Moreover, Gunning and others have considered the avant-garde film production of the 20s to be a reappearance of the cinema of attractions genre.[25]

During this 1920s avant-garde turn in cinema, Blaise Cendrars wrote of a new spectator in his *ABCs of Cinema*, "who is no longer immobile in his chair, who is wrenched out, assaulted, who participates in the action, who recognizes himself on the screen among the convulsions of the crowd, who shouts and cries out, protests and struggles."[26] Léger in fact would claim he wished to work in cinema because it surpassed painting's ability to make images "seen," by mimicking our moving eyes and temporal vision.[27] His alliance of cinema with the human experience of seeing tells us that the importance was in the audience reaction, even self-recognition, despite the fact that his images were put together to aesthetic abstraction.

At this moment of prolific avant-garde experimentation with the moving image, an example of collaboration between art and dance further reinforces what I believe is the period's shared interest to provoke a self-aware spectator through abstraction. I have written elsewhere about a francophone Belgian dancer, known as Akarova, who in the early 1920s, created performances termed by her contemporary artists alternately as "music architecture," "living geometry," and "pure plastics" (Figure 4.4). During the years of the Belgian abstract art movement *Plastique Pure* and its champion, a journal called *7 Arts* (1922–9), Akarova was married to Belgian constructivist and *Plastique Pure* artist Marcel-Louis Baugniet. Through her connection to him and the *7 Arts* circle, she created dances and costumes in close collaboration with avant-garde artists of many media and amid a network of Pure Plastic artists linked to Cubism, de Stijl, the Bauhaus, and Russian

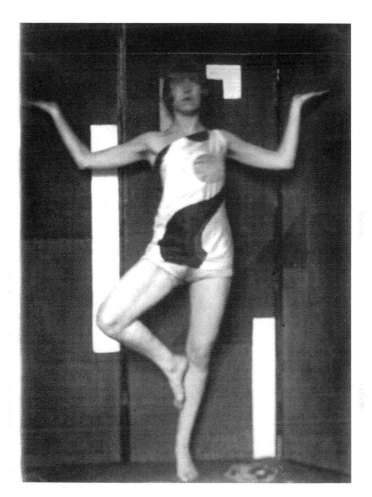

Figure 4.4 Marcel-Louis Baugniet, Photograph of Akarova, with costume and backdrop by Marcel-Louis Baugniet, 1923. Archives d'Architecture Moderne, Bruxelles. Photo © 2010 Artists Rights Society (ARS), New York/SABAM, Brussels

Constructivism.[28] The two most important forces driving Akarova's dance were first, her music—which she conceived as *space* that has been built and restructured by sound—and second, her choreographic skeleton, from which she based live improvisation. Akarova, therefore, began with music and marks in space, which together created a kind of architectural framework for her living performance. In imagining her dances, there should be a vibrating sound-environment in the theater, understood as an imaginary architecture through which Akarova's body

negotiated its forms. Visually, Akarova also used the formal elements of her stage—her costume, set, and gestures—to build a sense of connectedness between her body and this architecture.

References to a sense of fusion between the elements of Akarova's performances occur in contemporary reviews; as one put it, "her whole body interprets the musical work, becomes confused with it and at certain moments even seems to dominate it until the spectator no longer hears, but sees and understands."[29] Akarova's musical expression was not literal, or narrative, but was an abstract link between her body and the space around her. The dancer's great nephew, art historian Yves Robert, evocatively titled his biographical essay on Akarova "the gesture as a sign of sound matter" (*matière sonore*). In her dance then, he found not an affective relation to music, but rather the material reality of sound in space.[30]

Akarova's stage lighting also changed the viewer's perception of the dancer's relation to space; Antoine Seyl, who witnessed a lighting experiment Akarova performed at Henry van de Velde's School of Fine Arts, wrote that her "patterned movements were inscribed on this screen-like stage."[31] Light created a paradox of a permeating "plenitude" and a unifying "film" that could alternately bring out the moving form or fuse it to its ground.[32] Like her musical support, light seemed to be used by Akarova to create yet another layer of virtual webbing in space, through which her body could connect with the atmosphere of her performance. The space was thickened by sound, color, and now light. And Seyl's sense of a more permanent "inscription" of the fleeting dance, tells us these added increased physical presence to her movements and suspended them in a perceived image for the audience.

Baugniet would say that Akarova's work "was directly involved with the cultural avant-garde of the period ... it corresponded to our own aspirations in the field of plastic art."[33] To link Akarova's aims for dance with those of her painter peers is not so difficult, despite the artists' abstraction. Baugniet's more pictorial work in fact shows he saw Akarova's dance as the kinesthetic translation of his constructivist ideals. In his painting *Statisme* of 1925, Baugniet paints an image that solidifies Akarova as the representation of his avant-garde's most prized medium: architecture. The dancer's form and its surroundings are built of geometric blocks in varying textures of blue, brown, and white. Areas of fleshy rose depict a face, torso, arm, and breast. Posed in the flattened contraposition of an ancient frieze, her head and legs turn to the right, and her center faces the viewer. One arm is retracted solidly into her side, while the other is raised in a right angle and holds up a

horizontal blue rectangle like a caryatid. She is both supporting and built into the structure of the image. Her flesh merges with a diagonal spatial plane that intersects her waist, and the stylized round shape of her breast is embedded again symmetrically below her in brown (Figure 4.5). Baugniet expresses Akarova's dance as one that can be equilibrated into its space, thereby giving physical life and function to constructivist design. In his book *Essay on the psychology of forms*, Baugniet uses Elie Faure to describe dance's ability, through the abstract qualities of rhythm, to carry art into time and space. He quotes Faure's words: "Dance, in every era, like the cinema of tomorrow, is charged

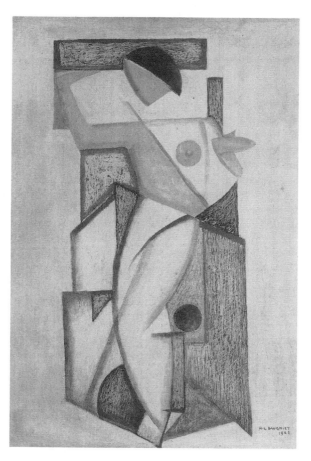

Figure 4.5 Marcel-Louis Baugniet, *Statisme*, 1925. Private Collection. Artwork © 2010 Artists Rights Society (ARS), New York/SABAM, Brussels

with reuniting plastic art with music by the miracle of rhythm both visible and audible, and to usher vividly into duration, the three dimensions of space."[34] The interest in uniting space and time, art and rhythm shows a concern beyond abstraction's formal qualities, beyond medium-specificity, and rather toward an encounter with other media in order to augment the possibilities of meaning for the viewer.

The very name of Baugniet's movement's literary vehicle, *7 Arts*, highlights an awareness and certain excitement around mixing media, including the only recently added seventh art of cinema. The explosion of plastic artists working in cinema in the 1920s created a new kind of living abstraction, similar to that which I believe occurred in Akarova's dance at this time. Unlike absorptive and autonomously displayed museum art—and its counterpart, the passive narrative film—avant-garde artists found in film abstraction a paradoxical theatricality of surprise that allows for a viewer's self-recognition and contact with the work of art. While Akarova's and Fuller's dances may have used abstract forms for a similar end, their dependence on a specific body in the real space of the theater limits the ability for a spectator's self-projection or for some universal reception. Film's theatrics, on the other hand, are carried by a single point of view shared by all spectators, and present visibility in an objectified form, that is, screened in two-dimensions and removed of a specific location in time and space, so that our senses are able to grasp them with new recognition of our own sensation of seeing. Moreover, by placing their images in time, artists in film could augment the viewer's engagement. Given a sequence, a viewer anticipates its logical completion—this can then be either fulfilled or thwarted by the artist's harmonious or dissonant visual combinations. As we watch the moving image, we follow the sequence and begin to *want* something from it, so that viewing motion is filled with a visceral desire.

Hans Richter's film *Rhythmus 21* (1921–3) consists of gray and white rectangles that slide across the black surface of the screen, receding and emerging forward, opening and closing. As their forms collide and overlap, their reduction in color and geometric forms emphasize the screen's planarity. But already my description opposes Standish Lawder's well-known description of the film's absolute flatness.[35] It seems more truthful to say Richter's moving images create volumes and spatial differentiations that engage the viewer's desire to enter into the screened image. Working in the same way that Fuller's dance does, the forms create depth through the phenomenon of perceived foregrounds and backgrounds, positive and negative forms, motion and stillness. By the expectation set up in the irregularly timed sequence of Richter's

animation, we are unable to see the image as a flat surface arranged with forms, but instead animate the moving forms with intention, projecting our vision into and extending the plane of the movie screen.

Eggeling's *Diagonal Symphony* (1924) likewise uses the temporality of film to animate the artist's abstract scroll drawings. Again, where Lawder sees no spatial complexity, only pure kinetics, I believe the sense of rhythm and musical structure that develops frame by frame produces an imagined kinesthetic space. The film's contrasts in tempo and varying complexity of form create in the viewer a desire for the completion of phrasing, which in turn activates the viewer's senses beyond vision and makes each form seem to work in the building up of an almost physical structure. There is a shift from seeing motion to feeling movement; this is kinesthesia, the phenomenological awareness of our own body position and potential for movement with regard to what is seen. These abstract animations paradoxically activate our senses of muscle and weight, a self-awareness that will be even better elicited by two filmmakers closely tied with dance: Fernand Léger and René Clair, who made abstract films while collaborating with the Ballets Suédois. Léger transitioned from dance stage to film screen in 1924 with his film *Ballet Mécanique* and wrote that he and Clair wanted to treat the "moving image as the leading character."[36] In his essay on this film, Léger explained that—by editing, framing, close-up, and fragmentation—his objects become freed of their environment and their associations, so that they may be seen for their abstract form.[37] Added to the distortion of Léger's photographic images is the film's discontinuous visual narrative, which disengages our voyeuristic passivity and demands the viewer decipher and unify what we see in some other way. Léger disrupts the spectator's habitual visual understanding, and then projects outward to activate the viewer into the spectacle, as Cendrars had hoped. For instance, Léger explained the sequence in the film where we see a woman climbing stairs repeatedly at faster and faster intervals by writing that he wanted first to amaze the audience, then to make it uneasy, and eventually to push it toward exasperation.[38] Like the cinema of attractions before it, Léger's abstraction of the photo-realism of cinema is demanding a response from his spectator. Again this is a *contradictory* use of abstraction to communicate with a beholder. It thereby repositions the Greenbergian and structuralist legacies surrounding the aesthetics and autonomy of abstraction in art historical accounts.

Richter and Eggeling were inspired by musical rhythm, and Léger and Clair hoped to make their images "dance"; however, the particulars of

filmic rhythm that the 1920s avant-garde films highlight in fact allow for an expansion of visual space that the natural rhythm of dance and music can only approximate. Through film's mechanical rhythmic control, the world's linear temporality can be slowed, stopped, even reversed, and these warps in time call on an imaginative aggregation of space—we might be able to use the Bergsonian term, extension. No longer a world to look upon, these films create a space to look into with a kinesthetic imagination.[39]

Perhaps Clair's *Entr'Acte* emphasizes the point best in its final scene. Created in 1924, *Entr'Acte* was to be an addition—or extension, if you will—to the Ballets Suédois performance of *Relâche*. The film contains a series of discontinuous narrative clips that startle and amuse, such as a meta-chase scene whose trajectory follows an impossible logic. We are finally shown a screen announcing the end of the film—"FIN"—only to have it crashed through from behind by the Ballets Suédois' director Jean Borlin. The perceived picture plane is broken and the fiction of an autonomous film world destroyed as it threatens to come in contact with the audience.

My brief examples here serve to show how film and dance not only intervene in the history of Modern art, but in doing so they also de-center the opticality and formal autonomy so dominant in the traditional art-historical account of abstraction. The kinesthetic viewing required by avant-garde dance and film demonstrates that theater, embodied self-projection, and kinesthetic desire are not necessarily in opposition with pictorial abstraction, and in fact might expand our understanding of the urges behind and experiences of formal abstraction.[40]

By 1923, the "seventh art" of cinema was included among the works of avant-garde art displayed at the *Salon d'Automne* in Paris. Shortly thereafter, Paul Valéry gave his "Philosophy of the Dance" lecture in which he described the special, "inner life" of dance, a life force that "resonates" in order to communicate to spectators who will feel "possessed by the rhythms so that we ourselves are virtually dancing." That kinesthetic response is precisely what I have found the dancers and artists in this essay to be seeking, and yet Valéry believed that the dance's resonance was merely accidental, that dance is so individually expressed that the resonant energy felt by the audience is in the end centripetal.[41] That is, because the life-force that expands out from a dancer is associated with a subjective, individual body, the universal goal of abstraction is limited. But as Lifar had hoped, film arrived to free dance from "the weight of exertion" and to create a new kind of dance from a more universal abstraction. Where the self-projection in dance is a one

way street, in film it is reciprocal. The life-force of the real objects are contained to the flat filmic surface; as with the dance, we project our senses into its imagined spaces, desiring to feel our way into the work, but through the mechanics of light and lens, the celluloid body also spurts outward to be grasped all together by its spectators.

Notes

1. This medium-specific model was laid out by Greenberg in a number of critical essays, including his "Modernist Painting." Reprinted in *Clement Greenberg: The Collected Essays and Criticism*, ed. J. O'Brian (Chicago, IL: University of Chicago Press, 1986, vol. 4, 85–93). The term "presentness" I borrow from Michael Fried's 1967 *Artforum* essay, "Art and Objecthood." Here, Fried asserted a qualitative difference between the presentness of Modern art and the spatiotemporal presence of works of Minimalist sculpture. See M. Fried, *Art and Objecthood* (Chicago, IL: University of Chicago Press, 1998) (pp. 148–172).
2. Méliès quoted in R. Thoumazeau and F. Ray, "Georges Méliès, illusionniste, du monde entier ..." *Noir Blanc* (October 7, 1929). Translation mine.
3. Lifar quoted in P. Leprohon, "La Caméra peut-elle servir la danse?" *Cine-France* (December 17, 1937). Translation mine.
4. T. Gunning, "Loie Fuller and the Art of Motion: Body, Light, Electricity and the Origins of Cinema," in *Camera obscura, camera lucida: Essays in honor of Annette Michelson*, ed. R. Allen and M. Turvey (Amsterdam: Amsterdam University Press, 2003, pp. 75–90).
5. D. W. Verkade, *Yesterdays of an Artist-Monk*, trans. J. L. Stoddard (New York/London: P. J. Kenedy & Sons, 1930) (p. 94). Originally published as *Le Tourment de Dieu: Étapes d'un moine peintre* (Paris: Rouart et Watelin, 1923).
6. With these qualities, the "decorative" has often been seen as a source for abstraction in art and has influenced and bolstered the medium-specific trajectory of formalism in the history of Modern art.
7. R. Marx, *Le Voltaire* (October 1, 1892), quoted in B. Thomson, *Vuillard* (New York: Abbeville Press, 1988) (p. 36). Roger Marx was a critic and collector of the Nabis and would become editor-in-chief of the *Gazette des Beaux-Arts* from 1902 to 1913. Marx also wrote an essay on Loie Fuller in 1893 and continued to support her career, paying homage to the dancer in a special edition monograph, *La Loie Fuller*, in 1904.
8. Roger Marx, quoted on a performance program of the Théâtre des Champs-Elysees (March 1, 1921). Location, Rondel collection, Bibliothèque Nationale de France (Ro 12133). Translation mine.
9. M. Denis, "Définition du néo-traditionnisme," *Art et critique* (August 1890), reprinted in *Théories, 1890–1910, du symbolisme et de Gauguin vers un nouvel ordre classique* (Paris: Rouart et Watelin, 1920).
10. These terms are indebted to Mallarmé's description of watching Fuller's dance with "suspense" and "transparent prolonging," to which I will return shortly. I also gratefully acknowledge a debt to Jonathan Crary's work on vision and perception in this period, in particular, *Suspensions of Perception: Attention, Spectacle, and Modern Culture* (Cambridge, MA: The MIT Press,

1999). Crary's exceptional histories of observing and attention in modernity have offered a model and vocabulary for my own attempt to tie down and conceptualize in language shifts between focus and periphery, attention and dispersion, that might occur when watching the dances and looking at the paintings of my study.

11. G. Rodenbach (1855–98), "Danseuses," *Le Figaro* (May 5, 1896), 1.

12. J. Lorrain, *Poussières de Paris: Pall Mall 1894–5* (Paris: Fayard frères, [n.d. orig. 1902) (p. 144). Lorrain (1855–1906) is the pseudonym for Paul Alexandre Martin Duval.

13. Paul Adam quoted in G. Lista, *Loie Fuller: Danseuse de la Belle Epoque* (Paris: Somogy Éditions d'Art, Éditions Stock, 1994) (p. 179). Translation mine.

14. A. Alexandre, "L'Art de la Loïe Fuller," undated, unidentified newspaper clipping, section titled "La Vie de Paris," Rondel collection, Bibliothèque Nationale de France (Ro12.115). Translation mine.

15. S. Mallarmé, "Le Seuil il le fallait fluide comme l'enchanteur," in *Documents Mallarmé*, ed. G. Millan (1896) (Saint-Genouph: Librairie Nizet, 2000, 60). Translation mine.

16. Mallarmé, "Stéphane Mallarmé, Loie Fuller and the Theater of Feminity," in *Bodies of the Text: Dance as Theory, Literature as Dance*, ed. E. W. Gollner and J. S. Murphy and quoted and trans. F. McCarren (New Brunswick, NJ: Rutgers University Press, 1995, p. 217).

17. I have written a more thorough study of the critical and visual links between Fuller and the decorative paintings of the Nabis Pierre Bonnard, Edouard Vuillard, and Maurice Denis. See "The Idea in Motion," chapter one of Nell Andrew, "Bodies of the Avant-Garde: Modern Dance and the Plastic Arts, 1890–1930" (Ph.D. diss., University of Chicago, 2007).

18. From the series: *Poetic Subject: 4 panels to decorate the bedroom of a young girl*, oil on canvas, 37.5 cm × 61 cm, Rijksmuseum Kröller-Müller, Otterlo the Netherlands.

19. Just as Mallarmé suggests occurred to him as a spectator.

20. An exhibition at the Art Institute of Chicago and The National Gallery of Art in 2005 collected 14 of these together in a stunning display to which my observations are indebted. These 14 are also reprinted in *Toulouse Lautrec and Montmartre*, exhibition catalogue (Princeton, NJ: Princeton University Press, 2005). I am also grateful for Sarah Kennel's exceptional descriptions and analysis of a number of the lithographs. S. Kennel, "Across the Veil: Symbolism, Dance, and the Body" (M.A. thesis, University of California, Berkeley, CA, 1995). Each print is approximately 37 cm × 27 cm. Locations include the Art Institute of Chicago, the National Gallery, the Boston Public Library, The Metropolitan Museum of Art, the British Museum, and private collections.

21. P. Valéry, *L'Ame et la Danse* (Paris: Librairie Gallimard, 1924) (pp. 5 -63). Translation partially taken from F. Kermode, "Poet and Dancer before Diaghilev," in *What is Dance?* ed. R. Copeland and M. Cohen (Oxford: Oxford University Press, 1983, p. 158).

22. L. Guido, "Rhythmic Bodies/Movies: Dance as Attraction in Early Film Culture," in *The Cinema of Attractions Reloaded*, ed. W. Strauven (Amsterdam: Amsterdam University Press, 2007, p. 144).

23. . Charensol, "Le Film abstrait," *Cahiers du Mois*. n.d. (1924). Clipping cated in the Rondel Collection, Bibliothèque Nationale de France (Rk 64).

24. e T. Gunning, "The Cinema of Attractions: Early Cinema, its Spectator d the Avant-Garde," and "Non-continuity, Continuity, Dis-continuity: theory of genres in early film," in *Early Cinema: Space, Frame, Narrative*, eds Elsaesser and A. Barker (London: British Film Institute, 1990).

25. e again T. Gunning, "The Cinema of Attractions," and more recently uido, op. cit.

26. Cendrars, "L'ABC du Cinéma," in *Modernities and Other Writings*, ed. . Chefdor (Lincoln, NB: University of Nebraska Press, 1992, p. 29).

27. ger, quoted in T. Gunning, "Cinema of Attractions," 58.

28. e N Andrew, "Living Art: Akarova and the Belgian Avant-Garde," *Art urnal* 68: 2 (Summer 2009), 26–49.

29. om a review quoted in G. Lista, "Akarova and the Avant-Garde: From ncretism to Autarchy," *Akarova: Spectacle et Avant-Garde 1920–1950*, ed. Van Loo (Brussels: Archives d'Architecture Moderne, 1988, p. 220).

30. Robert, "Akarova: le geste comme signe de la matière sonore," *Annales histoire de l'art et d'archéologie* 12 (1990), 111.

31. Seyl,"A l'Institut supérieur des arts Décoratifs," in *Aurore* (June 1929), ioted in F. van de Kerckhove, "Les Lettres Dansantes: Akarova and the lgian Avant-Garde" in *Akarova: Spectacle et Avant-Garde, 1920–1950*, ed. Van Loo, 362, op cit.

32. iovanni Lista quotes a review of the La Cambre performance that describes ght that was alternately "a very pale film" and "white plenitude." Lista, ikarova and the Avant-Garde," 263.

33. iugniet interview with Anne Van Loo in Van Loo, 201.

34. ie Faure, quoted by M.-L. Baugniet, *Essai sur la Psychologie des Formes* russels: Editions de la Maison du Poète, 1963) (p. 65).

35. iis from Lawder's groundbreaking book, *The Cubist Cinema* (New York: ew York University Press, 1975).

36. Léger, "Ballet Mécanique," in *Functions of Painting*, ed. E. F. Fry and trans. Anderson (New York: Viking Press, 1973, p. 49).

37. id., 48–50.

38. id., 51.

39. iese brief observations on the art historical importance and phenomeno-gical impact of certain avant-garde films of the 1920s deserve much more vestigation and print. Others, such as Malcolm Turvey and Noam Elcott r example, are tilling exciting terrain in this field.

40. liet Koss has argued that empathy and embodied vision in fact "unwittingly ilped to set the terms for the theory and practice of visual abstraction." e J. Koss, "On the Limits of Empathy," *Art Bulletin* 88 (March 2006), 141. iting Robert Vischer, Koss explains this was possible because any discus-n of "pure form" must be understood through embodied perception, hat "looks right" or is comfortable, i.e. the perception of a horizontal line omfortable) as opposed to a vertical one (uncomfortable).

41. Valéry, "Philosophy of the Dance" in *What is Dance?* eds. R. Copeland and . Cohen (1936), 55 (New York/Oxford: Oxford University Press, 1983).

Part II
Film Theory

5
Vertov and the Line: Art, Socialization, Collaboration

John MacKay

How might we best characterize the relationship between Soviet filmmaker Dziga Vertov's theory and practice, which he famously termed "Kino-Eye," and Soviet Constructivism? The task of answering this question, which has been expertly taken up by Vlada Petric[1] and Yuri Tsivian[2] among others, is complicated by a number of factors, not least the difficulty in pinpointing exactly (and usefully) what the theory and practice of these early 1920s movements were.

On the one hand, it certainly seems wisest, as art historian Maria Gough has argued, to regard Constructivism as primarily an ideology focused on the creation of *processes* of production, explicitly opposed to the traditional concern with the fashioning of discrete *art objects* as such.[3] To be sure, this emphasis was in part the consequence of the shift during the years of War Communism (1918–21) and devastating famine (1921–early 1922) to a committed utilitarianism on the part of artists like Aleksandr Rodchenko, Varvara Stepanova, and El Lissitzky, alongside a concomitant concern with the role of "artists" of bourgeois formation (and bearing all the traits of "bourgeois subjectivity") within a modernizing revolutionary society. The turn to (industrial) production processes—which were to yield a plenitude of useful objects without the intervening hand of the artist—was a way of both participating in the modernization of that new "Soviet" society, nearly ruined after eight years of world and civil war, *and* of suppressing the (limited and limiting) subjectivity that would, it was thought, imprint itself upon any art object these experienced art-makers might create. At the same time, it does seem that Constructivism as a practice does resolve itself at least partially into a certain array of recognizable formal preoccupations—with homogeneous geometric shape, for instance, with modularity and economy of structure and this is part

of what has prompted Yuri Tsivian to call both Constructivism and Kino-Eye "art movements in denial."[4]

As far as Kino-Eye theory goes, the situation is no simpler, not least because of the conceptual instability and heterogeneity of Vertov's now familiar pastiche of argument and exhortation. His emphasis on embracing the new at the expense of the old, and on the need to modify perception and sensibility to bring them "up to speed" with industrial modernity, are clearly derivative of the futurist provocations that had so influenced him in his youth; while his antagonism toward theater and fictional film recalls, in a radicalized and intransigent tonality, the nineteenth and early twentieth-century progressive intelligentsia's hostility to the "vulgar" fables purveyed through mass cultural channels—an attitude no doubt conditioned by Vertov's upbringing in a bookstore owned by just such a member of the intelligentsia (his father, Abel Kaufman). At the same time, Vertov's documentary insistence on "showing the working class to itself" points at once to the emergence of a certain Soviet iconography of proletarian imagery and to the origins of the great left-wing, counter-normative, nonfiction tradition, even as his stress on the camera's superior capacities of vision extends that "scientific" conception of cinema to which he had been exposed during his studies at the Petrograd Psychoneurological Institute between 1914 and 1916 (Figure 5.1).[5]

Beyond this, there are large gaps in our knowledge of the concrete nature of Vertov's relationship to Constructivism, at least up until mid-1922, when he began production of the *Kino-Pravda* experimental newsreels. While Constructivism was taking shape in 1921 and the beginning of 1922, Vertov was involved primarily in film exhibition in mobile cinemas and agitational trains, in a world far removed from that of studio experimentation with lines, curves, and volumes. (Indeed, I would postulate that it was in part Vertov's real-world experience as an agitator and "organizer" of propaganda networks that gave him a cachet among the Constructivists in the early 1920s, seeking as they were a similar kind of social efficacy for their own work.) After Vertov's group was granted permission by the state's All Russian Film and Photo Division to produce the *Kino-Pravdas* in May 1922,[6] its main supporter in the press was the Constructivist ideologue Aleksei Gan, who evidently advocated Vertov's non- (or rather, anti-) fictional practice primarily because he believed it helped to organize workers around the world into a single, self-conscious unit, and provided examples for the direct organization of "reality ... without the subjective narrowness ... of the heartsick maestros of art."[7]

Figure 5.1 Animated (spinning) intertitle constructed by Aleksandr Rodchenko on the basis of an earlier sculptural experiment for Dziga Vertov's *Kino-Pravda* 14 (1922). The text on the construction reads "On One Side," with "On One" and "Side" on opposite sides

If affiliation with the experienced organizer, agitator, and now filmmaker Vertov gave the Constructivists a certain link to proven utilitarian inventiveness, it seems they soon returned the compliment by imparting some of their growing fame to Vertov's films. It was Gan who introduced Aleksandr Rodchenko to Vertov, and Rodchenko began making intertitles for Vertov's films by the end of 1922, some of them adaptations of his Productivist experiments in modular design.[8] It seems that Vertov, possibly under the influence of Gan, was attempting through their inclusion to align his work with developments in Constructivism, in part as a kind of "branding" or "marketing strategy." The first half of 1922, after all, had seen major gatherings, publications, and exhibits of Constructivist work in Germany involving such figures as El Lissitzky and Hans Richter, both of whom later became good friends of Vertov. Rodchenko's mobile, sculptural intertitles first appeared, significantly, in a *Kino-Pravda* issue (number 14) dedicated to the Fourth Congress of the Communist International in Moscow (5 November–5 December 1922); thus, the film carries the implication that the Constructivism it so startlingly incorporates can be read as a kind of "New International Style" for the Left.[9] Vertov's strategy here, a canny bricolage of newsreel with modular sculpture, is perhaps best

read as an effort to accrue cultural-political capital, at a mome[n]t of high Constructivist energy and prestige. As such we might comp[ar]e it, following Thomas Elsaesser, to German Expressionist cinema's e[a]rlier capitalization upon German cultural reserves via a "combinati[on] of romanticism and technology," through the application (in the W[ei]mar case) of novel special effects techniques, appeal to popularize[d] folk material, and a mobilization of the prestige of both German G[o]thic romance and of painterly and poetic "Expressionism."[10]

In any case, by early 1925 Vertov had seriously fallen out with [G]an, not least because the latter had not only praised Lev Kuleshov['s] *The Extraordinary Adventures of Mr West in the Land of the Bolsheviks*—[a] film Vertov publicly termed "counterrevolutionary" at a special org[an]izational meeting of members of the Left Front of the Arts (LE[F] on 17 January 1925[11]—but because he had also turned to fiction [fi]lmmaking, albeit using nonprofessional actors. Gan's *Island of the [Yo]ung Pioneers* (also known simply as *Young Pioneers*), released in Septe[m]ber 1924, was based on a script written by one Veryovkin, the leade[r] of a troop of Young Pioneers (the Soviet Boy and Girl Scouts, about [wh]om more later). It featured a fictional proletarian father named An[dr]eev who beat his Pioneer children for being "commies" and for re[ad]ing the official Pioneer newspaper, alongside a detective story abou[t] the Pioneers tracking down bootleggers in the countryside.[12]

Though he also claimed to be "recording authentic life," [G]an defended his use of fiction and script at that same LEF meeting by [a]rguing that the fundamental goal of Constructivist film practice w[as] the "rationalization of labor," rather than shooting "life caught unaw[a]res" in accord with Kino-Eye slogans. Indeed, his goal in working with [n]onprofessional actors and professional editors (like his partner Esfir [Sh]ub) was to ensure that "our [social] nature would consciously demon[st]rate its movement within everyday life," a paradoxical formulation [to] be sure. For his part, Vertov attacked Gan's stress upon the rationaliz[a]tion of labor, arguing that such a principle could be applied to artisti[c] and nonartistic work alike, and thus had no role to play in distingui[sh]ing Constructivist *or* Kino-Eye creation from that of "so-called artists[.]" He berated Gan for asserting in the press that *Island of the Young Pi[o]neers* was a Constructivist film, as such a misleading claim would, he tho[u]ght, "undermine [public] confidence in our work."[13]

I mention these ancient quarrels not only to point out the [ra]ther obscure and convoluted relationships that existed between Verto[v] and his erstwhile Constructivist allies, but because they also help to [te]ase out what I think constitutes the most salient difference betwee[n] the

two movements. If Constructivism took as its goal the creation of new processes of production, using the construction of objects as occasions for experimentation in the "rationalization of labor," Vertov's Kinocs, at least until 1925 or so, took as their goal the socialization of the filmic representation of reality, and indeed, of access to the means of representation. Although I will not be able to develop the idea fully here, in this essay I begin to lay out the argument that what differentiates the two schools, despite their common antagonism toward "art," is two different conceptions of *objectivity*. Constructivism is bound to an ultimately anti-representational or (to use the terms of Lorraine Daston and Peter Galison) *structural* objectivity, where deductive and modular strategies for the *organization* of production, with proletarian factory labor as a model, were primary means of escaping subjectivism. In Kino-Eye, on the other hand, we find a still-representational and *mechanical* model of objectivity, underwritten both by the camera's supposedly near-automatic purgation of the conventional habits and limitations of (subjective) cognition, and by the socialization of cinema technology, effectively de-linking it from any narrowly individual viewpoint.[14] Yet this socialization remained, as I hope to show in my concluding section, largely on the figurative or metaphorical level, despite Vertov's attempts at redistribution of the means of cinematic production.

A major Constructivist article that helps to illustrate this distinction is Rodchenko's "The Line," presented in November 1921 just after the Constructivists had made their decisive Productivist shift toward the industrial process away from the making of artworks (and of paintings in particular). Rodchenko's article recalls Wassily Kandinsky's famous conception of (drawn, painted, inscribed) line as capable of representing the essential "tensions" within an object,[15] even as he offers both a new stress on the differentiating powers of line, and a freshly positive evaluation of mechanical aids to graphic creation:

> Non-objectivity [i.e., non-representational art] renounced the old expressivity of painting [...] ; it introduced entirely new ways of painting, more suitable for its forms—geometrically simple, clear, and exact—a blunter, coats of paint applied with a roller, pressing, etc. The brush, so necessary to convey the object and its subtleties in painting, became an insufficient and imprecise instrument in the new, non-objective painting, and it was crowded out by the press, the roller, the ruling pen, the compass. [...] The perfected significance of the line was finally clarified—on the one hand, its bordering and edge relationship, and on the other—as a factor of the

main construction of every organism that exists in life, the skeleton, so to speak (or the foundation, carcass, system). The line is the first and last, both in painting and in any construction at all. The line is the path of passing through, movement, collision, edge, attachment joining, sectioning. [...] In the line a new worldview became clear: to build in essence, and not depict (objectify or non-objectify); build new, expedient, constructive structures in life, and not from life and outside of life.[16]

The shift to a new, "industrial" repertoire and rhetoric of tools—from hand and brush to roller and compass—is clear, but a key ambiguity, important for our discussion, lies in the last half of the quotation. On the one hand: line, linear structure, is a factor "of the main construction of every organism that exists in life"—virtually a ground-element whose analysis would enable the "foundation, carcass, system" of any thing whatever, and its distinction from other things, to be discerned. On the other hand, the line is a tool for "building in essence," for building "new, expedient, constructive structures in life, and not from life and outside of life." That is, it is the foundation for a new "worldview" focused not on analysis or re-presentation of existing "organisms," but of the construction of the new as such. We will see that this distinction—often messy in practice, to be sure, especially in Rodchenko's own graphic and photomontage practice—offers us a rough heuristic for thinking about (representational, analytic) Kino-Eye visual practice, in contrast to (non-representational, often modular) Constructivist practice.

An illustrative example, one I have written about before in a different context,[17] can be found at the beginning of Vertov's first major feature film *Kino-Eye: Life Caught Unawares* from 1924. *Kino-Eye* is about members of the Young Pioneers organization from Moscow and its rural environs, and shows the youngsters engaged in agitational, philanthropic, and leisure activities in various urban and rural settings. *Kino-Eye* begins, as so often in Vertov's films, with a sequence intended to exemplify the old order: here, the dancing of (mainly) women who have evidently gotten drunk during a religious holiday. Although not immediately obvious—in part because of the rapid changes of camera angle and accelerating montage rhythm—the tipsy swirling of the women, especially when considered within the rhetoric of the entire sequence, inscribes a visual dominant of circularity (or what Roland Barthes might have called *circle-ness*).[18] Linking the spinning movements of the women to round objects prominently on view in the scene (pot, tambourine) and to an array of repetitive, ritualistic gestures, Vertov's

editing yields a fiercely energetic but increasingly exhausting spectacle creating, largely through graphic means, "an image of encompassed and squandered vitality (Figure 5.2)."[19]

An intertitle ("with the village Pioneers") announces what would seem to be a mere change of topic or setting. However, it becomes evident soon enough—and particularly by contrast with the preceding sequence—that we have passed into a fundamentally different space, one now defined by a rectilinear paradigm. The siding on the village building; the agitational poster applied by the Pioneers; a picket fence, waterfall, the filing-forward of marching Pioneers: all are coordinated to establish a new configuration of line that moves rectilinearly along all three axes in a way that signals forward-directedness and rationality. We are given to understand that energy hitherto expended on mindless circles has been released into a "progressive and architectural rectilinearity"[20]; we are made to perceive spatially the "bordering relationship" between two social "organisms," two different historical temporalities contradictorily co-present.[21]

At least four points of expansion and clarification need to be made here. First, if we inquire into the theoretical grounding for Vertov's graphic-compositional practice here, we are immediately led to his famous and enigmatic comments on the "interval" as the constructive basis of editing:

Kinochestvo is the art of organizing the necessary movements of objects in space as a rhythmical artistic whole, in harmony with the properties of the material and the internal rhythm of each object.

Intervals (the transitions from one movement to another) are the material, the elements of the art of movement, and by no means

Figure 5.2 Two stills from *Kino-Eye* (1924), with the dancing "village women" on the left, marching pioneers on the right

the movements themselves. It is they (the intervals) [that] draw the movement to a kinetic conclusion.[22]

The school of Kino-Eye calls for construction of the film-object upon "intervals," that is, upon the movement between shots, upon the visual correlation of shots with one another, upon transitions from one visual stimulus to another. [...] Besides the movement between shots (the "interval"), one takes into account the visual relation between adjacent shots and of each individual shot to all others engaged in the "montage battle" that is beginning.[23]

The "visual relation," Vertov explains, concerns the "correlation" of "planes," "foreshortenings," "movements within the frame," "light and shadow," and "recording speeds," and it is on the basis of these correlations that the Kinoc editor determines "the sequence of changes, the sequence of pieces one after another."[24] The result of the editor's work will be the discovery of "the most expedient 'itinerary' for the eye of the viewer ... amid all these mutual reactions, these mutual attractions and repulsions of shots."[25] No rules for finding this itinerary are offered by Vertov, although our example from *Kino-Eye* suggests that determining the correct itinerary among the intervals was itself a task determined by a quasi-Constructivist reading of revolutionary ideology: old and new are different in essence, and the experimental filmmaker would show the ways that difference was "revealed" in visible surfaces, both by "scientifically" discerning the distinct contours of the two phases, and demarcating as clearly as possible the difference between them, in a new kind of societal physiognomy that focused not on facial "expressive invariants" but on social practice itself (Figure 5.3).

Second, a salient contrast is to be found, I think, in much of the design work of Rodchenko, which explicitly operates with what seem to be (in Maria Gough's words) "modular units," capable of deployment in a virtually unlimited range of contexts, and ultimately of "nonrelational progression."[26] This Constructivist, nonmimetic use of line—which Gough shows to be of particular importance in the work of Constructivist Karl Ioganson, a Rodchenko associate who became a factory engineer—points to a "systemic" kind of construction,[27] one that turns not at all on a mechanically objective analysis of reality but on the *structurally* objective deduction of forms mechanically reproducible and functional within Soviet reality. This functionality—manifest as advertising—comes to fruition with Rodchenko's famous posters of the mid-20s, with their modular symmetries, diagonals, and blocks of text appearing and re-appearing as a serialized, theoretically limitless

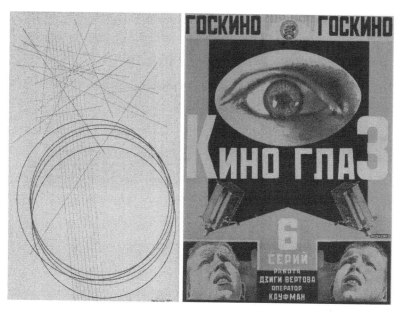

Figure 5.3 Two works by Aleksandr Rodchenko—on the left, an untitled linear construction in pen and ink on paper (1920); on the right, a lithograph advertisement, constructed in Rodchenko's rigorously symmetrical and modular manner of the mid-1920s, for Vertov's *Kino-Eye* (1924)

set of variations on an array of geometric features deduced, in the end, from the "frame" of the poster itself.[28]

Third, the same topos of swirling/disorganized old and rectilinear new is found, in a dizzying variety of permutations, in nearly all of Vertov's films.[29] What is crucial to observe at this point is a kind of mutual reinforcement, linking Pioneer and Kinoc, implied here by the editing and shot composition. If the Pioneers become the justification for the Kino-Eye's sudden passage into open space and progressive movement, the Pioneers depend upon the Kino-Eye for a full, comprehensible (though nonverbal) articulation of the novelty and dynamism that they both "represent" and are indeed attempting to realize concretely, within rural Russia itself. The thoroughly patterned and thoroughly representational (or "documentary") space of the Pioneers-on-screen becomes, in this way, a figure for collective authorship, inasmuch as Vertov's formal practice and the Pioneers' agitational practice legitimate each other.

Finally, the previous point seems far-fetched only if one fails to mention Vertov's intensive involvement with the Young Pioneers organization,

which, as it turns out, coincides almost with the organization's beginning. The Pioneers came into being in the first half of 1922, in the wake of the Civil War and on the basis of a reorganization of the already exist- ing Boy and Girl Scouts movement, which had achieved considerable prominence in Russia, especially in larger cities, prior to 1917.[30] After a complex period of gestation, involving both the willing and unwilling conversion of scout troops into pioneer troops, the Pioneer organization was fully set up by 1924.[31]

Vertov's connection with the Pioneers began in early 1923, when he established connections with a Pioneer troop attached to the tex- tile factory "Red Defense" (Krasnaia Oborona), located in Moscow's famous Krasnaia Presnaia area, site of an abortive proletarian uprising in December 1905. It was this troop, originally formed on 26 August 1923, that Vertov and Mikhail Kaufman filmed, both in Moscow and two villages near the city, in the summer and early fall of 1924.[32]

Vertov's involvement with the Pioneer group continued until at least 1926; in that year, the group organized a "Photo-Eye" circle (which adhered to the most fiercely Vertovian documentary principles),[33] and in 1925 either Vertov or Kaufman appeared at the group's third anniversary celebration in the guise of an ancient folk doggerel poet, *Ded Raeshnik* (Grandpa Doggereler). Vertov composed some verses for the occasion, the response to which can only be imagined (my translation cannot, alas, convey the comic, folksy cadences of the Russian original):

Well, I was glad when the pioneer
Spoke to us 'bout Kino-Eye.
Seemed like more than a hundred kids
Had crammed into the kitchen,
Packed in like herrings in a barrel.

...

The pioneer talked and talked and lambasted the old movies:
"Enough old lies and bourgeois rot,
Enough films about love and films about crooks,
The machinations of made-up actors,
Wigs, paints and cardboard sets.
Down with the script!" they said, and so on and so on,
"And give us instead for the first time KINO EYE"

...

This old grandpa wants to sign up with the Kinocs:
I'll turn the camera's crank, and let the working class be glad!

I'll show it [i.e., the working class] to itself.
HAIL THE NEW CINEMA![34]

Vertov managed to excite the youngsters enough to get them to proselytize for the Kino-Eye cause, within the framework of the Pioneer organization. Around 27 December 1924, for instance, the young Pioneer enthusiast Viktor Komarov helped to organize a Kinoc circle of at least 14 members at the "Red Banner" factory, which seems to have continued to meet for at least a year[35]; and interest was shown in the Kinocs by young peoples' film circles in places like Tula and Odessa.[36]

Vertov was mocked for his involvement with the Pioneers both by some members of the Left Front of the Arts (one of whom insisted that their organization "wasn't supposed to be an orphanage"),[37] and regarded with suspicion by the state, which was, of course, the main sponsor of the Pioneers to begin with. A disapproving report from 11 October 1924 of the Komsomol-led Moscow Bureau of Young Pioneers attributed the pronounced and extreme "bias toward [photographic and cinematic] technology" among members of the Red Defense troop to "Goskino's excessive enthusiasm for the troop."[38] And to be sure, many statements Vertov made in the wake of the film's release on 31 October 1924 make it clear that "collaboration" with the Pioneers was indeed his intention.[39]

Yet in *Kino-Eye*, we never actually see the Kinocs and the Pioneers working together, or indeed, together at all. Instead, the film depicts a classic early Soviet division of labor (but also cooperation) between *agitation* (the sending out of punctual, sharp motivational messages, like posters: this is the role of the Pioneers) and *propaganda* (the pedagogical elaboration of the arguments underlying the agitational message: this is the role of the Kinocs).[40] In moments like the famous "beef-to-bull" sequence, the film's announcement of its own work of revelation—its self-reflexivity—emerges as part of an effort to create an illusion of collectivity even while reflecting on the constructed nature of cinema: the illusion, that is, of co-creation, or mass authorship, of the film (Figure 5.4).

One notable characteristic of the Pioneer activists as represented throughout the film is their almost total refusal to react to Mikhail Kaufman's camera, despite the fact that it follows them everywhere and at relatively close quarters. An exception occurs almost unnoticeably in the film's first reel, just after our attention has shifted from rural to urban Pioneers. Two Pioneer girls, designated in the film as "Little Gypsy" and "Little Smoked Sprat," are shown going around the city

Figure 5.4 Two stills from *Kino-Eye* (1924)—the Pioneer girls "Little Gypsy" (left) and "Little Smoked Sprat" (right) glance at the camera tracking them from behind

hanging agitational posters that exhort citizens to do all their buying in cooperative shops and markets rather than in private ones.[41] In one shot, the camera follows them from behind in a forward dolly—one of many such moving shots in this unusually dynamic "newsreel" film—as they walk, poster and stool in hand, toward a wall upon which they expeditiously paste up their message. During the shot, however, both "Little Gypsy" and "Little Smoked Sprat" glance very briefly toward the camera, whether to receive some affirmation that they are doing the right thing, or to make sure the cameraman is doing his job, or simply out of nervousness or a spirit of mischief. The brevity of the glances—they are, in my experience, usually missed by spectators even after repeated screenings of the film—along with that hint of furtiveness (particularly detectable in the eyes of "Little Smoked Sprat"), suggests that the girls were instructed not to turn to the camera while being filmed. Whether or not that was the case, these two flashes of recognition are perhaps the most pointed acknowledgments on the part of the Pioneers in *Kino-Eye* of the Kinocs who are filming them.

I find the glances haunting, and they raise numerous questions. Was Vertov's failure to establish a truly collective form of film production primarily a matter of resources and institutional obstacles, or was it also a matter of wanting (as a filmmaker with a specific agenda) to continue to make a certain kind of art object, a certain kind of film (as his elaborate "linear analyses" would suggest he does)? Was it history—in this case, Soviet history—that stymied the Kino-Eye (and Constructivist) efforts to escape "the history of art," or were those efforts always already another Promethean expansion of the very category ("art") in opposition to which they imagined themselves acting? Although it answers none of these questions, the film *Kino-Eye* helps us to articulate them,

inas uch as it occupies a kind of midway point on the line stretching
betv en the later director-controlled and "classical" Soviet cinema, and
that other, truly socialized form of cinema production, a cinema that
sou; it to be something other than "art" and that—as the lightning
glar es of "Little Gypsy" and "Little Smoked Sprat" remind us—found
non but the most fleeting, indeed nearly invisible, realization.

Not s

1. Petric, *Constructivism in Film: The Man with the Movie Camera—A Cinematic nalysis* (Cambridge: Cambridge University Press, 1987) (pp. 1–21).
2. Tsivian, "Turning Objects, Toppled Pictures: Give and Take between Vertov's lms and Constructivist Art," *October* 121 (Summer 2007), 92–110.
3. . Gough, *The Artist as Producer: Russian Constructivism in Revolution* erkeley, CA: University of California Press, 2005) esp. 10–16. See also Dickerman, "The Propagandizing of Things," in *Aleksandr Rodchenko*, eds. . Dabrowski, L. Dickerman, and P. Galassi (New York: Museum of Modern t, 1998, pp. 62–99).
4. Tsivian, 95, op. cit.
5. e my essay "Film Energy: Process and Metanarrative in Dziga Vertov's *The eventh Year* (1928)," *October* 121 (Summer 2007), 41–78, esp. 56–8.
6. e "Iz Istorii 'Kino-Pravdy'" in *Istoriia Otechestvennogo Kino: Dokumenty, emuary, Pis'ma*, eds V. S. Listov and E. S. Khokhlova (Moscow: Materik,)96, pp. 130–6).
7. Gan, *Da Zdravstvuet Demonstratsiia Byta!* (Moscow: Press, 1923) p. 2, 6–7).
8. e Y. Tsivian, 101–4. Gough demonstrates clearly that Rodchenko's oductivist and utilitarian turn had occurred prior to his work on these nstructions (see Gough, 14, 46–50; and Dabrowski et al., *Aleksandr dchenko*, 304).
9. May 1922, a few months before Rodchenko did the titles for *Kino-Pravda* (November), the First International Congress of Progressive Artists was ld in Düsseldorf, where the International Section of Constructivists is formed, involving Theo van Doesburg, El Lissitzky, and Hans Richter)abrowski et al., *Aleksandr Rodchenko*, 304). 1922 also saw Lissitzky's volvement in the *First Russian Art Exhibition* in Berlin, his first solo hibition in Hanover, and his publication (with Ilya Ehrenburg) of the onstructivist journal *Veshch'* (M. Tupitsyn, *El Lissitzky: Beyond the Abstract ibinet: Photography, Design, Collaboration* (New Haven, CT: Yale University ess, 1999) (p. 226). Links between Russian Constructivists and figures from e Bauhaus were also established around this time.
10. Elsaesser, *Weimar Cinema and After: Germany's Historical Imaginary* ondon/New York: Routledge, 2000) (pp. 61–99).
11. GALI (Russian State Archive of Literature and Art) f. 2091, op. 2, d. 194, l. 3.
12. Gusman, "Iunye Pionery," *Pravda* (24 September 1924), 5. The film has ot survived.
13. GALI f. 2852, op. 1, d. 115, ll. 35ob, 39–40ob.

14. See L. Daston and P. Galison, *Objectivity* (New York: Zone Books, 2007), esp. 115–90 and 253–308.
15. See especially Kandinsky's important essays "Little Articles on Big Questions" (1919), pp. 421–27, and "Program for the Institute of Artistic Culture" (1920), pp. 455–72, in *Kandinsky: Complete Writings on Art*, eds. K. C. Lindsay and P. Vergo (1914/1926) (New York: Da Capo Press, 1994).
16. A. Rodchenko, "The Line," in *Experiments for the Future: Diaries, Essays, Letters, and Other Writings*, ed. and intro. A. N. Lavrentiev, trans. J. Gambrell, and intro. J. E. Bowlt (New York: Museum of Modern Art, 2005, pp. 111–15); here 112–14. The article is dated 23 May 1921.
17. See "Allegory and Accommodation: Vertov's *Three Songs of Lenin* (1934) as a Stalinist Film," *Film History* 18 (2006), 376–91.
18. See R. Barthes, "Myth Today," in *Mythologies*, trans. A. Lavers (New York: Noonday Press, 1989, pp. 119–27).
19. Ibid., 380.
20. Ibid.
21. For the classic philosophical discussion of "noncontemporaneous contradiction," see E. Bloch, *Heritage of Our Times*, trans. N. Plaice and S. Plaice (Cambridge: Polity Press, 1991, pp. 104–16).
22. "We: Variant of a Manifesto," in *Kino-Eye: The Writings of Dziga Vertov*, eds A. Michelson and trans. K. O'Brien (Berkeley, CA: University of California Press, 1984, p. 8); emphasis in original.
23. "Kino-Eye to Radio-Eye," 90–91, in *Kino-Eye*, op. cit.
24. Ibid., 90.
25. Ibid., 91.
26. Gough, 12, op. cit.
27. Gough, 93–6, op. cit.
28. On Rodchenko's speculations about how the picture's "support—the quadrangle of the canvas—could generate its figuration," see Gough, 49. Rodchenko's modular series has recently been extended by designer Shepard Fairey in an advertising campaign for Saks Fifth Avenue; see E. Wilson, "Consumers of the World Unite," *New York Times* (8 January 2009), E4, http://www.nytimes.com/2009/01/08/fashion/08ROW.html?_r=2.
29. The intriguing, vitally important exception seems to be *One Sixth of the World* (1926).
30. Historian V. A. Kudinov argues for the emergence of the Pioneer movement out of crisis, specifically "hunger, the introduction of NEP, the closing-off of positions for young people in [factory] production (they were generally let go first, given their lack of qualifications), and, as a consequence, a worsening of the material conditions and disappointment in the resultant divide between the ideals, goals and the practice of the ruling party. At the same time, world revolution, one of the goals of the Komsomol, had turned into a phantasm in which it was difficult to believe … . This prompted the leaders of the Komsomol and Party to search for new methods of Communist influence on the coming generation, and to regard children and teenagers as a reserve for the Komsomol. On 2 February 1922 the [Komsomol central committee] resolved to send a circular letter to all local organizations about the creation of children's groups linked to Komsomol cells" (V. A. Kudinov, *Detskoe i Molodezhnoe Dvizhenie v Rossii v XX Veke* (Kostroma: Kostromskoi

Godudarstvennyj Universitet, 2000) (p. 38). In my account of the Pioneers, I depend heavily upon the work of both Kudinov and Dorena Caroli (cited below)).

31. Ibid., 41. For more on the early years of the movement, see D. Caroli, *Ideali, Ideologie e Modelli Formativi: Il movimento dei Pionieri in URSS (1922–1939)*, intro. N. Siciliani de Cumis (Milan: Edizioni Unicopli, 2006) (esp. 43–60).

32. RGASPI-M (Russian State Archive of Social-Political History-Youth Organizations) f. 1, op. 23, d. 282, l. 23. I have been able to unearth only sketchy details about the actual chronology of the filming of *Kino-Eye*. The Kinocs (essentially Vertov, Mikhail Kaufman, and Elizaveta Svilova, with some involvement from Abram Kagarlitskii) were working on the film by mid-April 1924 (RGALI f. 2091, op. 2, d. 26, l. 22). Apparently filming for the most part in and around Moscow through June, they turned their attention to the Pioneers and their camp starting in July, and continued to work with them until around mid-September (RGALI f. 2091, op. 2 l. 396, l. 1, d. 390, l. 11). In her study of the Pioneers, Dorena Caroli indicates that a troop associated with and sponsored by the "Red Defense" factory in Krasnaia Presnia set up a camp in association with the village of Sonnikovo in the Pavlovskoe area in July–August 1924, 50 *versts* (33 miles/53 km) from Moscow; this is almost certainly the troop filmed by Vertov, and Sonnikovo (spelled "Sannikovo" in the intertitles) is mentioned in *Kino-Eye*. According to Caroli, the youngsters were involved in various practical activities (reading, distributing publications, repairing utensils for home use, working with young children); initially distrusted by the peasants, the Pioneers' local profile changed when one peasant woman got involved and set them to work on gathering the harvest and other farm labor. They also worked with young children in a local orphanage three or four hours a week, doing singing, gymnastics, and reading. Apparently, about 30 peasant children formed their own troop in the village, under patronage of the "Red Defense" Pioneers (Caroli, 68 (citing RGAPSI-M f. 1, op. 23, d. 282, ll. 24-27)). To my knowledge, no detailed montage list from the period of editing work exists; Vertov gave a speech introducing the film on 13 October 1924 (RGALI f. 2091, op. 2, d. 193, l. 12).

33. This group was probably connected to the "Photo-Eye" children's group associated with the Sovkino film factory in the later 1920s, when Vertov was in Ukraine. There were ten kids in this group who published a bi-weekly photo-newspaper, and took the very Vertovian slogan "No room for staging!" as their own (V. T. Stigneev, *Vek Fotografii 1894–1994: Ocherki Istorii Otechestvennoj Fotografii* (Moscow: URSS, 2005) (p. 44).

34. RGALI f. 2091, op. 2, d. 390, l. 13.

35. RGALI f. 2091, op. 2, d. 390, ll. 14-16. Vertov and Kaufman apparently attended at least one of this group's meetings, on 3 November 1925 (RGALI f. 2091, op. 2, d. 390, l. 26), and village Kinocs from Pavlovskoe apparently saw rushes of *One Sixth of the World* in October 1926, prior to the film's release, and commented on them (RGALI f. 2091, op. 2, d. 390, l. 30).

36. RGALI f. 2091, op. 2, d. 390, ll. 17, 25, 27, 28ob.

37. RGALI f. 2852, op. 1, d. 115, l. 55.

38. RGASPI-M f. 1, op. 23, d. 282, l. 31. The report indicates that the Pioneer group was associated with the "Krasnaia Oborona" ("Red Defense") factory

in the Krasnaia Presnia area; Goskino (*Gosudarstvennoe Kino*: State Cinema)
was the central film agency/studio for which the Kinocs worked.

39. See Michelson, ed., *Kino-Eye*, 70–71.

40. The best account of this distinction, which has been slighted or ignored in
much of the historical literature on "Soviet propaganda," has been provided
by Matthew Lenoe: "According to Lenin, propaganda involved extended
theoretical explanations of the socioeconomic processes that underlay sur-
face phenomena such as unemployment. By appealing to audience members'
reason, the propagandist aimed to cultivate in them a whole new worldview.
Propaganda was a process of education that required a relatively sophis-
ticated, informed audience. Agitation, on the other hand, motivated the
audience to action by appealing to their emotions with short, stark stories.
The agitator did not seek to change his listeners' worldview, but to mobilize
them. Agitation was the tool of choice for unsophisticated, even ignorant
audiences when quick action was required. Definitions from the first edition
of *The Great Soviet Encyclopedia* link propaganda with education and agita-
tion with organization/mobilization" (M. Lenoe, *Closer to the Masses: Stalinist
Culture, Social Revolution, and Soviet Newspapers* (Cambridge, MA: Harvard
University Press, 2004) (p. 28). The greatest "metafilmic" reflection on this
distinction in Vertov is in the "beef-to-bull" reverse motion sequence in
Kino-Eye, where the agitational Pioneer posters urging passersby to "shop in
the co-op" are then elaborated, on the propaganda level, by the Kino-Eye's
playful retro-explanation of the actual process of producing meat, and the
revelation of the absence of any hateful middlemen (merchants) in that
process. (On the relationship of the Pioneer/Kino-Eye collaboration to the
Soviet "worker correspondent movement," see J. Hicks, *Dziga Vertov: Defining
Documentary Film* (London/New York: I.B. Tauris, 2007) (pp. 15–21.)

41. The rather sketchy plan for the film indicates that the girls' real names were
Sima and Zhenia; RGALI f. 2091, op. 2, d. 26, l. 2.

6
Quoting Motion: The Frame, the Shot, and Digital Video

Trond Lundemo

The tension between the still and the moving image has always been a central issue for film theory. In the early writings on cinema, when the medium was new, motion was usually identified as the distinguishing trait of cinema. Still today, in an age of conversion from analog film to digital files, film theory grapples with the issue of movement. The reason why motion remains a key issue is that it is, and has always been, a very slippery concept. There have always been multiple concepts of motion in film studies, a fact which derives from opposing philosophies of movement. The various concepts of movement have often been the fuel for film theory in the history of cinema, and remain an issue for theory in the age of the digital. The various approaches to movement, either as perceived by the spectator or as produced by the cinematic apparatus, cut through the classical distinction between formalist and realist theories from Munsterberg to Bazin. The elusive phenomenon of motion became central for film semiotics in the 70s, and remains the distinguishing feature of, for instance, the image typologies in Gilles Deleuze's film philosophy.

These contesting theories of cinematic motion, I will argue, can be identified and analyzed through the techniques employed for the quotation of movement. Film theory runs against the problem of quoting its object of study. In printed publications, motion as such is "un-attainable," and it can only be outlined through techniques devoid of motion, as written descriptions, frame enlargements, and charts and tables. This problem was a major topic in the "textuality" debates of the 70s. In Raymond Bellour's seminal piece "Le texte introuvable" (1975), written as a response to Christian Metz's work on film and language, the filmic image remains inaccessible for quotation exactly for these reasons.[1] However, while the observation that cinematic motion is lost

in written description and frame enlargements is important, it is also bordering on the self-evident. The relevant question is rather, which theories of motion are embedded in the various techniques of quotation? This issue gains further importance in an age when cinematic motion could be argued to be exactly quotable, through convergence of media in the digital techniques.

I will here outline two techniques of quoting motion by two key film-makers and theorists in the Soviet Union of the 1920s and 1930s: those of the eternal contrahents Sergei Eisenstein and Dziga Vertov. Their respective techniques of quotation are based on contesting philosophies of movement. These two positions are, not only important in their own right, but all the more so when cinematic movement has been transformed by the digital image. Eisenstein's and Vertov's quotation techniques derive from their respective theories of montage, and more exactly, where motion occurs in montage. An "excavation" of these theoretical positions will provide us with tools for understanding how motion is transformed and reduced in digital video. Eisenstein's notion of movement is based on still elements acting on each other. They may be frames or shots. Vertov's theory of montage, on the other hand, relies on a dispersal of frames. The spaces *between* the photograms, not the isolated frames, are the source of movement in cinema.

Why should it matter how we conceive of movement in cinema, as long as we see movement? It matters insofar as these two positions express two contesting theories of what constitutes motion and stillness. These theories represent a division between different aesthetic and political notions of movement in cinema, which in turn becomes vital for understanding the principles of movement in the digital moving image. This division particularly highlights the differences between digital and cinematic motion. By clarifying the differences between theories of movement through quotation techniques, we may then compare a typology of filmic citations with the use of movement in current digital imaging.

Eisenstein, art history, frame enlargements

The representation of movement has, of course, been a key concern throughout art history. A genealogy of such representations can be traced from early stone carvings to various schools of sculpture and painting. A key period of transition occurs with photography, and especially with its quest for shorter exposure times, as in the intermittent photography of Eadweard Muybridge and the chronophotography of Etienne-Jules

Marey. With cinema, however, the image acquires self-movement. This opens the possibility of a variability of movement within the image, and the issue is no longer only the representation of movement in the external world, but the production of movement by the image. The motion of the image becomes itself a thing to be analyzed and quoted. The privileged point of entry for such an analysis is the montage in cinema. Since different theories of montage are developed in films and in theoretical writings in the late 1910s and early 1920s, these need to be quoted and analyzed.

It is well known that Sergei Eisenstein and Dziga Vertov were rivals due to their disagreement about the value of referentiality for cinema. By contrast, little has been said on how their disagreement about film montage led them to different methods for analyzing filmic movement in their writings. Eisenstein's involvement in the history of art was by far more pronounced than Vertov's. As is well known, Eisenstein identified the principle of montage in various art forms from many distant periods and cultures. Montage is the structuring principle of Japanese haiku poetry and Kabuki theater as well as in ideography.[2] However, the methods of montage are different for different art forms. The spatial arts, like painting and sculpture, are bound to stillness and can only suggest movement through montage. The temporal arts, on the other hand, such as music and poetry, represent a spatial extension through montage. Both of these montage techniques produce new dimensions on a conceptual rather than on a material level. Cinema, in turn, synthesizes these principles of montage into a medium with both spatial and temporal dimensions. The categorization of the spatial and the temporal arts is the key issue addressed by Gotthold Ephraim Lessing's *Laokoon* (1766). This canonical text is discussed by Eisenstein, since he was eager to justify his theory of montage by looking at the representation of movement throughout the history of art.[3]

The perennial principles of montage in art history come together in the historical emergence of cinema, Eisenstein claims, because it overcomes the division of the spatial and the temporal arts. However, since the principles of montage of other art forms have been produced on a conceptual and mental level, this is also true for montage in cinema. This leads Eisenstein to a theoretical duality implicit in his dialectical method, as the frame or the shot only serves the higher purpose of "the global image," which is produced on a mental level. Consequently, whether the shot entails movement on a "retinal level" is less important, as the montage takes place on another level. This dualistic position is also why Eisenstein privileges the conceptual end product of a film

or a sequence. He never directly responds to a criticism formulated by Kazimir Malevich in 1928, to the effect that the filmmakers of the Soviet Union make use of cinema to perpetuate an old tradition of easel painting (that of the Wanderers), instead of using cinema for the medium's own potential.[4] However, Eisenstein's response can perhaps instead be found in his answer to Béla Balász's comment on the limitations of the "image riddles" of Soviet montage.[5] The distinctive property of cinema is not in the shot itself, but in montage, the conceptual dimension of the structure of the shots.[6] The representation aspect of the shot is subordinated to its work in a montage context. Eisenstein's relative disregard for the individual shot informs his conceptualism.

The most famous sequences in Eisenstein's films are composed of relatively static shots internally. For instance, Eisenstein's use of such nondiegetic inserts as the Napoleon statuette or the image sequence of gods in *October* (1928) relies on static objects quite isolated in the space of the shot, often against a neutral background. These kinds of shots often convey a person or an object, frequently in close-up, in a static position, and without camera movement. A mental movement occurs only at a different level, as a product of the individual shots. This property in Eisenstein's method of montage makes his films predisposed for quotation through frame enlargements. The frame can very well stand in for the shot as long as they are both understood as predominantly static. The tradition of quotation from Eisenstein's films, both by himself and by others, testifies to this principle of montage. The milk separator sequence in *Old and New* (1929), the gods image sequence in *October*, or the three stone lions in *Battleship Potemkin* (1925) are among the most frequently quoted shots in the history of cinema.

Eisenstein's theory of montage is based on the distinction between motion within the shot, and the mental movement produced through montage. Eisenstein attributes movement within the shot to a persistence of the frames in the mind of the spectator, as a sophisticated version of the now discredited explanation of filmic movement as persistence of vision.[7] As explained by Max Wertheimer and Hugo Münsterberg early in the history of cinema, this theory is inadequate as an explanation of cinematic movement.[8] Movement occurs in between the frames, according to the theory of the *phi* phenomenon, and not as a superimposition of static frames within the spectator's vision. Eisenstein's misconception of the movement within the shot may well be what leads him to a dichotomy between the retinal and the conceptual. Whether the persistence of the image is in the mind or in the eye, the theory in both cases presupposes a synthesis of movement based on

the "melting together" of the frames into one continuous image. If the movement within the shot results from the frames "melting together" into one, representing the shot in one frame enlargement doesn't seriously corrupt the movement of the film. The juxtaposition of frame enlargements in print becomes almost analogical to the juxtaposition of shots in editing, resulting in both cases in a conceptual movement of a different kind than that within the shot.

The shot is reduced to a static element which, as soon as it finds the right placement, can set thought in motion. The shot is a static unit, but it functions as a detonator in Eisenstein's famous analogy between the combustion engine and cinematic montage. Such a shift from a retinal to a conceptual movement also explains why in 1927, Walter Benjamin deployed the same metaphor when he spoke of "the explosion of the dynamite of the tenth of a second" in relation to Eisenstein's *Battleship Potemkin*.[9] This idea of the "moment of danger" and the lightning of the instant became central to Benjamin's works on history and may indicate a parallel notion of "montage" in the two authors. The important notion in our context is that there is a qualitative shift taking place from the shot to the montage. The "detonation" sets into motion what is in itself predominantly static.

Eisenstein's writings present the psychology of perception and cinematic montage in a very complex, and sometimes contradictory, way. In his essay "Laocöon," Eisenstein makes a case for the analog processes between the frames within the shot and between the shots in montage. Both acquire movement through "collision."[10] The "basic phenomenon" (Eisenstein employs the German term *Urphänomen*) of cinema is that the juxtaposition of static frames stimulates the perception of movement. This is also the principle of montage between shots. What this comparison betrays is not that motion within the shot and the montage of shots draw on the same psychological principles, but rather that Eisenstein conceives of the shot as a static element in itself. The analogy between frame and shot understands the photogram in isolation as the basic element in filmic movement through montage. This results from a confusion between the frame as a still element and as part of a moving image. The photogram in motion is of a different order than the single frame on the film strip. It never exists in isolation, but only in continuous change in relation to its surrounding photograms.

As argued above, in Eisenstein's theory of montage the relatively equivalent role of the frame and the shot in terms of movement derives from an art historical reading of montage. Art history itself becomes an object of montage in Eisenstein's films. Due to his understanding of the

shot as relatively static in itself, artworks enter the montage structures of the films. Existing works of sculpture and architecture serve a "potential" for montage, as in the use of Rodin's sculptures in *October*, a choice which Rosalind Krauss has compared to a virtual museum.[11] For Eisenstein, the quotation of paintings is not qualitatively different from those of film shots, as the frames are seen as receiving movement only at a later stage in the process of montage.

In Eisenstein's synthesizing approach, various strands of art history seem to come together in cinematic montage. Cinema is the medium where these efforts throughout art history are unified. One can for this reason see a clear continuity between Eisenstein's theories of a universal language and the "intellectual cinema" of the 1920s, and the growing concern with art history from the 1930s. Also the later texts are concerned with universality. Both periods in Eisenstein's theory see montage as fundamentally similar in structure to human consciousness. This isomorphism between image and mind moves towards the idea of a universal language, something which in turn has consequences for the quotation of the moving image. With a universal language, there are a finite number of structures that one can discover or invent in order to communicate universally. If there is a universal way of thinking, there should also be a reserve for possible montage structures.

Eisenstein's experiments with the quotation of his own moving images on the white page are hard to reconstruct, as most publications date from after his death. This is why it is necessary to keep in mind that quotations inside Eisenstein's writings can also be the work of others. His own manuscripts were often unfinished sketches, overlapping fragments across texts, or texts in progress. As a result, Eisenstein's written work does not contain his final choices of illustrations for his post-mortem publications. At any rate, it seems that his manuscripts were conceived with plans for many kinds of illustrations. More specifically, montage structures are visualized in the most eclectic ways with comparisons in art history, music, poetry, theater, architecture. I would argue that the frame enlargement is the most obvious way of citing Eisenstein's montage principle in published form. On the contrary, Vertov's completely different approach to montage finds its equivalent in the numerical charts and diagrams he left on paper.

Vertov, movement, and numbers

Dziga Vertov's concept of montage departs from the spaces between the photograms in projection and the movement within the shot. The

number of photograms in a shot matter because they already constitute movement and change. This is the reason for his experimental quotation techniques. Vertov's theory of cinematic movement depends on its difference from human everyday perception, and consequently, the history of art cannot provide him with a pre-history of cinematic montage, as in the case of Eisenstein (Figure 6.1).

Dziga Vertov ascribes a relative autonomy to the shot because it contains movement in itself. As a potential object for freeze-frames, slow motion, "the negative of time," and any kind of new connections, Vertov's shot is already fully part of cinema's revelation of the material world. According to Vertov's theory, there is no qualitative difference between the movement within the shot and the movement between shots. The shot is a dispersal of photograms which will enter into connections that produce intervals. This is the core of Vertov's analytical discussion on paper through a plethora of tables, charts, and diagrams. A crucial principle in Dziga Vertov's quotation in charts and tables to describe his own method of montage is the "integrity of movement." The representation of the visual content of the image is based on the charting of numbers of photograms and how these numbers relate to each other in space and time. In most cases, Vertov refrains from frame enlargements to quote a shot. In fact, this technique can neither represent the variations and intervals of movement within the shot nor its duration.

Vertov's principle of an "integrity of movement" within the shot and his interest in the interval is in this sense an emphasis on the distance *between* frames. This distance is demonstrated and analyzed not only in publications, but also in Vertov's own films. A shot is often repeated, halted, and re-animated inside a different sequence later in the same film. The typical example would be the editing table episode of *Man with a Movie Camera* (1929), where the frozen image—the single photogram—is gradually revealed as part of a sequence of photograms. This technique is already a form of quotation of movement, but in cinematic rather than published form. As a result, the single shot is not represented as a still image in isolation, but through the ways in which the frame enters into relationships with the surrounding frames. The single shots are then shown as rolls with labels on the editor's shelf. This is a charting technique that gives priority to random access to the frames within the structure of the montage, rather than reducing the shot to the single frame as in the practice of quotation through the frame enlargement.

Attention is called to the spaces between photograms and between shots in a variety of ways in Vertov's films. One instance is the frequent

104

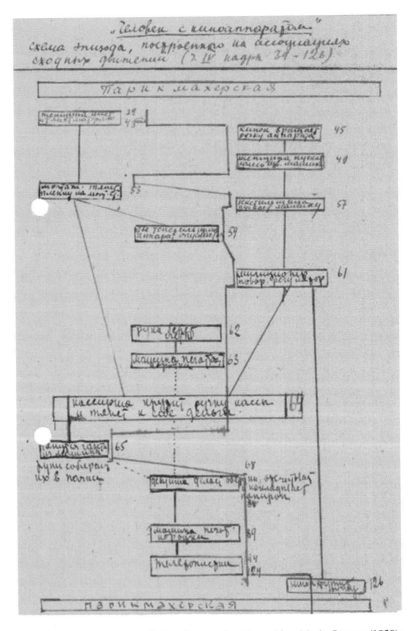

Figure 6.1 Dziga Vertov, editing diagram for *Man with a Movie Camera* (1929): the hair salon sequence. http://www.cinemetrics.lv/vertov2.php

insertion of black or white frames within or between the shots. The decomposition of movement and loop-like repetitions are other ways of exploring the intervals between frames. Again, *Man with a Movie Camera* provides plenty of examples. The juxtapositions of the human eye in close-ups, the camera lens, and the blinds in the window early in the film go all the way down to two frames per shot. This flickering editing serves to demonstrate the differences between this technique and the superimposition constructions elsewhere in the film. The decomposed and looped movements of sequences with sports would be equally impossible to represent in the form of a single frame enlargement, as the whole principle of the interval is within the shot. These sequences demonstrate how the frames in projection do not "melt together" into one image, as erroneously propagated in the "persistence of vision" explanation of cinematic movement. On the contrary, the integrity of the photogram means that it maintains its distance to the surrounding ones. The spaces between the photograms produce the motion, as noted by the theorists of the *phi* phenomenon. Consequently, a shot can never be reduced to the stillness of the frame. Neither can the shot be illustrated or quoted through frame enlargements. This principle forms, in my opinion, the main difference between Vertov and Eisenstein in their opposing theories of movement and montage.

Vertov's preoccupation with film technology emphasizes the interdependency of shooting and projection, and especially the work at the editing table in between these two processes. His whole political and aesthetic film theory departs from the spaces between the frames to produce a non-anthropomorphic form of perception. The interrelationship between analysis (shooting) and synthesis (projection) produces a movement that can become "elastic." The contraction of movement in fast motion, its suspension in the frozen image, its dilation in the *Zeitlupe* (slow motion) or "the negative of time" are all techniques based on the space between the analysis and synthesis. It is in this sense that Vertov "puts perception in the objects themselves," to quote Gilles Deleuze.[12] The perceiving agent is not a human spectator, but a machine, and perception is no longer limited to living beings. Cinema produces a "gas-like" state of the world, Deleuze continues, thanks to Vertov's diagrammatic montages and intervals. The dispersal of the frames and the shots goes beyond the solid and the fluid, and all the way to a gas-like density. By approaching cinema as a machine that works beyond and outside the human eye, Vertov's ambition is to make cuts and incisions into the streams of light and sound. Vertov's philosophical agenda—to use cinema to surpass an anthropomorphic model

of perception—merits analysis from other perspectives than that of our experience of films.[13]

To return to Vertov's writings, he resorts to numbers of shots and frames per shot. The table offers a simultaneous access to all the numbers making up the sequence. It also keeps attention on the single frame of each shot, as this is the qualitative basis for the intervals making up the sequence. This, in turn, indicates that the composition of the sequence is only perceptible as movement. If Vertov represents the structure of the sequence as a table of numbers, instead of as a series of stills, it is because a series of stills doesn't have access to the representation of the length and movement of the images. Vertov's numerical indexing of the shots differs theoretically from alternative techniques of indexing based on frame enlargements. The diagrammatic and numerical approach doesn't make movement redundant, but presents the composition of the shots as a molecular, dispersed entity. If Vertov is the filmmaker who more than anyone else works with the spaces between frames and shots, with the interval between one photogram and the next, this is also what is given priority in his technique of quoting montage structures as charts and tables.

A table of numbers is, of course, not the cinematic movement itself, but it still allows motion patterns and intervals to be reconstructed on the basis of this information. These methods of reproduction avoid the immobilizing stance of the conventional frame enlargement analysis and allow for movement to be reconstructed on the basis of the accessible information. Vertov resorts to these tables because they "quote" linear movement in a system of random access. Were we to compare Vertov's charts and tables with Raymond Bellour's exemplary attempts to bypass the unquotable filmic text, through the sequence analysis printed on the page,[14] Vertov's diagrams fall outside the domain of figurative representation altogether. No visual images at all seems a better way to convey movement than the film still, since the latter would ignore the intervals and spaces between the frames in cinema.

Few works, if any, have been subject to such a wide-ranging multitude of annotation techniques as those of Dziga Vertov. One explanation for this lies in the formal complexity of the editing of many of his films. The film theorist and historian Yuri Tsivian supplements Vertov's table of the numbers of photograms in the flag-raising sequence from *Kinoglaz* (1924) with stills from each shot of the sequence to make it visually comprehensible to the reader.[15] These illustrations convey two different complementary approaches to quotation, but they are also based on two conflicting notions of cinematic movement. As shown

in the contrast to the pre-disposition for quotation through frame enlargements in Eisenstein's theory of montage, Vertov's theory is at odds with such a technique. The frame enlargement, as developed by Raymond Bellour or deployed by Tsivian, conflates the spaces between the frames into one static image. Vlada Petric's book on *Man with a Movie Camera* is perhaps the most eclectic example of various ways of suggesting movement through illustrations.[16] Petric's analyses comprise frame counts with arrows indicating camera movement, graphic patterns of movements, together with frame enlargements.

All techniques of illustration or quotation are valuable for the study of Vertov's work, because they bring out the assets and limitations in every technique. It is useful to note that Eisenstein shows interest in Vertov's technique of analysis of the flag-raising sequence in *Kinoglaz*.[17] Eisenstein here stresses the static quality of the single shots in the film, and argues that this is the reason for the success of this sequence as well as of Vertov's own analysis of it. Eisenstein's comment reveals the fundamental difference between the two filmmakers' concepts of montage. Whereas Eisenstein sees static shots in the image as well as in the charts, Vertov's use of numbers and diagrams aims, on the contrary, to convey the integral movement within the shots of the sequence.

Eisenstein's praise of Vertov is a rare instance where he doesn't apply his criticism of a film form that needs a measurement. In his well-known attack on the *kinoki* (Vertov and his collaborators), Eisenstein complained that their films can only be analyzed with a ruler, and not by visual impression or impact:

A[n ...] example may be found in Vertov's *Eleventh Year*, where the metric beat is mathematically so complex that it is only "with a ruler" that one can discover the proportional law that governs it. Not by *impression* as perceived, but by *measurement*.[18]

Vertov's diagrams and charts are such measurements. Eisenstein's emphasis on the *impression*—namely, to the stage after the synthesis has occurred—makes him echo Auguste Rodin's views on the cinema in his book *L'Art* published in 1912.[19] Rodin observed that the film camera has the vision of a machine, and does not at all show the truth of human perception. This criticism of cinema was not unusual in the early years of the technology. As we have seen, for Vertov, the very capacity of the machine to go beyond human perception is its key importance. Later on, Eisenstein returns to Rodin in his essay "Laocöon" during his discussion of Watteau's *Embarquement pour Kythère* (1717).[20] Rodin takes

Watteau's painting as the proof that the arts of the hand convey the truth in human perception better than the automatisms in the camera and projector. Eisenstein agrees with Rodin that human impression is the point of reference for art, but finds that these impressions attain their highest level of impact in the montage of cinema. Eisenstein believes that the filmic image transcends the stillness of the separate elements and forms mental movements as synthetic montage constructions

Eisenstein's discussion of Rodin's preference for the human impression of movement over that of the machine gives us an occasion for a small digression. It is common, in the natural sciences, to reverse the process of an experiment to see if the result is reversible and thus sound. As an example of relevance to our context, the French theorist of photography Michel Frizot claims that chronophotographer Etienne-Jules Marey strove for years to produce a functioning projector, only to be able to see if his chronophotographic analyses would return to normal movement when reversed.[21] In our case, given the argument that movement cannot be quoted through a still frame, we could briefly ask whether the still image can be quoted in a film? This is of course a topic for a whole dissertation, so I will only look at Eisenstein's view of montage in art history and contrast it with a brief moment in a film by Jean-Luc Godard.

Eisenstein's analysis of Watteau's painting could very well be why Jean-Luc Godard returns to it in his film most explicitly devoted to the relations between painting and cinema. *Passion* (1982) can be seen as a commentary on Eisenstein's preoccupations with art history. In Godard's film, grand works of painting are re-created or quoted as *tableaux vivants* set within a film production. While all other paintings are explored as tableaux vivants, Watteau's painting is rendered through an exterior tracking shot which inadvertently links the three different phases in the composition of the painting. Like our grasp of the moment, the composition fades away as we become aware of it. Godard's position, however, differs from Eisenstein's celebration of cinema as synthesis of the arts. Watteau's painting, like all paintings, is unquotable in cinema because it belongs to a different temporality. Watteau's compositions can only coincide with the film for an instant. The temporality of cinema doesn't make it the synthesis of all the arts, the way Eisenstein would have it, but makes other art forms unattainable for the cinematic movement.

Quotation and movement in the regime of the digital

In cinema, everything still is infused with a fixed duration and a material dimension of movement. Cinema, in turn, has proved irrevocably

resistant to quotation outside its own medium of the moving image. The digital, on the other hand, submits every medium to its own temporality and code. This is, of course, why it has been so successful in the medial conversion and the convergence of the archive. The archival access policy of digitization of various media demands a conversion of printed texts and manuscripts, sound recordings, photography, and film into digital files. Through storage, the digital approach brings about a homogenizing convergence of heterogeneous sources. The question of the quotation of the moving film image seems to have its answer, almost to the point of losing its relevance, in the convergence of media into one and the same code. Consequently, all media are subject to the same operations of search, and copy, cut, and paste.

Cinematic movement depends on the succession of frames in projection, where the spaces of darkness between them secure the movement of the image. This technique is at odds with the contemporary techniques for reproducing movement in digital images. One could even question whether there are photograms or even space at all in a medium where everything is stored as binary digits (bits).[22] Today, most digital moving images depend on video compression through the MPEG standard, which entails a reduction of movement in order to fit the moving image into a restricted storage space.

The video compression works in the following way. The software divides each frame into small blocks of pixels to analyze the changes from one frame of video to the next. A group of pictures (frames) is established around a key frame at regular or irregular intervals (the I-picture, for intra-picture, meaning it is spatially compressed, like the JPEG standard). On the basis of key frames, P- (for predictive) pictures are established in between to predict the whereabouts of each block of pixels. In between I- and P-pictures, in turn, B-pictures use motion compensation from both the preceding and following I- and P-pictures. Just like B-movies used to make a film program economical to produce, these "bi-directionality predictive" pictures make the moving-image files economical in terms of data storage.

This compression technique warps the distance between the frames, the dark passages where movement really happens in film. The psychology of the perception of movement may be the same as in cinema—based on the *phi* phenomenon—but the technology of movement works in a different way. Compression means that part of an image is a repetition of the previous, with only some updated parts where it is strictly necessary. The result is a partial pseudo-movement only taking place in some areas of the image at the expense of the

micro-movements of the photographically based filmic image. Since there are certain defined thresholds for when a section of the image is updated or not, it results in a compromised movement where only the plainly visible counts. Of course, we could ask why this matters, as long as all the changes in the movement that we can perceive are there. On a phenomenological level, there are limitations to the movement of the digital image that occur on a micro-movement level, perceptible in fast pans, for instance. It could also be suggested that micro-movements function like overtones in sound, giving a specific color to the movements perceived. These issues are, of course, dependant on the degree of compression of the files.

The key point here is the political aspect of this digital mode of movement. The techniques for video compression are the same as the ones used for video surveillance through automated pattern recognition. Thus the updated "blocks of pixels" from one frame to the next depend on the recognition of changes in the patterns of light. This software is allied with the techniques for recognizing a particular behavior or the features of a face in surveillance. The conditions for movement in the digital image are the same as those that make digital surveillance cameras tools for the world-wide surveillance web. The problems associated with searching images in visual databases through iconic criteria instead of linguistic ones, the QBIC (Query By Image Content), an IBM registered trademark, are connected to the relations between stillness and movement and the role of the photogram. One key limitation in digital pattern recognition techniques is that a still image may be analyzed numerically, whereas the moving image involves so many factors and parameters—such as trajectories, changes in luminosity, and scale—that the technique is hard to apply. The biometric functions of video surveillance are very hard to implicate on a fail-safe basis. So just like the problem of film quotation through frame enlargements, iconic searches in image databases tend to disregard movement and analyze not movement itself but a qualitatively different phenomenon: the single stilled photogram. Just like the problem of quotation begins with the freezing of motion, the pattern recognition techniques freeze the image and analyze an abstracted instant within a movement.

Just as the digital moving image can be at rest or be set into motion with a click, the frame is set into motion through the detonation of montage. The digital image is, however, a simulation of cinematic movement as it proceeds through updated sections of the image, leaving the other sections still. What makes the digital image so well disposed for surveillance, as we saw earlier, is its mode of movement,

always verging on stillness. It is in the frozen moment, the static pose, that persons, positions, and objects become recognizable and accessible through automatic image retrieval techniques. The updated image is, for this reason, not an image of movement, but a new frame in a sequence of still images.

Digital video compression is consequently at odds with Vertov's principle of integrity of movement within the shot. Movement is conflated in digital images because the photograms melt into each other, with one frame standing as the point of reference for the surrounding ones. In his re-elaboration of *Man with a Movie Camera*, Harun Farocki's double-channel film *Gegen-Musik/Counter-Music* (2004) pinpoints exactly the issues at stake in the shift from the photographic to the digital, by pitching the individual against the collective or the mass. Farocki's film asks what a "city symphony" based on today's available images would look like. Through Vertov's famous film, Farocki discovers that the Soviet filmmaker's depiction of the individual in contrast to the crowd is radically different from how this relationship is depicted through digital technology.

On one screen of this double-channel film, there is a moving image from a surveillance camera with a line of people passing through the gate of a building. On the second screen, Farocki displays an intermittently updated image of immobile dots representing each person entering the building. Each dot, in turn, corresponds to a number calculated by the software on the basis of the information on the first screen. Through a series of inter-titles, Farocki claims that Vertov and Walter Ruttmann did not understand the movement of the crowd in the same classifying way as the one adopted by this tracking system: "Both Ruttmann and Vertov envisaged something different/for them the crowd was not a lump to be dissected/and rendered as numbers."

Is it true that Vertov didn't understand the crowd this way? I don't think that Vertov would be alien to the idea of equating the individual to a number or to a dot in a chart. His numbered reels of film anticipate the random access of digital databases. He frequently made use of charts to illustrate the composition of a film as a formal analysis. Also, it would be hard to ascribe to Vertov an absolute respect for the integrity of the individual in a traditional humanistic sense. Vertov's constructivism wants to overcome the division between man and technology that informs such paradigms. However, Farocki's comment is not about the individual in Vertov's films, but rather about the production and reproduction of movement. The digital software, he argues, counts people by freezing the movement of the crowd at the passage

of an individual. The digital image is constructed on movement as a product of immobile points.

But what is cinema, one could object, if not frozen instants in a movement? Doesn't cinema depend on these immobile points in the movement of bodies for its function?[23] The single frame on the film strip is qualitatively different from the frame in projection, while movement is produced in the spaces between the individual frames. Gilles Deleuze has shown how there is no contradiction between a Bergsonian principle of time and the temporality of the cinema technology, even if Bergson's original equivalence of cinema with schematic intelligence was based only on the still frame and led him to the opposite conclusion.[24] Cinematic movement cannot be approached on the basis of still frames captured by the shooting camera. It has to be understood as transcending the single frame in projection. These two positions in the theory of filmic movement are represented by Eisenstein's pre-disposition for frame enlargements and Vertov's charts and diagrams, respectively.

The main goal of Dziga Vertov's quotation technique is to maintain the integrity of movement and duration of a sequence. The movement of the image is given priority over its mimetic relationship with an object or an event. Vertov quotes moving images in a way that makes the whole composition of a sequence available at a glance, while securing the temporal integrity of the structure. This vital difference between Eisenstein and Vertov in their understanding of the photogram's relationship to movement is still today instructive for a comparison with the production of movement in digital video. The film debates of the teens and the 20s may still today provide us with an understanding of what goes on beyond the plain visibility of the image. The problem of quotation in film warrants further study in order to better understand the technological and political aspects of digital imaging in relation to surveillance.

It would, of course, be a flawed idea to place Sergei Eisenstein as a proponent of the technique of movement of the digital image, and Dziga Vertov as a resistance fighter. No one could guess, in the first half of the twentieth century, that there would be a digital image, and even less what would be its technology of movement. Their respective theories of montage only lend themselves to an argument about digital movement in retrospect. Within another technology of movement, Dziga Vertov could also be said to anticipate certain "digital" features, in the sense that he represented movement in digits, charts, and numbers.[25] Still, these two positions allow us to better understand what is at stake with the issue of movement in the regime of the digital.

The automated pattern recognition made possible by digital technology leads to new techniques of surveillance. These call for new principles for analysis of the moving image, as well as for possible techniques of resistance to the ways these images are implemented. Through an archeological approach to the philosophy of movement in the film theories of the 1920s, it is possible to excavate different positions in relation to the exploitation of movement in digital technologies. In the case of Eisenstein, with his priority on signification in montage, a synthesis of movement into still images prevails. This is due to his teleological search for a universal mode of thinking. The latter, for Eisenstein, is located in a universal language as well as in a history of art converging into the cinema. On the contrary, with Vertov, it is possible to find a position of resistance against digital movement and surveillance. In an age of pervasive changes in image technologies and techniques of surveillance, Vertov's stance may be the most valuable for film theory today.

Notes

1. R. Bellour, "Le texte introuvable," in *Ça cinéma* (1975), 7–8. In English: "The Unattainable Text," in *The Analysis of Film*, ed. C. Penley (Bloomington/Indianapolis: Indiana University Press, 2001, pp. 21–7).
2. S. Eisenstein, "Beyond the Shot," [1929], in *S. M. Eisenstein Selected Works, Volume 1; Writings, 1922–1934*, ed. R. Taylor (London: British Film Institute, 1988, pp. 138–42).
3. S. Eisenstein, "Laocöon," [1937] in *S. M. Eisenstein Selected Works, Volume 2; Towards a Theory of Montage*, eds M. Glenny and R. Taylor (London: British Film Institute, 1991, pp. 109–202).
4. K. Malevich, "And Images Triumph on the Screen," in *Essays on Art; 1915–1928; vol. I*, ed. T. Andersen (Copenhagen: Borgen, 1971, pp. 226–232). Originally published 1925: "I likujut liki na ekranakh," *A. R. K. Kino* 10 (1925), 7–8. This background for Eisenstein's conceptualism is established by F. Albera, "Eisenstein and the Theory of the Photogram," in *Eisenstein Rediscovered*, eds I. Christie and R. Taylor (London: Routledge, 1993, pp. 200–10).
5. B. Balázs, *Schriften zum Film; Zweiter Band; "Der Geist des Films," Artikel und Aufsätze 1926–1931*, 89 (Budapest: Akadémiai Kiadó, 1984).
6. S. Eisenstein, "Bela Forgets the Scissors," [1926] in *S. M. Eisenstein Selected Works, Volume 1; Writings, 1922–1934*, ed. R. Taylor (London: BFI, 1988, pp. 77–81).
7. S. Eisenstein, "Laocöon," 121.
8. M. Wertheimer, "Experimentelle Studien über das Sehen von Bewegung," *Drei Abhandlungen zur Gestalttheorie* (1912) (Erlangen: Verlag der Philosphischen Akademie, 1925). H. Münsterberg. *The Photoplay: A Psychological Study* (1916) (New York: Dover, 1970) (pp. 25–30).

9. W. Benjamin, "Erwiderung an Oscar A. H. Schmiitz," *Die literarische Welt* (March 1927).

10. S. Eisenstein, "Laocöon," 121–2.

11. R. E. Krauss, *Passages in Modern Sculpture* (1977) (Cambridge, MA: The MIT Press, 1993) (pp. 9–10).

12. G. Deleuze, *Cinema 1; L'Image-mouvement* (Paris: Minuit, 1983) (pp. 117–21).

13. Malcolm Turvey offers a critique of Vertov's theory as well as the rest of what he calls the "revelationist tradition" (where he also includes Deleuze) because it depends on a categorical confusion between what can be seen and what cannot. Turvey's critique remains entirely within a phenomenological dimension of perception, and cannot account for a perception outside human boundaries. M. Turvey, *Doubting Vision; Film and the Revelationist Tradition* (New York: Oxford University Press, 2008) (pp. 55–58).

14. For a couple of well-known examples of "sequence analysis," see R. Bellour, "Le blocage symbolique" [on *North By Northwest*], *Communications* 23 (1975) 235–350. In English: "Symbolic Blockage," *The Analysis of Film*, 77–192. See also T. Kuntzel, "Le travail du film, 2," *Communications* 23 (1975), 136–189.

15. Y. Tsivian, ed., *Lines of Resistance; Dziga Vertov and the Twenties* (Sacile, Pordenone: Le Giornate del Cinema Muto, 2004) (pp. 109–14).

16. V. Petric, *Constructivism in Film: The Man with the Movie Camera—A Cinematic Analysis* (Cambridge: Cambridge University Press, 1987).

17. Y. Tsivian, ed., *Lines of Resistance; Dziga Vertov and the Twenties* (Sacile, Pordenone: Le Giornate del Cinema Muto, 2004) 10: 152 and 10:156.

18. S. Eisenstein, "The Fourth Dimension in the Kino: II." *Close Up* (April), an appendix to "The Filmic Fourth Dimension," trans. W. Ray. Reprinted 1977 as "Methods of Montage." In *Film Form; Essays in Film Theory*, 73 (New York: Harcourt Brace Jovanovich, 1930).

19. A. Rodin, *L'Art* (1912) (Lausanne: Mermod, 1946) (pp. 116–18).

20. S. Eisenstein, "Laocöon," 113–14.

21. M. Frizot, *Etienne-Jules Marey; Chronophotographe* (Paris: Nathan, 2003). However, it seems clear from Marey's writings that he was striving to construct a projector that was able to show movement differently from the normal human perception, as in loops, time-lapse photography, and slow or decomposed motion. E. J. Marey, *Le mouvement* (1894) (Nîmes: Jacqueline Chambon, 1994) (pp. 309–16).

22. D. N. Rodowick argues this position in: *The Virtual Life of Film* (Cambridge, MA: Harvard University Press, 2007) (pp. 110–41).

23. We know that this interest in the analogies between the procession of people—*le défilement*—and of the film strip has for a long time interested Jean-Luc Godard (in *Ici et ailleurs* (1974), *Grandeur et décadance d'un petit commerce du cinéma* (1986), and *On s'est tous défilé* (1988)).

24. Deleuze, 9–22.

25. I am here indebted to the research project at the Austrian Film Museum and the Departments of Computer Studies and Cinema Studies at Vienna University. See *Dziga Vertov: The Vertov Collection at the Austrian Film Museum*, eds T. Tode and B. Wurm (Vienna: Österreichisches Filmmuseum, 2006, pp. 160–217).

7
Malraux, Benjamin, Bazin:
A Triangle of Hope for Cinema
Dudley Andrew

Malraux encounters cinema

André Malraux became professionally involved with the cinema in the mid to late 1930s, coming to it along the well-trod path of adaptation, that is, as a way to exploit his novels, to elaborate their aesthetic in a different medium and to disseminate their politics. But at this very moment he was also formulating his vast project in the history of art, where cinema was the latest art that needed to be accounted for and where photography played the key enabling role throughout. World War II interrupted—permanently it turned out—whatever notions Malraux may have harbored for engaging in further filmmaking or film theory. But, as if in recompense, the Occupation raised up a most prodigious acolyte, André Bazin. Bazin was devoted to Malraux and, as he launched his career as film critic in 1945, he seemed eager to develop what Malraux had started, banking on his hero's ideas. However, Bazin was even more devoted to the cinema and would soon take his own route into territory Malraux had more casually wandered into in the 1930s.

Although he made one of France's greatest films and authored a highly influential short treatise on the medium, Malraux did not take up cinema as a calling the way Bazin or Truffaut or Godard (who all idolized him at times) would. Cinema was simply an unavoidable and attractive phenomenon for this hyper-modern novelist and rambunctious art historian; he had to engage the art of the century in some manner. Malraux was an amateur without a deep stake in the profession of filmmaking or criticism; however, "amateur" was the term with which Bazin explicitly praised the director of *Espoir* (Hope)—Malraux's only completed film (not really complete)—linking him with Renoir in

those films, commercial failures all, when the director savors "a ᵼnd
of delectation designed for insiders, a complicity of friends wh are
making a film together for their pleasure."[1] As for criticism, the 940
"Esquisse d'une psychologie du cinéma" (Sketch for a Psycholo / of
Cinema), remains definitely a "sketch," never fleshed out with fᵼ ther
reflections. Still, it stood as the most influential view of the seven ᵼ art
produced in France until Bazin and Edgar Morin came along aftᵼ the
war. Bazin didn't hesitate to claim that "It is no accident that Mᵼ aux
is the contemporary writer who has spoken best about the cinemᵼ The
fact is there are affinities between his style and the language ᶜ the
screen."[2] So let's examine those affinities.

As it was for virtually every Parisian growing up in the twer ᵼeth
century, cinema was part of André Malraux's intellectual diet ᵼom
an early age. He watched both popular and serious films, ar he
followed, at some distance, the debates over this upstart art that ᵼged
in so many journals of the 1920s. Cinema was an expression ᵼ an
ascendant modern culture that would bring Malraux to fame anᵼ ᵼhat
he himself helped usher in. Cinema and Malraux might best bᵼ een
as untutored and unruly; both worked on the edges of legitimacᵼ and
both had a rebellious streak. Yes, the future cultural minister ᵼ gan
as cultural militant. Rebellion is the subject of his great novel *Les
Conquérants, La Condition humaine*, and *L'Espoir*. The often darinᵼ and
always personal politics he displayed throughout the 30s propellᵼ his
reputation until it stretched over that decade like no one else's. W ᵼner
of the Prix Goncourt, dashing friend of André Gide, a stallion in G ᵼton
Gallimard's stable, he was massively influential and constantly v ble.
He pressed the fame he garnered from *La Condition humaine* to ᵼach
the first rank of the Popular Front. He presided over the famous ᵼaris
Congress of Writers in Defense of Culture in June 1935, then held ᵼrth
brilliantly at a similar event the next summer in London, before ᵼ ᵼing
to Madrid and to the adventures that would lead to *Espoir*, novᵼ and
film. He spoke his mind as an independent voice of consciencᵼ yet
he spoke it in a politically modernist idiom whereby the indiᵼ lual
mind finds itself carried forward into putative "self-expressior on
waves of mass movements, revolutions. I see him as the modeᵼ ᵼho
best embodies in the socio-political sphere the conundrums that ᵼ ᵼuld
define cinema's auteur theory, whereby a "director's" vision mᵼ ᵼ be
ferreted out of situations he could scarcely have controlled. In ᵼed,
Malraux's tragic humanism stems from his unshakeable belief in ᵼdi-
vidual genius and his equally unshakeable realization that modᵼ ᵼity
has obviated the individual, if not genius. Cinema is a medium—ᵼ ᵼ we

still all it an art?—that exhibits this conundrum in its technological and industrial organization. Malraux couldn't avoid it.

In the key year of 1937, in the midst of grand literary and political accomplishments, Malraux revealed the extent of his first passion, art. At the time, and given the dire national and world circumstances, his inaugural essay in *Verve*[3] could have been taken as a self-indulgent trifle, a retreat from his grueling agenda of writing and organizing. Undeniably art had served his ambitions as a young man, for he had made a reputation (colored by notoriety) in the early 1920s as a precocious hunter of Asian objects after an apprenticeship to the legendary collector Daniel Kahnweiler. But by the 1930s many considered this early adventure with art to have been a pretext to the bold literary and political career he invented in Indochina. They were proved wrong by the *Verve* article which announced an unprecedented history of art, at least as ambitious as the literary accomplishments it would rival, and more long-lasting than his leftist activism. Cinema would have to play a role in this history, since of all the arts it was most patently political thanks to its mass appeal. And as a mass art, neither the novelist that he was, nor the art historian he was becoming could avoid it, or wanted to avoid dealing with it.

At the outset Malraux's rapport with the cinema may not have been so very different from that of numerous other contemporaneous French literary figures: André Gide, Roger Martin du Gard, Eugène Dabit, Pierre MacOrlan, Blaise Cendrars. All of them dipped their toes into the dirty pool of cinema, but none dove fully in. And it was definitely through literature rather than painting that Malraux approached it. The cinema comes up in brief sentences in two of Malraux's novels of the late 20s, but without elaboration.[4] In 1927, spurred by populist writer Henry Poulaille, he joined key intellectuals in an effort to pry *Potemkin* from the censorship ban in which it was strapped in France. Here, and then repeatedly, he suggested that the cinema might very well take over the cultural function of the novel, agreeing with Trotsky on this point in their nocturnal meeting at Saint-Palais in 1933.[5] That this subject should come up in such a legendary rendezvous suggests that Malraux's thinking about cinema was bound up with his thinking about revolution and art.

The next year, in June 1934, following the Stavisky riots, Trotsky was deported to Scandinavia; Malraux responded by helping form the Committee for the Defense of Culture, leading to the Popular Front. Along with his editorials and speeches, Malraux somehow found the time and perhaps the need to debate literary issues. In this same June

1934, in the pages of *La Nouvelle Revue Française*, he used a review of a new Russian novel to proclaim: "There now exists in Europe an entirely new kind of literature, books whose value comes not from what the author adds to a tale via experiment, subtlety, or quality, but what comes exclusively through the choice of the events he recounts. In cinematic terms I would say that alongside photographically-based literature we are seeing the beginnings of montage-based literature."[6] Malraux asserts that this new form of writing has incubated in nations where the tragedy of violence has been unavoidable (he mentions the USSR and China, along with "parts of the U.S.," probably thinking of Faulkner whom he was wildly promoting), or where violence is surely about to erupt (he predicts that Spain will be the next cauldron forging such fiction). When this review appeared, Malraux was already on his way to the USSR for the Soviet Writers' Congress, and he would go to Spain exactly two years hence, and where his prediction of violence would indeed come true. In Spain he would himself contribute to this new style of narration via montage, with *L'Espoir*.

In 1935, between these two voyages of political commitment, he wrote a remarkable preface to a reportage published by Andrée Viollis called *Indochine S.O.S.*[7] Doubtless attracted to the book's Southeast Asia subject and its undisguised leftist politics, he was even more taken by its style, which he characterized as cinematic. Employing terminology taken from rhetoric, Malraux praises Viollis for forging a literature based on metonymy and ellipsis rather than on metaphor. He points to the book's hard descriptions (their objectivity) as these become supercharged when set starkly (elliptically) against one another (in montage). Using this intrepid female journalist's shocking descriptions of colonialism, he advocates the sequential layout of multiple points of view on any given event, since these constitute a choral treatment of the event. Did he not have *La Condition humaine* in mind in characterizing literature via cinema in this way? After all, he had gone so far as to prepare a script of part of that novel in 1934, discussing it, evidently in some detail, with Eisenstein on the set of *Bezhin Lug* (Bezhin Meadows, 1937) during the trip to the USSR.

Malraux's remarks about cinematic language were instantly picked up by Roger Leenhardt, André Bazin's predecessor at *Esprit*. Leenhardt quoted from that obscure preface to *Indochine S.O.S.* in an article on "Cinematic Rhythm," late in 1935. There Leenhardt approved the idea of the modern novelist as journalist, as stenographer of a fast-moving and violent world where choices about what should be recorded have to be made on the spot and where excess must be pared so relations

stand out starkly. Filmmakers should note recent developments in the literary field where instead of concocting plots and characters to form idealized allegories of private or social existence in the classic manner, today's most innovative novelists do better by stitching harsh descriptions together elliptically to deliver an event or an idea concretely, in its essence, and with a rapidity consonant with the pace of twentieth-century life. And cinema naturally tended toward this aesthetic since ellipsis, Leenhardt declared, was its chief rhetorical figure, opposed to metaphor, a pretentious, willful figure that generally increases bombast by adding thick layers of authorial meaning atop the hard turf of straight photography.

Leenhardt's views were similar to those being developed simultaneously by a brilliant new literary scholar, Claude-Edmonde Magny, the only female in the 1932 graduating class at the École Normale Supérieure. Magny tracked the literary trends of the times better than anyone else in Paris, publishing long essays and books once the war was over. She too lionized Malraux ("le fascinateur" as she called him in a powerful 1948 essay in *Esprit*) as by far the most modern novelist in France. She showed how he took the hard-hitting American style to a metaphysical level through attention to hard facts on the one hand and limited point of view on the other. She became a fixture at *Esprit* where she inevitably ran into Bazin, who credited her more than once, most importantly in that section of his essay on Italian Neorealism where he links Rossellini to the American novel. But his first mention of her came in his review of Malraux's *Espoir* which he published in the elite journal *Poésie* during the summer of 1945.[8] Malraux was sufficiently impressed with what he read that he wrote Bazin a letter the following March praising his acuity. This was no ordinary review, Malraux recognized, first of all, because it wasn't interested in judging or ranking the movie. Although Bazin confesses at the outset that he shares the positive opinion of most reviews, he intends to dig deeper into Malraux's stylistic advances, keyed by Claude-Edmonde Magny's views, published in an earlier number of *Poésie*, on the philosophical significance of ellipsis in novels and films. Bazin was likely also in dialogue with Leenhardt whose review of *Espoir* came out a month earlier. Leenhardt had declared it the only recent combat film likely to endure, and he put it on a par with the greatest French film of all, *La Règle du jeu*; the two films in fact had been completed and first screened almost simultaneously in 1939. Pulling back from that article on "cinematic rhythm" written a decade earlier, in which he linked Malraux with the new elliptical literary style, Leenhardt recognized that in *Espoir* an artistic instinct had led

the novelist-turned-filmmaker to abandon metonymy at key moments and conjure metaphorical figures worthy of Eisenstein.

Bazin encounters Malraux

Under the tutelage of Leenhardt and Magny, then, Bazin was primed to credit Malraux's contributions to filmic narration and specifically to "style in cinema," the subtitle of his essay. Style emerges as a certain consistency in the manner an author fleshes out a representation with significance, whether this be achieved through cutting away (ellipsis) or adding on (comparison). Bazin cites Malraux's *Sketch for a Psychology of Cinema* on the equivalence between cineaste and writer:

> One can analyze the mise-en-scène of a great novelist, whether his object be the narration of facts, the portrayal of the analysis of character, or even an interrogation on the meaning of life, whether his talent tends to a proliferation, like that of Proust, or a crystallization, like that of Hemingway, he is led to relate—in other words to summarize and put on stage—in other words to make present. I call the mise-en-scène of a novelist the instinctive or premeditated choice of instants to which he is drawn and the means he uses to give them a particular importance.[9]

Now Bazin is usually taken as the source of "mise-en-scène" criticism, yet in citing this passage he seems to have worried that the search for style through any means, including mise-en-scène, would compromise cinema's more primary pact with those instants (and situations) it "is drawn to." As for ellipsis, Bazin thought Leenhardt hasty to claim it as natural to cinema; it is a stylistic figure available to all the arts of narration, employed differently in each. In cinema ellipsis can interrupt the unity of space and time that is the standard condition of cinematography, a recording technology designed to capture and deliver situations voluminously and synthetically. So when Malraux aggressively slices sections out of the continuity of a sequence in *Espoir*, in fact he does so in a literary manner—the way Hemingway would, or he himself as a writer—since the shock to our perception registers the presence of the author who underlines what he deems significant by a jagged cut.

The same authorial aggressiveness would seem to hold true for "comparison," as Leenhardt himself stressed in pointing to the close-up of the sunflower after the traitor has been knifed. Such revolutionary

montage, Leenhardt said, lets *Espoir* stand poised between a strident soviet style and a type of realism that unrolls like an American novel. In general, Leenhardt found filmed metaphors pretentious; he ridiculed overwrought silent films that so often are gummed up with soulful superimpositions. For their "poetic images" he was glad to substitute the hard-edged "shots" found in the best sound films that accord with the new "taste for the matter-of-fact, the document, which characterizes modern times."[10]

Bazin shared Leenhardt's taste for documentary shots over "diaphanous images,"[11] yet he too was prepared to credit the judicious deployment of comparison. He approved Malraux's felicitous term, "rapprochement," as it suggests how concrete and unadorned images can quite naturally lead the spectator to additional levels of meaning. Bazin concludes: "In its narrative aspect cinema is an art of ellipsis, but insofar as plastic reproduction of reality goes, cinema is an art of potential metaphor."[12] He isolates a fine example of the latter in *Espoir*:

> When the dynamiters leave the grocery, a slight movement of the camera brings to the foreground an enigmatic demijohn into which acid is dripping from a funnel, drop by drop ... the crystalline noise of the drops sounding in the dramatic silence of the room, the waves of their impact on the liquid ... the very form of the object vaguely evocative of an hourglass, all these details among which the writer would choose and which he would surround by comparisons, are given to us in a raw state charged with meaning by way of the multiple potentials of metaphors.[13]

Far stronger than the ellipses that sharpen its narrative, then, are the potential layers of significance within *Espoir*'s "plastic reproduction of reality." These are visible in the film's visual organization, which Bazin interrogates as though it were a tableau; *Espoir* responds loquaciously. For Malraux was predisposed to experience the tragedy of Spain's contemporary history in light of Spanish painting, Goya and El Greco above all.[14] He once called El Greco's *View of Toledo* (1561) the first Christian landscape because its tormented Spanish vista figured the sufferings of Christ. *Espoir*, with its pathetic representation of villages and mountains, strives in the same way to figure human agony framed within such landscapes. In the final episode, one of the planes that courageously took out a key bridge and neutralized a Francoist airfield has crashed into the mountains. Several members of the crew have died, others are hurt and would die without aid from the peasants who inhabit the lowlands. The procession of the peasants bearing the

wounded down from the mountain, 11 minutes in length with an original score composed by Darius Milhaud, is filmed as if it were the deposition of Christ from the cross. This theme, this landscape, and particularly Malraux's treatment, call up El Greco's great canvas. As in Eisenstein's later films, *Espoir* glows with the aura of traditional art. Both men were devoted to the great stylists of the past. It must have gratified Malraux that Eisenstein referred so often to El Greco.

With Goya, the subject matter is that much closer. In the most famous of the "Disasters of War" cycle, known as *The Third of May, 1808* (1814), a defiant rebel virtually throws himself on the French guns that execute him. The figure of the crucifixion haunts this composition too, and amplifies the film's most dramatic scene: a Republican suicide squad drives a car straight into a firing cannon (where the camera has been placed). Just as Goya's canvas radiates revolutionary hope through the brilliant white shirt at its center, so Malraux's sequence expresses its hope (its *espoir*) in the sharp cut from the violent death to a flock of birds that streak across the sky, a blinding sun behind them. The very materials of the medium, pure light and motion, here sanctify a metaphor, made famous in the finale of Carl Dreyer's *Passion of Joan of Arc* (1928) when the birds fly up as her soul is released from the pyre. *Espoir* may have been made by a novelist, but it proved to be a film in which the power of its imagery—at once realistically concrete and sublimely abstract—compensates for the insufficiency of its elliptical narrative.

Despite his own literary training, and although he had devoured Malraux's fiction, Bazin treated *Espoir* not as an adaptation but "as a direct creation, as personal as a novel or a painting." The "Sketch for a Psychology of the Cinema" readied him for this. He would have read it in *Verve* in 1940 where it appeared as the fourth preview Malraux offered to the grand world history and psychology of art he would publish in three volumes, beginning in 1947.[15] Malraux's inclusion of cinema within the mission of the arts may have enticed Bazin to venture beyond his literary comfort zone (beyond the novel) and to venture into the complexities of a new kind of art history just then being adumbrated by Malraux, where technology, aesthetics, and psychology intersect. For this is exactly how Bazin's earliest texts situate themselves, especially "The Myth of Total Cinema" and "The Ontology of the Photographic Image." In the latter he directly footnotes the "Sketch,"[16] no doubt happy to rest on Malraux's authority since his own essay appeared in an imposing anthology published in 1945, called *Problèmes de la peinture*, edited by art historian Gaston Diehl, and alongside entries by Duffy, Matisse, Cocteau, and Rouault.

Benjamin encounters Malraux

In this, his foundational essay, Bazin stands, rather like Malraux, somewhere between literature and art in a space that might be called cultural aesthetics. Seemingly unbeknownst to Bazin, that same space had already been visited by Walter Benjamin, whose "Work of Art in the Age of Mechanical Reproduction" (1935–37) rivals "Ontology of the Photographic Image" as the most influential essay ever written on cinema. Composed a decade apart, both pieces get at their true subject, cinema, by registering the effect of photography on painting. Malraux's "Sketch" is dated halfway between these essays, covertly conveying Benjamin to Bazin at least in its simultaneous implication of psychology, technology, and aesthetics. If Bazin knew of Benjamin, it would have been through Malraux. A relay of footnotes advances what meager direct evidence of actual influence exists, for Malraux cites "the remarkable writings of M. Walter Benjamin," just as Bazin cites Malraux's "Sketch."[17]

But just how well did Malraux know Benjamin? Evidently they met shortly after the artwork essay came out (translated by Pierre Klossowski, the brother of Balthus, with whom Malraux was well acquainted). In the spring of 1936, Malraux told the flattered Benjamin that he wanted to use his ideas in a "manifestly theoretical book" he had in mind, and Benjamin was hopeful that this might lead to the regularization of his status in France.[18] In June, Malraux did in fact mention Benjamin's essay in his address to the London Congress of Writers,[19] but within a month he was in Spain fighting Franco. Benjamin was impatient. He took Malraux to be a leader of a feeble French political avant-garde which, his letters make clear, he wanted to jolt.[20] But Malraux's political commitment—did Benjamin credit this?—had taken him from the Parisian cultural scene. He traveled to North America in 1937 to beg financing for the war and for the film he hoped to make; and then he went back to Spain.[21] Concurrently he somehow developed his art essays for *Verve*. It would be in the last of these, written just after *Espoir* premiered in the weeks before the Nazi invasion of Poland, that he returned to the ideas that had brought him and Benjamin together. However, his "theoretical book" had been reduced to a "Sketch" and his elaboration of Benjamin's ideas had shrunk to a single footnote, and one that rather misrepresents the artwork essay. Benjamin never read Malraux's "Sketch" for it appeared in the summer of 1940, just after he had left for the Pyrenees in a desperate attempt to escape France.

Even without noting their 1936 meeting, Rosalind Krauss has argued from internal evidence that Benjamin supplied the final ingredient for

Malraux's incipient *Psychology of Art*, a project announced that) ar.[22]
Not everyone agrees; Henri Zerner insists that Elie Faure and enri
Focillon, the two giants of French art theory of the time, had alread laid
the groundwork for Malraux's adoption of photography for compa tive
stylistic analysis.[23] Whatever the actual biographical facts may be, it i lear
that in the mid-1930s Benjamin and Malraux seemed equally pre ient
in suggesting that the sociology of art must inevitably shift in li; t of
photography and cinema. They realized that the ecclesiastical order f art
had given way to the secular order represented by the museum. Bu fter
photography, after the cinema, and after Duchamp and surrealism, hat
was the future of the museum? Both agreed that the mechanical repr luc-
tion of images (specifically photographically produced prints of artv rks)
had democratized art, but they disagreed over the consequences (this
development. Benjamin holds that this demystification constitut the
first step toward a new aesthetic, a vulgate, in which the everyday orld
could be represented, spoken of, and criticized by ordinary peoj e in
their own way (released from the alienating ideology summed up i the
term "aura"). Malraux worries about the debilitating vulgarity of p(ular
uses of art and so clings to a traditional hope that artistic values, or, 1ore
precisely, the artistic quest, available to the masses through books f art
photos, will uplift democracy and redeem modern life. In effect he I ped
not to eliminate aura, but to generalize it, to let it glow in every I me,
emanating from prints and books of reproductions, that remain ca ble,
even in a necessarily diminished state, of transmitting the silent v(e of
the indomitable artistic spirit, less through the beauty of specific art acts
than through the evidence of the accumulated thrust of civiliz ion
expressed in its collective presence in photographic sequence.

Representing the thrust of civilization through an arrangeme t of
photographs of artworks came naturally to Malraux, but would have een
anathema to Bazin. For Malraux was already at home in the world (the
museum within whose walls all objects, deracinated from their cul res,
become forms available for a purely stylistic history.[24] Photog phy
further neutralizes individual artworks, physically preparing 1em
to submit to the design of the art historian. Through photogi hy,
paintings from the Prado and the Louvre can be instantly comj red;
sculpture and fresco can enter into dialogue. Details on portals c 1 be
isolated so as to answer massive tapestries, since photographs ing
everything into the hands of the historian on 8 × 11 sheets or on 3 mm
slides, projected at the same scale, side by side in lecture halls. T day,
artworks of every size and in all media find themselves reconstitu d as
arrangements of pixels on the windows of a computer screen.

Now Malraux recognized in this operation of "neutralization" the violence done to the original: to its texture, color, scale, and context. Yet, though photographic reproduction the spirit of art—the epic struggle by which humans respond via personal or social style to their tragic plight—can be tracked in artifacts of every sort, including those that were never conceived entirely for contemplation: African masks, ornamental pottery, and so forth. And it is the spirit of art that counts most for Malraux. By sequencing reproductions, the art historian constructs what is essentially a storyboard of the dramatic script of humanism.

Benjamin would have approved this use of photography as pastiche (though he surely would have scorned Malraux's overriding tale of humankind's heroic quest). As Rosalind Krauss points out, photography raises artistic signification over artistic beauty and uniqueness. Photographs encourage the semiotic use of paintings, each one of which takes its place as a unit in a differential, comparative system. Though hiding behind his library, Benjamin wanted the working class to understand art as a system, and to come up with a political use of art. These two men, so different in temperament, shared hopes for photography as a tool to democratize art and for cinema as the democratic art of the century.[25] But where Malraux expected mankind to look in awe at the history of art, and listen to "The Voices of Silence," Benjamin disdained spectacles whose visual logic leaves no room for "fragmentation or commentary, [so that] the passive recipient is condemned to a silence that excludes the redemptive moment of language."[26] The debate we can imagine between them would have taken place on the eve of the barbaric Hitlerian onslaught. Benjamin, dark and apocalyptic, fearing that civilization had come to an end, took his life; Malraux, guided by civilization, ever full of "espoir," became a resistance leader and later a cultural minister.

Bazin versus Malraux

Not that Malraux thought of civilization as a continuous glorious ascent. He begins the *Sketch* by setting up his cyclic, nearly Spenglerian system in which Renaissance painters and sculptors progressively reduced the symbolic mission the arts had played in the Middle Ages. Egged on by science, they fostered industries and technologies to represent natural objects in three dimensions, leading to the Baroque obsession to reproduce the illusion of movement. Benjamin may have found the possibilities of redemptive allegories in the Baroque age, but

Bazin found the visual aesthetic of that era a cul-de-sac. He believed that in trying to display "a kind of psychic fourth dimension that could suggest life,"[27] the Baroque traded in the art and mission of painting for mere techniques of representation, aiming to attract and satisfy what Malraux calls today's uncouth Sunday afternoon museum patron who only likes paintings that seem to be talking to you. Bazin adopted Malraux's cyclic history, in which photography and cinema had led art out of its impasse (its "tortured immobility"). These mechanical arts took over the lucrative but vulgar trade in life-like images and became the key media in art's decadent twentieth-century phase.

Television was the furthest development anyone at the time could project along the highway that opened up for image-makers at the fork of the Baroque.[28] The other road—twisting, sometimes overgrown (and a dead-end, Benjamin believed)—was that of genuine art, which recognized that the "secret flower of modern painting [would] blossom forth ... [as] more and more the revelation of an inward vision."[29] Accepting Malraux's position here, but reversing its implication, Bazin introduced the Christian paradox that the lowest shall be highest. Elaborating a theological conceit, he calls perspective "the original sin of western painting," because it turned artists away from a concern with the spiritual, substituting for it the visual satisfactions of this world. Original sin, yes, but Bazin makes of it a *felix culpa*, a "happy fault," since this sin would ultimately lead to the arrival of a redeemer: photography, and then cinema. By taking unto themselves the flesh and blood of earthly existence, these inventions released painting to pursue its loftier spiritual mission. Bazin leapt past the more traditional Malraux, for whom art was a voice from beyond the earth. In place of the voice, Bazin believed in the trace, the remnants of something real recorded by photography and cinema. Fruit of science and popular culture, these technologies affect art certainly, and may be used in artistic creation, but their uses go well *beyond* it, or, if you prefer, slip *beneath* it.

Even though he may have been partly responsible for Bazin's ruminations, Malraux, the Nietzschean, had no time for the lowly. For him if mankind would be redeemed, it must be by Prometheus, by human genius courageously expressing its own spirit in art. For him the technologies of photography and cinema solve nothing so long as they remain on the side of the natural world, where they contribute only to the proliferation of mundane appearances. And so, where Bazin and Benjamin were prepared to grant these technologies a role in culture wider than high art, Malraux imagines a cinematic art on a par

with great painting; his *Sketch* was written in the afterglow of *Espoir* to proclaim that cinema stands in the direct line of serious image creation in the West. He must have applauded when the Museum of Modern Art inaugurated its film department in 1936, the same year that the Cinémathèque Française was founded.

Malraux's high-mindedness tested the allegiance of his disciple, Bazin, who would have been uncomfortable with such an elitist attitude—the attitude, it must be told, held by most intellectuals between the wars. Not only did Malraux care only for the highest moments of cinematic achievement, he wanted to jettison everything that came before D. W. Griffith, consigning it to the product of the *cinématographe* (the machinery of visual reproduction), not the *cinéma* (the art of expression that makes use of such machinery). Like Erwin Panofsky, Gilbert Cohen-Seat, and Edgar Morin who would soon follow him, Malraux dates cinema's birth not at 1895 but circa 1910 with the development of systematic editing strategies. Bazin meanwhile wrote passionately about *Paris 1900*, a compilation of fragments from the *cinématographe* that he found absolutely compelling and a crucial treasure for anyone demanding to know just "What is Cinema?"

In fact, on most scores Malraux would line up with Eisenstein, whenever Bazin and the Russian are opposed. *Espoir* wants to be another *Potemkin*, not just to cite it. Selecting expressive faces and terrain, Malraux was determined to create a revolutionary artwork out of the revolutionary reality he encountered in Spain. The bold visual metaphors (that sunflower) and the elegiac finale, are directly modeled on *Potemkin*[30]; they depend on intellectual and rhythmic editing patterns that supplement the recorded images with a surplus of significance. The raw material of the shots may derive from the soil of Spain, but that material is transformed and humanized, having been chosen by the camera and placed just so by the editor. *Espoir* follows a common version of the modernist aesthetic: "The function of Malraux's images is precisely that of projecting a series of multiple perspectives upon reality, so that its every aspect is mirrored against every other, to be refracted finally against the membrane of a single consciousness, that of the author himself."[31] At the moment Malraux was filming *Espoir*, Eisenstein summarized his method, and Malraux's as well, by declaring that the scores of fragments glued together in a film must return the spectator to the "single image that hovered before the artist."[32]

The line is clearly drawn. Bazin, while admiring both men, believed Malraux and Eisenstein to hold an out-of-date view of film, and even of art. Because "Malraux's aesthetic proceeds by a discontinuous choice

of instants,"[33] he is at cross-currents to a modern form of cinema Bazin could sense emerging after the war, as Renoir, Welles, and the Neorealists showed how one could coax stories from a noisy background that unrolls not in fragments but in long takes. The "choice" in such films belongs not only to the filmmaker but to the spectator who picks the story out of a dense space-time continuum that might contain other stories.

These two lines of thought conveniently oppose themselves as space opposes time. Malraux's fragments, whether numerous photographs of artworks destined to find their slots in his art history books or hundreds of shots meant to be arranged and juxtaposed within a movie, amount to pieces in an overall puzzle the *spatial* design of which is progressively revealed in the course of reading or viewing. What Eisenstein called the pre-existent "single image hovering before the artist" is progressively and gradually unfurled like a banner. On the other hand, it is *time* that Bazin, following Bergson, treats as pre-existent, time that extends before and after the spatial designs that humans construct.

His feel for the integrity of time explains Bazin's hesitancy about ellipsis, the technique by which an auteur in literature or film takes the viewer or reader straight to what is significant in a plot or design. Ellipsis does violence to the continuity of nature that the camera respects in its "take." Bazin often sides with nature against the human in this regard. Human beings continually make use of ellipsis, our instinctive reflex of perception, in adapting to the conditions surrounding us, many of which lie out of sight. Cinema reminds us of just how much we don't attend to, how much time, for instance, we consider wasted or useless or excessive. On one hand, ellipsis derives from the condition that keeps us from knowing everything; on the other, ellipsis organizes experience to suit our needs and projects; writers and filmmakers deploy it systematically for their "plots" as they pare away what they deem inessential. Ellipsis is the temporal equivalent of framing. And framing, Bazin asserts, can only be provisional in the cinema, a medium sensitive like no other to what lies beyond the edges of the screen in the infinite and unknowable volume (and continuity) of space-time.

Bruno Tackels may have been the first to suggest that Bazin was a closet reader of Benjamin, or that, in any case, he delivers the same radical view of art, and one quite distinct from Malraux's traditional view.[34] Where Malraux senses the value of photography in delivering traditional art, Benjamin and Bazin understand that these technologies have completely upset the standard function of art. For Benjamin, they let mankind look at the world (including at artworks) without

the ideological encumbrance of aura; photography brings formerly unknown realities to the surface, out of the optical unconscious, to challenge what are rightly called "traditional views" of reality. Bazin says the same thing, Tackels points out, when he praises photography for startling us with a virginal world, letting us perceive "the real behind reality." For both men this new technology of perception "constructs reality by itself, and thus opens up the possibility of transforming it."[35] Thinking art eternal, Malraux failed to recognize that neither art nor the world can be the same after photography; indeed after photography and the mechanical arts, it is no longer clear what the difference between reality and art might be, an ambiguity Bazin appreciates to the limit, as Tackels reminds us in pointing to the essay where Bazin confounds the differences between Chaplin, Charlot, Hynkel, and Hitler. Unlike Malraux and Benjamin, Bazin was writing in the wake of Hiroshima and the Holocaust. Historical moment as well as personality helps explain the differences in tone among these three men who tried to think the future through cinema.

Bazin certainly understood the lure of Malraux's tragic humanist vision, but cinema had pushed him beyond it, to what Angela Dalle Vacche calls an anti-anthropocentric, scientific idea in which man recognizes his decentered position in a vast universe. For Malraux the world comes discontinuously to the artist whose persistent consciousness puts the pieces into place until they form a signifying pattern. Bazin takes the anti-Cartesian and reverse position: consciousness is intermittent as it samples sections and instants of a world that is continuous in space and time, a world that extends beyond the frame, beyond consciousness.[36] In rare, usually brief moments of unwarranted revelation, whether above or below rational intelligence, cinema has been known to deposit vision at the door of the real, as when Ingrid Bergman looks uncomprehending into the maw of the volcano at the conclusion of *Stromboli*. Unlike the ellipses that are lacunae between shots, spaces that the viewer progressively fills in while tracing the dot-to-dot arrangement of a film, the ellipses that trouble Bazin constitute negative evidence for a world vaster than what has been filmed. Bazin was drawn to filmmakers whose images and characters (whether fictional or genuine) exhibit both tentative attachment and humble ignorance to that vaster world. This relation, this probing, searching style of filming and of existence, he characterized as "ambiguous" (tentative, unfinished) and he opposed it not just to propaganda but to every declarative style whose overconfidence is undermined by the ontology of the medium. Before being shaped by humans, shots are primordially tied to matter

and to time. Bazin could feel this link to the physical, historical world in *Espoir*, and so did not treat it as an adaptation of a novel. He watched the film as something authored by a genuine writer, André Malraux, but also as a record of a place in Spain in 1938 with just this landscape, just this look of the village, just these faces, and just this light. The films he believed in were always deeply rooted, the opposite of the de-racinated photos of artworks in Malraux's *Museum without Walls*.

Style after humanism

"On *L'Espoir*, or Style in Cinema" should be seen as a corollary to Bazin's "Ontology" essay which preceded it by only a few weeks. In the latter, cinema's value is shown to be based on the retreat of the human in automatic, technological representation; whereas in the Malraux article, style is lauded as the achievement of an individual or a culture—in any case, solely a human attribute, indeed a synonym for human value *tout court*. Bazin instinctively associated the term with writers: "Style is the man himself" and a particular style is evident on every page of Malraux's novel *L'Espoir*; Bazin wanted to know how to locate this same Malraux—his style, that is—on screen. And here he delved into specific figures (that demijohn dripping water as a kind of hourglass) and figurative techniques that operate in both media. In cinema these require more than the writer's imagination; they require an actual occurrence in space and time, whether this be in studio or "on location."

Bazin turned from literature to cinema because the latter is open to the vast extension of space and the unbroken continuity of time that surround what we—and novelists—are conscious of. Following Bergson, he understood that humans limit space and time in relation to their specific situations; shaping time with ellipses and framing space through various points of view, as they constitute significant specific "durations," which a work of literature exists to record or to replicate in its reader. Style is nothing other than a consistent manner of framing experience that visibly organizes the space and time of a work of art, that localizes its perspective, and that can be projected past the work onto other situations. In a given author a single style can pass from one novel or poem to the next. After immersing ourselves in an author's perspective, we can adopt his style to look at the world at large. Malraux attracted Bazin both because in novel after novel he exhibited a significant style that was attuned to the situation of interwar modernity, but also because he taught himself to observe the styles of other authors

and artists, and of other periods and media. Malraux became an encyclopedia of significant artistic perspectives. As an art historian, he aimed to portray the sum and the variety of these.

Malraux and Sartre inspired postwar French youth. How could they not? They were world-famous novelists, art critics, and politically committed men of resistance. Although close inspection reveals rifts between what were effectively two different generations, the "young Turks" at *Cahiers du Cinéma* stood in awe of them. Since Sartre spoke of achieving freedom by becoming the "author of one's own life" within the "situations" history has laid out, he was applauded. As for Malraux, he had demonstrated the feel of freedom and transcendence in his novels, and in his encompassing history of artistic styles. The fact that he had made a legendary film, and that he lifted cinema into the story of mankind's tragic quest made the future New Wave directors proud. They wanted to pick up the cinema where Malraux had laid it down; so in their criticism they celebrated auteurs who had signed their works with the freedom of their styles, even in Hollywood; later they emulated Malraux in the seriousness with which they would go about making films themselves. They understood Malraux's intuition better than he did himself: cinema had become perhaps the key site of artistic creation in modern culture.

Bazin, on the other hand, though often adopting the terminology and themes of Malraux and Sartre, was not a modernist of their stripe. From Sartre he latched onto the problem of presence and absence in the status of images, going beyond the philosopher by intuiting a post-classical position that gives credence to intermediate states of consciousness and of being. From Malraux he adopted an evolutionary schema of artistic styles, yet he understood that photography and cinema didn't add to tradition but instead opened onto a whole new dimension, inaugurating a different developmental history altogether. Bazin believed that cinema's trajectory relates to the story of art the way the New Testament relates to the Old: references and continuities echo and flow between the technological media and the older ones, but cinema holds out a quite different promise. Bazin was able both to recognize the importance of traditional art and the place of the artist (the Old Testament) while proselytizing for cinema's more scientific and ethnographic role (the New Testament). His enduring relevance—which today exceeds that of the New Wave he helped generate—stems from his promotion of the non-artistic dimension of great films (the dead time in De Sica, the rough sketch in Rossellini, the miscasting in Renoir, the aging of Bogart's face) or of his concern for films that have nothing

to do with the canons of art. He took seriously modes and genres where the notion of the auteur simply doesn't apply: scientific, amateur, industrial, newsreel, medical films that lead us toward aspects of reality otherwise unavailable.

Until his devastating 1957 critique, "De la politique des auteurs," Bazin was taken as an indispensible source for auteurism and the critic who consistently showed cinema's contribution to the established arts, especially the novel. Hadn't he authored the first important auteur study (*Orson Welles*, 1950)? Wasn't he the one who encouraged his young disciples in the "policy" that defined *Cahiers du Cinéma*? He was a prestigious ally whose "On *L'Espoir*, or Style in Cinema," curried favor with Malraux, an even more prestigious ally. Malraux's grateful response effectively announced the "auteur policy" by acknowledging the continuity of an artist's style from early work to later (and across media).

Bazin's *Espoir* essay indeed furnishes vivid examples of Malraux's overall style; but its most striking move—one Truffaut or Godard would repeat a decade later—praises the film's faults, its "amateurism," which he treats as lapses from standard practice wherein a powerful personality expresses itself. If cinematic style is the visible evidence of a creator's manner of framing space and delimiting the flux of time, then the more visible that effort, the more authentic the film. And *Espoir* felt utterly authentic to Bazin. Its strapped conditions may have been responsible for its impoverished look, but they also contributed to its immediacy, for even if many scenes were shot in studio, the haste and rough edges evident everywhere in the film register the chaotic feel of the actual battle that was still raging, sometimes right nearby. Malraux worked with whatever material he could shoot, shaping it as best he could, shaping it, that is, as Malraux shaped everything, with his own élan.

In the final paragraphs of his essay, Bazin advances the most central notion of the auteur policy as it would develop: he writes that Hollywood has managed to depersonalize all its films. A bevy of "creative personnel" guides assembly-line productions where the bias of any identifiable authorial perspective has been leveled in advance. Bazin points to the fate of Hemingway and Faulkner whose careers in Hollywood were squandered, their distinctive styles emasculated. Taking Malraux to be in their company, he wonders if the style so apparent in the "amateur" *Espoir* could ever stamp itself onto a big budget French production. Could his style preserve itself? If given enough money and stars, how would Malraux adapt *La Condition humaine*?

Ma aux meets the New Wave

"If were to make another film," concludes Malraux's appreciative lett to Bazin ... but there would be no follow-up to *Espoir*. Indeed the would be little if any cinema in the life of André Malraux, not unt April 1959 when, in a momentous decision, he authorized, as Mir ter of Culture, that *The 400 Blows* should represent France at Car es. Godard, ecstatic at the decision, saluted the great author und whose ministerial umbrella the fledgling New Wave could shelter whe need be. Until the Langlois affair of 1968, Malraux, this most fam us of French authors, stood behind the young directors who had pro ulgated the idea of the film author. And Sartre, it should be noted, pub cly praised *Breathless* in 1960. However, these leading public figures got hind the rambunctious New Wave at a time when both saw their repu ations ebbing. Malraux's position alongside de Gaulle would cost him restige in academic and artistic circles (Sartre would throw darts at h n), while the latter's existentialism was receding, to be replaced who sale by structuralism. Claude Lévi-Strauss and Roland Barthes spec ically gunned him down; their names, not Malraux's or Sartre's, wou l be the ones to look for in the most lionized journals of the 1960s, incl ling *Cahiers du Cinéma*. By the time Foucault wrote "La Mort de l'au ur" in 1968, the New Wave had itself expired.

F cault's announcement would not have flummoxed Bazin. He had lready written something similar 20 years earlier. Were the future aut rists listening to this?

> 1 e rather recent, individualistic conception of the "author" and of
> t "work," ... was far from being ethically rigorous in the seventeenth
> c tury and started to become legally defined only at the end of the
> e hteenth Furthermore, the standard differentiation among the
> a s in the nineteenth century and the relatively recent subjectivist
> r tion of an author as identified with a work no longer fit in with
> a aesthetic sociology of the masses in which the cinema runs a relay
> r e with drama and the novel and does not eliminate them.[37]

But is post-humanist Bazin was not understood at the time; instead, his say on style in *Espoir* provided some of the principles that shaped the lly humanist auteur policy. Perhaps inadvertently he abetted the exc ses that would shortly characterize auteurism when he next turned to N lraux. To conclude his 1949 article "Painting and Cinema," Bazin lists Malraux as an exemplary critic whose writings on El Greco are so

sympathetic with the painter that they amount to artistic co-creation.[38] This idea of creativity-within-tradition is precisely what Malraux himself was advancing in his *Musée imaginaire*. The modern artist (Picasso is the favored example) begins by making a pastiche of past masterworks, rearranging them into an order governed by his own personal values. That new order amounts to the next step in the history of style, the one the artist must take himself, Picasso's style as the next accretion on the coral reef of culture. Clearly Malraux the art historian is in tune with Malraux the novelist who described with such intensity certain discrete moments of experience, each brilliantly lit by the imagination, as they reflect off each other and form a constellation, a pattern, in his mind and later in the mind of the reader. Just so, as art historian he filters from all possible artworks those that are sharpest in definition, most striking or personal to perception. Then, laying these side by side, he figures a pattern that the alert reader, leaping across inevitable gaps, rejoices to comprehend. When put together this way, these selected artworks—mere facts of culture, and seemingly autonomous in themselves—take on a significance that reveals the meaning of style, whether this be the style of a single artist like El Greco, or of a period, or, in aggregate, a major style like mannerism by which the human condition has been movingly, tragically, expressed.

The auteur policy matured in the 50s during the height of Malraux's influence on ideas of art. He was the model for young film critics who dreamed of becoming auteurs in their own right by constituting a constellation of recalled scenes, motifs, and tendencies visible here and there (that is, elliptically) across a filmmaker's extensive body of work and forming the pattern of a significant worldview. If Malraux's stunning pages on El Greco in *The Psychology of Art* really did amount to co-creation, as Bazin intimated, then Rohmer and Chabrol believed they could do the same in the book they prepared on Hitchcock. This is why Godard could claim that making films and writing about them were equivalent activities, since both amount to the creative patterning of fragments, whether these are individual shots taken by a camera, or scenes recalled from films viewed at various times and places.

With photography as his instrument, Malraux gathered images from all periods and continents, then dared to demonstrate their coherent stylistic achievement. "Psychology of Art," indeed! In the books, whose production values he took care to oversee, Malraux supplied plenty of auratic lighting supplemented by striking camera angles to isolate each artistic instance, intentionally deracinating it so that it

might better serve as an example of one style or another that he could magisterially describe. Through this process, the entire career of, say, El Greco becomes Malraux's *essential* El Greco with just one or two photographs, to be slotted within a constellation that is part of the sublime night sky of art. Cinema enters that sky like a comet, streaking past familiar constellations as it illuminates the night, pointing to the current and future state of mankind's artistic (that is, spiritual) condition. No wonder Godard would refer, time and again, to Malraux in his *Histoire(s) du Cinéma*, a work surely meant to complete Malraux's sketch of cinema, and a work itself made up of fragments of films taken from Godard's vast image bank.

Bazin, beyond Malraux

But just what was Malraux's vision for cinema? Emmanuel Loyer could as well be speaking for Godard when he writes:

> Like all the image arts [cinema] is based in a process of sacralization that Malraux lays out magisterially. For the western world on its way toward de-christianisation, a civilization that has lost its meaning, culture now occupies the place formerly bestowed on religion for the transmission of values and for man's metaphysical quest. If cultural centers [Malraux's famous "maisons de la culture"] are the cathedrals of the 20th century, then movie theaters are its ardent chapels: anyway, weren't cathedrals not already projection rooms whose stained-glass windows brought to life marvelous ancient legends thanks to luminous rays passing through them? Speaking of his *Napoléon*, Abel Gance laid out a program that Malraux would not have denied: "All legends, all mythology and all myths, all the founders of religions and indeed all religions await their celluloid resurrection, and the heroes are pressing at the gates."[39]

Does this final citation from Abel Gance, that self-consecrated auteur, sound familiar? It should: Walter Benjamin uses it to conclude the second section of the "Work of Art" essay where he corrosively adds a single sentence to undercut such bombast: "[Here Gance] was inviting his readers, no doubt unawares, to witness a comprehensive liquidation." Both Benjamin and Bazin believed that cinema should bring myths down to earth. Gance postures like a hero sitting for a sculptor; he urges cinema to monumentalize history rather than hand it over to spectators to learn from and use it as they please.

· Like Gance, Malraux promulgates an old view for a new medium; his cinema would accord with his tragic humanism, entering the epic history of the cycles of art only after it learns to downplay its technological facility, so as to use its technological conditions as material to be transformed and transcended. Malraux's view is not far from that of Arnheim or Panofsky, two other renowned art theorists of his generation who assimilated the cinema within the arts thanks only to its techniques of framing and cutting. All three ignored the ontological difference of photography that blazed in the eyes of Benjamin and then Bazin.

Cinema is distinct from the pure arts over which Malraux presides. Its images do not belong in the first instance to the imagination, since they are captured by a machine through whose lens light passes indiscriminately. Even in the absence of anyone directing them, raw newsreels, for instance, can readily appeal to viewers; in any case most films suggest a separation between an extensive subject and the intensive directorial vision striving to discipline it, to author a discourse through it. Is this why Malraux never took up the genre of the film on art, which after all is a subgenre of documentary? Did cinema's recording mechanism seem vulgar to the man who celebrated the transcendence of the artistic imagination?

Still how could he have ignored the work of his future son-in-law, Alain Resnais, especially *Van Gogh*, produced by fellow art historian Gaston Diehl in 1948 just when Malraux's *Psychology of Art* makes a god of the same painter?[40] If its servile documentary function kept Malraux from taking the film on art seriously, it brings cinema at least to the level of the kind of art criticism Malraux himself is engaged in. The relation of Resnais' film to Van Gogh's oeuvre, Bazin suggests, is parallel to the relation a critic has to the artist he writes about where "creation is the best critic of the original" because it proceeds from something already aesthetically formulated.[41] For Van Gogh's paintings exist quite apart from Resnais' film which nevertheless does something artistic with them, something that strives to reach the creative level of those paintings. In the same way, the purportedly mundane practice of art criticism can strive for and occasionally reach the art it presents. Baudelaire, Bazin implies, re-creates (that is, creates in his own right) the Delacroix he expounded on so beautifully; Valéry likewise re-creates Baudelaire whom he loved to write about, write through, as well as read; and André Malraux is as much creative artist as the El Greco he has delivered to us with such power in *The Psychology of Art*. Following this logic, Bazin can conclude "Painting and Cinema" by praising Resnais (creator alongside Van Gogh)

at the expense of lesser cineastes, whom he finds to be mere academic art historians: "Films about painting will be worth precisely as much as the men who make them." Resnais is an artist worthy of Van Gogh.

And so, where Malraux views art as inhabiting a sacred zone of the imagination, Bazin treats both cinema and criticism as mundane practices producing forms in which the imagination subordinates itself to what pre-exists and outlasts it. To the extent that they choose a subject and adopt a consistent and consequential point of view, filmmakers and critics can create a body of work, just as does the artist. This is the matrix of auteur criticism and we should extend it to Bazin. For just like Resnais, who creates something new out of the painters whose works he films, Bazin presents his own layout of the filmmakers he loved: Orson Welles, Charlie Chaplin, Jean Renoir. It was Renoir who claimed that every worthy filmmaker reworks a single obsessive idea in film after film. Isn't it the same for Bazin, who repeats a variant of the same idea case after case, giving us his Renoir (or Welles or Chaplin) in review after review, essay after essay? Bazin follows Malraux's method, selecting striking examples from the work of the film artists he loves. When placed next to one another in the books that these reviews post-humously became, a vision of the world emerges from these examples: Bazin's vision seen through the visions of his chosen directors.

Then there is this essay you are reading, my essay that features André Bazin, cut and pasted from his articles, each of which goes beyond its partial deployment and attempted synthesis in my writing. A large cabinet in my office holds copies of all 2600 of his articles, constituting a huge Bazin memory bank. For this essay I have pulled dozens of sheets from the cabinet; together they form a very partial but consist-ent Bazin, a level or plateau of "identity" from which (that is, through my Bazin) we can view, say, Alain Resnais, who himself was constituted by Bazin's selected vision of his essay films. Resnais gave us his Van Gogh in just the same manner. Thus each work stands outside its subject without traducing that subject; each seeks its own synthesis, an "image consciousness" Sartre would say, a plateau of understanding. And every plateau stands as the potential launching site for another ascent up the mountain that is the quest of the artistic drive, the mountain that can never be framed, let alone conquered. André Malraux would have appre-ciated this vocabulary of tragic pursuit. But whereas he focused on the great geniuses who scaled the mountain with their art, Bazin explored the inhuman mountain like a geologist, layer under layer. To Buffon's adage "Style is the man himself," Bazin replies that cinema puts every man, together with his style, back in his place on this earth.

Notes

1. A. Bazin, "On *L'Espoir*, or Style in Cinema," in *French Cinema of the Occupation and Resistance*, trans. S. Hochman (New York: Frederick Ungar, 1981) (p. 156).
2. A. Bazin, "On *L'Espoir*," 145.
3. A. Malraux, *La Psychologie de l'art* (1937). Verve 1.
4. Denis Marion has identified two sentences from *La Tentation de l'Occident* (1928) which bring up respectively the West's peculiar affinity for film, and the effect of films on spectators. Then in *Les Conquérants* (1928), Garine declared that you cannot contest filmed propaganda with words, only with images. See D. Marion, *Le Cinéma selon André Malraux* (Paris: Cahiers du Cinéma, 1996) (p. 7).
5. See C. Cate, *André Malraux: A Biography* (London: Hutchinson, 1995) (p. 176). This scene is re-staged by Alain Resnais in his 1975 film *Stavisky*.
6. A. Malraux, "Review of Michel Matveev," *Les Traqués. Nouvelle Revue Française* (June 1934), 1014. "Toute une littérature se constitue actuellement en Europe, de livres dont la valeur n'est plus dans ce que l'auteur ajoute d'expérience, de subtilité ou de qualité à un récit, mais uniquement dans le choix des événements qu'il rapporte. En terme de cinéma, je dirais qu'à côté d'une littérature de photographies commence à se constituer une littérature de montage."
7. A. Malraux, Preface to *Indochine S.O.S.*, by Andrée Viollis (Paris: Gallimard, 1935).
8. *Poésie* started with the Occupation in 1940 and could boast a litany of well-known authors and critics as its contributors. Cl-E. Magny could often be found in its pages, writing on existentialism in the French novel, or on the American novel and its relation to the cinema. Interestingly, in the issue following Bazin's piece, one finds an article by the 20-year-old Gilles Deleuze!
9. A. Bazin, "On *L'Espoir*," 149–50.
10. R. Leenhardt, "Rhythm," in *French Film Theory and Criticism II*, ed. R. Abel (Princeton, NJ: Princeton University Press, 1988, p. 204).
11. R. Leenhardt, *Les Yeux ouverts: entretiens avec Jean Lacouture* (Paris: Seuil, 1979) (p. 80).
12. A. Bazin, "On *L'Espoir*," 151.
13. A. Bazin, "On *L'Espoir*," 151–2.
14. Malraux began *L'Espoir* before having seen Picasso's *Guernica*, another obviously relevant Spanish painting, first exhibited in the Spanish Pavilion of the Paris International Exposition of 1937. He later asked Picasso to illustrate his novel. See Malraux, *Picasso's Mask* (New York: Holt Rinehart and Winston, 1975) (p. 45).
15. Malraux, "La Psychologie de l'art," *Verve* 1 (1937); "Psychologies de Renaissances," *Verve* 2 (1938); "De la représentation en l'Occident et en l'Extrême-orient," *Verve* 3 (1938); and "Sketch for a Psychology of Cinema," *Verve* 8 (1940).
16. This seems to have been the first footnote of Bazin's publishing career, and an inaccurate one as it turns out. For more detail on the gestation of Bazin's "The Ontology of the Photographic Image," see my Foreword to

the 2004 Edition of *What is Cinema? vol. 1* (Berkeley, CA: University of California Press).

17. See M. Dall'Asta, "Beyond the Image in Benjamin and Bazin: the Aura of the Event," in *Opening Bazin*, ed. D. Andrew (New York: Oxford University Press, 2011).
18. J.-M. Monnoyer, *Introduction to Écrits français*, by Walter Benjamin (Paris: Gallimard, 1991) (p. 12).
19. A. Malraux, "Sur l'héritage culturel," in *La Politique, la culture* (Paris: Gallimard, 1996, p. 136).
20. W. Benjamin, Letter to Max Horkheimer, 28 February 1936, in *Gesammelte Briefe, vol. V, 1935–1937*, ed. T. W. Adorno (Frankfurt: Suhrkamp Verlag, 1999, p. 252). His letter expressing guarded hope that Malraux might write something about him was written 10 August 1936, by which time Malraux had already left Paris for Spain.
21. See the chronology established by J. Michalczyk, *André Malraux's Espoir: the Propaganda/Art Film and the Spanish Civil War*, Appendix E (University, Miss.: Romance Monographs, 1977).
22. Krauss also indicates that Malraux accepted, or made use of, only the first, most apparent stratum made visible when Benjamin used photography to cut deeply into art history and even into the nature of the artwork. See her "The Ministry of Fate," in *A New History of French Literature*, ed. D. Hollier (Cambridge, MA: Harvard University Press, 1989, pp. 1001–2). See also her "Postmodernism's Museum without Walls," in *Thinking about Exhibitions*, eds. R. Greenberg, B. Ferguson, and S. Nairne (London/New York: Routledge, 2005, pp. 241–5).
23. H. Zerner, "Malraux and the Power of Photography," in *Sculpture and Photography*, ed. G. Johnson (New York: Cambridge University Press, 1998, p. 120).
24. R. Krauss, "Postmodernism's Museum without Walls," in *L'Entre-Images: Photo, cinéma, vidéo*, by R. Bellour (Paris: La Différence, 1990, pp. 241–5).
25. Malraux's plea for democracy encounters the irony of the fact that his little "Esquisse d'une psychologie du cinéma" (Sketch for a psychology of cinema) came out originally in a luxury journal, and its first appearance in book form (1946) was in a Gallimard limited edition of numbered copies that one can only associate with fine art. So much for mechanical reproduction. I first read Malraux's "Sketch" in the special collections at the University of Iowa where trained personnel brought it to me and made sure that I didn't mishandle their precious copy, no. 78 (of a print run of 200).
26. R. Berman, *Foreword to Reproductions of Banality: Fascism, Literature, and French Intellectual Life*, by Alice Kaplan. (Minneapolis, MN: University of Minnesota Press, 1986).
27. Bazin, *Ontology*, 11.
28. In "Sketch for a Psychology of Cinema," Malraux actually mentions TV as the coming medium: "The same confusion that led the Florentine populace to applaud Giotto's figures as being 'truer to life;' and the enthusiasm of these tuscans for his 'new' Madonnas was not perhaps so very different from that which would ensue today were television suddenly to enter every home."
29. Malraux, "Sketch for a Psychology of Cinema," section 1.
30. In a note to volume two of *The Psychology of Art*, written in 1948, Malraux attributes his motivation for *Espoir*'s descent from the mountain to an

equivalent sequence in *Potemkin*, the procession of the citizens of Od(a to honor the body of the sailor.

31. R. Tarica, "Imagery in the Novels of Malraux: an Index with Comme ary" (Unpublished dissertation, Harvard University, 1966), 179. Reprodu d in John Michalczyk, André Malraux's *Espoir*, 48.

32. S.M. Eisenstein, "Montage 1938" appearing as "Word and Image," *The Film Sense* (New York: Harcourt, Brace, Jovanovich, 1969).

33. Michalczyk, *André Malraux's Espoir*, 179.

34. B. Tackels, Bazin, Brecht, Benjamin. Paper presented at the Journée d' ıdes 'Bazin-Benjamin,' 21 December, University of Paris (2000). Tackel first addressed the Bazin-Benjamin connection in: 1994. Le Théâtre à l'épo. e de la reproductibilité de l'oeuvre d'art. Théâtre/Public 116–118 (March).

35. Tackels, "Bazin, Brecht, Benjamin."

36. Angela Dalle Vacche goes further, seeing Bazin within the post-cl sical science of Darwin and Einstein. See "The Difference of Cinema in the ! tem of the Arts," in *Opening Bazin*, ed. D. Andrew (New York: Oxford Uni rsity Press, 2011, p. 144).

37. Bazin, "Adaptation, or the Cinema as Digest," in *Film Adaptatio* ed. J. Naremore (New Brunswick, NJ: Rutgers University Press, 2000, pp. 23 :5).

38. Bazin, "Painting and Cinema,"169, in *What is Cinema?* Vol. 1. Eisen :in's great passages on El Greco (and specifically on the paintings of Toledo . the storm) can be found in "Synchronization of Senses," in *The Film Sense,* ans. and ed. Jay Leyda, 103–5. New York: Harcourt Brace, 1947.

39. E. Loyer, "Malraux et le cinéma: du désir d'épopée à 'l'usine des) /es." *Cahiers de la Cinémathèque* 70 (October 1999), 48. "Comme tous l(arts de l'image, [le cinéma] s'inscrit donc dans un processus de sacrali tion que Malraux met en scène magistralement: dans un monde occiden l en voie de déchristianisation, et plus généralement dans une civilisation eı)erte de sens, la culture au XXe siècle occupe la place dévolue jadis à la r(gion dans la transmission des valeurs et la quête métaphysique. Si les mais(s de la culture sont les cathédrales du XXe siècle, les salles de cinéma so t ses chapelles ardentes; d'ailleurs, les cathédrales ne furent-elles pas elles-ı mes des salles de projection où les vitraux, sous l'impact des rayons lum eux, animaient d'antiques et merveilleuses légendes? Abel Gance, à propos son Napoléon, dresse un programme que Malraux ne démentirait pas: 'Tou s les légendes, toute la mythologie et tous les mythes, tous les fondateurs (reli-gion et toutes les religions elles-mêmes attendent leur résurrection lumi 'use, et les héros se bousculent à nos portes pour rentrer."

40. I elaborate this point at great length in "Malraux, Bazin and the G ture of Picasso," in *Opening Bazin*, ed. D. Andrew (New York: Oxford Uni rsity Press, 2011, pp. 153–66).

41. Bazin, "Painting and Cinema," in *What is Cinema?* Vol. 1 (Berkele CA: University of California Press, 1967, p. 169).

8

Poetic Density, Ontic Weight: Post-Photographic Depiction in Victor Erice's *Dream of Light*

Simon Dixon

> *Now it has been perceived that reality is hugely rich, that to be able to look directly at it is enough; and that the artist's task is not to make people moved or indignant at metaphorical situations, but to make them reflect (and, if you like, to be moved and indignant too) on what they and others are doing, on the real things, exactly as they are.*
>
> Zavattini (1953)

> *It's not surprising that these cinema-painting flirtations result in great films ... because what they are talking about and what they are exploring, each in their own way, is the limit degree of the human gaze at the end of the twentieth century.*
>
> Lajarte (1993)

Victor Erice's *El sol del membrillo/Dream of Light* (1992) is a documentary about the Spanish realist painter Antonio López García. The film is an ekphrastic project, a treatment of one art form by another; but *Dream of Light* is more about film than painting, more theoretical than descriptive. It thus oscillates between art film and documentary, following the rules of documentary but addressing problems most vexing to theorists of film art. Erice's choice of painter is crucial to his film-aesthetic agenda. The paintings of Antonio López mine the surface of experience, figure time experienced as duration and revealed in weathering, decay, patina, and putrefaction, all transformations in substance and quality. This temporality is taken up by Erice to forge a new film aesthetic, a new variety of lyrical documentary, at a time of crisis for the film image as photographic celluloid gives ground to digital depiction; but

he specifically needs the work of López to explore the limit of filmic depiction established in the European art film. Together then, López and Erice match the contingency of the film shoot with the constraint of academic painting and produce not, as one might expect, a moribund documentary about an apparently conservative artist, but an ambitious and probing meta-film that tests the limits of documentary. *Dream of Light* combines actuality with a complex mise-en-scène, a lengthy and meticulous editing process, and a carefully designed sound track. The result is more a philosophical work of art than a form of documentation; less a record of a painter at work than a self-conscious proposition about film's relation to painting and to life.

A contrast with Erice's earlier, philosophically ambitious *El espíritu de la colmena/The Spirit of the Beehive* (1973) indicates that Erice has turned to the "painter documentary"—an inherently theoretical genre—as a way of addressing the state of cinema in the late twentieth century, at the very moment when the film image succumbs to a new logic of the digital. The treatment of space and time in *Spirit of the Beehive* is strongly reminiscent of Antonioni: slow, pensive, and philosophically ambitious; the exemplary "time-image" art film that Gilles Deleuze distinguishes from the "movement image." For Deleuze, the post-World War II art film disrupts the spatiotemporal order, sustained by rules of causal logic and continuity, of the dominant Hollywood product. Time measured by and reduced to movement—the standard narrative mode—gives way to a more complex order in which filmic duration begets contemplation. Deleuze's two volumes are both philosophical and historical: the shift from movement-image to time-image is a response to historical circumstance: war, dislocation, ruin, grief.[2] In *Dream of Light* Erice has identified the treatment of temporal duration proposed by Antonioni and pushes it to a logical conclusion—only to discover that in film history there is no conclusion, only a perpetually shifting plastic material and a vexed temporality.[3] López may be nostalgic for a childhood vision of quinces in Tomelloso; but Erice is nostalgic for earlier manifestations of the filmic—for the pictorial weight of silent film—and for Neorealism, a cinema that promised a poetics of directness. Erice knowingly and self-consciously posits the painter documentary as a film-theoretical site, the place where the postwar European art cinema finds itself in the mirror of painting, and he reaches, in *Cahiers* critic Tristan de Lajarte's incisive estimate, an apotheosis of concentration—film's "ultimate possibility" (Lajarte, 1993, 112).

Dream of Light operates within the axes of time and ontic presence: the seasonal life cycle of the quince tree prompts a meditation on being,

and on film's treatment of being. Time here is multifaceted: historical, memorial, durational, cyclical. The overt citation of Dovzhenko's *Earth* in the close treatment of fruit on the tree suggests agricultural time, that is, pre-filmic, pre-industrial time in which each season gives way to the next in a benign cycle. The painter retreats to his garden to escape the violent displacements of modernity: the train and airplane that are film's modern siblings. Temporality intersects with ontic presence—the root factuality of being itself—when the human subject is faced with his or her own mortality, which is experienced as the dissipation of presence, now understood as finite and fugitive, into memory. López and Erice suggest that the painting process provides experiential abundance for the artist, but falls short as philosophy. For Erice, film faces no such limitation; he seems envious of the simplicity and directness of the painter's relation to nature. Erice wants a cinema without its attendant industrial baggage, a simple cinema of direct witness whose "images have a real identity ... something that is truthful."[4]

The shape of duration

In Picasso's cubism time, when allowed into the figurative equation, leads to distortion, the breaking of monocular perspective, as stasis gives way to visual itinerary. Erice proposes a further elaboration of the cubist engagement of time with the pictorial, but to such an ambitious degree that he rejects cubist style. Here the monocularity of the camera eye is retained; displacement is rigidly denied by the painter (whose nails and grids make a great show of constraint) and distortion is forbidden. Yet time passes, the painter paints within these spatial constraints, and the effect of time on the motif must be accounted for no less rigorously than in Picasso's or Braque's earliest cubist works. This is not simply time then but duration, the sense of time as it relates to experience, and also the sense of presence provided by contemplation; it is barely measurable, manifested not in figure-against-ground displacement but in qualities better understood by archaeologists: dust, oxidation, fading. *Dream of Light* suggests that duration exceeds the capacities of painting, that we are in a conceptual territory that painting can only fully explore with the prosthetic and finally redemptive supplement of film.

The quince tree is film's foil and counterpart. To the naked eye, a film seems to be moving, yet proves on closer inspection to be made up of static images; a tree is static to the naked eye, and proves on more patient inspection to be growing and moving. López, whose pictures routinely take years to complete, starts to paint his backyard quince

tree in oils, concerned to capture the leaves in early morning sunlight. He discovers as the months go by that the tree is moving and changing size and shape, the quinces get larger and heavier and so the boughs droop, the spreading leaves hide the quinces. López has positioned the tree too high on the canvas, and wants to drop the horizon line by five or six centimeters which necessitates starting again from scratch, painting over the original. This is one of many moments in the film where López's method as an artist can be read as a *figure* of the filmic: here is what Pascal Bonitzer has called *décadrage*, or re-framing—with a hint of *décalage* or articulate discrepancy. All López really wants to do is tilt the camera of his eye upwards, pulling into the frame the off-screen space that is at present hidden, above the tree.[5] This is much easier done for the filmmaker than for the painter. For the viewer, as for López's friend and fellow artist Enrique Gran, the prospect of starting again seems "cruel," a temporal cruelty, the cruelty of boredom and repetition; but for López it also provides the final painted image with a palimpsestic layering, what the painter calls "the bed," a trace presence that remains part of the finished art work. Erice provides this resonant articulation in brief moments of overlap dissolve, but usually the physical investment of artistic labor is wasted in film, whose images are more easily captured by the robotic eye of the camera. Finally López abandons the unfinished canvas, taking it down to his basement storeroom, and begins once more on a new surface in pencil. Still no luck: the problem is not the medium, but the artist's own pace of work, which is laboriously slow and painstaking (pencil is potentially faster than oil, since it has no drying time, but it is schematic in comparison with paint's fullness, and fullness is precisely the valued quality of both painter and filmmaker).

López claims that his task is to paint the fleeting moment of autumn sunlight as it falls on the quince tree, but the temporal disjuncture between object and its representation on canvas is common to much of this painter's work. He wants to do more than capture an instant; he wants to capture a particular time of year, called in Spain "the sun of the quince tree"(*el sol del membrillo*)—a time of seasonal change for trees, but metaphorically a time of reflection for those entering life's autumn.

Film is the final medium of choice; painting *gives way to film*—as if in some natural cycle—and the quince tree project ends with the fallen and now rotting quinces filmed in time-lapse (Figure 8.1). This is not a nature documentary: we do not see time-lapse footage of a quince devoured by bugs and bacteria.[6] The point for Erice is aesthetic and conceptual, having to do with film's capacities as a medium. Here the

Figure 8.1 Dream of Light (1992), by Victor Erice (Film still)

integrity of the pro-filmic is replaced by a new integrity of the filmic in *truquage*: our attention turns away from the garden in Madrid and onto the surface of the film itself, its objecthood.

In the closing sequence, after López has removed the easel and taken down his frames of reference, returning the tree from mise-en-scène to nature, a reversal of roles occurs. López now becomes the model for his wife, the painter Maria Moreno, and he drifts into a reverie about his childhood. Now the image of the quinces is accompanied by the lyrical cello score of Pascal Gaigne and a voice-over of the artist relating a childhood recollection of a quince tree in Tomelloso. Presented initially as a sort of still-life motif, the tree is finally revealed as a fetish of memory—precisely that which lies outside the phenomenological bracket—a trigger of nostalgic reverie for a man reaching midlife.

Dream of Light mixes video and cinematography with painting and drawing, but forcefully places what seem to be conservative painterly methods in the context of electronic media to create a new vision of the real at the very boundary between Gilles Deleuze's movement-image and time-image. Erice posits the process of painting as the logical apotheosis

of the time-image (the dominant mode of the film) and contrasts this with the sonic counterpart of the movement-image in which sensory–motor links are restored (the world outside the garden, which continues to operate according to the dominant spatiotemporal order of mainstream cinema). The analogy with Deleuze's thesis is especially clear in Francisco Serraller's comment on "the absence [in López] of gestural leanings, which, evocative of temporality, never attracted him in spite of his fundamental artistic concern with time."[7] This may seem paradoxical, but Deleuze provides a precise account of a filmic temporality in post-World War II film in which time is *not* measured in gestural movement. As López paints from life in his own garden, he is constantly bombarded with the off-screen sounds of jet planes landing, or information on the radio about terrorism, about the first Gulf War, and about the collapse of the Soviet Bloc. While the soundtrack records movement as a foil to the image track's contemplative stasis, the image track also tests the limits of Deleuze's wholesale division of cinema's spatiotemporal order into two modes. As López's marks on the leaves and quinces attest, the tree's boughs *do* move and the film witnesses this movement. The passage of time (eight months) is measured by this movement, so it is also (logically) the limit degree of the movement-image; really the point at which Deleuze's categories dissolve.

A subtext of the film's treatment of distended time is the ratio between physical art events (daubs applied, lines drawn) and artworks produced. López seems to be sufficiently wealthy that he can engage in a slow enterprise without immediate financial reward. The Polish workers who are remodeling his house note that if the sand doesn't arrive soon for their plastering (a notably time sensitive activity, done against the clock), they will be "out of pocket"—a condition that subjects their work to the demands of capitalist productivity, with measurable results (holes are filled, walls are plastered, construction projects follow the classic narrative line). Conversely, López produces an art object with no apparent closure, no apparent marketability, whose value comes closer to that of a sacred artifact, and whose purpose is philosophical, if not overtly religious. The movement-image outside the garden (more heard than seen), that world in which, as Raúl Ruiz has noted, decisions made are *immediately acted upon*, is associated with capitalist (Hollywood) film production.[8] Consistent with this condition of López's painting is the almost hidden fact about the film: that it was made on a shoestring, and nearly not made at all. This poverty of means again allies the film to Neorealism: back in 1953 Zavattini specifically noted that the cinema "has not yet found its morality, its necessity, its

quality, precisely because it costs too much."[9] In this respect *Dream of Light* has no worry: it would be hard to imagine a more humble and moral subject than a man, in a garden, painting a tree. The project was not only proposed by Maria Moreno (López acknowledges this over tea in the garden with his children), but also financed by her. Moreno then is a presence of the producer in the text, rather like Jack Palance in Godard's *Contempt* (1963); only here she is a benign source of both the idea and the means, and the answer to this nagging question about the possibility of closing out the demands of productivity (generating artistic product, as in Warhol's studio-as-factory) and allowing López to indulge himself in the luxury of free time.

It is Moreno, not López, who asks the workers how the construction work is progressing; and it is Gran, not López, who comments on the high cost of paint. And while the time-image world of López is sequestered, governed by the duration of the tree's fruition, the Polish workers are bound by the time–work ratio of the city outside. The ethos of productivity under which they labor is that which also determines the time–event ratio of mainstream cinema. The complex relation between the scarcely productive López and the painter-spouse-producer Moreno emphasizes the peculiar unpopularity of film's poetic mode and its need for patronage; rather as Theo van Gogh sustained Vincent.

Another film about a painter, Jacques Rivette's fictional *La belle noiseuse* (1992), has been taken up by Thomas Elsaesser as a commentary on the "end of cinema" (a phrase left deliberately ambiguous, since "end" means both historical closure and purpose or goal).[10] *Dream of Light* deals with the same subject precisely. Erice forces cinema back to its place in the history of art, pits it against painting, and in the process marks out the limits of the new digital images as substantive when it comes to image status (the sternest critic must acknowledge in them a graphic value), but mute on the issue of time as, unlike documentary images, they are not the vestigial traces of a lived history. The film image is redeemed here not by its photographic indexicality and guarantee of substance (this is the source of the crisis, in the likes of *Forrest Gump* (1994), which seamlessly integrates Tom Hanks and John F. Kennedy), but by its *temporal indexicality*, which has the textual quality of a poetics of film, or a musicality, rather than an aura of otherness-made-present via celluloid. The spectatorial experience of filmic time is its own reward; it is not a copy of *other* time. This temporality (really, as Erice has acknowledged of his editing, a kind of musicality, a linear form, a rhythm) is film's claim to theatrical objecthood. López is also painting the tree specifically *for* Erice's film, whose scope is temporal

and processual, as if mapping the shifting silt of a river delta, or the constantly wind-blown dunes of a desert. The film finally achieves a wisdom about the brevity and fragility of life, in which the memory of childhood experience and the anticipation of mortality are constant and intermingled conditions of present experience.

Ontic integrity: painting and the film image

For a true measure of the status of the film image in the age of the digital *nouvelles images*, we must turn away from the cinema's drama and enter the world of the painter, the theorist of the image par excellence. Thomas Elsaesser speaks of the debate

> about the material, linguistic and psychic support of the cinema—all driven by the fact that the photographic image could no longer be taken as the medium's self-evident basis, thereby doing away with any analogical relation between reality and the image. It is against this background that in a fundamental sense, painting could become a metaphor for the cinema (as the medium associated with the history of the photographic image) in contrast with the electronic or digital image.[11]

Classic documentary films like *Man of Aran* or *Industrial Britain* might eventually have the status and the marginal appeal of brass rubbings, or the death masks of great figures in history, but they already have, in contrast with computer-generated fiction, the image status of fine painting. It is precisely the integrity (*integro*) of such images that Lopez is trained to bring to his pictures and that Erice wants for film; a fullness that is not *plenitud*, but a steadfast truth to nature.[12]

As Pedro Almodóvar embraces television and the world of ubiquitous media flow, Erice re-thinks the art film in the context of image ontology, which in snapshot photography can be an issue of indexicality, but in film must intersect with duration. *Dream of Light* emerges not as an apologetic for a conservative, academically trained painter but as the other side of the digital coin, addressing head-on, via painting, film's image crisis that the digital age has ushered in. Erice reviews Rossellini's realist project at the moment it might seem to dissipate into so many pixels. The digital threatens film of the neorealist tradition by valorizing computergenerated plasticity over indexical witness, graphic fiction over "reality." This ontological threat is compounded by the experience of film history, which shows that technological possibility

ofte determines the character of the film medium and the substance of
film irt (we have sync sound because we *can* have sync sound), rather
tha academic or classical rectitude. Erice already laments the passing
of s nt cinema, and he now resists the dominant, industrial model of
film ntertainment. But he is not unique; numerous contemporary cin-
east have turned to painting as a means of addressing this upheaval
for e photographic image, including Godard, Rivette, Jarman, Altman,
Roh ier, and Pialat.[13]

A *La belle noiseuse* suggests, making a film about a painter is much
clos to theatrical rehearsal than painting-as-image. In *Poetics of Cinema*,
Raú Ruiz describes such a condition in film. Deriding the "central
con ct theory" that governs Hollywood narrative, Ruiz argues that in
film iewing, "boredom" (which is, of course, anathema to Hollywood
dire ors like George Lucas, Steven Spielberg, and James Cameron) might
be ' good thing." For Ruiz, the boredom of a viewer faced with long,
con mplative, un-distracting, un-entertaining films, like those of Rivette
or t s one by Erice, produces in the film "an ontological weight."[14] Ruiz
talk specifically about "Saint Gregory's paradox," which

c curs when the soul is both at rest and yet turns on itself like a
c :lone around its eye, while events in the past and the future van-
i in the distance. If I propose this modest defense of ennui, it is
ŗ rhaps because the films I am interested in can sometimes provoke
t s sort of boredom. Those who have seen films by Michael Snow,
(u, or Tarkovsky will know what I mean. The same goes for Andy
\ rhol, or Jean-Marie Straub and Danièle Huillet.[15]

Rui: chosen films propose a temporality that makes the necessary
con ntration on a detail, the struggle with an oblique line or phrase,
intc ı kind of enhanced presence: poetic reading, in which the intel-
lect restles with the possibilities of meaning in the text, is itself the
artv rk's chief reward. Whether film, poem, or modern novel, the art-
wor s strategy is to enhance *its own reality as a text*, which is to say, as an
obj t-site of hermeneutic engagement. Erice's earlier films certainly fit
this oetic model; but *Dream of Light* might be seen as an essay on this
very ondition: on the value of a cinema that foregoes the easy rewards
of e tertainment, addressing instead the difficulty and the rewards of
the oetic—or, to put it in Bazin's and Zavattini's terms, a cinema that
forε es the visually entertaining pleasures of *geography*, to extol the
stre iously excavated rewards of *geology*. This is what Erice has called a
"cir ma of resistance," one that "resists the dominant models."[16]

The portrayal of the tree ignores history (the kind of monumental history that, as it occurs, is called "current affairs"), which belongs to the soundtrack, punctuated as it is by event-driven news reports that reduce time to sound/image units that finally qualify as "history." The soundtrack also offers us a measure of the artifice in a film that purports to be documentary. Erice has acknowledged the importance of an extended editing period, in which he manipulated the footage for aesthetic ends, but Hasumi Shigehiko has also pointed out that what we hear is not brute document:

> Erice explains that the painter always comes out into the courtyard with a portable radio in his hands, and that he almost always paints while listening to classical music on the radio. Because of recording limitations, the director was unable to use the soundtrack that he recorded as he filmed For radio and television, Erice hired the same announcers who would have actually appeared on the air on the days in question, and had them record appropriate audio portions for those days in the film studio.[17]

It is not clear what these "recording limitations" are (copyright, or sound quality?), but this passage reveals the degree of design that goes into the film's sound environment. These soundtrack events, the nuts and bolts of Ruiz's "central conflict theory," offer the kind of linear "movement-image" causal narration we expect of Hollywood films; but López—too busy being bored, so to speak—ignores them. Erice borrows these news events as a temporal armature on which to hang his images; but they also provide an ironic contrast to the project of painting the tree, telling of things that the Hollywood film would find more important than painting.

The digital image is disembodied and can, in principle, proliferate. Whether or not it does proliferate is not really at stake—the problem is that with its free, limitless paint applied by an indifferent robot, it has no anchor in the prior-real, and is therefore a threat to the cineaste's investment in truthful anteriority. Erice chooses the painter documentary because it is required by its subject matter to register the relation between the artist's body and the image produced; it is a forceful reply to digital entertainment. If, in Elsaesser's formulation, painting can be read as a metaphor for cinema, the many fictional painter films that appear in the 80s and 90s, such as *La belle noiseuse*, *Caravaggio*, *Love is the Devil*, or *Vincent and Theo*, are metaphors of the global cultural institution called cinema, which propagates predominantly fictional

films—seamless, conventional narratives. Conversely, documentaries on painters, insofar as they truncate fictional elaborations of the pictorial, are metaphors not of cinema, but more precisely of the *filmic* representational mechanism at the heart of the cinematic institution.

In the early 90s when *Dream of Light* appears, the filmic faces an image crisis brought about by the reduction of the pictorial to binary code, and the illusionist manipulation of that code. The tendency of the digital film picture is toward a logic of the eternally present *same*, replacing the analog image's logic of the eternally anterior and spatially constrained *other*—an other which the photograph re-presents; a location and an existence beyond and prior to the representation. The digital character Buzz Lightyear, from *Toy Story* (1995), is a convenient example: he is the *referent*, and the copy we buy at a toy store is the *sign*—a reversal of the photographic order caused by the over-determination of computer modeling that does away with Bazin's already contentious notion of a stable referent of which the photograph is a trace and guarantee. According to Bazin's photographic ontology that has long governed the valorization of documentary cinema, there is always an anterior other of which the photograph is an index.

Despite Erice's alignment with the Neorealist and New Wave tradition, the new digital episteme surfaces unexpectedly here in the painter's method like an extended para-praxis. The digital image, to the extent that it is digital, does not ask us to consider it as a representation of an *other*, but to accept its unity with itself. It is this logic of *sameness* that governs Antonio López's rather uncanny marking of the quince tree with paint. (Figure 8.2). The painter here looks like a case study from neurologist Oliver Sacks in *The Man Who Mistook His Wife for a Hat*: a patient who, if asked to "paint a tree," would not represent the tree on canvas, but reach out to cover the tree itself with paint. It's as if he had missed the point because of some neural wiring problem, a problem not of creative function but of dislocated logic. But it is precisely this confusion between the tree *as same* (López marks the leaves and quinces with white paint) and *as other* (he also represents them in paint on canvas) that makes the initial gesture such an eloquent drama of the new digital conditions in which *representation* has given way to *generation*.

The reductive nature of the digital logic is not entirely new to film; the matte shot in Hollywood that incorporates a glass painting already replaces the referent with the prefabricated sign; but the digital image that paints film in the 80s takes this practice to a new pixelated reduction in which three-dimensional modeling, not simply two-dimensional painting, is put into movement by computational power.

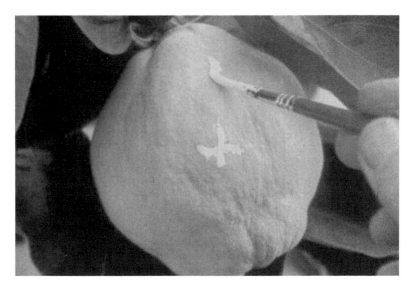

Figure 8.2 Dream of Light (1992), by Victor Erice (film still)

The novelty supplied to film by the digital is the mixture of illusionistic three-dimensional modeling and movement; but it also takes to an unprecedented degree the photograph's reification of the world: the computer-generated image stops dead the romance of alterity (the heart of cinephilia) that the analogical has always promised.

The digital is not announced in Erice's film, but in its dogged pre-occupation with the status of the film image, *Dream of Light* exhibits symptoms of the digital revolution—stressing image at the expense of story—at the very moment that the CGI's new look has appeared in cinema. The daubing of the quince tree is not the only moment of logical dislocation redolent of the new digital circumstance for the image: when, at the close of the film, Antonio López himself becomes a model for Maria Moreno, and we see a sort of *trompe l'oeil* shot where she seems to be daubing him (not his life-sized portrait) with paint, we are brought to an abrupt realization of the mirroring of film in painterly realism. Again the old order, in which there is a comfortable gap between motif and representation, model and painting, is here short-circuited: the model is confused with its representation; the other becomes the same.

Merleau-Ponty speaks of Cézanne's "schizothymia" as "the reduction of the world to the totality of frozen appearances and the suspension

of expressive values." In contrast with the Hollywood mainstream film, the postwar European art film itself (of which Chris Marker's *La Jetée* is an extreme case) leans to the schizothymic, returning film's mere movement (Lumière's sufficiency of delight) to frozen Muybridgean stasis. Mainstream cinema associated with Hollywood is all expressive value; it relishes the drama of a chase and the narrative possibilities of montage, but seldom pauses to dwell on the status of the image.[18] Merleau-Ponty's claim in "Eye and Mind" that "only the painter is entitled to look at everything without being obliged to appraise what he sees" is dramatized by López, whose concentration only on the appearances of the tree excludes any expectation of pruning it, eating its fruit, or even collecting the fallen fruit for jam.[19] Merleau-Ponty's elaboration of this claim for the painter's special status extends to the political realm:

> incontestably sovereign in his rumination of the world, possessed of no other "technique" than the skill his eyes and hands discover in seeing and painting, he gives himself entirely to drawing from the world—with its din of history's glories and scandals—canvases, which will hardly add to the angers or the hopes of humanity; and no one complains.[20]

For Merleau-Ponty as for Erice, the glories and scandals of history are specifically associated with sound; and the "din" to which the painter, focused on the image, remains scarcely aware, threatens to corrupt the silent, contemplative realm of the purely visual. But lest we complain that López is oblivious to the Gulf War, to the collapse of the USSR, or to the trial of terrorists, we should acknowledge that, while painting, he chooses to listen to the radio, which keeps him engaged in the world, but which also limits his sovereignty to the sheltered precincts of his own garden. The radio is the present age; it marks the difference between López and Cézanne, alone before his mountain, or Van Gogh, alone in the fields of France. López devotes himself to the life of the tree despite history's din, perhaps in defiance, as if to construct a shelter of peace and contemplation in a storm of political urgency.

The nostalgic quality of the film, especially strong when Enrique and Antonio reminisce about their youth as art students, and which governs our retrospective reflection upon the film as having been, all along, a song of remembrance, also reminds us of Merleau-Ponty's comment on Cézanne that "[o]nly one emotion is possible for this painter—the feeling of strangeness—and only one lyricism—that of the continual rebirth of existence."[21] This rebirth, for Cézanne a condition of perception

itself, and which introduces equivocation into perception, has for López and Erice an extended and metaphysical value that is promised in the closing shots, as the new downy quinces emerge in the warm spring sunlight. Our death, it implies, is no more final than that of new fruit, which is seen as part of an ever-continuing cycle of life.

Notes

1. As a mode of description, *ekphrasis* provides film—especially documentary film—with a long pre-history; but it also provides a historical context for the treatment by any camera of the pro-filmic object, the semiotic referent, or the painter's motif. Notable literary examples include Keats' *Ode on a Grecian Urn*, in which the art of the poem describes a work of ceramic art; and Homer's elaborate description in the *Iliad* of a shield made by Hephaistos and given to Achilles.
2. The opening shots of Rossellini's *Germany, Year Zero*, which take us through the bombed ruins of Berlin, are exemplary. (*Cinema 2: The Time-Image*, xi) For Deleuze, such ruins were once the site of action: here the passage of time was reduced to the terms of movement; but now they are empty, and their empty and static temporality weighs heavily for having once been full of action. While Hollywood's reduction of time to narrative causality is in some respects a cliché, Deleuze finds in Hitchcock a singular exception (*Cinema 1: The Movement-Image*, 200–205). In particular the problematic temporality of *Vertigo* tests the limits of Hollywood's insistence upon story at the expense of depiction.
3. The issue of plasticity, or film's materiality, is explored in depth by the Soviet theorist Vsevolod Pudovkin, whose essay "The Plastic Material" (1929) promotes the principle that the work of film is done less in the studio or on location than at the editing table, by manipulating celluloid (or now by manipulating digital information). The notion of plasticity, still alive in Tarkovsky's term "sculpting in time," is especially appealing in the era of silent film; but the many historical shifts, to talking pictures, widescreen, television, video tape, and now to digital film, all militate against a materialist essentialism for "film." A decade and more after *Dream of Light*, film scholars have responded to the advent of the digital with theoretical work; but the digital is not solely understood as a problematic of indexical plasticity or image veracity. While D. N. Rodowick in *The Virtual Life of Film* (2007) begins with a consideration of medium specificity, on the reasonable assumption that the film medium has shifted from light-sensitive emulsion to binary code, he soon turns his attention to the digital image's new relation to anterior alterity and an "ethics of time" (73–87). Mary Ann Doane, in *The Emergence of Cinematic Time* (2002) (1–32) and Philip Rosen in *Change Mummified* (2001) (301–49) move directly to the problem of temporality; as if, responding to the new digital image, they must re-think film's basic definition by first returning to the primitive moment. And when Erice invokes the language of silent cinema, it is safe to say that he is thinking less of Chaplin than of Dovzhenko, or even Marey's earliest inquiries into filmic movement *tout court*.

4. "An Interview with Victor Erice," in *An Open Window*, ed. L. C. Ehrlich (2000) (p. 44).
5. P. Bonitzer, *Peinture et cinéma: Décadrages* (Paris: Cahiers du cinéma/Editions de l'Etoile, 1987).
6. We find precisely this treatment of painting's temporality in Peter Greenaway's *A Zed and Two Noughts* (1985), which juxtaposes the Attenborough natural history documentary with Vermeer.
7. F. Calvo Serraller, "Enlightened Reality: The Paintings and Drawings of Anonio López Garcia," in *Antonio López García*, eds M. Brenson, F. Calvo Serraller and E. J. Sullivan (New York: Rizzoli, 1990, p. 34).
8. This is the cinema capitalism that Jean-Luc Godard repeatedly decries at the heart of film art, and which he first explores with the sharp satire *Contempt* (1963). Art is at odds with profit motive; but in film, capital is integral to creativity, a paradox that remains unresolved by the plot and lingers throughout Godard's subsequent attempts to match art and ethics. Raúl Ruiz begins his *Poetics of Cinema* with a personal account of his struggle with the "central conflict theory" of films that arrived in Chile from the United States. Why must any successful film conform to this narrative straitjacket? Indeed, Ruiz's own film, *The Hypothesis of the Stolen Painting*, proposes a different mode of filmmaking altogether.
9. Zavattini, 224.
10. "Rivette and the end of cinema," *Sight and Sound* 1:12 (April 1992), 20–23.
11. Elsaesser, 22.
12. Both *integro* and *plenitud* are translated in the subtitles as "fullness," but the distinction really poses a cinematographic question: is it possible to produce a film image with the *ethical* integrity implicit in the patient treatment of the quince by the painter? Can a film image match, Erice wonders, the existentialist work implicit in López's treatment of the tree?
13. Among these films are Godard's *Passion* (1982); Rivette's *La belle noiseuse* (1991); Jarman's *Caravaggio* (1986); Altman's *Vincent and Theo* (1990); Rohmer's *Les quatre aventures de Reinette et Mirabelle* (1987) and *Les rendez-vous de Paris* (1995); and Pialat's *Van Gogh* (1991).
14. R. Ruiz, *Poetics of Cinema* (Paris: Editions Dis/Voir, 1995, vol. I) (p. 13).
15. Ruiz, 13.
16. Ehrlich, 2000, 43.
17. Hasumi Shigehiko, "From Vélazquez's Mirror to *Dream of Light*," in Ehrlich, 2000, 230.
18. "Cézanne's Doubt," in Johnson, 71.
19. "Eye and Mind," in Johnson, 123.
20. "Eye and Mind," in Johnson, 123.
21. "Cézanne's Doubt," in Johnson, 68.

References

A. Bazin, "The Ontology of the Photographic Image." in *What is Cinema?* Trans. H. Gray (Berkeley, VA/Los Angeles, CA: University of California Press, 1971).
P. Bonitzer, *Décadrages: Peinture et Cinéma* (Paris: Editions de l'Etoile/Cahiers du cinema) (1985).

F. Calvo Seraller, "Enlightened Reality: The Paintings and Drawings of Antonio López-García," in *Antonio López-García*, eds M. Brenson, F. Calvo Serraller and E. J. Sullivan (New York: Rizzoli, 1990, p. 34).

G. Deleuze, *Cinema 1: The Movement-Image*, trans. H. Tomlinson and B. Habberjam (Minneapolis, MN: University of Minnesota Press, 1991).

G. Deleuze, *Cinema 2: The Time-Image*, trans. H. Tomlinson and R. Galeta (Minneapolis, MN: University of Minnesota Press, 1991).

M. A. Doane, *The Emergence of Cinematic Time: Modernity, Contingency, the Archive.* (Cambridge, MA: Harvard University Press, 2002).

L. C. Ehrlich, "Interior Gardens: Victor Erice's *Dream of Light* and the "Bodegón" Tradition," *Cinema Journal* 34:2 (1995), 22–36.

L. C. Ehrlich, *An Open Window: The Cinema of Victor Erice* (Lanham, MD: Scarecrow Press, 2000).

T. Elsaesser, "Rivette and the End of Cinema," *Sight and Sound* 1:12 (April 92), 20–23.

G. A. Johnson, *The Merleau-Ponty Aesthetics Reader* (Evanston, IL: Northwestern University Press, 1993).

T. de Lajarte, "Cherchez les fruits," *Cahiers du cinéma*, 467: 8 (1993).

V. I. Pudovkin, *Film Technique and Film Acting*. Memorial Edition. Trans. and ed. I. Montagu (New York: Grove Press, 1970).

D. N. Rodowick, *The Virtual Life of Film* (Cambridge, MA: Harvard University Press, 2007).

P. Rosen, *Change Mummified: Cinema, Historicity, Theory* (Minneapolis, MN: University of Minnesota Press, 2001).

R. Ruiz, *Poetics of Cinema* (Paris: Editions Dis/Voir, 1995, vol. 1).

C. Zavattini, "Some Ideas on the Cinema," in *Film: A Montage of Theories* (1953), ed. R. D. MacCann (New York: Dutton, 1966, pp. 216–28).

Part III
Visual Studies, Art History, Film

9
Of the Face, In Reticence

Noa Steimatsky

> Are you framing her head or her elbow? Or purposely
> not framing? That would be the best. See what
> I mean—If you get her head, the framing is bad. Make
> it half her head and half her hand.
> —Robert Bresson[1]

> There is a *work* of the negative in the image, a "dark"
> efficacy that, so to speak, eats away at the visible (the
> order of represented appearances) and murders the
> legible (the order of signifying configurations).
> —Georges Didi-Huberman[2]

Not only the face *in* the image, and not only the face as itself *already*
an image, but the *image as face* beckons. And as one considers the face
as medium for thinking *in* and *through* the cinema, one must contend
with the image as such. Privileged object of representation, imprint of
identity, figure of subjectivity, the face is also a mode and an ethic of
address.[3] In response, one navigates between the obvious, at times so
obvious as to be overlooked, and the marginal, at times so marginal as
to present a constant but low horizon, a primal ground, hard to retrace
without a deliberate lunge. One special perspective has propelled for
me such layered aspects of the face, and of the look upon the face.
I had come upon a recent study that establishes a physiological basis,
demonstrated in magnetic resonance brain imaging (MRI), for what has
long been noted in clinical observation: that unlike healthy children,
autistic children see and respond to the human face—including that of
their own mother—in a way no different from their perception of other
objects. At the same time another category of objects might become a

159

privileged focus, subject to the kind of attention, that innate "expertise," that is normally accorded to faces. The terms invoked in this study—the human face, the mother's face, the face versus other objects, visual salience—presented striking correlations to the basic terms that had drawn me to consider the face on film in the first place.[4] Thinking with these terms especially on certain work of Hitchcock, Warhol, and Bresson, I have begun to consider that the leveling of the face with other objects might serve to re-focalize considerations somewhat outside the orbit of expressive plenitude analyzed in such seminal work as Jacques Aumont's *Du Visage au cinéma*[5]—that it might unravel something in the image not quite contained by the paradigms of narrative and attraction as prime cinematic dispositions.

The notion of an autistic gaze as model might serve to explore—even if by negation—the ways in which the face stands out in the visual field, the ways in which its supreme visuality also takes the image to points of crisis and blockage. More specifically, it serves to reflect on habits that the cinema, like other image systems, has cultivated to mediate anthro-pomorphic hierarchies, to synthesize expression and focalize subjectivity *in* the visual, and to consider what remains—or what emerges—when that mode is blocked. Autism presented a distinct, anomalous, but internally coherent system defined against ordinary perceptual experi-ence as against conventional systems of representation; in this, autism also reflects back upon these systems. Its visual economy—with the characteristic avoidance of the face and withdrawal of the look as key parameters—might be defined precisely against cinema's more familiar investment in the visual repertoire of unfolding psychic states.

In its exploration of the time-based image, cinema seems almost inherently constituted,—largely in conjunction with the close-up,—as machinery to exploit the expressive and projective powers of the human countenance. Yet certain work, like so much of Robert Bresson's, posits a radical challenge to this principle. Bresson's modes of composition,— visual and poetic rhetoric,—his framing and editing, the organization of movement and temporality, and certainly his notorious direction of the actor/model,—all seem poised to harness or deny expression, to withdraw the potentialities of the face in a move so drastic as to evoke a strangely vivid relation to autism. This is evidently *not* to put the filmmaker, or any of his characters (asocial, psychotic, or suicidal as they might be), on the psychiatric couch, but to read autism in the constitution of a cinematic system and consider its visual disposition and its broader implications. And as autism informs, in fact, the study of childhood and perceptual development generally, so the austere

work of a filmmaker deeply ambivalent about cinema's basic means of articulation might inform our understanding of counterforces, a "work of the negative"[6] operating in the image at large. Importantly, these negative powers are drawn against a foil of narrative cinema, not in the metaphorical juxtaposition of fragments or an altogether abstract film. For it is thus that such negativity oscillates productively with the continued weight of the figural, and serves to advance exploration of human agency, and the human countenance itself, though its powers might now be mediated in another order.[7]

In his critique of the pitfalls of conventional "communicativeness,"—most explicitly the fallacy of the expressive actor,—Bresson lays bare the habits that the cinema has cultivated to focalize and mediate anthropomorphic hierarchies, to fuse image with subjectivity and interiority. His narrowing down, decentering, and de-framing of the visual field tears the human countenance from emotional syntheses and the symbolic repertoires it has inherited from other mediums. The opaque face (or face-to-face) and the displaced or withdrawn glance prevail in his work, affecting both the work of his models (as he calls his actors, beautiful as they invariably are) and his camera and editing work. His shots are obstinately composed and paced to level persons, objects, and spaces; they raise barriers everywhere between things, or else drain them in a flat, opaque field, wherein the face is displaced as measure and medium of address.

But what, and how, are we to learn from a world of psychic illness, considered primarily in childhood pathology?[8] Vestiges of autism are also considered in the root of normal development, as in primal phases preceding the differentiation of perceptions and senses, of self from world, instantiated in the taste-smell-contact-sight continuum of the infant at its mother's breast. When differentiation does come about it may be nothing less than the "heart-break at the centre of human existence."[9] In the pathological form of autism, it might be said to recur over and over again. In such terms British psychoanalyst Frances Tustin—working in the footsteps of Melanie Klein and D. W. Winnicott—described autistic experience and perception in studies from the early 1960s to the 1980s. She suggests that a measure of poetic response may elicit coherence from the undifferentiated, forbidding totality of autistic phenomena, and yield insight to its terror and its pathos. For such psychotic material as the therapist encounters involves nonintegrated "primitive stuff" in the leveling of interior and outside objects, human and inanimate, body parts, words, sounds, textures, feelings, and material things all experienced indiscriminately, and devastating emotional and social response.[10]

I re-sort in four broad, mutually dependent categories features of
autistic perception drawing largely (though not exclusively) on Tustin's
case histories and her operative figures. It will become apparent how
such classification could serve to reflect on the cinema, and perhaps on
a disposition of the image even more broadly conceived.

Facial reticence/evasion of eye contact

> Stephen shows many of the features which are typical of autistic
> children. There is the avoidance of direct eye-to-eye contact … .
> He does not cooperate but cuts himself off from me. He leaves his
> mother without a backward glance and shows none of the normal
> responses to people. Physically, he is well formed and his face would
> be attractive were it not so expressionless … . I call autistic children
> "shell-type" or encapsulated children … . Such children are often
> thought to be deaf and some even try to walk through objects as if
> they were blind.[11]
>
> Autistic children do not look directly at people, but take in a
> great deal by peripheral vision. This over-developed fringe aware-
> ness means that fringe shapes are formed which can never be clearly
> focused and which constantly elude the children … . Such peripheral
> shapes also impede the attachment to the mother, which is fostered
> by looking at her face, especially at her eyes.[12]

This most pervasive trait we recognize, in milder forms, also in nor-
mal everyday contexts. Combined with lack of facial expression, the
averted look implies the avoidance of face-to-face reciprocity as a basis
of social interaction. In this category we find inseparable, then, the face
and the look as bound up under a principle of *facing*. Not the look or
gaze as disembodied extraction, but as supported by a *surface* which
the look activates as prime visual, specular medium of address and of
being addressed. I approach here in the negative mode of reticence. The
autistic child's withdrawal is embedded in the lack of facial expression,
in turning away, in averting one's eyes and oneself from the look of
others. The pathological avoidance of address effects that self-absorbed,
self-centered impression that gives autism its name—yet the autistic
child has little that can be called a "self." His or her withdrawal or
reticence is predicated on diffusion of a subject warding off an acute
experience of separateness, isolation, and vacuity.[13]

The term "reticence" does not figure in the sources on autism con-
sulted here, but is designed to give them a rhetorical turn. In Classical

rhetoric *reticentia* is a figure of interruption: the breaking off or falling silent in the middle of speaking, as if unable or unwilling to confront something which it is impossible to express.[14] A reluctance to tell or show more than bare fragments, themselves figures of ellipsis; disjointed, peripheral glimpses; reticence as discursive mode that matches a rhetoric of the face and of the look, all place us in the court of Bresson. It is not a neglect of the visual:—a misjudgment by some critics that Bresson is not a director of the image.[15] I posit reticence as an assertive rhetoric of the image: seen in the models' repeated movements of withdrawal or turning of the back; in the frequent *de*-framing of face or head; and in the acute sense of obstruction in the face itself, effecting that impenetrable (or some say otherworldly) quality whereby the face becomes its own barrier.

Facial reticence as bound up with the withdrawal of the look gives us pause in the orbit of narrative cinema. An elaborate trajectory evolves in the narrow angle that spans from the direct (and taboo) look to the camera, to the ubiquitous articulation of the eye-line match that supports the shot/reverse shot and the reaction shot. A great part of the life of the cinematic face takes place right there, where also suturing of the subject is said to occur, and on which Jean-Pierre Oudart dwelled, with Bresson's *Trial of Joan of Arc* as his curious paradigm for the fruition of suture in accentuation *and* syncopation.[16] Oudart's convoluted argument—which ultimately renders suture as an instrument of tragic consciousness—aside, suture broadly understood would connote the syntactic cohesion of image and spectator mainly in shot/reverse shot. In this it partakes of, but is not synonymous with, my notion of "address." The potentiality and true interest of the face, the deeper force of address, may in fact emerge in its *interference* with the basic articulations in the ordinary flow of the cinematic discourse. The reticence discussed here is one such mode of interference. I have explored some of these issues—the pitfalls of a strict subjugation of the face to syntactic operations, and how the face only achieves its freedom in swerving from such syntax—in an essay on Hitchcock's *The Wrong Man* (1957).[17] In Bresson's work, related questions and doubts take a different course in the withdrawal of the face as part of the breakdown of identification, the fragmentation of space, and syncopated temporality. The face and the look are obstructed by the proliferation of elaborately de-framed shots, or due to characters repeatedly turning to vacate the frame, so that we sense our own look as torn, orphaned in their withdrawal. When the shot-reverse shot *is* employed, it might be subtly mismatched, or deliberately drained of expressivity. With the automatism of the model,

no expression "glues," "fills up," or "projects" from one shot to another. André Bazin had noted this already in Bresson's *Diary of a Country Priest* (1950), where characters seem to be constantly "withdrawn from our look" as part of a deliberate aesthetic of impoverishment: a conception comprising the temporality of "an image which shies away by the simple fact of not developing."[18] Bresson spends as much time on such movements of withdrawal as on "positive" moments of action or expression; he gives as much emphasis to spaces burdened by their absence than even to "acts of seeing."[19] One confronts his just-vacated spaces—especially interiors but often also in narrowed-down exterior spaces—as one confronts someone's back being turned in close image, as a palpable negation acutely perceived in the very constitution of his images and their temporal unfolding.

Consider the sequence wherein, late in *Au hasard Balthazar* (1966), Jacques the childhood sweetheart returns to offer with his love for Marie a way out of the social and personal disaster that her family's predicament and her infatuation with Gerard—the gang leader with an angel's singing voice—have plunged her. Balthazar the donkey, whose impassive presence traverses the film, is not included in the shot that establish the space of Marie and Jacques' conversation on the bench (itself established early in the film as a metonymic figure for their relationship). Yet in the conversation sequence there is a temporal lapse, conveyed through an explicit ellipsis in its verbal content but also, and more enigmatically, in a cut away from Marie's lowered profile as she talks, to an extended close shot of Balthazar's head as he grazes and over which the musical theme now recurs. One might hypothetically construe and link both these successive shots as Jacques' point of view, yet such retroactive anchoring does not quite stabilize or *contain* the shot of Balthazar's head. Nor does the fact that the donkey's left side might seem to mirror Marie's right profile establish any literal spatial binding, as if these were a matching shot/reverse shot pair of sort Yet the mirroring cut from girl to the animal's head could be said to convey another order of exchange: a departure from the human conversation taking place and indeed a questioning of the extent to which face-to-face reciprocity within the spatiotemporal continuity can "communicate" at all. The shot/reverse shot had already imploded in the film's unforgettable alternation of Balthazar and the circus animals—tiger, bear, monkey, and elephant—earlier on, where the wild hyperbole of the series of heads and their impenetrable stares seems to pull the rug from under any simple identification of visual coordinates with the proper sense of address, consciousness, or meaning thus projected. Undoubtedly,

nothing about Bresson's use of the donkey, here or anywhere, would impose any such anthropomorphizing intentionality that an animal's face or look, might be made to imply via the shot focalizing or editing schemes of more conventional cinematic uses of animals. No cinematic maneuver will force these stunning, hieratic animal heads into direct conversation, identification, or any fabricated reciprocity.

Following the conversation scene is a shot of Marie taking care of Balthazar for the last time: set up from inside the dark stable, she is seen to come in with the streaming, humid light, her arms full of hay. The camera pans and dollies at a medium-close range to follow the lateral movement of her body. Even as facial expression is limited or altogether elided, the camera work makes salient her deeply absorbed, withdrawn disposition; it allows her head to slip out of the frame as she approaches Balthazar so that it is fringe information—the girl's middle, her arms as she places the hay, then a sidelong view of the donkey's head—momentarily focalized as we hear the girl, evidently contemplating Jacques's proposal, say off-screen: "I will love him, I will love him." Marie then steps into the frame again, the middle of her body obstructing the animal's close-up; finally the camera turns leftward again to follow her movements as she leaves. The meandering relay between the girl's averted countenance and the animal's large dark eye links the two here as throughout the film, but never invests it with direct identification. Both, here as in the cut away from Marie's head to the donkey in the conversation scene preceding the passage to the animal, suggest a sense of self-absorption and intimacy, but it also presents an opacity, defying direct address or ordinary communicative functions at a formal or social level. With the withdrawal of the face and removal of the look as focalizing measures in a hierarchy of perception—wherein we habitually valorize intention, intellection, individual subjectivity—one is left to confront something more primal and opaque, from which such signifying functions have been drained. Consider finally—as Godard suggests in his seminal interview with Bresson on this film—that the donkey's look, by sheer physiognomic position of the eyes at an angle to its front, disrupts in any case our earlier binding of looking and *facing*.[20] Yet in considering Balthazar as (it is often said) Bresson's ideal model, how does one proceed to read Bresson's dictum that the model is "all face"? "All face" might then be understood not as endowing the entire body with a reflective, subjective expressivity but, rather, that the face—like an animal's head—might be as opaque, as resistant as a body as if coated with the rough hide of a beast of burden.[21] The face may come to constitute its own barrier and, if it would return our look,

perhaps not in the direct, communicative immediacy to which cinema only so rarely gives the lie.

Face and other objects/animate and inanimate

In his *Notes on Cinematography* Bresson writes: "one single mystery of persons and objects." He then writes of the *"equality of all things. Cézanne painting with the same eye and the same soul a fruit dish, his son, the Montagne Sainte-Victoire."*[22] What may initially be read as the exalted suggestion of a hidden or otherwise spiritual dimension in a "mystery" not available to immediate perception is of a piece with the modern painter's leveling of still life, portrait, landscape. Animate and inanimate things are grasped as a single hermetic entity that displaces human identity, and that peels the visual from the readable. This leveling of persons and objects, of anthropomorphic and aniconic forms, challenges our intuitive response to the human face as standing out in the visual field and, from that privileged position, endowing it at will with order and with expressivity.[23] In the cinema the human face is a traditional measure of the shot: the range of close-up, medium close-up, medium shot, and so on is firstly defined by the face. For the face is positioned high in a hierarchy of attention and meaning that routinely follows anthropomorphic projection and identification—with regard to figure and ground, orientation, narrative focalization and other varieties of relations unfolding within and across shots. What does it mean, then, to disrupt or even reverse this hierarchy, to pull the face effectively downward to a world of inert matter where other objects would seem to await the human glance to endow them, too, with a face? What does this tell about the workings of the image? How does it effect the cinematic charge of the face?

MRI scans of the brain registering which areas "light up" in response to visual stimuli confirm what clinical accounts had noted: autism's leveling of face and non-face objects diverges from ordinary perception. The normal response to the face is a ubiquitous preference, an "expertise" motivated from early childhood by need and social interest. Physiologically it may be associated with the amygdala part of the brain that responds to objects as emotionally salient and thus contributes to differentiation, recognition, and identification—say, of the mother's face as distinct from all others—and to the understanding, down to the utmost nuance, of the emotional and social relevance of mutable facial expression. This expertise makes evolutionary sense: it pays for the child to identify the mother's face, and to read faces generally with

a degree of refinement not normally available (without special training) to any other object. We take this expertise for granted. In autism, however, it appears indiscriminately focused and without social value; it may be directed to other objects, say types of washing machines, or buses, or doorhandles. Autism presents consistent scenarios instantiating this pathological challenge to functions of salience detection. Its objectification of the face is among the most devastating in a complex of perceptual, cognitive, social, and emotional symptoms.[24]

Causes of autism—whether genetic, physiological, or psychological— apart, writings on childhood development return to the autistic inability to differentiate between people and things that inflicts the earliest relationship with the mother. Tustin considers how a child's "own hands can be experienced as a mouth, as also the mother's breast and the experience of her encircling arms and certain features of her face."[25] In failing to deal with faces *as faces*, the child ducks the terrifying "not me" aspects of the world, while certain autistic objects are harnessed to reproduce something like an infantile self-sufficiency, that enclosed primal non-differentiation of the world, which is also an inability to integrate its parts in meaningful hierarchies, and to place oneself in relation to them. Bruno Bettelheim noticed this in a case history reported in Th*e Empty Fortress*:

> Each part of [Laurie's] body seemed an object apart from the others, and the various parts of her unrelated to each other … . Similarly she made us feel she did not see us as whole persons, but was only aware of that part of us, a hand, a shoulder, an arm that did something for her or with her at the moment … . No awareness of the rest of us, not to mention a look at either us or our faces.[26]

Tustin's account of comparable phenomena paints painfully sharp detail:

> In undifferentiated states, the tendency is to be aware of similarities rather than differences. Thus, objects which, to our more differentiated awareness, seem very unlike are experienced by the relatively undifferentiated child as being the same …. Thus the nipple, his penis, his head, his stinkers, a pipe in the therapy room, a button on a cushion, the toy red bus, and his "Daddy" all evoked the same reactions.
>
> It is not that they are similar and so can be used to *represent* each other. They are felt *to be* the same … . In this state, live and inanimate objects [are] treated in almost the same way.[27]

Despite her evocative language and resort to poetic citations, Tustin emphasizes, importantly, that autistic non-differentiation does not yield some magical animistic heaven—as the Romantic imagination might ascribe to a prelapsarian state of childhood—but rather that autism's leveling of persons and objects is a form of blotting-out of consciousness. It sucks the life out of the things of the world, collapsing its aspects and discriminations, depriving them of countenance within meaningful hierarchies. She writes:

> Animism and autism seem to be opposite modes of operation of the primitive mind. Animism consists of endowing objects with life; pathological autism is a death-dealing process which blocks out things with body stuff to make them non-existent. It also reduces alive people to the state of inanimate things In pathological autism this distinction either has not been made with any clarity ... or has been blotted out However, there seems to remain in the depths of all of us (or in some of us), vestiges of comfort-seeking autistic inertia which exert a backward pull. Freud seems to have been referring to this when, in *Beyond the Pleasure Principle*, he wrote of the pull to return to the inanimate which he associated with his concept of the Death Instinct.[28]

Might one not describe an anti-animistic inclination inflecting a certain cinematic lineage that defines itself against the more "natural" inclination of motion pictures toward an inherent animism? Cinema may be related in this way, too, to a much longer history of figuration wherein "death-dealing"—or at least dealing-with-death—is a fundamental concern, a defining element of art. Many of Bresson's tableaux and narratives dramatize a conflict between action—a protagonist's investment in a project, anything from coffee grinding to pickpocketing[29]—and a negative or morbid inertia. His principle of automatism in the work with his models is an instance of this: the draining of expression vacates will, intention, sovereign action or articulation. Physical attitudes, glances, faces, shoulders, feet, are leveled with chairs, cups, bottles, or doors. When an action does seem to endow the inanimate world with life-like mobility, it is often enfolded into a "death-dealing" submission to elemental gravity. Consider the very movements of suicide, displaced onto toppling, falling objects in the opening of *Une Femme douce* (1969), a sequence which also interlaces accented close shots of inert objects in the pawn shop with subtly mismatched or altogether averted glances, all enframed as flashback within a scene of narration wherein the heads

of both narrator (the husband) and listener (the maid) are consistently de-framed. Consider as well the suicide scene in *Mouchette* (1967), where it is only upon the girl's thrice-repeated topple down to the pond that one realizes, in retrospect, how a seeming activity of play has been in effect our misreading of the morbid repetition of Mouchette's unfolding movement of death, in submission to nothing more than the angle of a mound of earth that will suffice to topple her into the water. Even if certain gestures or instances of attention endow a hand or foot in Bresson's cinema with the luminosity of a face, even if some intimation of a "countenance" would seem to touch a provincial or urban corner in these films, this is most often as foil against a universal condition of withdrawal.[30]

Flat world and second skin

We are in a universe of surfaces where perception slides from faces to heads to arms to armfuls of hay, traversing categories and senses: human to animal to inanimate forms, from bodies to walls, to doors and doorways, and from material objects to glances and sounds that— without synthesis in a projected expression or intention—block and conceal, rather than anchor our look. Rather than reflect back to us, our perception seems absorbed, drowned with these hermetically self-isolated elements, in an opaque continuum of fragments.

A vivid figure that Tustin extracts from the sort of shapes which her patients persistently evoked is that of a "second skin"—like a crustacean shell, or suit of armor that holds together the undifferentiated-yet-nonintegrated parts of the autistic world: a continuous surface perched over vacuity, to fend off what Tustin calls the "black holes" of terrifying emptiness and separateness. Autistic objects, perceived and used as "parts of the child's own body," are extended as "parts of the outside world experienced by the child as if they were his body."[31] Inside and out are undifferentiated as the child seems to construct out of himself and his objects a "hard and shell-like" surface or "second skin," which he could thereby turn as a "hard back" to protect a "soft front." One empathetically imagines (or remembers) the vulnerability of belly, eyes, face, all drawn inward (as it were) against the yawning darkness of one's nursery. The autistic draining, leveling, and effacement of inside and out, self and world, face and non-face, produces this extensive two-dimensional terrain from which all depth has been abolished. Depth would mean the actual solidity of bodies, an awareness of extensions in space *and* time, as well as a sense of interiority in the

possibility of symbolic depth or meaning. But anything that can be construed beyond the immediate facade is abolished. And where depth and function, actual or imaginative, are blocked, no play or fantasy is associated with objects (or persons, which amount to the same), since these maintain an inanimistic, static, inflexible quality. The autistic skin or armor is unchanging and rigid but, Tustin considers, it can break.[32]

"Flatten my images (as if ironing them)."[33]

Soon after the conversation sequence in *Au hasard Balthazar*, Marie promises Jacques she must settle things with the gang for the last time. There follows a harrowing scene in the abandoned farmhouse that had served for her sexual encounters with Gerard. The actress Anne Wiazemsky's peculiar gait and her withdrawn expression are amplified in Bresson's brief but stunning choreography and montage of paced, repeated, at once interlaced and halting movements of the girl's search through the house: opening doors, looking through to different rooms, vacating spaces, pausing to listen. The framing is almost consistently in medium shot, enhancing the tight confines of already shallow spaces. Walls, doors and doorways, enclosed, accumulated and overlapping surfaces convey a sense of flat, bare but oppressive interiors, a zone not entirely defined or enclosed but never quite open. It is a barrier erected between the protagonist's look and our own, separating the two orders of looks, from both sides of the screen, as it were. While the girl obviously sees more than we are offered, while her movements and looks guide and focalize the sequence, her face and reactions reflect nothing more than just what these walls and doors yield within the narrow confines of the frame.

In a central, typically Bressonian shot at the heart of this sequence the camera is set up within a room, closely facing a door which Marie opens only enough to allow her slender body to slip in, pause at the threshold to look, approach the camera, pause again, and turn to exit from frame-left, leaving the door ajar. Her exit and the pause that follows accentuate off-screen space and a temporality emptied of action. In this, perhaps his most notorious perversion of conventional cinematic economy, Bresson omits nothing of the entire process of entries and exits, amplifying the spatiotemporal extensions surrounding it. While so much may be pared away, elided, or hidden in Bresson's world, and in the spaces he affords it, the approach to, the opening, shutting or (perhaps more emphatically) part-shutting of doors, and how such doorways continue to transpire (as it were) even after an otherwise minor action has passed—this is always laid out in its entirety. We are only offered minimal glimpses—earlier in the film and in the section

that follows, when Marie's father and Jacques will come to find the beaten naked girl—of the miserable, sordid mess of this house. For the sequence itself, while made up, technically, of reaction shots, denies us, in the course of Marie's wandering and looking through the house, any reverse field views. It leaves us with only one side of the world, as it were, to intensify these bare, flat spaces. The emphasis, it seems to me, is not even on a positive "act of seeing"[34]—as in looking outward and fleshing out the space that would meet such a glance—but rather on the subjection of the girl's look *to* these compressed, "ironed-out" spaces: she *suffers* them as they seem to burden and drain her look, in shot after shot.

Yet there is something here that can be articulated only by this reticence—of actor, of camerawork and editing, of the image, of perception at large. For even on the level of diegesis, and retroactively, one conjectures that there is more in this house, and more of the girl's response than what we are offered as image. It might be said that the barrier erected between the protagonist's perception and our own, a blank space thus gaping between diegesis and image, yields for an instant the sort of dread sensed in a horror film. But it further propels us to an altogether different dimension of the reticence of perception, of the unrepresentable. For all the ills and miseries of this provincial setting will not add up to more than a formulaic causality of the goings-on—will not explain the subsequent disappearance of Marie— except insofar as the final passage to Balthazar's death will offer some symbolic synthesis, greater than the limited personal experience of this one girl. It is the form of that reticence that we see in Bresson's manner of framing, de-framing, halting, displacing, obstructing the synthesis of objects, looks, and responses, draining and leveling them all as an unfolding surface.

Might we consider that this surface itself ultimately *takes the place of* the face? The reticent perceptual disposition evoked by Tustin's autistic imagery affords a new sense of consistency to Bresson's recurrent practices: his models' inexpressive façades, the host of de-framing devices, the editorial rhythm that levels faces and persons with inert objects or vacated spaces limited in scope, narrowed down, shut to the world. What remains to confront us in the Bressonian image is often an obstruction, a blocked or almost-blocked surface (even as this surface may *be* a face, but it is the face-as-barrier): an extensive, hermetic second skin that deflects onto other surfaces. Yet even if deflected, dissimulated, even in highly mediated form, does not Bresson's image address us after all— not in the immediacy of the shot but as an effect of cumulative surfaces

articulating in reticence? This is not a direct projection of subjec /ity
onto an object charged by expression or identification, yet, in an her
order, the image as a whole addresses us: not the frame or shot but)er-
ceptual totality unhinged from the formal particulars of the indiv ual,
from personal, passing expressions—a totality that one still c s a
cinematic image unfolds *as face*. Human, animal, or inanimate irts,
and all *their* parts, partake in it. The door left ajar is a recurrent tr e—
a medium—of the passage thus afforded from reticence to ad ess,
figuring our suspension on the threshold of interiority.

Object/image and language

The obtuse refusal, or pathological inability to hold the sign tog her
is the domain of psycholinguists. Tustin herself—not really a stru iral
analyst—seems reluctant to pursue this domain beyond her key ob rva-
tions on the difficulty of discussing psychotic symptoms: disconn ted,
primitive material involving essentially pre- or nonverbal experier s.[35]
She notes an autistic non-differentiation of material objects and v rds,
the collapsing of speech into echolalia, whereby "other people's \ irds
may be repeatedly echoed so that the delusion is maintained that ose
'not-me' words are part of the subject's own mouth and have hus
become 'me'." These word-sounds, signifiers picked from the su ace
of things, seem propped as barrier to keep the world and its terr s at
bay, to blot out its holes and gaps—perhaps those very gaps that d ne,
for the semiotician, the structure of the sign. And as that struct e is
shattered, a host of signifiers follows indiscriminately—since one ord
might mean different things, or nothing, and subject and object i ght
reverse roles. Behind these empty signifiers, as behind the "second n,"
or the "empty fortress," the child can hide.[36] Symbolic represent ion
of one thing by another, of a feeling by an object, an object by a ord
is obstructed; but feeling, object, action, sound, word, are experi ced
as *same*: barely formed or found stuff, partaking of the child's own)dy,
blotting consciousness.[37] This indeed is a "death dealing process.'
 The withdrawal of the image from its own languages and si ify-
ing functions seems difficult to claim when we are concerned /ith
figurative cinematic forms that carry iconographic and narrative on-
notations, and where reference, or just figural identification ag nst
ground embeds linguistic operations as a matter of course. Ye the
autistic isolation of signifiers might serve to discern such inst ces
where absences, blanks, seem inserted *between* image and sign, a l to
discern as well the terror, the abandon, and the potentiality of hat

remains *as image* thereby.[38] An account of autistic perception from this perspective approaches an archaic, or indeed primitive modality of the image, or of its foundations just preceding representation. Bresson may be said to have recovered something quite primal, an inert perception of a world from which human agency and, in some sense, signification have been pared down—yet he does so by means of the most deliberate and sophisticated apparatus.[39] He touches on something archaic and vulnerable but which persists in perception and intimates its voids, and its possibilities; something that remains when cinema suspends its perpetual sublimation of the image to signifying functions, when it tears the sign apart and lets the image, unmoored from individual expression or articulation, *face* us.

Some viewers would say that this is what allows for some ultimate signification, beyond the confines of the particular and manifest world, to be intimated in his cinema. André Bazin touched on it when observing, still in *Diary of a Country Priest*, how radically Bresson sets "the face cleared of all expressive symbolism, reduced to the epidermis" against a "written reality"—itself glossed as the "brute fact" of the film's textual source. Bazin's expression itself evokes a slippage from verbal significartion to matter in Bresson's *Diary*, figured by its chain of displacements: writing, reading, erasing, spilling, ingesting, and disgorging ink, wine, or blood. The abundance of close-ups in that film are welded in an epidermal surface of an "increasingly impoverished image" which itself, finally, undergoes "Assumption"—such as Bazin sees in the film's final reduction to the pure sign of the cross against a luminous screen.[40] This is what remains after the Deposition of the body, and after the Assumption of its image. Bresson's reticence in this way opens onto another model, the Christological rhetoric of the Incarnate image and its Iconoclastic critique, wherein one intimates, as well, one of cinema's most ambitious philosophical wagering of icon and symbol, image and text.

No synthesis of image and language, not the social face-to-face, not empathetic identification, not an open book but a door ajar—could one say that, even when a face, in reticence, will not yield, the image may command our look, may itself address us? It is a domain that cannot be immediately available in the visible, it is a gap lurking therein that emerges as a condition of the face. It cannot be a sheer visual or plastic entity; it must always turn away from us so as to address us: is its reticence that signals to us, that compels us. But that will also always, depend on our own capacity and our willingness to address it.[41]

Notes

I am grateful to Yael Abelman-Shavit, psychoanalyst (Paris), and to Robert T. Schultz, associate professor of psychology and child psychiatry and director of the Yale Developmental Neuroimaging Program (New Haven, CT), for conversations on autism. In taking their clues to different domains, responsibility for all resulting distortions is obviously my own.

1. These are Robert Bresson's instructions to camera operator Jean Chiabaut when shooting *Mouchette* (1967), as seen in Theodor Kotulla's documentary *Au hasard Bresson* (1967), included in the Criterion 2006 DVD edition of *Mouchette*.
2. G. Didi-Huberman, *Confronting Images: Questioning the Ends of a Certain History of Art*, trans. J. Goodman (University Park, PA: Pennsylvania State UP, 2005, pp. 142–3).
3. The face is of course a prime ethical figure for Emmanuel Levinas. See for instance his "Sensibility and the Face" and "Ethics and the Face" in *Totality and Infinity*, trans. A. Lingis (Pittsburgh, PA: Duquense UP, 1969 , pp. 187–219).
4. I first heard of these findings by Robert T. Schultz and his colleagues over public radio late in the year 2000. See also R. T. Schultz, et al., "Abnormal Ventral Temporal Cortical Activity During Face Discrimination among Individuals with Autism and Asperger Syndrome," *Archives of General Psychiatry* 57:4 (April 2000), 331–40, and D. Grelotti, I. Gauthier, and R. T. Schultz, "Social Interest and the Development of Cortical Face Specialization: What Autism Teaches Us About Face Processing," *Developmental Psychology* 40:3 (April 2002), 213–25.
5. Jacques Aumont, *Du Visage au cinéma* (Paris: Editions de l'Etoile/Cahiers du cinéma, 1992).
6. Didi-Huberman, *Confronting Images*, 142.
7. Facial reticence and its related negative modes of the image as I approach it here are defined, then, in the context of a cinema that insists on maintaining the human agent as carrying the central burden of meaning within a narrative temporality. These are central to Bresson's exploration of human efficacy within vaster schemes that exceed the singular human agent. The tension that he set up between representing and withholding, figuration and deposition, the doubt that inflects the image is thematized in the Christological constitution of Bresson's work.
8. In turning to autism as model by which to differentiate fundamental dispositions of the image, I am perhaps attempting something analogous to Roman Jakobson's model of aphasia in differentiating the metaphoric and metonymic poles, in his classic essay "Two Aspects of Language and Two Types of Aphasic Disturbances" (1956) in R. Jakobson and M. Halle, *Fundamentals of Language*, 2nd rev. edn (The Hague: Mouton, 1971, pp. 69–96). I find the single, and inspiring, application of autism to the considerations of modern art in A. Michelson's "*Anemic Cinema*: Reflections on an Emblematic Work," *Artforum* 12:2 (October 1973, 64–9). Michelson cites a case study, described by Bruno Bettelheim in *The Empty Fortress*, as suggesting an alternative language system comparable in its complex totality to the apparatus of Duchamp's work. However, the role of the face as key to the autistic

economy, and its implications for the study of the image were not the focus of Michelson's essay. More recently, Raymond Bellour had recourse to work on childhood development in reconsidering basic cinematic articulations, as in "Daniel Stern. Encore," *Trafic* 57 (Spring 2006).

9. Frances Tustin's *Autism and Childhood Psychosis* (n.p., UK: Science House, 1972, p. 87). This as well as Tustin's *Autistic Barriers in Neurotic Patients* (New Haven, CT/London: Yale UP, 1986) are my main sources in this study.

10. Tustin observes how out of that undifferentiated totality "child and therapist seem to be spinning a poem, or dramatizing a play, in the attempt to communicate about it." *Autism*, 39–40. Tustin's citations from Shakespeare, Eliot, Ted Hughes, and others throughout her work index her struggle with autistic material and the turn of poetry as verbalizing it without reducing its complexity.

11. Tustin, *Autistic Barriers*, 21–2.

12. Tustin, *Autistic Barriers*, 154.

13. Tustin, developing Winnicott's discussion of privation, in *Autism*, 75.

14. For these and related rhetorical figures see "Silva Rhetoricae" on www.rhetoric.byu.edu. Accessed on 29 October 2008.

15. See, for instance, S. Sontag, "Spiritual Style in the Films of Robert Bresson," 1964, rpt. in *Robert Bresson*, ed. J. Quandt (Toronto: Cinematheque Ontario Monographs no.2, 1998), 60: "form for Bresson is not mainly visual. It is, above all, a distinctive form of narration. For Bresson film is not a plastic but a narrative experience." Compare this to Bazin's observation on *Diary of a Country Priest*: "I doubt if the individual frames in any other film, taken separately, are so deceptive. Their frequent lack of plastic composition, the awkwardness and static quality of the actors completely mislead one as to their value in the overall film." Originally in A. Bazin, "*Le Journal d'un curé de campagne* et la stylistique de Robert Bresson" in *Cahiers du cinéma* no. 3 (June 1951), 7–21. 1967 trans. by H. Gray rpt. in Quandt, 37. It is also true that, alongside his own references to his origin as a painter—though he never showed any of that work—Bresson observed in a 1966 television interview about *Au hasard Balthazar* in Criterion 2005 DVD: "The great difficulty for filmmakers is precisely not to show. Ideally nothing should be shown but that is impossible."

16. Jean-Pierre Oudart first imported "suture" from psychoanalysis to cinema, with Bresson's *Trial of Joan of Arc* (1962) as his curious paradigm: it is a film, he says, "which takes on the specifically tragic nature of its language, even accentuates it, and allows the suture of a deliberately syncopated discourse." Oudart claims that *Au hasard Balthazar* fails, by contrast, to come to terms with the fundamental duality of space that is the essence of "the cinematic." Instead, the linearity of *Balthazar* prevents the spectator's suturing of the discourse and thus produces an absence. "This makes Bresson without a doubt the most ambiguous figure in modern cinema." J.-P. Oudart, "Cinema and Suture," *Cahiers du Cinéma* 211 and 212 (April and May 1969); English trans. by K. Hanet in *Screen* 18:4 (Winter 1977–78, 35–47).

17. Noa Steimatsky, "What the Clerk Saw: Face to Face with *The Wrong Man*." *Framework Journal of Cinema and Media* 48:2 (Fall 2007, 111–36).

18. Bazin, "*Le Journal d'un curé de campagne* et la stylistique de Robert Bresson," 9, my translation. I discuss Bazin's analysis in great detail in my essay

"Incoherent Spasms and the Dignity of Signs," *Opening Bazin*, ed. D. Andrew (New York: Oxford University Press, 2010).

19. P. Adams Sitney emphasizes the weight of such "acts of seeing" in Bresson in "Cinematography vs. the Cinema: Bresson's Figures," 1989, rpt. in Quandt, 146, 150. The weight of spaces vacated by figures as by narrative action is also at the heart of Michelangelo Antonioni's work. A comparison of the two masters' work with cinematic space suggests, however, also marked oppositions, as between Antonioni's open grids and Bresson's deliberate narrowing down of the visual field, as well as other aesthetic and philosophical aspects which belong in a different inquiry.

20. Interview by J.-L. Godard and M. Delahaye, "The Question," 1966. Trans. J. Pease 1967, rpt. in Quandt, 479.

21. *Notes on Cinematography*, 1975, trans. J. Griffin (New York: Urizen Books, 1977, p. 40). This interpretation is embedded in the gloss that Bresson offers in his footnote to this aphorism, quoting from Montaigne on the rogue who, in being questioned how he could walk about with only his shirt upon him in the cold of winter responded: "and have you not, good Sir, your face all bare? Imagine I am all face." Catherine Flynn further elaborated (in an unpublished paper) how this "reverses the usual understanding of face and body as, respectively, sensitive and less sensitive. In calling his robust unclothed body 'all face,' [Montaigne's rogue] implies that his face is toughened skin, a hardy surface that withstands exposure to both the elements and the public as a matter of course."

22. Bresson, *Notes* 26, 136 respectively; emphases in the original.

23. "Aniconic" means basically "non-iconic," in the sense of non-anthropomorphic, non-figurative. This term is used broadly in theological and anthropological discussions of religions or cultures that forbid the representation of god, or even any image making.

24. I rely here, again, on R. T. Schultz, et al., "Abnormal Ventral" and D. Grelotti, et al., "Social Interest."

25. Tustin, *Autism*, 61.

26. B. Bettelheim, *The Empty Fortress: Infantile Autism and the Birth of the Self* (New York: The Free Press, 1967, p. 101).

27. Tustin, *Autistic Barriers*, 83–5.

28. Tustin, *Autism*, 83–8. In an aside Tustin comments in these pages on autistic attitudes of otherwise healthy persons who treat others as if they were objects: this, she considers, is the stuff of which fanatics are made, 86.

29. Sontag describes such sections of Bresson's films devoted to "the beauties of personality effaced by a project. The face is very quiet, while other parts of the body, represented as humble servants of projects, become expressive, transfigured." Sontag in Quandt, 68.

30. By and large, even in those films—*A Man Escaped* (1956), *Pickpocket* (1959)—where the protagonists emerge, spirited and with a palpable sense of flight from the downward pull of the world and its confinements, one senses that such instances of grace are drawn against such continued universal opacity and bareness.

31. Tustin, *Autism*, 48, 64 respectively. See also "'Grit' and 'Second Skin' Phenomena" 55–8, and "Autistic Objects" 64–72. Tustin clearly differentiates

these autistic objects ("totally me") from Winnicott's transitional object, understood as the child's first "not me" possession.

32. Tustin, *Autistic Barriers*, 55–7, 63, 104, 114.
33. Bresson, *Notes*, 22.
34. Sitney, "Cinematography vs. the Cinema," in Quandt, 146, 150.
35. Tustin, *Autism* 39–40.
36. Tustin, *Autism* 68, 48–9.
37. One might consider that the found object of photography, Duchamp, Surrealism, cinema—the object assimilated in whole or part, or at least as shadow or optical surface—discloses in such a way not just the ironic and semiotically astute operations of advanced art but, in its brute *incorporation*, recovers something (threateningly) primal, pre-verbal, something that dodges forming and figuring.
38. This forbidding margin—confronted by Georges Didi-Huberman in several works, including *Confronting Images*, cited in my epigraph—is avoided like the plague by film scholarship, with limited exceptions in those Barthes-influenced "excess"-studies; one turns, of course, to "The Third Meaning" (1970): "If you look at these images I am talking about, you will see the meaning: we can understand each other about it 'over the shoulder' or 'on the back' of articulated language ... thanks to what in the image is purely image (and which, to tell the truth, is very little indeed), we do without speech yet continue to understand each other." In Roland Barthes, *Image Music Text*, ed. S. Heath (New York: Hill and Wang, 1977).
39. I'm grateful to Dudley Andrew for discussing Bresson with me in these terms.
40. Bazin, "*Le Journal d'un curé de campagne* et la stylistique de Robert Bresson," 15, my translation.
41. I have been inspired here by Thierry de Duve's discussion of a different category of limit-images: a body of portraits taken between 1975 and 1979 of men, women, and children photographed before being killed at the S-21 extermination compound in Phnom Penh: "I have no way of knowing whether a work of art contains a universal address except the feeling of being addressed personally by it [....] More often than not in truly innovative art, that feeling hinges on my capacity or my willingness to address the work so that it addresses me." In "Art in the Face of Radical Evil," *October* 125 (Summer 2008), 3–23.

10
Remapping the Rural: The Ideological Geographies of *Strapaese*

Lara Pucci

In 1929 the Italian critic and caricaturist Mino Maccari published a characteristically polemical woodcut in his journal *Il Selvaggio* ("The wild one")—the mouthpiece of the fascist cultural movement of *Strapaese* ("super-country"). Here, Maccari pictures an imagined landscape in which (super)city and (super)country are diametrically opposed, separated by a purgatorial river in which—according to the accompanying caption—the undecided drift aimlessly in leaking boats (Figure 10.1).[1] The super-city, this caption tells us, is defined by child-unfriendly Rationalist architecture and its cosmopolitan intellectual inhabitants: F. T. Marinetti dressed in the attire of the Royal Academy of Italy, and the monocled critic Ugo Ojetti catching a ride with the beret-wearing writer Massimo Bontempelli.[2] By contrast, the caption tells us, the super-country is populated by pregnant women and playing children, surrounded by a hilly, tree-rich landscape. The focal point of this clash of geographies and cultures is the collision between Bontempelli's Fiat 509 and an oak tree, perhaps an ironic reference to the crash described by Maccari's eyewitness Marinetti 20 years earlier in his "Founding and Manifesto of Futurism".[3] In a reversal of Marinetti's regenerative collision, which inaugurates the Futurist rejection of the past and celebration of the machine, Maccari casts the symbol of organic longevity as victor over contemporary automotive technology.

A comparable scene introduces the theme of urban–rural conflict in Alessandro Blasetti's 1931 film *Terra madre* ("Mother earth"). The young Duke Marco returns—by car—to his family's farmland estate after years of absence in the city. After being greeted with a prodigal son's welcome from the authority-hungry peasants, Marco rejoins his city-dwelling companions in the car to set off for his country mansion. Amongst

Figure 10.1 Mino Maccari, *Strapaese e stracittà* (Supercountry and supercity), woodcut, published in *Il Selvaggio*, 30 December 1929, reproduced in 1976 facsimile, vol. 3, p. 61 (© DACS 2011, ©V&A Images/Victoria and Albert Museum, London)

the passengers are the duke's fiancée—a beret-wearing urbanite named Daisy—and the prospective buyer of the estate, which we are led to believe is being sold by the duke to finance his urban lifestyle. The incompatibility of their urban modes with this rural context is articulated by a close-up of a Dunlop-branded car tire spinning uselessly in the mud. The automobile, symbol of urban, industrial wealth, is thus immobilized by the rural landscape.[4] Daisy jokingly suggests that the developer resurface the road in car-friendly parquet, underlining the point made by the foreign branding of the tire: it is not simply the urbanness of the duke's entourage that displaces them in this landscape, but their non-Italianness.

Like Maccari's caricature, Blasetti's film shows foreign-influenced urban culture to be incompatible with an Italian landscape. The projection of the foreign as a means of asserting a national identity is a common feature of cultural debates under Fascism. As well as being motivated by the regime's xenophobic nationalism, it was also, as Claudia Lazzaro argues, a response to the artistic pluralism of Fascist Italy.[5] In a competitive marketplace, demonstrable Italian-ness was the key to official acceptance.[6] The *strapaesani* saw themselves as defending rural Italy against the cultural contamination that had already infiltrated Italian cities. In Maccari's well-known caricature *Cocktail*, published in *Il Selvaggio* in 1932, this notion of cultural contamination—and its knock-on effects for Fascist demographic policy—is embodied in the juxtaposition of the inebriated, scrawny, scantily-clad figure of the urban barfly, and the robust, healthy body of the nursing mother associated with rural domesticity.[7] The foreignness of her disease is identified by the title of the print, which in turn refers to the regime's campaign for linguistic autarchy, which sought to purge the Italian language of foreign influences.[8]

This battle is narrativized by *Terra madre*, which has been linked to the values of *Strapaese* in both contemporary criticism and more recent scholarship.[9] Blasetti presents Marco with a choice of women as well as locations: his fiancée Daisy (urban, cosmopolitan, materialistic, urban) and the peasant woman Emilia (rural, hardworking, maternal). The regime's linguistic nationalism is again inscribed in the naming of these characters, which opposes the Anglo-American Daisy with the traditionally Italian Emilia, who shares her name with Mussolini's native region. This caricatured association of woman and place was further simplified by newspaper advertisements for the film which, recalling Maccari's 1929 woodcut, distilled the narrative into a choice between skyscrapers/scantily-clad urbanite and trees/demure peasant.[10]

However, as Emily Braun has argued, *Strapaese*'s traditionalism and ruralism should not be understood as an outright rejection of modernity. The rhetorical excesses of *Il Selvaggio* sought to temper what it perceived to be "the overwhelming force of modernization."[11] Equally, the movement's promotion of the regional—from its bases in Tuscany and Emilia Romagna—was not meant to be at the expense of the national. The dual significance of *paese* as national and provincial homeland was deliberately invoked in the name of the group, and the enduring qualities of peasant culture were seen as a source for national regeneration. As Roger Griffin has argued, the transformative power of the past was a key factor in the fascist organization of time, which defined the present in terms of the past.[12] This qualitative conception of time finds parallels in fascism's symbolic uses of space, which according to Mark Antliff's analysis can be understood as a response to the homogenizing effects of capitalist time and space.[13] *Strapaese*'s traditionalist regionalism was one product of this pursuit of qualitative difference, Mussolini's cult of *romanità*, which celebrated Imperial Rome as a prototype for Fascist Italy, was another.[14]

These alternative models of regenerative cultural heritage demonstrate Antliff's point that fascism is most usefully discussed in the plural: "rather than considering fascism as a monolithic term, we should speak of competing fascisms."[15] This is particularly pertinent to a discussion of *Strapaese*, which, fearing the regime's own homogenizing practices, sought to define itself in opposition to alternative manifestations of fascism. Founded in the wake of the Matteotti crisis in 1924, the movement's journal *Il Selvaggio* aligned itself with the rural, regional, and apparently "revolutionary" origins of fascism.[16] Contributors to the journal, Ottone Rosai and Curzio Malaparte, as well as its editor Maccari, had been active in the Tuscan squadrism of 1920–21. As the regime was established, the *selvaggi* continued to advocate the palingenetic spirit of squadrism in opposition to the "normalising and bureaucratizing tendencies" of the centralized Fascist state.[17] In cultural terms too, *Strapaese*'s adherents feared the standardizing effects of state-sanctioned mass culture, as well as internationalist influences, both of which were identified as a threat to the indigenous culture of rural Italy. As witnessed by Maccari's caricatured landscape, the cultural fascisms rejected by the group included: the myth of *romanità*, which endorsed Mussolini's centralization of power; the Futurist cult of the machine; Rationalist architecture; and the internationalist language of the Novecento ("twentieth century") movement led by Bontempelli defined by the *strapaesani* as *Stracittà*, a catch-all term for cosmopolitan culture.

The term *Strapaese* was coined in 1926, as Maccari put it, "to defend with drawn sword the rural and village character of the Italian people. [It] is the bulwark against the invasions of foreign fashions and ideas and of modernist civilization."[18] This perceived need to defend Italy's cultural heritage against foreign contamination was part of a broader fascist discourse of cultural autarchy, which sought to transfer the regime's economic policy of self-sufficiency to the realm of culture. Defining the role of a future Italian Academy in 1927, Fascist official Giuseppe Bottai advocated the preservation of "the artistic patrimony of our race, which must be protected—as it is not today—not only from the harmful effects of time [...] but especially from foreign influence and contamination."[19] Aligning racial with cultural nationalism, Bottai's words exemplify the fascist conception of an inherited and indigenous Italian tradition. Alongside the racial lineage traced by Bottai, the fascist narrative of cultural inheritance was also rooted in the land, as evidenced by the frequent appearance of the term *autochthonous* (native to the soil) in contemporary discussions of indigenous culture.[20]

This was nowhere more the case than in the pages of *Il Selvaggio*, where Italian culture was firmly rooted in terms of landscape and humanity. By way of contrast, American culture was characterized as insubstantial, mechanical, and lacking in geographical rootedness:

> America descends to the sound of dollars, with its black idols, the cocktail, jazz, fashion, the imbecility and dazzling glitter of a civilization that is *all sea foam and no land*, all machine and no heart [my italics].[21]

As Walter Adamson has argued, the emergence of anti-Americanism in *Il Selvaggio* in 1926 was part of a wider debate surrounding *americanismo* in Italy, in response to the growth in American consumer culture during the 1920s.[22] This prompted fascist intellectuals, including the *selvaggi*, to adopt a more reactionary stance, mining indigenous tradition in an attempt to counter the perceived transatlantic invasion. The artists associated with *Strapaese*—Ardengo Soffici, Carlo Carrà, and Ottone Rosai foremost amongst them—evoked this geographical rootedness in repeated representations of Tuscan landscapes that privilege key iconographic components: cypress and pine trees, haystacks, rolling hills, and anonymous farm buildings with terracotta roofs (Figure 10.2). These integrated landscapes picture buildings, trees, and the intermediary architectonic form of the haystack, as equivalent components, the importance of which is often underlined in titles that take the form

of simple iconographic descriptors, for example: *Campi e colline* (Fields and hills, Soffici, 1925); *Muro e cipressi* (Wall and cypresses, Rosai, 1927); *Pagliai* (Haystacks, Carrà, 1929).

Collectively, and through repetition, these motifs can be read as a visual vernacular, functioning—(in the manner of Tuscany's verbal vernacular—(as a synecdochic national language.[23] The symbols of Tuscanness employed by Soffici, Carrà, and Rosai are used to suggest historical continuity with an enduring past.[24] The apparently unchanging nature of the rural landscape, dotted with anonymous farmhouses, native trees,

Figure 10.2 Ardengo Soffici, *Campi e colline* (Fields and hills), 1925, oil on panel, 61.5 × 47 cm, Galleria Nazionale d'Arte Moderna, Rome (reproduced with permission of Caterina Soffici, and the Ministero per i Beni e le Attività Culturali, photo: Alessandro Vasari)

and the products of customary agricultural practices, is pictured as the landlocked antithesis of the transatlantic froth Maccari envisaged being washed up on Italian shores. The abiding qualities of this rural heritage are underscored by the relatively undifferentiated modes of representation employed by the artists in the depiction of these motifs.

Terra madre establishes its own rural iconography through similar pictorial means, with the key motif of the Mediterranean pine defining the graphic landscapes of the title sequence. Within the film itself, trees appear repeatedly as ciphers of rural rootedness. Silhouetted against expansive skies, the Mediterranean pines assume the iconic qualities of the motifs adopted by the *Strapaese* painters. Framing key stages of the duke's disrupted return to origins—as he surveys his estate on horseback on the morning after his arrival, and is confronted by Emilia over his decision to sell the land (Figure 10.3)—these arboreal forms seem to function as reminders of his own rural roots, just as he appears to be severing them.

Notions of solidity and grounding are also evoked by the aural construction of place in *Terra madre*—a significant development, not only because this was one of the first sound films to be made in Italy, but also because it marks Blasetti's return to a landscape previously explored in his silent film *Sole* (Sun, 1929).[25] Diegetic sounds of pickaxes hitting the earth, the thudding hooves of charging cattle, and the footsteps of running peasants resonate with the surrounding landscape, reinforcing the physical and symbolic solidity of place and the connectedness of its inhabitants to it. This is complemented in the idyllic opening sequence by "Soviet-inspired shot composition" that integrates the working peasants with their landscape.[26] The choral chantey that overlays the diegetic sounds of labor evokes a sense of collectivism, which, according to the authoritarian values of fascism, will only be empowered by the intervention of the landlord, Duke Marco. Conservative narrative content subverts revolutionary form: the language of Soviet filmmaking is translated into a tale of class reconciliation and submission to authority.[27]

The ideological flipside of the peasants' groundedness is the sense of disorientation that Marco experiences due to his absence from that landscape. He is literally *spaesato* —(spiritually) lost as a result of his disconnection from his national and geographic identity. As he tells Emilia, referring to himself in the third person and concealing his true identity from her: "He doesn't know how to react [...] I no longer recognize him myself. He lives just like that, without a reason." This echoes *Strapaese*'s conception of the city as site of moral disorientation. As one

Figure 10.3 *Terra madre* (Mother earth) dir. Alessandro Blasetti, 1931. Set photograph (reproduced with permission of the Archivio Fotografico – Cineteca del Comune di Bologna)

contributor to *Il Selvaggio* put it: "the provinces have faith in their ideals and the cities don't know what they believe."[28] Following the path mapped out by *Strapaese*, Emilia anticipates the narrative trajectory of redemptive return to nature, reassuring the undercover duke that it would be enough for him to set foot on his native land and he would stay forever. In other words, his physical reconnection with this rural landscape will restore his geographical and moral bearings.

In his recent work on cinema and fascism, Steven Ricci identifies the narrative trope of "inevitable return to origins" as one of the ways in which filmic texts responded to a fascist context in which internal migration was discouraged and rural life was associated with reproductive

and agricultural fertility.[29] Mussolini's land reclamation campaigns sought to expand Italy's rural territories by making habitable and culti-vatable land that had been historically inhospitable and unproductive. The Pontine Marshes outside Rome—the setting for Blasetti's film—was the primary site of Fascist agricultural reclamation. These malaria-ridden swamplands were transformed into one of the most fertile areas of the country: new towns were built, repopulation was encouraged, and Mussolini declared a new province to have been conquered.[30]

This formed part of a larger government campaign to boost wheat production. Consistent with the idea of colonialism at home, this agricultural campaign, known as the Battle for Grain, was conceptualized in fascist discourse as a military struggle, much like the associated demo-graphic campaign, or Battle for Births. The opposition in this civic war were, in the words of Mussolini, "the disorganized forces of nature" over which Fascism had triumphed through force of will.[31] Evidently, these geographical interventions also functioned as symbolically loaded sites on the regime's rhetorical map, expanding the ideological space in which autarchic, natalist, and colonialist discourses could be deposited.[32]

Terra madre's exposition of these intersecting campaigns was officially recognized in its selection for screening at a presentation of Fascist agri-cultural and rural repopulation policies to the US Bureau of Commercial Economics in December 1931.[33] The representation of landscape in Blasetti's euphoric closing sequence presents a didactic narrative resolu-tion in line with these ideological objectives: the return to rural origins; the rejection of the self-obsessed urban woman in favor of the maternal peasant; the restoration of arable productivity. Toward the end of the sequence, the landscape of the duke's estate is shot through the filter of cascading grain, stressing its restored fertility, and symbolizing the reproductive fertility of Marco and Emilia's union.[34] This victory in the Battle for Grain is attributed not simply to the duke's presence, but to his modernization of farming practices.[35] The sequence opens with close-range shots of tractors tilling the soil. Recalling the earlier close-ups of pickaxes working the land and the displaced car tire strug-gling through it, these shots highlight the impact of the duke's return to origins. Replacing decadent with functional technology and manual with mechanized labor, the interventions of benevolent authority are pictured as a positive regenerative force.[36]

Much as the duke (and the Duce) oversaw the remodeling of the Pontine Marshes, the *Strapaese* painters carried out their own acts of rein-vention on the Tuscan landscape. Representing their rural surroundings

through the lens of Renaissance pictorial tradition, these paintings invoke an indigenous cultural past in their Trecento-inspired form as well as in their traditional peasant content. In *Processione* (Procession, 1933) Soffici adopts Giotto's qualitative perspective, depicting monumental peasants engaged in Catholic ritual against the backdrop of a diminutive but symbolic landscape. The representation of a religious procession is echoed in the ritualistic repetition of what were, by now, established ciphers of Tuscanness in the *Strapaese* vocabulary—the haystack, hills, cypress trees, and rural dwelling. Clustered together in the center of the composition and made highly visible through the gap between the figures in the foreground, these motifs are framed by Soffici as inanimate participants in this Catholic ritual, thus underlining the cyclical nature of rural life—governed by the seasons and Catholic dogma—and symbiotic relationship between the landscape and its inhabitants.[37] Rendering the scene in fresco technique, Soffici signals another marker of continuity with indigenous cultural heritage.

As well as resonating with the regime's strategic (re)construction of the *Medioevo*—the late Middle Ages and Renaissance—to lend historical legitimacy to the fascist present, Soffici's recourse to fresco in the early 1930s can be understood in relation to a broader European revival of mural painting.[38] As Romy Golan argues: "By aspiring to the mural condition, easel painting would be given a destination, a home, and thus a function as an antidote to the 'homelessness' of modernism."[39] It was a position shared by Soffici's fellow *strapaesano* and former Futurist Carlo Carrà who, having published a monograph on Giotto in 1924, signed Mario Sironi's manifesto of mural painting in 1933, the year of Soffici's *Procession*, and the V Milan Triennale, at which frescoed murals were dominant.[40] As Golan has observed, this urge to ground painting in architecture—literally or metaphorically—became more pronounced in the 1930s as the effects of the Depression heightened anxieties about modernity.[41] The case for cultural homecoming was particularly pronounced in Italy, as the increased political isolation of the 30s brought a greater sense of urgency to the regime's campaigns for autarchy.

This search for autochthonous roots in pursuit of a vernacular modernism saw architects turn to painting as painters turned to architecture. In March 1932 the Florentine architect Giovanni Michelucci published a pictorial essay in *Domus* linking the architectural motifs of Giotto's frescoes to contemporary Rationalist buildings.[42] In August of the same year he adopted a similar strategy in a second photo essay for *Domus*, this time locating the roots of Rationalist design in the traditional Tuscan farmhouse.[43] Within the autarchic context of the 1930s, Michelucci's claims for the Italianness of

contemporary architecture through the invocation of multiple pasts– om
iconic frescoes to anonymous farm buildings—can be understood as tra-
tegic response to the accusations of internationalism levied at Ratic list
architecture, by the *strapaesani* among others.

Lacking the national canon available to the *Strapaese* painters, Bl tti,
as we have seen, embraced the formal innovations of Soviet cin a.[44]
Denying the influence of foreign filmmaking practices, Blasetti ims
these techniques for Italy and for fascism by linking them to lig-
enous landscapes and folk cultures, and by dissociating them om
the revolutionary politics with which they had been develo d.[45]
Consequently—befitting its status as industrial as well as cultural pr ict,
in these autarchic times—*Terra madre* was received as "the most Ital of
Italian films," marking a revival in the fortunes of national cinema

Rather than deny the modernity of his medium, Blasetti soug to
exploit its kinetic potential to articulate, in contemporary languag the
importance of cultural continuity with a folkloric past. Like the tr ors
within the diegesis, the avant-garde techniques deployed in the fi ing
of a conservative return to origins, can be seen to resolve ter ons
between tradition and modernity. Agricultural and cinematic tech lo-
gies come to the fore in the film's closing sequence, which opens ith
a procession of tractors and deploys montage, after Eisenstein's n del,
for dynamic rather than narrative effect. Blasetti's use of montage the
point of conservative narrative closure, marking the reproductive s ual
union between landowner and peasant, exemplifies Antliff's assess ent
of fascism's "transference of the dynamism of class conflict to a lm
of avant-gardism."[47]

If the cultural homecoming of *Terra madre* is articulated more th igh
narrative content than filmic form, the film's significance as a cu ral
product was understood in terms of Italy's artistic heritage. Filn vas
to be seen as the latest manifestation of a cultural lineage dating ack
to the Renaissance. Singling out *Terra madre* for patriotic praise one
contemporary critic argued that Italy should be able to speak its
cinema with the same pride as that felt for the work of Dante, Ra ael,
and Michelangelo.[48]

Within this autarchic context of the 1930s, the Florentine writ ind
critic Corrado Pavolini made a similar argument for vernacular hi-
tecture, elevating the humble *casa toscana* to the illustrious can of
Italian artistic heritage:

The admirable proportions and perfect geometry of these h ble
buildings, the virile and sweet harmony of the walls, and the eff t of

precise dimensions of this exceptional native skill were suggestive a Giotto or a Fra Angelico.⁴⁹

When Pavolini was writing in 1933, the year Soffici's cultural homecoming reached its final destination in his *Procession* fresco, the enduring and unchanging qualities of vernacular architecture had informed the artist's earliest moves away from the international avant-garde in the late teens and early 1920s. Following his experience of fighting alongside peasants in the trenches, Soffici retreated from the elitist conception of culture held during his prewar alignment with Futurism. Echoing his physical return from Paris to Tuscany, Soffici's cultural homecoming anticipated the broader architectural impulse Golan has identified in European painting from the late 1920s. The Tuscan farmhouse—(which was to become a central motif in the *Strapaese* vocabulary, and which would later be celebrated by Michelucci and Pavolini—(took center stage in Soffici's *Casa colonica* painting of 1920, the year he recast his own practice as that of a grounded builder in a climate of cultural chaos:

> Today [when] we concern ourselves seriously with serious and grand things, without distractions, with our minds free of petty preoccupations [...] let others break their necks on the road to the abyss where they have arrived following us, and where we now see them tumbling among their "dadas," while we have stopped to build our own house.⁵⁰

As we have seen in Maccari's definition of *americanismo* as "all sea foam and no land," Italian culture is configured by Soffici as stable and grounded in the face of the precarious freefall of the international avant-garde. Blasetti chose instead to master the freefall, directing it back to nature, as an alternative route to cultural stability. The divergent return journeys to rural origins followed by Soffici and Blasetti were perhaps indicated by their choice of location as well as media. The landscape of rural Tuscany, which had shaped and been shaped by a long-established pictorial tradition, mapped out an indigenous path. Blasetti's Pontine Marshes had, on the other hand, only just arrived on the map, reformed by the interventions of fascist modernity.

What is clear, in each case, however, is that these are mediated landscapes. Despite *Strapaese*'s claims that, as Braun puts it, "Italy would be viewed from the bottom up, from the vital roots of the earthy peasantry, or *Italia barbara* (wild Italy),"⁵¹ these pictorial and filmic landscapes are the products of top-down interventions, remodeled by

fine art heritage and technological innovation. Where *Terra madre* contributes to the invention of the Pontine Marshes as ideal fascist landscape in the manner of the publicity campaigns surrounding their reclamation, *Strapaese* contributes to the reinvention of rural Tuscany in the manner of the regime's "reinvention of tradition" through the revival of regional customs.[52] The regenerative power of *Italia barbara* comes less from the agency of the peasants themselves than from the use of the peasant as "a mythic prototype for the fascist 'new man'," much as the transformation of the duke occurs in Blasetti's narrative.[53]

Despite *Strapaese's* opposition to the cultural practices of the regime, and Blasetti's denial of political subtext, both *Terra madre* and the landscape paintings can be usefully understood through one of the regime's central discourses—that of *bonifica* or reclamation.[54] What began life as an agricultural policy to create arable farmland, fed into fascist concepts of imperialism and autarchy to produce the initiatives of *bonifica della cultura* (cultural reclamation) and *bonifica umana* (human reclamation). The articulation of explicitly Italian landscapes in the language of Giotto or Soviet montage can both—in their variance—be understood as part of this discourse. This was not lost on contemporary observers. Much as Mussolini claimed to have "tamed" nature through the land reclamation program, Blasetti's *Terra madre* was presented in Washington, DC, as evidence of the Duce's reclamation of the "bohemian" world of spectacle, combining, through form and content, the campaigns for cultural and agricultural reclamation.[55]

Notes

I am grateful to the British Academy for the Postdoctoral Fellowship that has made this work possible; and to Umberta Brazzini of the Mediateca Regionale Toscana, and Michela Zegna, Anna Fiaccarini, Cecilia Cenciarelli, Roberta Antonioni, and Alessandra Bani of the Cineteca di Bologna, for their support of my research. I also wish to thank Martin Lefebvre and Matthew Philpotts for their helpful comments on an earlier version of this essay. Unless otherwise stated all translations from the Italian are my own.

1. Mino Maccari, *Strapaese e Stracittà*, woodcut, published in *Il Selvaggio* (30 December 1929), 57; reprinted in 1976 facsimile vol. 3, 61, reproduced in *Le riviste di Strapaese e Stracittà: Il Selvaggio – L'Italiano – 900*, ed. Luciano Troisio (Treviso: Canova, 1975) (Figure 7).

2. The Royal Academy was a topical target, having recently been inaugurated in October 1929.

3. F. T. Marinetti, "The Founding and Manifesto of Futurism," in *Futurism: An Anthology*, eds L. Rainey, C. Poggi, and L. Whitman (New Haven, CT/ London: Yale University Press, 2009, pp. 49–53). This reversal of car crash fortunes might also be read as a critique of Marinetti's institutionalization—(He is now dressed in the garb of the academies his manifesto had promised to destroy.

4. See J. Hay, *Popular Film Culture in Fascist Italy: The Passing of the Rex* (Bloomington, IN: Indiana University Press, 1987) (p. 139).

5. C. Lazzaro, "Forging a Visible Fascist Nation: Strategies for Fusing Past and Present," in *Donatello Among the Blackshirts: History and Modernity in the Visual Culture of Fascist Italy*, eds C. Lazzaro and R. J. Crum (Ithaca, NY: Cornell University Press, 2005, pp. 13–31, 14, 27).

6. Ibid.

7. M. Maccari, *Cocktail*, linocut, *Il Selvaggio* (15 June 1932), 30; reprinted in 1976 facsimile, vol. 3, 208.

8. The campaign was institutionalized with the founding of the Italian Academy in 1929. See R. Ben-Ghiat, "Language and the Construction of National Identity in Fascist Italy," *The European Legacy* 2:3 (1997), 438–443. Ben-Ghiat notes that the word "cocktail" was a long-standing symbol of American decadence in Italy.

9. For example, a review of *Terra madre* published in *Gazzetta del Popolo* on 5 March 1931 described the film as activating the contrast between "strapaesano and stracittadino." See Fondo Blasetti (FB), *Terra madre* scrapbooks (TM) at the Cineteca di Bologna. However, the movement's own journal *Il Selvaggio* found the contrast between rural and urban to be insufficient, criticising the presence of urban practices in the film's rural setting (the groomed eyebrows of the peasant protagonist, the sounds of the tango and the foxtrot at the party hosted by the duke's entourage) and the absence of scenes of urban corruption, which, according to the reviewer, would have better highlighted the healthy qualities of rural culture. See D. De Marco, "Recensione di film campestre," *Il Selvaggio* (15 October 1931) 64; reprinted in 1976 facsimile vol. 3, 148 (neither the film nor the director is named in this review). In more recent scholarship, James Hay (as in note 5) is amongst those to have read *Terra madre* in terms of *Strapaese*.

10. The advertisement discussed here, which is typical of those used to promote the film, appeared in an unidentified Brazilian newspaper (FB) (TM).

11. E. Braun, "Speaking Volumes: Giorgio Morandi's Still Lifes and the Cultural Politics of Strapaese," *Modernism/Modernity* 2:3 (1995), 89–116, 95; with reference to O. Bisorco [pseudo. Mino Maccari], "Gazzettino ufficiale di strapaese," *Il Selvaggio* (24 November 1927); reprinted in Luisa Mangoni, *L'interventismo della cultura* (Bari: Laterza, 1974, pp. 140–41).

12. R. Griffin, "'I am no longer human. I am a Titan. A god!' The Fascist Quest to Regenerate Time," in *A Fascist Century: Essays by Roger Griffin*, ed. M. Feldman (Houndmills, UK: Palgrave Macmillan, 2008, pp. 3–23, 13).

13. M. Antliff, "Fascism, Modernism, and Modernity," *The Art Bulletin* 84:1 (March 2002), 148–69, 162.

14. Antliff, 161. As Antliff argues, this recourse to tradition as a means of countering the capitalist standardization of time and space was not exclusive to fascism or to Italy, but was rather part of a broader vernacularization of modernism in

the interwar period. For a comprehensive study of this tendency in France see, R. Golan, *Modernity and Nostalgia: Art and Politics in France between the Wars* (New Haven, CT/ London: Yale University Press, 1995).

15. Antliff, 165.
16. See Braun, 97–8 (n. 27). The Socialist Deputy Giacomo Matteotti was kidnapped and murdered by fascist squads in June 1924. In response to the backlash that followed, Mussolini assumed greater control of party activities, seeking to centralize (and institutionalize) political and cultural initiatives. The founding of the National Institute of Fascist Culture in January 1925 coincided with Mussolini's landmark speech on the 3rd of the month, generally held to be the starting point of the dictatorship.
17. W. L. Adamson, "The Culture of Italian Fascism and the Fascist Crisis of Modernity: The Case of *Il Selvaggio*," *Journal of Contemporary History* 30:4 (October 1995), 555–75, 560.
18. O. Bisorco [pseudo. Mino Maccari], *Il Selvaggio* 4 (16 September 1927), cited in J. Hay, *Popular Film Culture in Fascist Italy: The Passing of the Rex* (Bloomington, IN: University of Indiana Press, 1987) (p. 132; English text adapted from James Hay's translation).
19. G. Bottai, "Outcome of the Fascist Art Inquiry," originally published in *Critica fascista* 5:4 (15 February 1927), 61–4, reproduced in translation in *A Primer of Italian Fascism*, ed. J. T. Schnapp, 233–41, 237. A prominent intellectual, Bottai founded *Critica fascista* in 1923. He was also Undersecretary of the Corporations at this time, and would become Minister of the Corporations in 1929 and Minister for National Education in 1936.
20. See Lazzaro, 15.
21. O. Bisorco [pseudo. Mino Maccari], "Gazzettino Ufficiale di Strapaese," *Il Selvaggio* (16 September 1927), quoted in translation in Adamson, 564–5.
22. Adamson, 557.
23. While the regime's suppression of regional dialects formed part of the campaign for linguistic nationalism in the early 1930s, its leisure-time organization (Opera Nazionale Dopolavoro) promoted regional culture with the aim of neutralizing it (and nationalizing it) through state control. See Ben-Ghiat (1997), 440. Tuscan dialect might be understood to have a peculiarly national significance, given that it forms the basis of standard Italian language.
24. Braun has made this argument in relation to the constancies of style and subject matter in Giorgio Morandi's still-lifes. Morandi was regarded by the *strapaesani* as "their resident genius." See Braun, 105–6.
25. Filmed partly on location in the Pontine Marshes, *Sole* explores the agricultural reclamation project (*bonifica agricola*) initiated by the Fascist government in this region. *Terra madre* is discussed here in the context of these reclamation policies and the discourses surrounding them.
26. See P. Garofalo, "Seeing Red: The Soviet Influence on Italian Cinema of the Thirties," in *Re-viewing Fascism: Italian Cinema, 1922–1943*, eds P. Garofalo and J. Reich (Bloomington, IN: Indiana University Press, 2002, pp. 223–49, 237).
27. Garofalo, 224.
28. L'Eremita, "La metropoli e la provincia," *Il Selvaggio* (2–8 August 1925), cited in translation in Adamson, 561.
29. S. Ricci, *Cinema and Fascism: Italian Film and Society, 1922–1943* (Berkeley, CA: University of California Press, 2008) (pp. 162–3). Reviews in Italian language

newspapers aimed at expatriates evoked the idea of a virtual return to origins in the act of viewing *Terra madre*. Readers in Egypt were advised that this "film italianissimo" would be particularly enjoyed by Italians abroad (*Il Giornale d'Oriente*, Alexandria, 7 January 1932). The Montreal newspaper *Italia* described the film's tour of the US as "a solemn and very Italian patriotic and artistic event" ("Terra madre inizia il suo giro trionfale," *Italia*, Montreal, 2 January 1932). Meanwhile, *Variety* adjudged that the film would "not suit the American market except the Latin element. The subject is too Italian to meet with their approval" ("Mother Earth fine for Italy Only," *Variety*, New York, 25 March 1931). (All FB TM.) This seems consistent with James Hay's discussion of the parallel developments of cinema and telephony as: "technologies of empire—(not simply constructing modern cities in previously remote provincial areas inside national borders [...] but of maintaining settlements beyond the national border." J. Hay, "Placing Cinema, Fascism and the Nation in a Diagram of Italian Modernity," in *Re-viewing Fascism*, eds J. Reich and P. Garofalo (Bloomington: Indiana University Press, 2000, pp. 105–37, 121).

30. P. Binde, "Nature Versus City: Landscapes of Italian Fascism," *Environment and Planning D: Society and Space* 17 (1999) (pp. 761–75, 768). Mussolini's declaration was made during his speech at the inauguration of the new town of Littoria (now Latina) in 1932.
31. Ibid.
32. Charles Burdett's analysis of the ideological function of the new towns through Foucault's model of the heterotopia is particularly useful in this respect. See C. Burdett, "Journeys to the *other* spaces of Fascist Italy," *Modern Italy* 5:1 (2000), 7–23, especially 16–19.
33. The event took place on 15 December 1931 and seems to have been widely reported in the press. See, for example, "Terra madre presentata a Washington in onore di sua eccellenza il Senatore Barone De Martino," *Italia*, Montreal, 2 January 1932; "Il film 'Terra madre' proiettato a Washington," *Gazzetta di Venezia* (16 December 1931); "Il film 'Terra Madre' rappresentato in una cerimonia a Washington," *Popolo di Trieste* (16 December 1931); "Una serata Italiana a Washington," *Il Solco Fascista*, Reggio Emilia (16 December 1931); "Terra Madre proiettato a Washington," *Vedetta d'Italia*, Fiume (16 December 1931) (all FB TM).
34. Vito Zagarrio reads the presence of sheaves of corn as symbols of "sexual insemination." See V. Zagarrio, "Ideology Elsewhere: Contradictory Models of Italian Fascist Cinema," in *Resisting Images: Essays on Cinema and History*, eds R. Sklar and C. Musser (Philadelphia, PA: Temple University Press, 1990, pp. 149–72, 154).
35. Marco tells Emilia that the arrival of the machines means that women no longer have to work in the fields, and as is suggested by the symbolic abundance of grain, freedom from work signals her availability for reproduction.
36. See R. Ben-Ghiat, *Fascist Modernities: Italy, 1922–1945* (Berkeley, CA/ Los Angeles, CA: University of California Press, 2001) (p. 82).
37. On the cyclical nature of rural life, see Antliff (2002), 158.
38. D. M. Lasansky, *The Renaissance Perfected. Architecture, Spectacle & Tourism in Fascist Italy* (University Park, PA: Pennsylvania State University Press, 2004).
39. R. Golan, "From monument to *Muralnomad*: the mural in modern European architecture," in *The Built Surface Volume 2: Architecture and the pictorial*

arts from Romanticism to the twenty-first century, ed. K. Koehler (Aldershot, UK: Ashgate, 2002, pp. 186–208, 186). Also see Golan's monograph on this subject: *Muralnomad: The Paradox of Wall Painting, Europe 1927–1957* (New Haven, CT/London: Yale University Press, 2009).

40. C. Carrà, *Giotto* (Rome: Valori Plastici, 1924). On the Manifesto and the Triennale, see Golan (2002).

41. Golan (2002), 186.

42. G. Michelucci, "Conntatti fra architetture antiche e moderne," *Domus* (March 1932), reproduced in Lasansky, 195.

43. G. Michelucci, "Fonti della moderna architettura italiana," *Domus* (August 1932), reproduced in Lasansky, 199.

44. One contemporary discussion of national cinema made just this point, that "cinema is an art that has no canons." See M. Albani (*Da Oggi e Domani*), "La nazionalità della cinematografia," *Piccolo della Sera delle ore 18*, Trieste (1 January 1932), (FB TM).

45. See Ben-Ghiat (2001), 82. Blasetti would later acknowledge the influence of Soviet filmmakers on the Italian cinema of the late 1920s, indicating that he "read with interest and attention" the work of Eisenstein, Pudovkin, and Ekk, but that it would be some years before he was able to see their films. Alessandro Blasetti, "Italian Cinema Yesterday," reprinted in *The Fabulous Thirties: Italian Cinema, 1929–1944*, eds A. Aprà and P. Pistagnesi (Milan: Electa, 1979, p. 40), cited in Garofalo, 236.

46. Ibid.

47. Antliff, 154. Antliff aligns his own evaluation with that of Andrew Hewitt. See A. Hewitt, *Fascist Modernism: Aesthetics, Politics, and the Avant-Garde* (Stanford, CA: Stanford University Press, 1993) (p. 137).

48. Albani (as in note 45).

49. C. Pavolini, "Case toscane," *L'illustrazione toscana* (1933): 2, quoted in translation in Lasansky, 199. Having previously argued that the regionalist project of *Strapaese* was incompatible with Mussolini's desire to transform Italy into a great modern nation, this article sees Pavolini resituate himself in debates between the local and the national, and between tradition and modernity. See "L'omino di bronzo," letter from Corrado Pavolini, with responses from Ottone Rosai and Mino Maccari, *Il Selvaggio* (7 September 1926), cited in Mangoni, 136–7. Pavolini's father was the journalist and politician Alessandro Pavolini, leader of the Fascist Party in Florence (1929–34) and Minister of Popular Culture (1939–43).

50. A. Soffici, "Apologia del futurismo," *Rete mediterranea* (September 1920), quoted in translation in W. L. Adamson, "Soffici and the Religion of Art," in *Fascist Visions: Art and Ideology in France and Italy*, eds M. Affron and M. Antliff (Princeton, NJ: Princeton University Press, 1997, pp. 46–72, 61).

51. Braun, 98.

52. On the filmic invention of the Pontine Marshes in newsreels, see F. Caprotti and M. Kaïka, "Producing the ideal fascist landscape: Nature, materiality and the cinematic representation of land reclamation in the Pontine Marshes," *Social and Cultural Geography*, 9: 6 (September 2008), 613–34. On the OND's revival of regional culture, see Ben-Ghiat (1997), 440.

53. Antliff, 151. Antliff is discussing the regenerative uses of history in the Third Reich here, as part of a comparative discussion of German and Italian fascisms.

54. Blasetti preferred the idea of a human subtext, suggesting that "the return to the healthy traditions of the land" was a "profoundly human" rather than a political story, though he does concede that the outcome of the narrative can be identified with the "admirable effort" of fascism. See "Terra madre: Dai germi fecondi della nostra terra solatia sorge tripudiante la ricchezza della stirpe," *Domenica del cinema*, Trieste, 1 March 1931, 2. FB TM.

55. Ben-Ghiat notes this aspect of the film's presentation in Washington, DC. See Ben-Ghiat (2001), 84.

Part IV
Painters and Filmmakers

11

Artistic Encounters: Jean-Marie Straub, Danièle Huillet, and Cézanne

Sally Shafto

For Erika Mueller

*Life is a series of encounters and chance meetings, and this
holds true for our work; otherwise, it's worth nothing.*

Jean-Marie Straub

*All painters, if they were serious, would have ended up
painting like Cézanne at the time!*

Jean-Marie Straub

*It is true that there is hardly one modern artist of impor-
tance to whom Cézanne is not father or grandfather, and
that no other influence is comparable with his.*

—Clive Bell (1922)

The work of some filmmakers seems regularly nourished and sustained
by painting and art history. In the immediate postwar period, there
was a flush of films about artists, including several by the young Alain
Resnais, in an attempt, so it is thought, to bolster belief in the eternal
value of great works of art. Starting with Stanley Kubrick's *Barry Lyndon*
in 1975, a new era in cinema–painting relations began, as filmmakers
increasingly referred to painting, Jean-Luc Godard's *Passion* (1982),
Derek Jarman's *Blue* (1993), and Wim Wenders' *The End of Violence*
(1997), to name a few. The filmmakers Jean-Marie Straub and Danièle
Huillet, although long interested in the painter Cézanne, never cited
an overriding interest in the cinema–painting dialogue. In a 1987 inter-
view with Jacques Aumont and Anne-Marie Faux, Jean-Marie Straub
commented:

> Today you can't read a shooting script without finding things like:
> 'I would like a light like in a Vermeer painting,' But it's not
> possible: no filmmaker can make films under these conditions! [...]
> This perpetual reference to painting is frightening.
>
> (Aumont and Faux, 1987, 35)

The French word Straub used for "frightening" is *effrayant*. His long-
time collaborator, Danièle Huillet, went even further, calling cinema's
referencing of painting a sign of film's decadence (Aumont and Faux,
1987, 39). Nor were these filmmakers particularly interested in exhibit-
ing in a museum, as Godard, Agnès Varda, and Chris Marker have all
done, even though the first of their Cézanne films was commissioned
by the Musée d'Orsay and the second was inspired by Cézanne's visit to
the Louvre. In fact, Jean-Marie Straub has said that he doesn't even like

museums and that he wants to flee after half an hour in one (Lafosse, 2007, 171). What then is the source of their interest in Cézanne?

What is at stake for them in their film, *Cézanne*, is their *encounter*, as Straub would put it, with the painter, whom they've admired for many years. In fact the entire filmography of this filmmaking couple can be read as a series of encounters that Straub describes as veritable *"coups de foudre"* and "shocks" (Raymond, 2008, 91). Straub often quotes François Truffaut's dictum about there being two kinds of filmmakers: those who want to make films in general and those who want to make one film in particular (Raymond, 2008, 99). If Truffaut falls into the former category, it is clear that Jean-Marie Straub and Danièle Huillet fall into the latter.

Before turning specifically to Straub and Huillet's encounter with Cézanne, I would like to point out another, also between a filmmaker and a painter. In 1968 the British filmmaker Peter Watkins was in Oslo for a conference and there for the first time he discovered the paintings of Edvard Munch. So taken was Watkins with Munch's work that he decided to do a film on the painter. Like Straub and Huillet, Watkins has what the French call *une personalité entière*, an uncompromising character, and at the beginning of the 1970s, he moved his family to Oslo to be closer to his subject. His film *Edvard Munch* (1974) is one of the most moving and personal films about an artist ever made. It is also very different from the Straub and Huillet film on Cézanne.

Jean-Marie Straub was born in 1933 and Danièle Huillet in 1936, just over a century after Cézanne's birth in 1839. By his own admission, as a young man growing up in the eastern French city of Metz, Straub was not particularly focused on becoming a filmmaker. Straub and Huillet first met in 1954 at the Voltaire high school in Paris, where they were both enrolled in the Institut des Hautes Etudes Cinématographiques preparatory class—which Straub left after two weeks. That same year Straub came up with an idea for a film on Johann Sebastian Bach that he offered to the filmmaker Robert Bresson, whose work he esteemed. Bresson counseled him to make the film himself. By 1958, the year that Straub left his homeland as a conscientious objector to the Algerian conflict, he already had a script. It would, however, take ten more years to make this film. In between he and Huillet made two other films, both based on their encounter with the fiction of Heinrich Böll: *Machorka-Muff* (1962), and *Nicht versöhnt* (Not reconciled, 1965).

After their Böll and Bach films, the directors subsequently encountered the works of the composer Arnold Schoenberg, the German playwright Bertolt Brecht, the German Romantic poet Friedrich Hölderlin, and

the Italian authors Elio Vittorini and Cesare Pavese. Straub recalls the electrifying effect his viewing of Schoenberg's opera *Moses und Aaron* had on him in Berlin in 1958. It would be no understatement to say that their entire lives' work seems built on such pivotal *encounters*. Their choice of painter is hardly accidental: the filmmakers had an encounter with Cézanne. After seeing their film *Fortini/Cani* (1977), Jacques Rivette told the filmmakers it had made him think of Cézanne and urged them to read C. F. Ramuz's study of the painter (Aumont and Faux, 1987, 39). For Straub and Huillet, all of Western painting can be summed up with just two painters: Giotto and Cézanne. Often, the filmmakers have presented their films in cities just to see a painting by Cézanne, who is, according to Straub, the greatest "French painter" (Lafosse, 2007, 167).

The first of their two Cézanne films, entitled *Cézanne*, was commissioned by Virginie Herbin of the Musée d'Orsay, who initially proposed that they do a film on early Cézanne to coincide with the museum's 1988 traveling exhibition, *Cézanne: The Early Years 1859–1872*. Herbin attended a presentation in Avignon where the filmmakers spoke "so much about Cézanne that the idea seemed obvious to me" (Herbin, 1990, 530). But the couple, who were then at work on *Schwarze Sünde/Black Sin*, the last of their films on the Greek philosopher Empedocles, initially turned down the invitation and told her to ask Godard instead. Finally recognizing that they had been thinking about Cézanne for the last 20 years, they agreed to do the film (Raymond, 2008, 34). Their *Cézanne* is at great pains to avoid falling into the category of a documentary or a film about an artist. There is no biographical information given, nor is any historical overview proffered. Because of what Jacques Aumont has termed "the Straubian hatred of inflation," the filmmakers rigorously avoid showing Cézanne's most iconic works (Aumont, 1990, 99), just as in their films they have generally chosen not to use professional actors with well-known faces. Neither is this film nor its successor, *Une Visite au Louvre*, an illustration of Merleau-Ponty, Meyer Schapiro, Lionello Venturi, or John Rewald's vision of the painter (Figure 11.2).

Instead, Straub and Huillet offer us a highly personal encounter with the painter's oeuvre in much the same way that Cézanne's pictures of Mont Sainte-Victoire, for example, are recognizable but highly individual interpretations of the mountain. Just as Cézanne's paintings challenged viewers in his day, so too are Straub and Huillet's films regularly termed "difficult" by those with no prior knowledge of their work. *Cézanne* lasts 51 minutes, an unconventional length for a film. (The filmmakers also made a German-language version of the film, entitled

Paul Cézanne im Gespräch mit Joachim Gasquet, that lasts 63 minutes and that I have not yet seen (Hüser, 2008, 275)).

Cézanne includes a mere ten works by the artist, with only one in the first half hour and, aside from three lateral tracking shots, no camera movement. All the paintings are carefully shown in their frames. The fact that the paintings are often slightly off-kilter in the film frame seems to evoke Cézanne's own occasionally self-consciously awkward framings. Even the voice-over is unusual: read by Danièle Huillet, the voice-over frequently does not observe the punctuation of the original text, and breaks and pauses occur in unexpected places. Straub and Huillet's *Cézanne* self-consciously breaks with tradition and convention.

The filmmakers focus not on Cézanne's early period, but on the last decade of his life between the spring of 1896, when he first met the young writer Joachim Gasquet, on whose memoir the film is based, and 1906, when he died. Art historians widely regard this late period as having "special importance" in the Cézanne corpus because of the extraordinary developments in his work (Reff, 1977, 13). Although the filmmakers confine themselves to the painter's last decade, they do not show the works in strict chronological order.

The choice of the Gasquet text is critical to understanding how the filmmakers organized their film, and in fact it cues the images that are shown. In their filmography, the film closest to this one is surely their Bach film, *Chronik der Anna Magdalena Bach* (The Chronicle of Anna Magdalena Bach, 1968), which is based on historical documents from the period. Although their *Cézanne*, unlike the earlier film, is not a costume film, it nonetheless reveals a profound understanding of the painter, just as *The Chronicle of Anna Magdalena Bach* does of the musician.

The Gasquet text has the advantage of providing one of the fullest accounts of the painter by a contemporary. Cézanne himself never wrote a treatise on painting, and there are few important primary documents on his life prior to 1894. It is well known that the novelist Emile Zola, who had been an intimate of Cézanne's in their youth, first in Aix-en-Provence and later in their early years in Paris, based his novel *L'Oeuvre* on Cézanne and the Impressionists. But the main character of *L'Oeuvre*, the painter Claude Lantier, while owing much to Zola's childhood friend, owes even more to his fictional lineage: he is the son of Gervaise and Lantier in Zola's previous novel *L'Assommoir*. The suicide of Claude Lantier in *L'Oeuvre* is seen as the natural and unopposable result of unfortunate hereditary forces. Ultimately, the Zola novel is a *roman à thèse* illustrating its creator's ideas and in no way illuminating Cézanne's artistic process. According to the Cézanne scholar John

Rewald, Cézanne identified more with the painter Frenhofer in B; ic's
Le Chef-d'oeuvre inconnu than he did with Zola's Claude Lantier (R(ild,
1936, 166). By all accounts, Cézanne was secretive, very sensitiv(ind
easily took offense: shortly following the publication of *L'Oeu* in
1886, he unequivocally broke with the novelist.

Joachim Gasquet was the son of another childhood friend fron ix,
Henri Gasquet. John Rewald reminds us that we know very little out
Cézanne's relationship with the younger Gasquet, who was o of
Cézanne's last friends and one of his first biographers. Most of wh we
do know about their friendship comes from Gasquet himself (R(ild,
1959, 7). It is important to note that Gasquet's book was first pub(ied
in 1921 (Kear, 2002, 138), thus 15 years after the painter's death. (ien
they met, Cézanne was 57 and Gasquet 23. After 1900, their f(nd-
ship cooled: apparently, Cézanne came to feel that the younge(ian
was interested in his work for purely speculative purposes. Ther(ter,
they rarely saw each other before their definitive break in 1904. R ald
observes that Gasquet's "imaginary conversations" with the pain do
not closely rely on Cézanne's letters and therefore should be consi red
as occasionally owing more to Gasquet's imagination than might igi-
nally be thought (Rewald, 1959, 8).

Aware that the text is sometimes fanciful, the filmmakers ca(illy
strip it of all excess and topical references deemed un-Céza(an.
The entire voice-over of the *Cézanne* film consists of Danièle (llet
reading Cézanne's passages in the text, with Jean-Marie Strat as
Gasquet, occasionally interjecting. Gasquet's book is divided int(wo
parts: the first consists of his biography of the painter, and the s(nd,
entitled, "Ce qu'il m'a dit" (What He told Me), provides the ba: for
the two Cézanne films by Jean-Marie Straub and Danièle Huille(he
second half of Gasquet's book is divided into three parts: "The N if,"
"The Louvre," and "The Workshop." The dialogue from their first C(ine
film is drawn primarily from "The Motif," while the film's final dialo e is
drawn from the end of "The Workshop." Their second Cézanne filr *Une*
Visite au Louvre, is based on "The Louvre" chapter of the Gasquet b k.

The filmmakers have carefully chosen passages in the text that em
in synch with the images they have chosen. Looking at a page om
their script for *Une Visite au Louvre* (Figure 11.1), we see how D; ièle
Huillet has appropriated the original text, truncating the sentenc(ind
transforming it into a kind of musical partition. Interestingly, i the
passages selected from Gasquet, there are numerous references t the
painter as a "sensitive plate" or as a "receptacle of sensations, a br 1, a
recording machine." What better metaphor for a filmmaker?

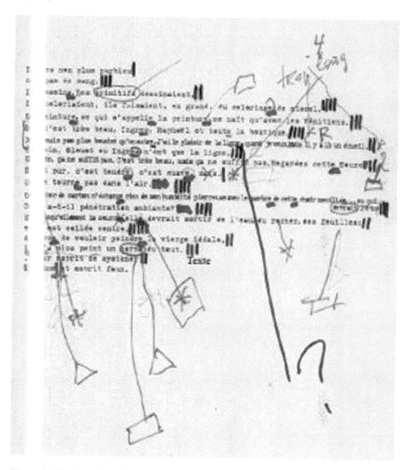

Figu **11.1** Page from Straub-Huillet script for *Une Visite au Louvre*, 2004

J as the filmmakers were at pains in their Bach film to include
exa ples of all the composer's musical genres, so here too their careful
sele ion of just ten works encompasses the painter's various motifs:
Mo Sainte-Victoire, still-lifes, portraits, and bathers. Cézanne is today
rec nized as exceptional among great artists for his ability to divide his
att ion between such different genres (Murphy, 1968, 94). Likewise,
the m is careful to include at least one example of the principal media
Cé ne worked in: oil, watercolor, and drawing.

S rtly before meeting Gasquet, Cézanne had ended his friendship
wit nother man of letters, Gustave Geffroy, who wrote in 1894 the first

serious appreciation of Cézanne (Geffroy, 1894, 248ff). The two men, Geffroy and Gasquet, could not have been more different. While Geffroy was a Parisian man of the left, an atheist, and a contributor to the review *La Justice*, edited by Georges Clemenceau, and whose major work was devoted to the revolutionary Louis Blanqui (1896), Gasquet was a Catholic chauvinist from Aix, who in 1917 published a book entitled *Bienfaits de la Guerre* (The benefits of war). Years later Edmond Jaloux, a mutual friend of both Cézanne and Gasquet, described Gasquet's ideas as a precursor to Vichy (Rewald, 1959, 20–21.) While Geffroy's outlook was clearly more in line with that of Zola, the mature Cézanne, a Catholic and an anti-Dreyfusard, found himself more naturally in sympathy with Gasquet. Cézanne gave at least five paintings to his young friend, including one of Mont Sainte-Victoire and *The Old Woman with a Rosary* (Figure 11.2.)

Straub and Huillet's first film, *Cézanne* (1989), begins with a view of Aix-en-Provence with a traveling shot to the left, followed by another traveling shot to the right, ending on the Mont Sainte-Victoire—a leit-motif in the painter's final years. These two contemporary shots are then followed by two photos, taken in 1906 by the artist Ker-Xavier Roussel, of Cézanne painting on the hill of Les Lauves, from where he could see Mont Sainte-Victoire. In 1901 the painter bought property in the area of Les Lauves, just north of Aix-en-Provence, and built a studio to his specifications. On the crest of Les Lauves, Cézanne discovered a new exhilarating vista. Suddenly the Sainte-Victoire was no longer the "chopped off cone

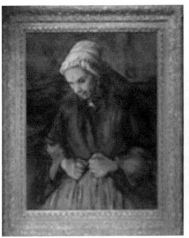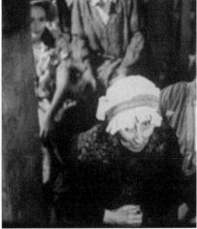

Figure 11.2 Cézanne, *Old Woman with a Rosary*, 1896, National Gallery of London; (r) Still from Renoir film Madame Bovary, 1933

that he had earlier contemplated but an irregular triangle" (Rewald, 1977, 95). The first 33 minutes of the film show several shots of the landscape surrounding Aix from the Lauves area, today heavily industrialized; in fact, these shots mirror the beginning of Gasquet's text, "What He Told Me," where Gasquet describes Cézanne painting Mont Sainte-Victoire (Figure 11.3).

The first half hour of the film thus consists of the following: several filmed shots in and around Mont Sainte-Victoire, one painting, three photos of Cézanne that include the previously mentioned two by K. X. Roussel and one by Emile Bernard, and three film clips. Given the emphasis on nature in the film and its importance to Cézanne, whose early years were associated with the birth of Impressionism and *plein air* painting, it is no accident that the photos chosen all show the painter outdoors.

Cézanne painted *Old Woman with a Rosary* in 1896 (Rewald, 1996, vol. 2, 808, 279), right before undertaking Gasquet's portrait. In the film, this painting is introduced by the following passage from Gasquet's book that quotes the painter:

> When I was painting my Old Woman with a Rosary, I saw a Flaubert colour, an atmosphere, something indefinable, a bluish russet colour that seemed to me to come from Madame Bovary. I was afraid for

Figure 11.3 Mont Sainte-Victoire, still from Straub-Huillet film, *Cézanne*, 1989

ô alors vous bien-aimés —
partagez action et gloire,

Figure 11.4 Mount Aetna, still from Straub-Huillet film, *The Death of Empedocles*, 1987

a while that it might be too literary, and therefore dangerous, so I tried to get rid of my obsession by reading Apuleius, but it didn't help. That wonderful blue and russet colour had a hold on me. It struck a chord in my heart. It was flowing all around me. [...] I carefully examined all the details of the woman's clothes—her cap, the folds of her apron—and I deciphered her sly expression. Only later did I register that the face was russet, and the apron bluish, just as it was not until after the picture was finished that I remembered the description of the old servant at the agricultural show.

(Gasquet, 1991, 151–152)

Since Gasquet owned *Old Woman with a Rosary*, it is not surprising that he should mention it in his imagined conversations with Cézanne. The words he attributes to him are in accordance with what we know about the painter who abhorred literary influences and struggled throughout his career to be true to nature. The reference to Cézanne re-reading Flaubert comes from a letter the painter wrote to Gasquet on 29 September 1896 (Cézanne, 1978, 320). The image track then immediately cuts to the scene of the "Comices agricoles" (the agricultural fair) in Jean Renoir's 1933 adaptation of Flaubert's *Madame Bovary*. Given the fact that the *Cézanne* film lasts just 51 minutes, this clip from the

Renoir film, lasting seven minutes and 30 seconds, seems astonishingly long, even troubling. Understanding the filmmakers' singular use of it will bring us closer to understanding their methodology. Ostensibly, this long scene interests the filmmakers for the moment when the pious old woman goes to receive her medal: Cézanne had thought of the Flaubert character while painting his *Old Woman with a Rosary*. The old woman, however, doesn't appear until five minutes after the beginning of the clip. Most first-time viewers don't necessarily grasp the analogy, having gotten caught up in the conversations between Emma Bovary and her maid, between Charles Bovary and Homais on the virtues of surgery, and later between Emma Bovary and her lover-to-be, Rodolphe.

Along with Bresson, Jean Renoir is one of a handful of filmmakers whose work has been important for Straub and Huillet. Between 1955 and 1956, Straub even worked for Renoir as an assistant on *French Cancan* and *Elena et les Hommes/Paris Does Strange Things* (Hüser, 2008, 277; Roud, 1972, 23–26). The filmmakers felt it was impossible to cut the scene, that the scene had to be respected in its entirety. This block-like style, notwithstanding its potential for misdirecting the spectator, seems particularly characteristic of the Straub and Huillet modus operandi and their materialist approach seems very akin to Cézanne's (Raymond, 2008, 83). For Adrian Martin, citing Jean-André Fieschi, Straub and Huillet are "materialists in every sense," because they are dealing with "material history, material world, material of film" (Martin, 2006; Fieschi, 1980, 867–73). It's worth adding that Jean Renoir was of course the son of the painter Pierre-Auguste, a colleague and friend of Cézanne's.

The length of this scene also suggests a correspondence between the provincialism of Charles Bovary with that of Cézanne, who despite having lived many years in Paris never lost his solitary, small-town nature (Florman, 2008). Cézanne, like his fictional counterpart, was particularly maladroit with members of the opposite sex. It seems likely that Cézanne himself recognized this affinity, and the scene in turn highlights an analogy between Flaubert and Cézanne, and by correlation, with Straub and Huillet themselves. In his search for perfection and his devotion to work, Cézanne was to painting what Flaubert (1821–80) was to literature and, some might say, what Straub and Huillet are to film. The filmmakers here follow Gasquet who wrote of Cézanne: "He worked. That is the motto of his whole life, its summing-up. He went on painting. His whole existence depended on it. He worked, as only he and Flaubert did, to the point of ecstasy or anguish" (Gasquet, 1991, 95). Throughout his text, Gasquet

emphasizes the similarity between Flaubert and Cézanne and even prefaces the second half of his book, "What He Told Me," by calling the painter's life "the life of a saint" (Gasquet, 1991, 146), a clear reference both to Flaubert's *The Temptation of Saint Anthony* and to Cézanne's painting of the same title. Frequently not content, Cézanne often reworked the same painting over many years, occasionally even destroying his work. Flaubert began *The Temptation of Saint Anthony* and dissatisfied, put it aside, finally publishing a third version in 1874 at the end of his life, the year that Cézanne finished his painting of the same topic.

Besides the clip from Renoir's *Madame Bovary*, the first half hour includes two other film clips, which are both from Straub and Huillet's film *Der Tod des Empedokles* (The death of Empedocles), which is based on the writings of Friedrich Hölderlin (Lafosse, 2007, 31). As with the Renoir, the Gasquet text cues these clips:

> And then this element in which we habitually move ... this sunshine, here's another thing This chance fashion in which its rays fall, the way it moves, infiltrates things, becomes part of the earth's fabric—who will ever paint that? Who will ever tell that story? The physical history of the earth, its psychology.
>
> (Gasquet, 1991, 152)

What, we may well wonder, is Hölderlin's romantic interpretation of the Greek natural philosopher doing in a film on the father of modern painting? The filmmakers point out that Cézanne, who received a classical education, had read Lucretius in Latin, and in the Gasquet text, Cézanne does in fact refer to Lucretius (Gasquet, 1991, 153). Lucretius, like Empedocles, narrated a cosmogony and the filmmakers have simply substituted the Greek poet and philosopher for the Roman poet and philosopher. Having just finished several films on Empedocles, Straub and Huillet were clearly still thinking of him when they undertook their film on Cézanne. These two figures were so closely associated in their minds that they originally distributed *Cézanne* together with their last film on Empedocles, *Black Sin* (1990), as a kind of diptych (Figure 11.4).

To fully apprehend their use of these two clips on Empedocles in their *Cézanne* film, we need an understanding not just of Empedocles but also of Hölderlin whom Straub has called the "greatest European poet" (Lafosse, 2007, 87). Once again, the filmmakers' artistic encounter is profoundly intertextual: they present us Gasquet's vision of Cézanne, Renoir's of Flaubert's *Madame Bovary*, and Hölderlin's of Empedocles.

In each case, we are dealing with artists who succeeded in redefining the frontiers of their respective arts: Cézanne as a painter, Flaubert as a novelist, Renoir as a filmmaker, and Hölderlin as a poet.

Dominique Païni notes that it was in Hölderlin's day in the early 19th century that a modern understanding of nature first arose. This new attitude toward nature, dispensing with a religious, philosophical, or poetic justification, culminated in Cézanne's work at the end of the century (Païni, 1990, 19). The abstraction of late Hölderlin corresponds not just to Cézanne's painting but also to Straub and Huillet's filmmaking (Byg, 1995, 186). Just as the filmmakers' use of the long clip from Jean Renoir's *Madame Bovary* goes beyond the obvious correspondence between the old woman and Cézanne's painting, so here too what is at stake goes beyond the simple verbal evocation. Empedocles, the radical pre-Socratic philosopher, who was ostracized by his peers from the community of Agrigentum, suggests in turn both Cézanne's years in the wilderness—between 1877 and 1895, Cézanne's work was shown in only two minor exhibitions—and the incomprehension with which the filmmakers' own work has so often been received. In the first clip from *The Death of Empedocles*, Empedocles is accompanied by his young disciple, Pausanias, who joined him in exile. It is easy to see herein an analogy between Empedocles' relationship with Pausanias and Cézanne's own relationship with a group of younger men—Gasquet for a time and later the painters K. X. Roussel, Emile Bernard, and Maurice Denis—who all revered the painter in the final years of his life.

Following the first Empedocles' clip, we see a filmed image of Mont Sainte-Victoire while Danièle Huillet reads the line: "These rocks were made of fire. There is still fire in them" (Gasquet, 1991, 153), while on the image track, we see their filmed image of the mountain. According to Straub, Mont Sainte-Victoire, once the greatest reservoir for dinosaurs in Europe, was originally a volcano. Cézanne was famous for saying, "I don't paint anything I don't see" (Götz, 1995, 12), while Straub believes that "to show something, one must have seen something. And to see something, one must have looked at it for years" (Byg, 1995, 21). Straub maintains that Cézanne's long, patient study of Mont Sainte-Victoire gave him a profound insight into it (Aumont and Faux, 1987, 52).

The first clip from *Empedocles* lasts four minutes and 30 seconds, while the second, lasting five minutes, ends the first part of the film (28:43–33:42); it, too, is cued by the preceding passage from Gasquet read by Huillet: "By tilling my field, I would start to grow a lovely

landscape ..." The image track then cuts to show us a lovely land ape
that Empedocles would have known: Mount Aetna surrounded y a
cloud. It is thought that Empedocles died by throwing himself in the
volcano. (see Figure 11.4)

The second half of the film, lasting 15 minutes, shows us nine di-
tional images by Cézanne. The second painting, *Apples and O* *ges*
(*c.* 1899, Rewald, 1996, vol. 2, 847, 296), is similarly in synch ith
the spoken text, and was carefully chosen for what it reveals out
Cézanne's approach:

> I mean that on this orange I'm peeling or, indeed, on an le,
> a ball, or a head, there is a culminating point, and despite tr en-
> dous effects—light, shade, colour sensations—this point is a ays
> the one nearest our eye. The edges of objects recede towards an her
> placed on your horizon.
>
> (Gasquet, 1991 63)

It is during this disquisition that Cézanne tells Gasquet somethi he
had written in a letter to Emile Bernard and that has become one the
most famous dicta in modern art (Murphy, 1968, 77):

> I've written to a painter who came to see me, [...] who does a of
> theorizing himself. I'll sum up what I said to him in my lette ...]
> "Treat nature in terms of the cylinder, the sphere, and the con the
> whole put into perspective so that each side of an object, o f a
> plane, leads towards a central point."
>
> (Gasquet, 1991 66)

The third painting is the first of three shown of Mont Sainte-Vi ire
(1900–02; Rewald, 1996, vol. 2, no. 901, 315), without a doubt Céz e's
most famous motif in his later years. This painting, delicately colo in
predominantly blue tones, reveals its underdrawing, particularly the
tree in the left of the landscape. Once again, the image is evoked the
accompanying text read by Huillet:

> Colours are the expression, on this surface, of this depth. The ise
> up out of the earth's roots: they're its life, the life of ideas. Dra ng,
> on the other hand, is a complete abstraction. So that it must ver
> be separated from colour. [...] As soon as life breathes into it, d it
> is dealing with sensations, it becomes coloured. Fullness of dr ing

vays corresponds with fullness of colour. When you come down to
where in nature do you ever find anything drawn?

I e Cézanne indicates that the long-standing academic opposition
bet en colorists and draftsmen, followers of Rubens versus followers
of :olas Poussin, is irrelevant in his own work: he is occasionally a
col st and at other times a draftsman, and sometimes both, as in this
wo (Reff, 1977, 49). This opposition will play an important role in
the :cond Cézanne film by Straub and Huillet, *Une Visite au Louvre*
(se igure 11.1).
 1 : fourth painting shown is another of the Mont Sainte-Victoire
see from Les Lauves (1904–6; Rewald, 1996, vol. 2, 931, 325). It is
on f Cézanne's most beautiful portraits of the mountain. With no
un drawing visible, it shimmers in abstract prisms of green and
blu while we hear Huillet read the following passage from Gasquet:

nes in colour, planes! The coloured place where the heart of the
nes is fused, where prismatic warmth is created, the encounter
planes in sunlight. I produce my planes with the colours of
' palette, do you follow me? You have to see the planes ...
arly ... but fit them together, blend them. They must turn and
erlock at the same time. Only volumes matter. Let air circulate
ween objects if you want to paint well.

(Gasquet, 1991, 167)

Th ast phrase, "Let air circulate between objects if you want to paint
wel points up the fact that several of the works chosen by the film-
ma rs are either unfinished or suggest that they are unfinished because
of amount of white space left on the canvas. In this approach among
oth s, Cézanne is rightly considered the father of modern painting.
 1 cue for the fifth painting, *Rocks and Branches at Bibémus* (1900–04;
Rev d, 1996, vol. 2, 881, 309), begins in the dialogue heard at the end
of fourth painting:

1en I get up from painting, I feel a sort of intoxication, a sort of
tasy; it's as if I were stumbling around in a fog I'd like to lose
'self in nature, grow again with nature, like nature, have the stub-
rn shades of the rocks, the rational obstinacy of the mountain, the
idity of the air, and the warmth of the sun.

(Gasquet, 1991, 167–8, 169)

Here the fifth painting is introduced as the Huillet/Cézanne voice-over continues without stopping: "In a green my whole brain would flow in unison with the sap rising through a tree's veins" (Gasquet, 1991, 168).

The sixth painting, shows a third version of Mont Sainte-Victoire also seen from Les Lauves (Rewald, 1996, vol. 2, 917, 321). Here Cézanne has thinned his oil paint so much that it resembles watercolor and reveals a lot of white space. Despite its summary nature, it conjures up perfectly the mountain. Shown for only six seconds, this image is unaccompanied by the Gasquet text and the silence here suggests that it is meant as an auditory equivalent of the white space called for by Cézanne in his paintings.

The seventh work is a watercolor, *Still Life with Apples, Bottle, and Back of Chair* (1902–6); executed in a predominately red coloring, it is shown for 54 seconds. Cézanne gave renewed importance to the still-life genre. But unlike many of his predecessors, he did not approach his still-lifes as examples of domestic intimacy but rather as examples of geometrical forms. Nor did he try to hide the contrived nature of his still-lifes (Murphy, 1968, 94–5). While the medium of watercolor lent itself perfectly to the Impressionists' attempts to capture fugitive visions, Pissarro, Monet, Sisley, and Renoir only rarely employed it. Instead it was Cézanne, wanting "to make something solid and lasting out of Impressionism, like the art in museums" (Gasquet, 1991, 223), who took full advantage of its potential. In his final decade, Cézanne turned increasingly to watercolor, a medium that allowed him to experiment more easily and to perfect his oil technique (Lindsay, 1969, 279). On the voice-over, we hear a passage from the end of Gasquet's text "The Workshop":

> I paint my still-lifes [...] for my coachman who doesn't want them; I paint them for children on their grandfathers' knees to look at while they drink their soup and babble. I don't paint them for the German Kaiser's pride or the Chicago oil magnate's vanity.

Straub and Huillet's choice of this passage evokes their own desire to have a following among the people, and not just among what Serge Daney called the Straubian international, even if the common man or woman—like Cézanne's coachman—has difficulty understanding their films.

The eighth painting is an example from Cézanne's "Bathers" series (Rewald, 1996, vol. 2, 855, 300), one of three that the painter did in his final decade. The Bathers represent the painter's lifelong ambition

to paint nude figures *en plein air* like the Old Masters, as in Titian/ Giorgione's *Le Concert champêtre* seen in *Une Visite au Louvre*. This life-size painting is shown for nearly two minutes, without dialogue, but is accompanied by the sound of wind blowing. This sound calls to mind Straub's frequent reference to D. W. Griffith's statement: "What the modern movie lacks is beauty—the beauty of moving wind in the trees, the little movement in a beautiful blowing on the blossoms on the trees" (Byg, 1995, 21; Gianvito, 2006). Cézanne worked on this life-size painting for nearly ten years, and probably began it in his Paris studio on the Rue Hégésippe Moreau in the 18th arrondissement, which he rented from the summer of 1898 until the fall of 1899 (Götz, 1995, 226). Of all Cézanne's motifs the Bathers remain for many scholars the most controversial: their mise-en-scène is clearly imaginary and the female nudes incredibly awkward (Novotny quoted in Rewald, 1996, vol. 1, no. 855, 510). Nonetheless, Matisse owned one and he and the English sculptor Henry Moore were both deeply inspired by them. Danièle Huillet herself first encountered *Les Grandes Baigneuses* at the age of 16 (Lafosse, 2007, 167).

The ninth picture (Rewald, 1996, vol. 2, 950, 352) is a painting of Cézanne's gardener, Vallier (1905–6), one of his final paintings. In his late period, the artist frequently painted simple folk—servants and peasants—with great respect (Schapiro, 1969, 126). According to John Rewald's catalogue raisonné of the painter, Cézanne's final seven paintings were all of Vallier, including this one. In his final years, when the artist painted neither his wife nor his son, he frequently used Vallier as a model, painting him a dozen times. This image is accompanied by Danièle Huillet reading from the end of the chapter "The Workshop":

> Painting is the devil ... you keep thinking you've got hold of it, but you never have. [...] One never knows one's method. It seems to me that I wouldn't know anything even if I painted a hundred years, a thousand years, without stopping. [...] I devour myself, kill myself, in order to cover fifty centimetres of canvas Never mind That's life.
>
> (Gasquet, 1991, 224)

This last line is followed by a distinct pause before we then hear Huillet/ Cézanne end the dialogue portion of the film with the well-known Cézanne refrain: "C'est effrayant, la vie" ("Life is terrifying!"; Gasquet, 1991, 224).

This is followed by one final work by Cézanne, a drawing of a standing nude woman (1898–99), a study for the painting of the same

title (Rewald, 1996, vol. 2, 897, 313). This drawing was executed seven to eight years prior to the previous painting of Vallier. No sound accompanies this image and it remains on screen for a tantalizingly short four seconds. Having reached the end of Cézanne's output, why have the filmmakers now backtracked to this earlier work? Presumably, because Cézanne executed it after a model in his Paris studio, one of the few he did from a female model, possibly for another version of the *Large Bathers* (Rewald, 1996 vol. 1, 527–528). The filmmakers have backtracked to prepare us for the film's final image, a generous two-minute shot of the entrance gate to Cézanne's Parisian studio in the late 1890s on the Rue Hégésippe Moreau. Although there is a plaque outside the building, the filmmakers have chosen not to include it in the shot, just as none of the Cézanne works are accompanied by an identifying label. The film is thus bookended by the two geographical places central to the painter's life, Aix-en-Provence and Paris. Still, it would have been easy for the filmmakers to have closed the film with a shot of Cézanne's studio in Aix, where he spent the last six years of his life, and it is worth asking why in fact they did not. The filmmakers' rejection of a resolutely chronological order within the painter's last decade underscores that they were not engaged in a scientific, art-historical study. It also highlights Cézanne's physical proximity to the filmmakers whose Paris apartment is literally just around the corner.

In a 1968 interview after the release of *The Chronicle of Anna Magdalena Bach*, Jean-Marie Straub said he would not be able to do a filmed biography of a modern person, someone too close to him in time; for example, someone from the 19th century (Straub, 1967, 57). Twenty years later, Straub changed his mind, but unlike in their Bach film, where the Dutch harpsichordist Gustav Leonhardt and other musicians magically bring alive Bach's music on period instruments, there is no physical enactment of the creative act in their *Cézanne*. While Peter Watkins in his film on Edvard Munch found an exact look-alike in a young Norwegian, Straub and Huillet undoubtedly felt that such an approach would have been grotesque in a film on Cézanne. While Watkins's film via its verisimilitude succeeds in bringing us into the intellectual and emotional maelstrom of Edvard Munch's life, Straub and Huillet offer us an abstraction of the painter's life, just as Cézanne gave us abstractions of clearly recognizable elements in nature. Straub and Huillet have carefully juxtaposed ten works of art, three film clips, three photographs of the painter, and several filmed images. For those who take the time, this modest juxtaposition of diverse elements without any connectors or filmic punctuation is an example of the literary

technique *parataxis* and succeeds in giving us late Cézanne. The most famous example of parataxis in literature may be Julius Caesar's laconic line: "Veni, vidi, vici" ("I came, I saw, I conquered"), while Ezra Pound and Samuel Beckett also frequently employed it (see *Wikipedia* entry on parataxis). If Straub and Huillet's economic use of parataxis may initially seem incongruous—particularly in the inclusion of the three film clips—it ultimately creates artistic resonances that send us into continual *mises-en-abyme*: Cézanne and Gasquet; Cézanne and Charles Bovary; Empedocles and Pausanias; Empedocles, Hölderlin, Cézanne; and Cézanne, Flaubert, and Renoir, and all of these couplings or triplings force us to consider in turn their relation to the filmmakers who evoked them.

In the end, this film is not a didactic exposition about Cézanne but a subtle appreciation of him, based on parataxis and the filmmakers' profound understanding of him. Unfortunately, the Musée d'Orsay ultimately rejected the film and even refused to screen it publicly. Virginie Herbin, who commissioned it, deemed that the directors of the museum were ill-prepared for a film that was innovative in its very style (Herbin, 1990, 530). Interestingly, the voice-over of the film cuts the final phrase of Gasquet's text: "Je veux mourir en peignant ... mourir en poignant ..." ("I want to die painting ... die painting"), preferring instead to close the film with a shot of Cézanne's Parisian studio, thereby emphasizing his work and not his death. Curiously, Joachim Gasquet himself lay on his death bed as he wrote his memoir, which was published a month before he died in May 1921 (Kear, 2002, 141). The dying words Gasquet attributes to the painter are premonitory because he did just that: on 15 October 1906, Cézanne suffered an attack while painting and died a week later. What the filmmakers could not have known while finishing their film was that their ending would also seem strangely prescient of Danièle Huillet's own death. She died on 9 October 2006, on the eve of the centennial anniversary of Cézanne's demise.

Notes

I wrote this essay in two ideal locations: Paris and Williamstown, where I worked in the library of the Clark Art Institute. A few days before leaving Paris in September 2008, I spent the morning at the Bibliothèque du Film at the Cinémathèque Française reading and making photocopies on the two filmmakers. Later that day, I took a walk from my studio in the 18th arrondissement down to the 17th where I liked to visit the Jardin des Batignolles. Cézanne and his childhood friend from Aix-en-Provence, Emile Zola, would both have known

it, since they lived in the neighborhood. As I approached the Place de Clichy, across the street from the nondescript Ibis Hotel on the Boulevard de Clichy, I saw an older man in front of me—slightly stooped, with nearly white hair and a cigar stub in his mouth. Having just been thinking about the filmmaker, I wondered if indeed it could be him. The last time I had seen him, three years before, he still had his marvelous strawberry-blonde hair. Finally, plucking up my courage, I asked if he were Monsieur Straub. "Yes," he said and invited me for a drink. We chatted for a bit and then he walked me to Cézanne's last studio in Paris, a few minutes away.

An earlier version of this essay was originally published in October 2009 in the online film journal *Senses of Cinema*, where it is amply illustrated (Shafto, 2009a). In November 2009, I was invited by Florian Schneider and Annett Busch to present Jean-Marie Straub and Dànièle Huillet's two films on Cézanne in their curated cinema program *Of a People Who are Missing* in Antwerp. Annett told me of an article by the German scholar Rembert Hüser (2008) on Cézanne, which I read with great interest and which I include here in my citations.

My thanks to Miguel Abreu, Jean-Claude Gaubert, Judith M. Raab, and Marvin Zeman.

Quotations from *Joachim Gasquet's Cézanne* are taken from the Christopher Pemberton translation (Gasquet, 1991). All other translations are my own.

References

Cézanne

P. Cézanne, Cézanne's *Correspondance*. Recueillie, annotée et préfacée par John Rewald (Paris: Grasset, 1978).

P. M. Doran, *Conversations avec Cézanne*, ed. P. M. Doran (Paris: Macula, 1978).

L. Florman, conversation with the author (Columbus, OH, November 2008).

J. Gasquet, *Joachim Gasquet's Cézanne: A Memoir with Conversations*, trans. C. Pemberton (London: Thames and Hudson, 1991).

J. Gasquet, *Cézanne* (La Versanne, France: Encre Marine, 2002).

G. Geffroy *Histoire de l'Impressionnisme. La vie artistique*, 3ᵉ série (Paris: E. Dentu (H. Floury), 1894).

A. Götz, *Cézanne Paintings*, trans. from the German by Russell Stockman (New York/Dumont, NJ: Cologne/Abrams, 1995).

L. Gowing, *Cézanne: The Early Years 1859–1872*, ed. M. A. Stevens (New York: Abrams, 1988).

J. Kear, "Le Sang Provençal: Joachim Gasquet's *Cézanne*," *Journal of European Studies*, 32 (2002), 135–150.

J. Lindsay, *Cézanne: His Life and Art* (New York: New York Graphic Society, 1969).

R. W. Murphy and the Editors of Time-Life Books, *The World of Cézanne 1839–1906* (New York: Time-Life Books,1968).

C. F. Ramuz, *Cézanne: Formes* (Lausanne: International Art Book, 1968).

T. Reff, "Painting and Theory in the Final Decade," in *Cézanne: The Late Work*, ed. W. Rubin (New York: Museum of Modern Art, 1977).

J. Rewald, *Cézanne et Zola* (Paris: A. Sedrowski, 1936).

J. Rewald, *Cézanne, Geffroy et Gasquet, suivi de souvenirs sur Cézanne de Louis Aurenche et de lettres inédites* (Paris: Quatre Chemins-Editart, 1959).

J. Rewald, "The Last Motifs at Aix," in *Cézanne: The Late Work* (New York: Museum of Modern Art, 1977).

J. Rewald, in collaboration with Walter Feilchenfeldt and Jayne Warman, *The Paintings of Paul Cézanne, a Catalogue Raisonné*, vol. 1: The Texts (New York: Abrams, 1996).

J. Rewald, in collaboration with Walter Feilchenfledt and Jayne Warman, *The Paintings of Paul Cézanne, a Catalogue Raisonné*, vol. 2: The Plates (New York: Abrams, 1996).

M. Schapiro, *Paul Cézanne* (New York: Abrams, 1969, c1952).

Straub and Huillet

J. Aumont, "La Terre qui flambe," in *Jean-Marie Straub-Danièle Huillet*, ed. D. Païni and C. Tesson (Aigremont: Editions Antigone, 1990).

J. Aumont and A.-M. Faux, "Entretien avec Jean-Marie Straub et Danièle Huillet," in *La Mort d'Empédocle* (Dunkerque: Studio 43 M. J. C. de Dunkerque, DOPA Films, and Ecole Regionale des Beaux Arts, 1987).

U. Böser, *The Art of Seeing, the Art of Listening. The Politics of Representation in the Work of Jean-Marie Straub and Danièle Huillet* (Frankfurt: P. Lang, 2004).

A. Busch and F. Schneider, *Of a People Who are Missing*, Exhibition and ciné-club on the films of Jean-Marie Straub and Danièle Huillet, (Antwerp: Extra City, 12 November–20 December 2009), http://ofapeoplewhoaremissing.net/.

B. Byg, *Landscapes of Resistance: The German Films of Danièle Huillet and Jean-Marie Straub* (Berkeley. CA: University of California Press, 1995).

J.-A. Fieschi "Jean-Marie Straub" in *Cinema, A Critical Dictionary: The Major Film-makers*, ed. R. Roud (New York: Viking Press, 1980, vol. 2).

J. Gianvito, "From Yesterday until Tomorrow," in *Daniéle Huillet Tribute* (FIPRESCI, no. 3, 2006), http://www.fipresci.org/undercurrent/issue_0306/huillet_gianvito.htm.

V. Herbin, "Cézanne à Orsay: Entretien avec Virginie Herbin." Propos receuilis par Dominique Païni et Thierry Jousse. *Cahiers du cinéma* 430 (1990) 530.

R. Hüser, "Film von Lesen der Bidler. Danièle Huillets und Jean-Marie Straubs Cézanne," in *Lehrer ohne Lehre. Zur Rezeption Paul Cézanne in Lünsten, Wissenschaften und Kultur (1906–2006)*, Réd. par Torsten Hoffmann, 275–296. (Freiburg: Rombach, 2008).

P. Lafosse, *L'Etrange cas de Madame Huillet et Monsieur Straub* (Toulouse: éditions Ombres, 2007).

A. Martin, "Curiosity, Exigency," in *Danièle Huillet Tribute* (FIPRESCI, no. 3, 2006), http://www.fipresci.org/undercurrent/issue_0306/huillet_martin.htm.

D. Païni, "Straub, Hölderlin, Cézanne," in *Jean-Marie Straub-Danièle Huillet: Conversation en archipel*, ed. A.-M. Faux (Milan/Paris: Mazzotta/Cinémathèque Française, 1999), English translation by Sally Shafto available at: http://archive.sensesofcinema.com/contents/06/39/straub_holderlin_cezanne.html.

J.-L. Raymond, *Rencontres avec Jean-Marie Straub et Danièle Huillet*, ed. J.-L. Raymond (Paris; Mans: Beaux-Arts de Paris/Ecole Supérieure des Beaux-Arts du Mans, 2008).

R. Roud, *Jean-Marie Straub* (New York: Viking Press, 1972).

S. Shafto, "Artistic Encounters: Jean-Marie Straub, Danièle Huillet and Céz ie," *Senses of Cinema* 52 (October 2009), http://www.sensesofcinema.com/20 52/ artistic-encounters-jean-marie-straub-daniele-huillet-and-paul-cezanne/.

S. Shafto, "On Straub-Huillet's *Une Visite au Louvre;* Transcript for *Une Vi* *au Louvre*," *Senses of Cinema* 53 (December 2009), http://www.sensesofci na. com/2009/feature-articles/on-straub-huillets-une-visite-au-louvre-1/; p:// www.sensesofcinema.com/2009/feature-articles/transcript-to-straub-hui s-a- visit-to-the-louvre/.

J. M. Straub, "Sur *Chronique d'Anna Magdalena Bach*," *Cahiers du cinén* 193 (September 1967), 57.

1 2

Two-Way Mirror: Francis Bacon and the Deformation of Film

Susan Felleman

> "I would have been a film director if I hadn't been a painter."
> —Francis Bacon (Archimbaud, 1993, 16)

Although in the 1950s, when his reputation was first becoming internationally established, Francis Bacon was the subject of passionate disagreement and his work treated with suspicion by advocates of both realism and abstraction,[1] there has—since some time in the 1960s, with the advent of Pop Art and other postmodern turns in the art world—come to be considerable critical and interpretive consensus around the importance of his work and recognition of the part played in it by photography and film. Bacon's vivid experience of photographs and films is reflected in his conception and realization of a figurative oeuvre that is *not* illustration, that is stripped of narrative, yet registers the force of time and, rejecting sensationalism and explicit metaphoric content, conveys visceral sensation and psychosexual disturbances. As Sam Hunter noted in 1952, implicitly connecting Bacon's use of photography to continental philosophical preoccupations,[2] "Bacon has a Bergsonian horror of the static. Consequently he has tried to quicken the nervous pulse of painting by moving it closer to the optical and psychological sources of movement and action in life." (Hunter, 1952, 13) Yet the general understanding of Bacon's engagement with photographic artifacts and the cinema is missing something: investigation of how Bacon's apprehension of the cinematic and his figuration of life was not only inspired by photos and motion pictures, but also achieved a kind of paradoxically static cinema, or cinematic stasis, and has in turn since found an inheritance in motion pictures.

Although the parallels, echoes, reflections, and citations of Bacon's work to be seen in motion pictures have been occasionally noted,

and sometimes explored with great sensitivity, this afterlife has been insufficiently connected to the photographic and cinematic ancestry of that work itself and its inherently cinematic ambitions: its visceral and psychological force, violence, and eroticism. Not only did the paintings themselves aspire to these conditions of cinema, but their presentation also assured it. Bacon insisted that his paintings be exhibited glazed. When one sees one of his typically monumental canvases in a museum or gallery display, one sees a ghostly moving picture at the same time: the reflection of oneself and others moving about the space of the gallery. This reflection may be a familiar attribute of the experience of old master paintings in museums, but the theatrical spaces of Bacon's pictures—in which the figures are often isolated against passages of solid ground—assures that the corporeal incorporation of the viewer and reflections of movement are palpable.

This phenomenological, embodied experience of moving images falls beyond the purview of most art historical discourse, while the material properties (scale, texture, framing, glazing, etc.) and experience of the paintings are comparably irrelevant for most film scholars. So Bacon is the meeting point of a sort of mutual disciplinary incomprehension, or an interdisciplinary schizophrenia. Art history has attended exhaustively to the cine- and photographic sources of Bacon's oeuvre, but has almost nothing to say about his impact on moving pictures. Ironically, some film studies have themselves regarded Bacon as little more than a source, noting the citations of and iconographic, atmospheric, compositional, or chromatic borrowings from his paintings, but not connecting these with the cinematic intentions that inhere in them. The discipline—lately in the grip of widespread enthusiasm for the theories of Gilles Deleuze—may sense the potential film theoretical implications of his philosophical tract on Bacon but does not generally attend to the work or, more importantly, to the continuity between it and the cinemas that informed and followed from it.

Entire essays and books have concerned Bacon's relationship to the camera. Dawn Ades, a foremost scholar of Dada and surrealism—movements for which photography was central, was among the first to explore this relationship in an exhibition catalogue essay, "Web of Images" (1985). "Photographs are a different kind of visual source," she wrote, "and this is because of their status as record, as fact, or history. Bacon was intrigued by the 'candid camera' snaps of famous people in unguarded moments that became a source of popular amusement in the 1930s, and has also 'used' news photographs, photographs from wild-life studies, from medical books, polyphotos of himself [that is, photobooth

pics], photographs of friends, and perhaps most significantly of all, photographic studies of movement by Eadweard Muybridge." Ades goes on to argue that Bacon is "not so much using" such photographs "as attacking" them (Ades, 1985, 21–2). Bacon's attack transformed these photos from mute indexical traces into images with a kind of haptic power, images in which visceral sensation and emotion are restored. Twenty years later, Martin Harrison summarized the scholarship on Bacon's photographic and cinematic sources in *In Camera: Francis Bacon: Photography, Film and the Practice of Painting*, a well-researched, beautifully illustrated, somewhat conventionally art historical monograph that sees photographs and film images first and foremost as sources and situates them in an essentially psycho-biographical frame. Yet despite Bacon's occasional attempts to frustrate a biographical reading of his works (along with historical and other narrative approaches), it is difficult to avoid, given the emotional fervency of the works and prevalence of portraiture.

Harrison's narrative begins with the claim that Bacon's "debut," *Three Studies for Figures at the Base of a Crucifixion* (1944) "was fundamentally an expression of his isolation and despair," and continues:

A year later a snapshot triggered the equally ferocious *Figure in a Landscape*. He went on to appropriate masterpieces of art history and to co-opt photographs as agents for dismantling them into modern high tragedy. In half-tone reproduction a seminal Baroque painting by Velázquez was no more or less potent, or open to manipulation, than an image torn from a medical reference book or a close-up film still. Bacon explored the tensions between intelligence and sensation, abstraction and illustration, stasis and motion, order and chaos, to generate some of the most compellingly raw paintings of the century.

(Harrison, 2005, 7)

Even if photographs and stills are undeniably, and vividly, sources, triggers, and resources, there is a tendency to overlook what is specifically cinematic in Bacon's engagement with them: how the paintings effect a sense of temporal and spatial dynamism, a reanimation, or transformation. Bacon's signature distortions and deformations are synchronic images, or condensations of a cinematic (or serial) diachrony. Many of Bacon's avowed aims suggest the effort to convert and transform bodily events and emotions manifest in time into images. "I would like my pictures to look as if a human being had passed between them, like a snail,

leaving a trail of the human presence and memory trace of past events, as the snail leaves its slime," Bacon said, for example (Sylvester, 1980, 33). Philosopher Gilles Deleuze and writer and ethnographer Michel Leiris (surrealist, then dissident surrealist; contributor to *Documents* and *Les temps modernes*), among Bacon's more eloquent interpreters, have evoked the kinetic element of Bacon's work with many temporal and dynamic words. Deformation, dissipation, abjection, contraction, decomposition, and recomposition are all active processes that Deleuze notes in Bacon's work, along with the "reign of the blurry (*flou*) and indeterminate" and the not entirely metaphoric concept of the fall (*chute*).[3] Leiris characterizes Bacon's use of the canvas as "a theatre of operations," and elsewhere uses the terms "happening" and "flux."

Bacon's exposure to the powerful effects of cinema, particularly to seminal works of the avant-garde during the germinal phase of his career, on the Continent in the late 1920s, is certainly key to this cinematic invigoration of the canvas. Along with Eadweard Muybridge's serial motion studies, which it is appropriate to regard as both photographic and cinematic sources, other particular cinematic monuments are evident sources of imagery and inspiration for Bacon: Sergei Eisenstein's *Battleship Potemkin* (1925), Abel Gance's *Napoléon* (1927), and the two Surrealist collaborations between Luis Buñuel and Salvador Dalí, *Un Chien Andalou* (1928) and *L'Age d'Or* (1930). Gance's polyvision and employment of three screens inform Bacon's triptychs, as well as *Napoléon*'s innovative, dynamic cutting and cinematography, as for instance in the famous snowball fight scene, with its frenetic, hyperkinetic flying and blurring camerawork, and fervid superimpositions. From Gance, a painter can apprehend how the very technique of the artist (the handling of the camera, or brush) can mirror the passionate, kinetic engagement of the subject, and excite that of the beholder. Bacon's common culture with Surrealism—including the first period, with its emphasis on chance, automatism, and techniques of immediacy, but especially the period of the second manifesto (after 1929, a period of political urgency, the emergence of Buñuel and Dalí, Breton's purges and dissident movement)—is absolutely central to an understanding of the painter's iconography and practice. Bacon's interest in Freudian ideas, his exposure to *Documents*—its photography and the ideas of its editor, Georges Bataille, concepts and images related to the *informe*, the abject, and the base—all situate Buñuelian cinema particularly and Surrealism generally as significant stimuli. The impact of *Un Chien Andalou* on Bacon may be more conceptual than aesthetic, but the force of its graphic images of bodily violence—from eye slicing,

to seizure, sticking out of the tongue, and wiping away of the mouth—is an exemplary assault on its beholders' expectations, never mind their nerves. *L'Age d'Or*'s scandalous, abject, and perverse images of sexuality must have made an impression on Bacon, too.

A still of the screaming nanny in *Battleship Potemkin* is famously a source for the series of screaming mouths that appear with great regularity in Bacon's work from 1945 on (Figures 12.1 and 12.2). Bacon probably saw Eisenstein's film, along with Gance's and Buñuel's, in the same period—the 1920s—that he acquired a medical volume with

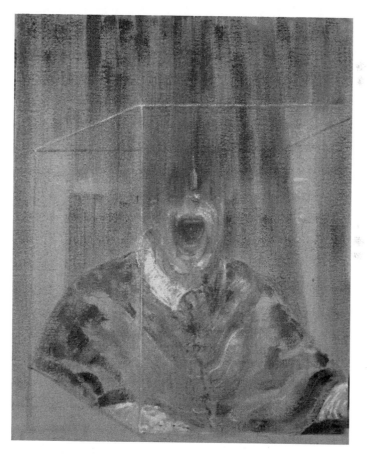

Figure 12.1 Head VI, 1949 (oil on canvas) by Francis Bacon. Arts Council Collection, Southbank Centre, London, UK/The Bridgeman Art Library © 2010 The Estate of Francis Bacon. All rights reserved/ARS, New York/DACS, London

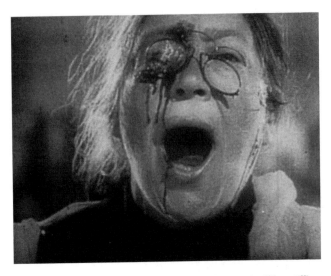

Figure 12.2 Battleship Potemkin (1925), by Sergei Eisenstein (film still)

photographic images of diseases of the mouth and regularly read and
retained copies of the journal *Documents* (which included, among other
material of obvious relevance, Bataille's essay "La Bouche," accompa-
nied by Surrealist photographer Jacques-André Boiffard's open-mouth
photograph, and Eli Lotar's photographs of Parisian abattoirs).[4] In the
same period, Bacon viewed Poussin's *Massacre of the Innocents*, a figure
in which, according to David Sylvester, the painter discovered "probably
the best human cry in painting," although, his interlocutor notes, "the
Eisenstein mouth was the one he copied obsessively."

Bacon must have been struck by more than the mouth, though, in
Potemkin. The entire film, especially its tour-de-force "Odessa Steps"
sequence, employs Eisenstein's powerful method of montage. As one text
vividly describes it: "the horror of the slaughter not just with mass, mur-
der, chaotic movement, fast cutting, and conflicting compositions, but
also ... the individual reactions and sensations of the victims ... So much
of the viewer's experience of *Potemkin* proceeds not from the eyes to the
brain but from the eyes to the nerves" (Mast and Kawin, 2000, 172). Such
language is reminiscent of Bacon's own: "I'm just trying to make images as
accurately off my nervous system as I can," the artist said of his attempt to
realize the violent immediacy of sensation (Sylvester, 1980, 82).

In his remarkable film portrait of Bacon, *Love is the Devil: Study for a
Portrait* (1998), John Maybury imagines the encounter between Bacon

and Eisenstein's famous sequence and the deeply dialectical way that Bacon might have experienced *Battleship Potemkin*, dramatizing both the painter's perverse pleasure in the film violence on screen and the reflection and cannibalizing of it in his studio—where the lens of the camera becomes both mirror and canvas so that it is briefly, and startlingly, only a thin membrane of glass in between the viewer and the assault of the artist's bloody brush. This vivid scene effectively translates the corporeal and spectatorial violence to which Bacon aspired.

"Each scene is like a brush stroke and by the end of the film, you've got the complete composition," said Maybury of his film, characterizing both the structural and visual intentions of his portrait of the artist, which centers on his often cruel, complicated relationship with George Dyer, Bacon's lover from 1963 until 1971. Dyer died of a lethal, suicidal dose of alcohol and drugs in their Paris hotel room two nights before the opening of Bacon's Grand Palais retrospective. The film captures with evidently uncanny fidelity the look and character of both the artist (played by Derek Jacobi) and his famously chaotic studio, but moreover it evokes the abject mood and implicit violence of Bacon's paintings. Given the filmmakers were denied permission to reproduce Bacon's work, this is no small feat. John Maybury, whose first feature film this was, had a background in experimental film and video. In the late 1970s and 1980s, he worked on small-scale independent works and on sets and design for Derek Jarman. He also became well known for his music videos for Boy George, The Jesus and Mary Chain, Neneh Cherry, Sinead O'Connor, and others.

In *Love is the Devil*, Maybury and his cinematographer John Mathieson used various innovative and experimental techniques to achieve cinematic correlatives to the temporal and spatial deformations—blur, smear, flicker, fluidity—of Bacon's paintings. They shot through old panes of glass and old lenses, borescope lenses, tracing paper and colored gels; they shot double exposures; they actually lit many scenes with bare incandescent household light bulbs, a familiar element of Bacon's iconography (and the painter's preferred form of studio illumination). And for some scenes they substituted their motion picture camera shutter with a handmade shutter adapted from a domestic hand drill that ran asynchronously. "We'd rev it at different speeds to make the image flutter. If you moved it away from the camera, you'd get these great flash-frames that would stretch and tear from top to bottom, creating images that jumped at you" (Willis, 1998, 50). "In other words," as John Ziniewicz puts it, "the highly complex camera movement designed by Arriflex to capture space perfectly within time

has been completely sabotaged in order to disrupt the conti ity
between space and time ... replicating the fleeting feeling evok by
Bacon's figure painting." Ziniewicz further points out how this ty of
technical experimentation is true to the spirit of Bacon's work, ng
his claim that "real imagination is technical imagination. It is i the
ways you think up to bring an event to life again. It is in the sear for
technique to trap the object at a given moment. Then the tech que
and the object become inseparable. The object is the techniqu nd
the technique is the object. Art lies in the continual struggle to me
near to the sensory side of objects" (Ziniewicz, 2004, 5–6). Thus *ove*
is the Devil bodies forth a violent exchange between art and bel ler
(or film and spectator) that takes back to their origins in cine itic
spectatorship some of Bacon's most signal accomplishments.

Love is the Devil finds cinematic equivalents for painterly atti les.
It deforms and inverts cinema and its objects, placing the specta in
a series of vertiginous and disturbing perspectives. During the en-
ing credit sequence, a figure is falling through black, abysmal ce.
At the end of the credits, the falling figure, which turns out be
Dyer attempting a break-in, lands, like Alice down the rabbit ho in
a perplexing world where he is assaulted by a savage montage of in es.
He has dropped in to Bacon's studio through a skylight (this pro bly
apocryphal but extremely cinegenic account of the two men's m(ng
was one of various Bacon was given to telling). Another entire ne
is shot as if through the bottom of a whiskey glass, a concei hat
evokes both the inebriation of Bacon's famous cohort at his haur the
Colony Room, and the distortions characteristic of Bacon's portr(of
many of those same friends. Inside Dyer's mind—in Maybury's fil —a
nightmare looks like Bacon's paintings.

One troubling paradox, though, in Maybury's powerful acl ve-
ment is that, in restoring the cinematic to Bacon's image—espe lly
in the context of what is, after all a biopic, albeit a fragmente(nd
unconventional one—it compounds it with narrative, threat ng
to turn Bacon's figures into illustrations ... his arresting momei of
sensation into sensational stories, aspects of traditional figuratioi hat
were anathema to Bacon, or so he generally claimed. But he was i on-
sistent in his articulations of how the personal informed his rk.
And there has long been a reading of that work which regard; as
illustrative, if somewhat veiled or closeted. Until recently, assum[ons
about the autobiographical content tended to feature homop bic
slurs, as with Peter Fuller's criticism. Now, there's a cautious eer
critical attention to the suppressed narrative of Bacon's oeuvr see

Co er, 1996 and Simon Ofield's "Comparative Strangers," in Gale
an tephens, 2008).

(tainly, though, to unpack the cinematic element that has been
dis ed into one of Bacon's agitated tableaux is to risk taking on the
ba ge of content: metaphorical, historical, and psychological. This
is e outcome of a notable earlier encounter between Bacon's work
an he cinema, Bernardo Bertolucci's *Last Tango in Paris* (1972). The
fil opening credits appear over two Bacon portraits from 1964 (one
of cien Freud and the other of Isabel Rawsthorne), which not only
"fc hadow the film's two major characters, Paul and Jeanne," but
als according to Robert Kolker, "prefigure both its visual style and
its chological perspective" (Kolker, 1985, 128). Bertolucci saw Bacon's
Gr l Palais retrospective while preparing to shoot *Last Tango in Paris*
an as profoundly impressed. He went back with Vittorio Storaro, his
cin atographer, and Fernando Scarfiotti and Gitt Magrini, his set and
co ne designers, respectively.

' ey were all very impressed," Bertolucci has told David Thompson
(Tl npson, 1998, 28). "Vittorio and Fernando ended up playing a lot
wi frosted glass, and I remember we did these close-ups of Marlon
be d the glass, which were very like Bacon. I would say, today we'll
do acon, bring the glass! The exhibition continued long enough for
m show it to Marlon." Elsewhere, Bertolucci has said of Bacon's
inf nce: "... the light in his pictures became another major key for the
sty ic cyphers we were looking for. I took Marlon to see the exhibition
be se I wanted him to respond to and reflect Bacon's characters. I felt
th is face and body were endowed with a similar, internal plasticity.
I ted Paul to be like ... characters that returned obsessively in
Ba 's work: faces eaten up by something that comes from within"
(U ri, 1987, 118). The aesthetic impact of the look of Bacon's paint-
in n Bertolucci's film is as obvious as it is paradoxical. I think that
Be ucci, who shares with Bacon an interest in psychoanalysis and
th bversive discourse of Georges Bataille (Thompson, 1998, 11, 68),
"m eads" his work (of course, as Harold Bloom reminds us, misreading
is inevitable and productive result of the anxiety of influence).[5]

[on's figures are not, after all, properly "characters," as Bertolucci's
ren ks suggest. Except in his portraits, they lack identities and nar-
rat context. And despite its notable emphasis on sex, abject and
de rate, even famously on painful anal penetration, *Last Tango*
is about sensation than it is about emotion and Oedipal pathos.
As leuze points out, Bacon achieves a kind of synchronic hysteria
in paintings: his "whole 'style' takes place in a beforehand and an

afterward: what takes place before the painting has even begun, but also what takes place afterward, a hysteresis that will break off the work each time, interrupt its figurative course" (Deleuze, 2003, 43–4). While the same might be said of Marlon Brando's performance in *Last Tango* at its most transparent and raw, Bertolucci's echoes of Bacon's images are not of this paralytic dis-ease. Rather they are somewhat anodyne echoes, poignant and sad, which insert the figure into a psychosexual and existential drama—in other words, use the figure as illustration.

Bertolucci's and Maybury's films ultimately cannot wholly avoid the illustrative, the sensational, and the cliché that Bacon's images refused, or cut off. Paul Valéry's espousal of sensation as "that which is transmitted directly, and avoids the detour and boredom of conveying a story" is for Deleuze the key to Bacon's approach. "Painting directly attempts to release the presences beneath representation beyond representation. ... Hysteria becomes painting. ... [the painter is not hysterical] ... abjection becomes splendor, the horror of life becomes a very pure and very intense life" (Deleuze, 2003, 51–52). When narrative cinema repays the compliment that Bacon has paid it in his pictorial condensation of time and motion, it inevitably threatens this "purity" and "intensity."

> "Fragments of narrative. If Bacon had made a movie, what would it have been and where would it have gone? And how would the cinema translate those textures and those spaces?"
>
> —David Lynch (Rodley, 1997, 17)

But I'd like to turn my attention from these two powerful art films to other categories of moving pictures that take Bacon's imagery as a source of inspiration and maybe come closer to realizing the hysterical, neurological intensity of the painter's vision. Since Bertolucci, numerous popular filmmakers concerned precisely with sensation have borrowed, or cited, mostly for visual effect, Bacon's "look": his iconography, his style, his palette. David Lynch, a painter as well as a director, is a lifelong admirer of Bacon. "I saw Bacon's show in the '60s at the Marlborough Gallery and it was one of the most powerful things I ever saw in my life," he says. Bacon's influence is evident visually and affectively in Lynch's oeuvre from the grotesque surrealism of *Eraserhead* (1977) to the oneiric reflexivity of *Mulholland Drive* (2001) and has been noted and explored by numerous critics, notably Martha Nochimson, using a phenomenological approach indebted to Merleau-Ponty, and Greg Hainge, who sees Deleuze's Bacon treatise as ideal for examining

Lynch's "bypassing of rationality" and "deliberate dissolution of narrative" (Hainge, 2004, 140). The tension between Nochimson's and Hainge's readings of what is Baconian in Lynch points to a central conundrum in both artists' work: the role of psychology. Hainge focuses on a scene from Lynch's *Lost Highway* (1997) and its consonance with "the Figural processes of Bacon's paintings described" by Deleuze:

> Constrained by the centripetal forces of the prison cell—just as our viewpoint is unavoidably contained by the placement of this figure in a monochrome cube—Fred is isolated and able to transgress the fixed boundary of his identity. Precisely as in Deleuze's analysis of Bacon in which the body of the isolated figure attempts to escape itself via a spasm—be it a spasm of love, vomit or excrement (Deleuze, 1981, 16–17)—in order to become a Figure, so here Fred vomits, his flesh appearing to peel away from him, and he becomes, literally, an other. It is this very process that for Deleuze, serves as a means for Bacon to 'break with representation, fracture narration, prohibit illustration, liberate the Figure' (Deleuze, 1981, 10); little wonder, then, that when Lynch uses this same process the plot should stop making sense.
>
> (Hainge, 2004, 144–5)

While it is impossible to imagine either Bacon's or Lynch's work without access to the basic concepts and vocabulary of psychoanalysis—the unconscious, dream work, sexuality and its discontents—to the extent that psychoanalytic interpretation offers an explanatory narrative, it is resisted and inadequate. As with the Surrealists, Bacon and Lynch revel in the darkness of the conceptual spaces probed by psychoanalytic thought, not in the light of its expository, explanatory, or therapeutic power.

Bacon's influence is less profound but still vivid in the work of numerous, less "irrational," contemporary filmmakers. According to the alien effects designers of Ridley Scott's *Alien* (1979), Bacon's *Three Studies for Figures at the Base of a Crucifixion* (1944) was the inspiration for the "look" of the creature in that film (Dodd, 1996, 13). Adrian Lyne's mind-bending suspense film, *Jacob's Ladder* (1990), is another that has an avowed debt to Bacon's painting, and achieves its unbearable sense of tension between reality and delusion using effects that are the cinematic equivalents to Bacon's smears and blurs. On *The Silence of the Lambs* (1991), a grueling psychological thriller, director Jonathan Demme had his production designer and cameraman study Bacon's work, and an almost direct citation (of *Painting*, 1946) is evident in

one gruesome scene. Posters for the horror film *Alone in the Dark* (Uwe Boll, 2005), a film I've not seen, are pastiches of Bacon's imagery. And recently both Christopher Nolan (Gordon, 2008, 56) and Myung-se Lee (David, 2008) in interviews have cited Bacon's work as a prominent visual influence on their films, *The Dark Knight* and *M*. Bacon's visual influence has been claimed with regard to numerous other films. There is some ironic, perverse beauty, it could be argued, that the ineffable frenzy, force, and horror Bacon digested from the screens of the avant-garde cinema of the 1920s, among other sources, return to film via his influence most vividly not in the self-conscious abjection of the European art cinema, but in movies—not without self-consciousness or art—generically and commercially disposed to surprise and excite audiences' nerves with extreme moments of shock, awe, and angst, as "illustrations" in the context of narrative.

But another category of moving image counters the narrative trap into which the Bacon influence is drawn in the art film and the Hollywood movie: artist videos. Two examples from the past decade, made to be seen in the gallery or museum context, evoke Bacon: Chloe Piene's *Black Mouth* (2004) and Paul Pfeiffer's *Fragment of a Crucifixion (After Francis Bacon)* (1999). The latter—a looped and reframed fragment from a bas-ketball video—manages to be both a found image and a direct citation of Bacon. *Fragment of a Crucifixion (after Francis Bacon)* (1999), displayed as a tiny digital moving picture on a small, flat LED screen, isolates one fragmentary moment from an NBA basketball game. The subject of the silent video is the screaming figure of Knicks forward Larry Johnson in a stadium, facing the camera after making a successful shot, it seems. The victorious shout is refigured—through reframing and repetition—into a horrible silent scream of rage or aggression that focuses on the gaping mouth, much as Bacon's famous screaming pictures do. Chloe Piene's *Black Mouth* (2004), a large format projection with sound, is about three minutes long. Its subject is a young woman, mostly undressed, wet and mud splattered, on her hands and knees in a dark, indeterminate space. The audio and video are slowed dramatically, as Elizabeth Walden notes, "so that the sound emitted from her gaping mouth is guttural and pained, sounding like an elephant trumpeting or some wounded animal." "Though achieved through different formal techniques, the short duration of the loop in Pfeiffer and slow motion in Piene," accord-ing to Walden, "the videos produce a sense of temporal 'holding,' in which affective content is allowed to unfold into intensity" (Walden, 2006). Perhaps it would be better to say that the affect, the sensation, is allowed to *transfix* (rather than unfold) into intensity. Walden applies

to Pfeiffer's loop Deleuze's distinction between sensation and feeling in Bacon's paintings. "The looping," she says, "like repeating a word until it is meaningless, empties the image of Larry Johnson of significance until we are left, not with a celebrity, indeed hardly with a man, but rather the raw explosion of affect through the flesh" (Walden, 2006).

The gaping mouth, the screaming subject, in both videos—as in Bacon's paintings—are transfixing and transgressive images of extreme abjection, of hysteria, or of unspeakable horror. Paradoxically, in these short videos it is both a moving and still image. Through technical manipulation, the artists achieve a kind of alienation effect—an existential eternal return—and conjure something like Bacon's "sensory side" of things.

> And on important occasions human life is still bes-
> tially concentrated in the mouth: rage makes men
> grind their teeth, while terror and atrocious suffering
> turn the mouth into the organ of rending screams.
> Bataille (1985, 59–60)

But perhaps the most suggestive cinematic correlative to Bacon's work could be neither ancestor nor descendent: Kenneth Anger's youthful trance film, *Fireworks* (1947) (Figure 12.3). Contemporary with Bacon's breakthrough paintings of the postwar years, *Fireworks* is "a dream of a dream," in which a "dissatisfied dreamer," played by Anger himself, "goes out into the night seeking a 'light' and is drawn through the needle's eye."[6] The dreamer finds his "light." His cigarette is lighted by a sailor with huge bundle of sticks (a flaming faggot); then the dreamer is beaten up, brutalized, and ripped open by the sailor's cohort. Anger's characterization of the film as "a dream of a dream" not only expresses its psycho-dramatic content, but also its form: organized around dream logic, affect, and symbolism, not conventional narration.

The photography, imagery, and editing of *Fireworks*—a non-sync-sound film—are reminiscent of and certainly indebted to the same avant-garde cinematic practices that have already been connected to Bacon, especially Eisenstein's montage and Surrealism, along with the psychodramas of Jean Cocteau and Maya Deren. The editing of the scene that Kelly Keating has aptly described as a "spectacular display of masochism," (Keating, 2009) in which the dreamer anticipates, then incurs a savage attack and evisceration in a theatrical, oneiric, dark space, is characterized by forceful graphic montage reminiscent of that of Eisenstein. The cutting between the close-ups of the subject's body

Figure 12.3 Fireworks (1947), by Kenneth Anger (film still)

and ecstatically pained, bloody face and the patently mock violence of his attackers opens up key ambiguities and emphasizes the dream-like element in the scene. As P. Adams Sitney noted, this "scene of orgasmic violence" is "constructed out of close-ups of the dreamer's body isolated in darkness and shots of the sailors performing violent acts just off screen. From above we see fingers shoved into the dreamer's nostrils, and blood shoots out of his nose and mouth. A sailor twists his arm, and he screams hysterically. A bottle of cream is smashed on the floor. With a broken piece a cut is made in his chest; hands separate the pudding-like flesh to reveal a heart like a gas meter. His chin is framed in the bottom of the black screen like a frozen wave. Cream poured from above flows over it into his mouth" (Sitney, 1979, 98).

It is unclear to whose hand the fingers shoved into the dreamer's nostrils belong. The position and framing is highly suggestive of a self-penetration, which underscores the fantasy and onanistic properties of the scene, and indeed the entire film. As Sitney implies and Keating elaborates, the scene is full of substitutions that are sexually suggestive, even obvious. There is "metaphoric slippage between the two holes of the nose and the holes of the mouth and the anus. In a sense, the pro-tagonist is being symbolically penetrated by the sailors at both ends of his body" (Keating, 2009).

This film has much in common with Bacon's work. Its central image is certainly the sustained look into the abyss of the silently screaming

dreamer's mouth. The theatrical isolation of the figures, the bestial atmosphere and treatment of the body as meat, the slippage between eroticism and violence, the consonance between technique and affect: all have deep synchronicity with Bacon's practice. Both artists revel in technique—indeed eroticize it—and create images that are paradoxically beautiful and horrible, images with an indexical stain or mark, images that are fraught with psychosexual abjection and paroxysm. At the end of *Fireworks*—after the sailor "opens his fly and lights a Roman candle phallus which shoots out burning sparks" (Sitney, 1979, 98)—Anger has scratched off an aureole of emulsion from the face of the sleeping man who is found with the dreamer, in bed. Bacon came to leave spurts of creamy, white paint across his canvases. How many times can these artists and their works be referred to as seminal without irony?

> Bacon's work was related directly to the concept of the paroxystic by France Borel This paroxystic aesthetic—one reportedly reinforced by the art historian Elie Faure in correspondence with Gance in the mid- to late 1920s—suggests parallels with Bacon's continued insistence, from the late 1940s onwards, on a convulsive unlocking of valves of sensation and particular kinds of extreme sensation. Bacon's art, it might be said, revolved around paroxysms of the body, but the paroxystic as mediated photo-mechanically, through film, and a spectacle of history.
>
> (Mellor)[7]

The deep synchronicity between Anger's and Bacon's work in the late 1940s bears further investigation. Almost certainly the two artists had no knowledge of one another in 1947 but their affinities in terms of influences, sensibilities, and aesthetic objectives—and the historical and cultural crucible of the immediate postwar moment—are profound. In 1949, Jean Cocteau saw *Fireworks* at the Festival du Film Maudit in Biarritz, was overcome with admiration, and invited Anger to Paris. Anger accepted with alacrity and lived on and off in Europe, including in London, for many years. He did, evidently, come to know Bacon. One of the many incomplete and now apparently lost films in Anger's vast filmography of lost works was "a short color film dealing with the paintings of the well-know [sic] English modern artist, Francis Bacon ... sponsored by the Institute of Contemporary Arts here and the British Film Institute, which has given me the color film. The film will be decidedly 'macabre' in nature. ..." (MacDonald, 2002, 254).

The synchronicity between the decisive moments in the care of
these two "seminal" figures of twentieth-century art speaks not o to
the affinities between the two but underscores the relationship be en
cinema and the ambitions and impact of the painter. The viev 1to
the photographic lens lends Bacon's practice a "paroxysmal," pai tic
apprehension of space and time, affording his figural canvases ai 1ra
of abstraction, a distance from narrative, drama, and illustratior he
view from the other side—the impact on screens of Bacon's influe —
is less abstraction than effect. Scenes, imagery, colors, tableaux in: ed
by Bacon turn the affect associated with his work into effects (he
cinema, a medium that—as is well known and often lamented— ids
itself to scenarios of sex and violence. Bacon's paintings are like tw ay
mirrors in their specular relation to film, reflecting but also permit g a
privileged view into the very nature of cinematic sensation.

Notes

This chapter began a long time ago as a paper delivered to the session "Fil nd
the Visual Arts" at the 2005 College Art Association annual meeting. I 1ld
like to thank the session organizer, Gail Levin, for including it then, and . Jela
Dalle Vacche for inspiring me to revisit it now. In between, many peopl ive
contributed to it: my husband and colleague, art historian Peter Chan ky;
John Ziniewicz, Tanya Lovejoy, Noah Springer, Liz Faber; Nadine Cove Jee
Tudor and the students in her graduate proseminar to whom I presented s of
this material in the Fall 2008; and Elizabeth Walden, who I hope will revi ind
publish her own enlightening paper on the video art referred to herein.

1. For example, John Berger and Peter Fuller in the UK and Clement Gre erg
 and Hilton Kramer in the US (see Harrison, 110–111).
2. Such preoccupations were more certainly those of Bacon's admirer than the
 painter himself. "It is hard to recapture the existentialist aura that surrc led
 Bacon's imagery in postwar Europe: the comparisons with Jean-Paul Sart ind
 Albert Camus, the references to the Blitz and the horrors of Auschwi the
 grandiose overreadings and philosophical generalizations that his work . ost
 inevitably attracted in the '50s and '60s," observes Linda Nochlin in her re\ / of
 the 1996 Centre Pompidou exhibition, *ArtforumI* 35 (October 1996), 109-).
3. Gravitational force, downward motion—a visual movement *à bas*—is ten
 evident in Bacon paintings, in form (paint that drips or pools) and c ent
 (figures that seem to have plunged, degenerated, or collapsed).
4. See R. Krauss and J. Livingtston, *L'Amour fou: Photography and Sur* ism
 (Washington, DC: Corcoran Gallery of Art and New York: Abbeville, 1).
5. H. Bloom, *The Anxiety of Influence: A Theory of Poetry* (Oxford: (ord
 University Press, 1973).
6. From Anger's own description for the video edition of the film as part his
 Magick Lantern Cycle (2009).

7. A. Mellor, "Film, Fantasy, History in Francis Bacon" (Gale and Stephens)8), p. 62. Mellor cites F. Borel, "Francis Bacon: The Face Flayed," in France el, *Bacon: Portraits and Self-Portraits* (London/New York: Thames & Hudson, '6), p. 190.

Re 'ences

D. :s, "Web of Images," in *Francis Bacon*, ed. D. Ades and A. Forge (London/
) York: Thames & Hudson/Harry N. Abrams, 1985).
M. :himbaud, *Francis Bacon: In Conversation with Michel Archimbaud* (London:
) don, 1993).
G. taille, *Visions of Excess: Selected Writings, 1927–1939*, ed. A. Stoekl
 (ineapolis, MN: University of Minnesota Press, 1985).
E.)per, "Queer Francis: Life, Death and Anguish in the Work of Francis
 F)n," *Queer Arts Resource*, http://www.queer-arts.org/bacon/bacon.html.
D. stin, New York Asian Film Festival 2008 Report 12: CSB Interviews Lee
) ing-se, Director of *M, Cinema Strikes Back* (7 July 2008), http://www.
 c mastrikesback.com/?p=2272.
G. leuze, *Francis Bacon: The Logic of Sensation*, trans. D.W. Smith (New York:
 (tinuum, 2003).
P. J d, *Spellbound: Art and Film* (London: British Film Institute, 1996).
D. r and M. Martino, *Francis Bacon: A Retrospective* (New York: Harry N.
 A ıms, 1999).
M. le and C. Stephens *Francis Bacon*, eds M. Gale and C. Stephens (London:
 T Publishing, 2008).
D. rdon, "Bat Trick," *Newsweek* (21 July 2008), 54–6.
G.] nge, "Weird or Loopy? Specular Spaces, Feedback and Artifice in Lost Highway's
 A hetic of Sensation," in *The Cinema of David Lynch: American Dreams, Nightmare
 1 ıns*, eds E. Sheen and A. Davison (London: Wallflower, 2004, pp. 136–50).
M. ırrison, *In Camera: Francis Bacon: Photography, Film and the Practice of
 F ting* (New York: Thames & Hudson, 2005).
S.] iter, "Francis Bacon: The Anatomy of Horror," *The Magazine of Art* 45:1
 (2), 11–15.
S. J -Gonzalès, "Beyond the Pale: Francis Bacon and the Limits of Portraiture,"
 (': *A Journal of Lesbian and Gay Studies* 6:4 (2000), 631–9.
K. Keating, "A Disruption of Masculinity: Masochism and Homosexuality
 i :enneth Anger's *Fireworks*," *The Great Within: Desire Nostalgia Art Film
 F ography Mass Culture* (2009), http://www.thegreatwithin.org/2009/07/
 c iption-of-masculinity-masochism-and.html.
R.] olker, *Bernardo Bertolucci* (London/New York: British Film Institute/Oxford
 l ersity Press, 1985).
M. ris, *Francis Bacon: Full Face and in Profile*, trans. J. Weightman (New York:
 F oli, 1983).
S.) Donald, *Cinema 16: Documents Toward a History of the Film Society*, ed.
 S acDonald (Philadelphia, PA: Temple University Press, 2002).
G. st and B. F. Kawin, *A Short History of the Movies*, 7th edn (Boston, MA: Allyn
 a Bacon, 2000).

M. P. Nochimson, *The Passion of David Lynch: Wild at Heart in Hollywood* (Austin: University of Texas Press, 1997).

M. Peppiatt, *Francis Bacon: Anatomy of an Enigma* (New York: Farrar, Straus and Giroux, 1997).

J. Pilling and M. O'Pray *Into the Pleasure Dome: The Films of Kenneth Anger*, eds J. Pilling and M. O'Pray (London: British Film Institute, 1989).

C. Rodley, *Lynch on Lynch*, ed. C. Rodley (New York/London: Faber and Faber, 1997).

P. A. Sitney, *Visionary Film: The American Avant-Garde*, 2nd edn (Oxford/New York: Oxford University Press, 1979).

D. Sylvester, *Looking Back at Francis Bacon* (New York: Thames & Hudson, 2000).

D. Sylvester, *Interviews with Francis Bacon, 1962–1979* (New York: Thames & Hudson, 1980).

D. Thompson, *Last Tango in Paris* (London: British Film Institute, 1998).

E. Ungari, *Bertolucci by Bertolucci*, trans. D. Ranvaud (London: Plexus, 1987).

E. Walden, *Reflexive Mimesis in Contemporary Video Art: Pfeiffer and Piene*. Unpublished Conference Paper (2006).

H. Willis, "Brush with the Gutter," *American Cinematographer* 79:9 (1998), 46–55.

J. Ziniewicz, *Love is the Devil* Compendium. Unpublished paper submitted to Professors S. Felleman and P. Chametzky for course "Modern Artists as Cinema Subjects" (Carbondale, IL: Southern Illinois University Carbondale, 2004).

Part V
Film, Museum, New Media

13

A Disturbing Presence? Scenes from the History of Film in the Museum

Ian Christie

Jacques Derrida famously said of archives that they are "places of power"—"there is no political power without control of the archive"—and I believe that museums are just as much "places of power" (Derrida, 1996, 2–3). Like the residences of magistrates that Derrida identifies as the source, both etymological and topographic, of the archive (*arkheion*), the museum is a symbolically charged place that proclaims recognition, lineage, and ultimately identity. To say that a painting is "in the Louvre," or perhaps "in the Clark," says almost as much about it as who painted it, albeit in a different register. It is deemed worthy of inclusion in a collection that itself constitutes authority. And so the issue of film in the museum is an issue of power, or lack of it, and also, as I shall suggest, an occasion of disturbance.

I am reminded of a story that Neil McGregor told about his early experience on becoming director of the British Museum. As the custodian of many famously disputed works, such as the "Elgin marbles" taken from the Parthenon in Athens, he quickly became used to successive campaigns and delegations asking for items in the collection to be "given back." So when he heard that a delegation from Kazakhstan wanted to make an appointment, he assumed the worst. But in this case he was pleasantly surprised to discover that his Kazakh visitors wanted to do just the opposite. Did he know that the wheel was invented in what is now Kazakhstan, and could they offer some objects to commemorate this for display in the British Museum? The Greeks might want their marbles back, but the Kazakhs wanted recognition.

From a very early date, film was in what I might call the "Kazakh position" of supplicant, seeking a place in the museum. The English moving-picture pioneer Robert Paul wrote to the British Museum as early as autumn 1896, to ask if the Department of Prints and

241

Drawings wanted to collect specimens of "animated photographs" (Bottomore, 1995). He received no answer, although the press reported this as an attempt to get the museum to collect "rubbish."[1] Boleslaw Matuszewski, a Polish-born photographer, also published a call for film to be collected as a record of contemporary history in 1898 which was similarly ignored (Matuszewski, 1898). At this juncture, inevitably, film appeared as an anomalous object from an archival point of view. It was a new substance: cellulose nitrate, or "celluloid," coated with emulsion and perforated to pass through a new machine; moreover, an object which could only be "read" by means of a similar machine. But it was also a new kind of text, or publication, as Paul, Matuszewski, and others argued. And it was as a textual publication that film first found a place in the archive, when American film companies deposited paper copies at the Library of Congress to claim copyright protection in the way that print publishers already did (Niver, 1985). In Britain, some producers tried a similar move, but only deposited token single frames at Stationers Hall (Bottomore, 1995).

The early dilemma over film's identity and place was not without precedent. First photography, and later sound recording by means of the phonograph, had posed similar challenges to the established scale of cultural, and therefore archival, values. What kind of object or text is it? And where does it belong? As we know, film would eventually create its own new place in the public sphere, in movie theaters or cinemas. But in terms of cultural status, where did it belong? As Derrida has also noted, the archive is both revolutionary and traditional; and we can see film exemplifying this apparently contradictory role. In fact, the films that entered the Library of Congress remained merely objects, unreadable for nearly half a century before the idea emerged of making viewable prints from the paper rolls, leading to the first "paper print" collection transferred to film in the 1960s, thus returning these Dead Sea scrolls to the status of legible text (Niver, 1985).[2]

Meanwhile, film entered the traditional museum in another way, as a part of the memorialization that followed World War I. The Imperial War Museum in London was established in 1917, and became almost certainly the first public museum to collect film (although Albert Kahn had done so as part of his private collection, the Archives of the Planet, from before the outbreak of the war) (Castro, 2006). For the Imperial War Museum, the British documentary about the Battle of the Somme, released in the autumn of 1916 shortly after the actual event, was an early and key exhibit, and the museum has since campaigned success-fully to have this film added to the UNESCO Memory of the World

Heritage register.[3] Here at least was early official recognition of film's affective power, if not its aesthetic status; and we might want to cross-reference this case with the celebrated remark attributed to US President Woodrow Wilson after a White House screening of D. W. Griffith's *The Birth of a Nation* that it struck him as "like writing history with lightning."[4]

The 1930s saw a worldwide move toward creating film archives, to preserve what was left of the medium's first quarter century; this seems to have been linked to an acknowledgment of its pioneers and their mortality (Houston, 1994). Georges Méliès was rediscovered in obscurity, running a toy stall in Montparnasse station, and feted in his final years; Louis Lumière was canonized as the medium's founding father, at least in France; while in Germany, Oskar Messter took steps to claim his founding role. And even in Britain, uncertain of its place in the history of invention, a group of veterans were persuaded in 1936 to speak about their early experiences (BKS, 1936). But it was in America that the most decisive step was taken, when the Museum of Modern Art created its film department. This was not the first occasion when a museum had embraced film as a tool of popularization; many were doing this by the 1920s, including MoMA itself with its showing of films about art. But what the MoMA Film Department proclaimed was, apparently, a belief in film as a legitimate branch of modern art.

Thanks to Haidee Wasson's research, we know that this move was not universally popular with the museum's trustees, some of whom apparently doubted the wisdom of this venture (Wasson, 2005). Bearing in mind Derrida's speculation on the violence and "danger" associated with archives, we might see such disquiet as a recognition of film's power to contaminate or undermine the carefully created secular religion of modern art. We might also recall that the MoMA's founding chief curator, Alfred Barr Jr, had himself felt the temptation to put the new Soviet cinema above traditional art media when he visited Russia in 1928–9. After seeing work by Eisenstein and Pudovkin, he wrote in his diary: "why does the Soviet bother with painting, when the kino offers a new and popular art, even if infected by propaganda?" (Barr, 1978). And in Soviet Russia, the embattled leader of the painterly avant-garde, Kasimir Malevich, was sufficiently troubled by the upstart claims of the film avant-garde to dispute their claims and to contemplate making a Suprematist film to trump what he considered the overestimation of Eisenstein's montage (Bulgakowa, 2002).

Malevich claimed that even montage cinema was little better than a revival of naturalistic art—a throwback to the era of the "Wanderers" in

Russian terms—compared with advances of Cubism and, of cours his
own Suprematism (Bulgakowa, 2002). MoMA's position on cinem vas
rather to embrace cinema as a whole, from its early years to the pr nt,
and to promote canonization along the axes of an evolving "film in-
guage" (which might be compared with Barr's language of modern as
illustrated in his famous "torpedo" diagram), with authorship as ed
to directors, considered to belong to national cinemas. The film d rt-
ment's founding head, Iris Barry, had been a pioneer critic in her ve
Britain, a co-founder of the London Film Society, and would tra ite
Maurice Bardèche and Robert Brasillach's *History of Cinema* to serv s a
primer of the medium's development (Bardèche and Brasillach, 1).[5]
What she and the museum did not do was to privilege artists' ns,
such as Fernand Léger's *Ballet mécanique* (1924), although they di is-
tribute this and other films by the Dada and Surrealist groups as p of
the museum's circulating film library. Instead, they cultivated link ith
Hollywood and worked to promote the canonization of D. W. G th
as the father of film narrative. So, while collecting, preserving nd
programming films played an important part in the museum's acti —
and film attendances certainly helped to counteract its elitist ima as
Wasson has shown—this activity was in effect kept apart from it le
in promoting Modernism in the "other" arts. In fact, the MoMA's rt"
and film have been kept fairly rigorously apart, until recently w a
growing body of contemporary art that exists in film and video for as
entered the upper storeys of the museum (whereas film has always en
in the basement)—finally legitimized as art by *bona fide* artists.

However, MoMA remained exceptional as film archives deve ed
internationally after World War II. No other major art museum ld
systematically collect the artifact of film, so this was left to a patch rk
of specialist archives, many of which began their own activit of
canonization, most influentially in the case of Henri Langlois' e tic
screenings at the Cinémathèque Française, attended by future me ers
of France's *Nouvelle Vague*. But there were others, such as Langlois' al,
Jacques Ledoux in Belgium, who actively promoted the contem ry
film avant-garde as much as MoMA did, and who was also respo le
for reassessing during the 1960s a major part of cinema's own c n:
Soviet filmmaking between the October Revolution and World W I.[6]
So film developed, not so much as an empire, but as what we migl all
instead an "archipelago" of its own—a worldwide network of ir tu-
tions that conserved, curated, and canonized film, but separately m
the institutions that performed the same functions for visual and p tic
art, other than at MoMA.

at would eventually bridge this separation was the emergence of exhibiting culture, as curators in galleries began to show film in a series of exhibitions that can be considered to have started in any in the 1960s, before becoming an international phenomenon latter decades of the twentieth century (Zoller, 2008). Inserting exhibitions into the prevailing gallery and museum culture was sy, as I can testify from having worked on several of them, including *Film as Film* in 1979 at the Hayward Gallery, London, and again Hayward in 1996, *Spellbound: Art and Film*.[7] The first of these rimarily concerned with demonstrating that film had a history , dating from the filmmaking activity of artists associated with ism, Dada, and many branches of 1920s Modernism, and showing mporary avant-garde filmmakers as inheritors of these movements *as Film*, 1979). Fifteen years later, *Spellbound* felt no obligation to rt this history, inviting contemporary artists and filmmakers to installations that reflected on a century of cinema (Dodd and tie, 1996).

eed, three of the contributors to *Spellbound* could be regarded ving parodied the idea of the modern museum by creating ncratic collections of objects that owed more to the sixteenth- eventeenth-century "cabinets of curiosities," or *Wunderkammer*, to modern gallery or museum practice.[8] Eduardo Paolozzi brought ier an assembly of casts and models designated as *Props for a Blue* , while Peter Greenaway showed an "exploded kit" of cinematic nts, including five vitrines housing a constantly changing cast of , surrounded by a vast array of suggestive objects, and accompa- iy a looped generic soundtrack.[9] Terry Gilliam's installation evoked rwellian future-world of his *Brazil*, with a giant filing cabinet, e drawers could be opened to reveal objects, both gruesome and , associated with the making of a film, while a projection of his ecent *Twelve Monkeys* was intermittently visible through the struc- n contrast to the artists' films—by Damien Hirst, Steve McQueen, oyd Webb—which also appeared in *Spellbound*, these installations iged forms of deconstruction of the cinematic experience, as did las Gordon's *24 Hour Psycho*, stretching Hitchcock's film to an ded frame-by-frame series of tableaux.[10]

: "centenary of cinema" provided an excuse for other boundary- ing exhibitions. Among these, *Art and Film since 1945: Hall rrors* (Los Angeles Museum of Contemporary Art, 1996, also ibus, Rome, Chicago) engaged more exhaustively in the manifold ar exchanges between art and film, while *Le Cinéma au rendezvous*

des arts (Galerie Colbert, Paris, 1995–6) focused on film and the French avant-garde in the 1920s and 30s. And perhaps most influentially, a continuing series of major exhibitions at the Centre Pompidou in Paris has blurred any clear distinction between visual art and film.[11] Meanwhile, the Pompidou has taken a stand, comparable to that of MoMA in the 1930s, by establishing a major "New Media" collection since 1996.[12]

So is this ultimately a story of harmonious recognition and eventual union, like a latter-day version of a nineteenth-century melodrama in which the long-parted lovers are finally reunited? I want to suggest instead that film remains "a disturbing presence" in the gallery and the museum, when it is a "primary" exhibit, rather than an audiovisual aid. Technically, film has certainly proved disruptive, requiring new technology and technicians. It interrupts visitor flow (films take time to view), causes lighting problems, and other difficulties for the museum. Yet it is primarily the activity of twentieth- and now twenty-first-century artists that has dragged film across the museum threshold—as with the 2008 Francis Bacon retrospective at Tate Britain, which could hardly ignore Bacon's extensive debt to film, but still managed to subordinate this to the status of "source material" in a clear (re)assertion of status.[13] Clearly, the more we interrogate the history of art in the twentieth century, the more obvious it becomes that many leading figures from different traditions and schools were stimulated by their interest in film. Yet this interest has taken many forms, with different consequences for the gallery and museum.

One early instance points to the very real practical problems that hampered such experimentation by artists, and discouraged such figures as Kandinsky and Picasso from pursuing film projects around 1911–13 (Christie, 2000). In 1914, the English painter Duncan Grant created a work he titled *Abstract Kinetic Painting*. This consisted of a canvas strip, about 14 feet long and a foot wide, to which Grant attached geometric shapes. It was intended to be unrolled and viewed through a rectangular window in an enclosing box, making it a kind of modernist version of the traditional peep-show—or, in contemporary terms, a near relation of the concertina *pochoir* print published by Sonia Delaunay in 1913.[14] When Grant's scroll became too fragile to display in motion, the Tate Gallery invited the painter and filmmaker Christopher Mason to film it in 1974, and to add the music that Grant had always imagined accompanying its display.[15] The result is a hybrid work which, in a sense, has escaped the material limitations of its original making and display to acquire a new life outside the museum in the digital era.[16]

In contrast to this isolated venture by Grant, Peter Greenaway has maintained a prolific career over 30 years as an artist working in many interrelated media. Having started as a painter, before working professionally as a film editor, painting and graphic work were central to a number of his early films. *A Walk through H* (1978), which introduced Tulse Luper—the continuing character in Greenaway's mythology, ends by revealing its source material as a series of paintings in a gallery. The ostensible plot of *The Draughtsman's Contract* (1982) turns on a commission to produce drawings of a seventeenth-century manor house; and in 2004, the house used as the film's location, Compton Verney, staged an exhibition of "Tulse Luper's suitcases." Before and since his *Spellbound* installation, Greenaway has created major installations in many European cities, notably *The Physical Self* for the Boymans van Beuningen Museum, Rotterdam (1991), and *Flying Out of This World* for the Louvre, Paris (1992), *The Stairs* (Geneva, 1994; Munich, 1995), and more recently, an exhibition accompanying his film *Nightwatching* (2007), based on Rembrandt's painting *The Nightwatch*.

Greenaway offers a unique instance of an artist-filmmaker who has long professed dissatisfaction with the medium of "theatrical" film, while continuing to produce such films, and who has also created what amounts to a personal genre of large-scale installation that aspires to an architectural presence outside the museum. Writing about his *Spellbound* installation, Thomas Elsaesser suggested that Greenaway's public commissions might be related back to the "British tradition of land(scape) art," now writ large on a series of Continental cities (Elsaesser, 1996, 78). Oscillating between the gallery, the cinema, and the cityscape, with other ventures into television and opera, Greenaway offers a sustained exploration and critique of the contemporary "society of the spectacle," refusing to accept the boundaries of any medium or its supposed "medium specificity." In the spirit of Elsaesser's earlier diagnosis, it is tempting to see Greenaway as returning to the multimedia artifice of the Jacobean era: a contemporary Inigo Jones.[17]

Before the era of cinematic exhibitions, there is a sporadic history of filmmakers venturing into the gallery. Jill Craigie's pioneering documentary *Out of Chaos* (1944) begins in the National Gallery, London, recording the views of visitors, before following such artists as Graham Sutherland and Henry Moore in their wartime commissions. Twenty-five years later James Scott challenged the conventions of the "art documentary" with two films inspired by exhibitions in London:[18] *The Great Ice Cream Robbery* (1971) is a playful two-screen response to Claes Oldenberg's exhibition at Tate Britain, which incorporates a "found

event" outside the gallery; and *Chance, History, Art* (1980) meditates on the complex legacy of Surrealism, with Scott's camera prowling the 1979 Dada and Surrealism exhibition in the Hayward Gallery, accompanied by the brash neo-Dada sound of the Sex Pistols' "Anarchy in the UK."

But recently, there have been more respectful, even reverential, cinematic visits to the museum in the contrasting forms of Alexander Sokurov's *Russian Ark/Ruskii kovcheg* (2002), and Jean-Marie Straub and Danielle Huillet's *A Visit to the Louvre/Une visite au Louvre* (2003). The former conducts us on a phantasmagoric exploration of the Hermitage Museum in St Petersburg, in which a time-traveling protagonist, based on the historical figure of the Marquis de Custine, conducts a lively debate about Russian culture with an unseen figure, the director, who constitutes a "camera-eye," traveling in an unbroken passage through the museum's galleries and corridors. Sokurov's focus is less on the works of Western art that constitute the Hermitage's precious cargo, than on the building as setting for a series of *tableaux vivants* that trace the trajectory of Russia's European identity, from Peter the Great to Nicholas II. Custine interacts, often playfully, with custodians and visitors representing different epochs of the museum, at one point delighting in the smell of the canvas, and at another tricking a blind woman into mis-describing what she "sees." In sharp contrast to this relegation of paintings to the status of decor, Straub and Huillet's visit to the Louvre meticulously frames a series of works ranging from Tintoretto and Veronese to Delacroix and Courbet, accompanying them with a commentary ostensibly by Cézanne, as reported by one of his early biographers. Both films, in their rigorous and idiosyncratic ways, refuse the art documentary convention of taking us "deeper" into individual paintings. Instead they retain the visitor's view, reinforcing the sense of the museum as a source of Derridian "power": a place of secular pilgrimage and, therefore, of both frustration and inspiration. A place, moreover, where the filmmaker can only be subservient to the power of "true" art.

Why should film cause a disturbance in the museum? Part of the answer lies in the traditional hierarchy of the arts, as this was codified during the Italian Renaissance. While architecture was self-evidently the most important art for Alberti, followed by sculpture, Leonardo argued for the higher status of painting as a new kind of science (Blunt, 1962, 28). And with painting successfully validated, subsequent centuries created a hierarchy of genres within painting, relegating all other artistic practices to the status of decorative or minor arts. As patronage moved from the church and the court, to become the prerogative of

commercial wealth, painting would become—as it has remained—the key marker of value, both aesthetic and monetary. Photography and its off-shoot, film, would face a long battle for recognition throughout the twentieth century, plagued by their associations with mechanism and vulgar popularity.[19] While film may offer itself as a handmaid to the arts, in the form of the educational documentary (alongside the exhibition catalogue and audio-guide), such re-composition and translation of the *substance* of painting that is involved in filming could hardly be considered art, until the recent era of the artist-filmmaker.

But another aspect of film's capacity to disturb, I want to speculate, may be due to its disconcertingly spectral nature. In their essays in this volume, Lynda Nead has discussed alchemy in relation to early film and Susan Felleman has invoked film's intrinsic capacity for eeriness. Moving pictures were quickly adopted by practising magicians in the 1890s as part of their repertoire of "modern magic," and much early writing about the medium refers to its ghostly images. Later, Theodor Adorno and Hanns Eisler would speculate on the need that was felt for accompanying music, to counteract the disturbing effect of figures apparently moving in silence (Adorno and Eisler, 1947). And again I turn to Derrida's stimulating *Archive Fever*, where he discusses at some length Freud's fascination with Wilhelm Jensen's 1903 novel *Gradiva*, in which a young archaeologist imagines himself back in Pompeii, meeting the object of his "archival fever," the alluring Gradiva herself, whose image comes from a Roman bas relief (Freud, 1959). A major part of the fascination of archives and museums is the potential they offer to return to the life of the past, to the *arkhe*, the beginnings.

Sergei Eisenstein wrote in his memoirs that "museums are at their best at night ... when ... there can be a merging with the display, rather than simply a viewing" (Eisenstein, 1995, 307). The "market-place" atmosphere of the Louvre by day, full of "profoundly indifferent crowds," repelled him, but two nocturnal museum experiences remained vividly in his memory. One was in the Hermitage, during the filming of *October* in 1927, when the "bluish twilight" of the White Nights made the Greek statues seem "to come alive and float in the blue gloom" (Eisenstein, 1995, 316). The other occurred in Mexico, while Eisenstein was filming his aborted epic *Que Viva Mexico!* in 1931. During a night visit to the museum of Mayan culture in Chichen-Itzá, the electricity failed; with only matches and a candle, he made his way among the statues of Mayan gods. Memories of Tolstoy describing "the effect of lightning when you see galloping horses" (Ibid., 316) gave way to a sense of entering "the dark circle of the underworld of mankind's early

beliefs," as the makeshift illumination "began to resemble the interplay of brilliant reason and the darker depths of the human psyche" (Ibid., 317). Here Eisenstein is evoking the museum as offering potentially both a proto-filmic animation of the inert and an atavistic experience of the return to the *arkhe*. There is a clear link with his account of the fascination exercised by cartoon animation, when "we know that they are drawings and not living things ... but at the same time we *sense* them as alive" (Eisenstein, 1988, 55). For Eisenstein, the English term "animated cartoon" was highly suggestive: "in this name, both concepts are interwoven: both 'animateness' (anima–soul) and 'mobility' (animation—liveliness, mobility)" (Ibid., 54). Although Eisenstein was ostensibly working from the Russian tradition of "historical poetics," his speculation recalls Freud's theory of the "uncanny" as produced by works of art which disturb by prompting a return of the inadequately repressed childhood animism that believes objects can come to life (Freud, 1955, 362).

Film, then, may be seen as inheriting and enhancing the animistic qualities of sculpture, painting, and photography; and in doing so, creating its own "uncanny." What was only a daydream for the hero of Jensen's *Gradiva*, becomes a more compelling excursion into the past for the film spectator, and one that may indeed challenge the power of the museum or the actual relic. While Eisenstein recalls "cinematic" encounters with museums at night, museum films are in danger of reminding the spectator of the mundane institutionality of the museum. Straub and Huillet bracket out the Louvre's modern visitors in favor of a spectral Cézanne; and Sokurov peoples the Hermitage with representatives of patrons and visitors from the past. Both engage with what the museum has become in a postmodern ultra-mediated world: a combination of Enlightenment memorial and theme park. Future visitors to the Hermitage will be able to imagine the costumed figures of Sokurov's film, and perhaps look for the fictitious room he created to represent the museum during the siege of Leningrad—somewhat like the "extra" platform at St Pancras where the train leaves for Hogwarts in the Harry Potter novels and films.

The modern museum has little choice but to accede to its place in the culture of democratic spectacle, and to embrace "interpretation" for a mass audience that is no longer willing to accept that exhibits "speak for themselves." Despite his reverence for its collections, Sokurov's film is as much about the Hermitage as a "labyrinth" in which historical time could be staged, made visible, as about its treasures.[20] Moving in a "continuous present" made possible by digital recording, his aim is

to recreate the debate about Russia's identity that raged throughout its imperial age, by using the phantasmagoric form he first developed for a similar fantasia on Russian literature, *Whispering Pages/Tikhiye stranitsy* (1994). The Hermitage may represent the ark of Russia's Petrine covenant, its destiny as a European nation as conceived by Peter I, and later elaborated in the mystical philosophy of Nikolai Berdyaev's "Russian idea." But there is little evidence in the film's final image of a ghostly sea surrounding this "ark," accompanied by the enigmatic phrase "we are destined to sail forever/to live forever," that Sokurov merely wishes to celebrate this affirmation of Russian culture—any more than Eisenstein wanted to celebrate the Romanovs in his portrayal of what was then the Winter Palace in *October*.[21] But what Sokurov does emphatically assert, here and elsewhere, is his belief in great art as conveying an experience of eternity, staging a complex interaction between mortality and abstracted time (Harte, 2005, 58). And it is in this that Sokurov's ambitions coincided with those of the Hermitage and its director, Mikhail Piotrovsky, "to pass on that almost holy thrill of the museum air and atmosphere."[22]

There is an important pendant to the unavoidable power play of *Russian Ark* in one of Sokurov's other "museum films," part of the series of "elegies" he has made alongside his features, from the beginning of his career in the 1970s. *Elegy of a Voyage* (or Journey) (*Elegiia dorogi*, 2001) was commissioned by Chris Dercon for the Boymans van Beuningen Museum in Rotterdam and is a short film about the kinds of personal journeys that bring each of us into museums, away from the bustle of city streets, of harbors and airports, to stand in front of masterpieces such as—in this case—Jan Breughel's small *Tower of Babel* and Pieter Saenredam's *Saint Mary's Square*. What do we experience, Sokurov asks? An affirmation of "eternal life," he suggests, in words that anticipate the final lines of *Russian Ark* (both spoken by Sokurov). Westerners may find such a claim idealistic or sententious in the world of museums-as-cultural-industry. But at the end of his lectures on *Archive Fever*, Derrida wrestled with the contradictions implicit in Freud's uncanny, which wants to "deny the virtual existence of the spectral space which he nonetheless takes into account" (Derrida, 1996, 94). In a similar way, Sokurov's "eternity" may trouble our irreligious rationality; yet we can hardly deny that the museum is both a *memento mori* and, potentially, a *memento vitae*; that it obliges us to consider what literally survives death and amnesia, and how such survivals live on into an indefinite future. If the museum is, in Carol Duncan's phrase, "a place to step out of time" (Duncan, 1998, 12), then Sokurov's museum films plunge us

back into a renewed awareness of time through the paradox of multiple temporality. Haunting their museums, they bring them and invite us to meditate on the strangely durable authority of historic spaceships.

Notes

1. "The ordinary work of the print-room at the British Museum is quite organised by the collection of animated photographs that have been p in upon the bewildered officials" (*Westminster Gazette*, 1897).
2. Fifty years later, a similar transcription has been possible using digita nology, to reconstitute films by Robert Paul that exist only as Filosco flip-books, as viewable works (see R. W. Paul, *Collected Works*, Britis Institute DVD, 2006, curated by Ian Christie).
3. Other films included in this register include *Metropolis* (Germany, 192 *Wizard of Oz* (USA, 1939), and *The Story of the Kelly Gang* (Australia, For full list see http://portal.unesco.org/ci/en/ev.php-URL_ID=17572{ DO=DO_TOPIC&URL_SECTION=201&URL_PAGINATION=180.html.
4. Although this has frequently been quoted, it appears to have been an tion by Thomas Dixon, author of the novel on which the film was bas Stokes, 2007).
5. On the process of canonization (see Christie, 1999, 31–3).
6. In the mid-1960s, the Cinémathèque Royale de Belgique, under the tion of Jacques Ledoux, mounted an ambitious cycle of screenings of R films, documented in silent and sound era catalogues.
7. I was a contributor to *Film as Film*, curated by David Curtis; and I co-c *Spellbound: Art and Film* with Philip Dodd, which took some five y come to fruition in 1996, and was one of a number of exhibitions in different countries during 1995–6, to mark the centenary of ci Other notable exhibitions in Britain that have helped legitimate f the museum include *Modernism: Designing a New World*, at the Victo Albert Museum, 2006, and *Dali and Film*, at Tate Modern in 2007.
8. Cabinets of curiosities were originally rooms stocked with rare o assembled by monarchs and merchants to demonstrate the range o interests. Notable collections included those of Rudolf II in Prague, Cl of England, and Athanasius Kircher. Some would form the nucleus first museums, as in the Ashmolean Museum, Oxford, originally ba the collection of Elias Ashmole (Impey and MacGregor, 2001).
9. In his catalogue essay, Thomas Elsaesser invoked "the cinema expanded or exploded view?" and listed the elements being abstrac Greenaway: "artificial light, actors, props, text, illusion, audience sound, changing imagery" (Dodd and Christie, 1996, 81).
10. There were films by Boyd Webb and Damien Hirst, as well as D Gordon's *24 Hour Psycho* installation.
11. These would include such exhibitions as *Joris Ivens* (1979), *Pathé: p empire du cinéma* (1994–5), *Alfred Hitchcock et l'art: coïncidences fatales* Voyage(s) en utopie: Jean-Luc Godard, 1946–2006 (2006), *Le Mouvem images* (2006–7).

12. chewing film, the Centre Pompidou New Media collection includes "video pes, sound documents, CD-ROMs and websites of artists that testify to 40 ars of the history of image and sound in the main movements of contem- rary art, covering performance and body art, minimal art, and conceptual d post-conceptual art."

13. display in the Bacon exhibition included a book by the leading British film storian Rachael Low, which Bacon owned, and captioned Low, who is still ve, as "dates unknown."

14. nia Delaunay created a continuous print some six-feet long, published as old-out book in 1913, that illustrated and counterpointed Blaise Cendrars' em, *La Prose du Transsibérien et de la petite Jehanne de France* (see Wye,)04, 71).

15. this, we might also be reminded of the painter Philippe De Loutherbourg's idophusikon" of 1781, which set paintings in motion behind a proscenium me with a musical accompaniment.

16. ant's painting can be seen as a still image at http://www.tate.org.uk/britain/ tistsfilm/images/abstractkinetic.jpg.

17. ainly known today as an architect, Inigo Jones (1573–1652) was equally mous in his lifetime for the design of court masques, with elaborate scenic fects.

18. ott had already made notable collaborative documentaries with a number artist-subjects: David Hockney in *Love's Presentation* (1967), *R. B. Kitaj* 968), and *Richard Hamilton* (1969).

19. discussed in Walter Benjamin's now widely anthologized essay (Benjamin,)68).

20. iis account of *Russian Ark* draws on production notes from the film's UK lease, November 2002, and conversations with Sokurov by the author, hich have been quoted in articles in *Sight and Sound* and in Beumers, 2007.

21. is worth remembering that Eisenstein was heavily criticized in 1928 for ving apparently produced a "Symbolist" film, due to his extensive and iborate use of the Winter Palace décor in *October*. See Taylor and Christie, '88, 216–20; 225–34.

22. ussian Ark shows that cinema can relate to the world of authentic museum ijects with tact, with reverence and with love, not merely from a fear of ing damage, but from a desire not to disturb, or rather from a desire to ss on that almost holy thrill of the museum air and atmosphere." Mikhail otrovsky, director of the State Hermitage Museum, quoted in the English- nguage press book for *Russian Ark*.

Re ences

T. rno and H. Eisler, *Composing for the Films* (New York: Oxford University] ;, 1947).

M. rdèche and R. Brasillach, *The History of Motion Pictures*, trans. and ed. I rry (New York: W. W. Norton/the Museum of Modern Art, 1938).

A. Jr, "Russian Diary 1927–28," *October 7* (Winter 1978), pp. 10–51.

W. ijamin, "The Work of Art in the Age of Mechanical Reproduction" [1936], i *luminations*, ed. H. Arendt (London: Fontana Collins, 1968).

B. Beumers, *The Cinema of Russia and the former Soviet Union*, ed. B. Beumers (London: Wallflower, 2007).

A. Blunt, *Artistic Theory in Italy, 1450–1600* (Oxford: Oxford University Press, 1962/1940).

BKS [British Kinematograph Society], *Before 1910: Kinematograph Experiences*, Proceedings, No. 38 (London, 1936).

S. Bottomore, "'The collection of rubbish'": Animatographs, arguments and archives: London 1896–1897," *Film History* 7 (1995), 290–97.

O. Bulgakowa, *The White Rectangle. Writings on film* [by Kasimir Malevich], ed. O. Bulgakowa (Berlin: Potemkin Press, 2002).

T. Castro, *"Les Archives de la planète*: A Cinematographic Atlas," *Jump Cut* 48, http://www.ejumpcut.org/archive/jc48.2006/KahnAtlas/index.html. Accessed on 20 January 2010.

I. Christie, "Canon Fodder," *Sight and Sound* 2:8 (December 1999), pp. 31–33.

I. Christie, "Before the Avant-Gardes: Artists and Cinema, 1910–1914," in *La decima musa: il cinema e le altre arti/The Tenth Muse*, Proceedings of the VI Domitor Conference (Udine, Italy: University of Udine, 2001).

J. Derrida, *Archive Fever: A Freudian Impression (Mal d'Archive: une impression freudienne*, 1995), trans. E. Prenowitz (Chicago, IL: University of Chicago Press, 1996).

P. Dodd and I. Christie, *Spellbound: Art and Film* [catalogue], eds P. Dodd and I. Christie (London: Hayward Gallery/British Film Institute, 1996).

C. Duncan, *Civilizing Rituals: Inside Public Art Museums* (London/New York: Routledge, 1995).

S. Eisenstein, *Beyond the Stars: the Memoirs of Sergei Eisenstein* [1946–7], trans. W. Powell and ed. R. Taylor (London/Calcutta: British Film Institute/Seagull Books, 1995).

S. Eisenstein, *Eisenstein on Disney*, trans A. Upchurch and ed. J. Leyda (London: Methuen, 1988).

T. Elsaesser, "Peter Greenaway," in *Film as Film: Formal Experiment in Film, 1910–1975*, ed. C. Dodd (London: Hayward Gallery/Arts Council of Great Britain, 1996/1979).

S. Freud, "Delusions and Dreams in Jensen's 'Gradiva'" [1906], in *Standard Edition of the Complete Psychological Works* (vol. IX) (London: Hogarth Press, 1959).

S. Freud, "The Uncanny" [1919], in *Standard Edition of the Complete Psychological Works* (vol. XVII) (London: Hogarth Press, 1955).

T. Harte, "A Visit to the Museum: Aleksandr Sokurov's *Russian Ark* and the Framing of the Eternal," *Slavic Review* 64:1 (Spring 2005), pp. 43–58.

P. Houston, *Keepers of the Frame: The Film Archives* (London: British Film Institute, 1994).

O. Impey and A. MacGregor, *The Origins of Museums: The Cabinet of Curiosities in Sixteenth- and Seventeenth-Century Europe* [1985], eds O. Impey and A. MacGregor (London: House of Stratus, 2001).

B. Matuszewski, "A New Source of History: the creation of a depository for historical cinematography (Paris 1898)," http://www.latrobe.edu.au/screeningthepast/classics/clasjul/mat.html. Accessed on 20 January 2010.

K. R. Niver, *Early Motion Pictures: The Paper Print Collection in the Library of Congress* (Washington, DC: Library of Congress, 1985).

M. Stokes, *D. W. Griffith's The Birth of a Nation: A History of "The Most Controversial Motion Picture of All Time"* (New York: Oxford University Press, 2007).

R. Taylor and I. Christie, *The Film Factory: Russian and Soviet Cinema in Documents, 1896–1939*, eds R. Taylor and I. Christie (London: Routledge/Kegan Paul, 1988).

H. Wasson, *Museum Movies: the Museum of Modern Art and the Birth of Art Cinema* (Berkeley, CA: University of California Press, 2005).

Westminster Gazette, "Issue of 20 February" (1897).quoted in Bottomore, 1995

D. Wye, *Artists and Prints: Masterworks from the Museum of Modern Art* (New York: The Museum of Modern Art, 2004).

M. Zoller, *Places of Projection: Recontextualising the European Experimental Film Canon*, Ph.D. thesis (Birkbeck College, University of London, 2008).

14

Elegy, Eulogy, and the Utopia of Restoration—Alexander Sokurov's *Russian Ark*

Jeremi Szaniawski

> *Все знают будущее, прошлое все забыли.*
> ("Everyone knows the future. It is the past everyone has forgotten.")
>
> —Alexander Sokurov

A bedridden child watches the ceiling of a barren hospital room, in some remote corner of a huge empire—the Soviet empire. He has no other contact with the outside world, or any other means of distraction, than the radio station in the room, playing classical tunes he will develop a great love for. The child is afflicted with bone tuberculosis, and soon a chunk of his leg will be removed. In the meantime he lets his mind wander, away from his sick and painful body, carried by the music, to depths and heights unsuspected. In spite of the limp incurred from the surgery, the sad and thoughtful child will live and grow, and soon become one of the world's most celebrated and adventurous cinematic *auteurs*. His oeuvre is deeply informed by the life-branding clinical ordeal as well as the gloomy loneliness of a long convalescence, brightened, like a spark in the dark, by the mellifluous tunes of the great masters of what, to him, is the only "real" music.[1] And, some 40 odd years later, in the winter of 2001, in spite of his limp, after years of walks through museums all over the Soviet Union, but also western and eastern corners of the world, driven by his endless love of high art (not only classical music, but also the great painters, especially Rembrandt, Rubens, El Greco, Van Dyck), he will walk across the many halls of a great museum and produce the first ever single-take feature film in cinema history. The utopian dream of a child who might easily have died or never walked again led to one of the great utopias in the history of the cinematic medium.

At the core of every museum and cinematic project, there lies a similar utopian drive. It consists of conflating a diverse set of temporalities within a block of space and time, and infusing them with a new (or "other") life, as it were. Alexander Sokurov's *Russian Ark* (2002) appears as the apex of this tendency. Stemming from an original commission by the State Hermitage Museum, St Petersburg, to showcase its prestigious collection, the film grew from what was originally a relatively modest documentary project to become one of the most extravagant cinematic accomplishments in history. Shot in one uninterrupted 86-minute take, going through 36 rooms and halls of the Hermitage Museum, it required four years of development, over 1000 actors and extras, 22 assistant directors, and countless technicians. This one single mobile take was made possible through new digital technologies, as well as the use of the Steadicam.[2] The film was shot on 23 December 2001, and wrapped at its fourth attempt,[3] after three false starts aborted after a few minutes of shooting. It premiered at Cannes in 2002, projected both digitally and on a 35 mm print, receiving mixed reviews[4] (Figure 14.1).

The production history of the film is an epic of its own, and can be read about or seen in many sources,[5] and so I shall not dwell upon it.

Figure 14.1 Commingling temporalities: The Marquis de Custine converses with some present-day Hermitage dwellers, under the floating gaze of the narrator/ Sokurov. But who smells of formaldehyde, here?

Besides, as Michael Anderson underlines, "the fact that *Russian Ark* is comprised of a single take might give one the wrong impression: that the picture is primarily a technical tour-de-force." Naturally the publicity around the film added to this (mis)conception.[6]

Not that one should downplay the role of the single-take seamless Steadicam aesthetics of the film, of course. There is, beyond the foolhardy nature of the enterprise (and Sokurov confided to me that everyone was telling him not to embark upon such a project, that it was pure madness), something extremely poignant in the poetic image it summons, and which the filmmaker has brought up himself: shooting a film "in one breath," which lends the project the fragile, ever on the verge of collapse, quality of a burning flame, flickering in the tormented winds of history and/or cinematic production realities and contingencies. Almost subconsciously, as we watch the film, we are aware of this phenomenological vulnerability—which probably reinforces the feeling of sadness—the end, the death of something flamboyant and full of bravura.[7] Style and content, as they should, go hand in hand in Sokurov, but it is the story (and in this case, the history) told by *Russian Ark*, its utopian project, which matters most. As so often in Sokurov, the tale is of personal and simple emotions, set in a frame of ample philosophical magnitude. The central metaphor, contained in the title, posits the museum as an ark.[8] It rocks back and forth on the murky and tormented waters of history, this alternative movement epitomizing the author's concern with the past and the present, with a will to enshrine (and also to reconstitute) the former and allow it to keep on sailing toward the future.[9]

As seen through the eyes of an invisible narrator (Sokurov himself) and his companion, the French and Russo-skeptic Marquis Astolphe de Custine (played with relish by Sergey Dreyden), the film invites the viewer on a voyage through 300 years of Russian Imperial history, with a few hints here and there of the post-1917 period (obliterating, however, most of the dark Soviet era). All the while, Custine's real-life accounts of his travels through Russia (1839) fuel the dissonant dialogue between the Western, critical perspective on Russian culture, and the narrator's "true Russian" voice. Custine, whose father and grandfather both lost their heads (literally) to the guillotine of the French revolution, traveled east to document and rehabilitate the values of monarchy. Horrified by what he saw in Imperial Russia, he quickly demurred and produced a scathing account of this autocratic regime. The fact that the two main characters are constantly shadowed by a discretely ubiquitous spy (Leonid Mozgovoy) is but one of the indicators of the problematic aspects of such an autocratic, controlling (or, in Foucauldian terms,

sovereign *and* disciplinary) society. These three characters (the narrator, Custine, and the spy) truly serve as a running thread through the various halls, where they meet historical figures (Peter I, Catherine II, Nikolay I and II, and their entourages, but also Alexander Pushkin, his wife Natalya Goncharova, and her lover, the man who would kill Pushkin in a duel, the forlorn Georges Charles D'Anthès (1812–95)), as well as contemporary visitors to the museum (including acquaintances of the director, playing themselves), in a temporal potpourri. As so often in Sokurov, grandeur is met with a mawkish and sad tenderness, and the cult(s) of personality and the celebration of an "Eternal Russia" are somewhat muffled by the director's even more formidable sense of nostalgia. Nostalgia for the past (naturally), but also for a present, the impermanence of which turns it constantly into past, invading even the (uncertain) future.[10]

Kriss Ravetto-Biagioli reminds us in her historiographic study of the film, that the etymology of the word *nostalgia* derives from the Greek *algos* (pain, ache, and by extension, desire, lack) and *nostos* (home) (Ravetto-Biagioli, 2005, 18), thus, literally, a desire to return home. The word, in its very nature, implies a movement, mental or physical, and a clear locale: the hearth, the home. The form that Sokurov decides to adopt in *Russian Ark* (here, the aesthetics of the long take, in almost perpetual motion, inside a palace that served as the Russian imperial family's hibernal dwelling space) becomes thought itself: the notion of a film "in one breath," akin to an unpunctuated very long sentence, a stream of consciousness. But beyond the Modernist *exercice de style*, the idea of the one take is also that of the continuity, Russian history uninterrupted up to 1917 and the Bolshevik Revolution. This, we could say, constitutes the conscious, avowed conceit of the film. But at the same time, there is, to be sure, the dreamlike quality of the uncanny Steadicam camera, yielding an almost weightless, disembodied floating movement, which in turns evokes the less explicitly critical, more instinctual logic of dreams. As Jamey Gambrell calls it: "a seamless, richly layered *dream* of art and history" (2003, 31, emphasis mine). If we wanted to invent a Deleuzian-inflected category, we could call this the dream-space and -time image, and indeed, Sokurov has produced a perfectly sealed block of cinematic time and space, within a space of many temporalities (the museum), "a film in *real* time about *unreal* time, where the past is always the present" (Gambrell, 2003, 31), and vice versa. If one wanted to place the film more in the "movement-image" side rather than the "time-image,"[11] one would be confronted with a series of aporias.[12]

Sokurov can be considered a Modernist and his corpus generally reflects a preoccupation with the passing of time (and diverse types of time) matching most of Deleuze's philosophical reflections on modernity. And yet, with its relatively easy to follow, almost entertaining nature, *Russian Ark* seems to be one of Sokurov's least "Modernist" films. Indeed, with its preoccupation with history and overt nostalgia for Imperial Russia, but also its more or less cryptic homage to Fellini (in the final sequence, *Casanova*, *Amarcord*, and *And the Ship Sails On* the locale, the abundance of cast and details and somewhat fragmented and anecdotal nature of the film's segments), it foregrounds a key notion of postmodernism, as Fredric Jameson taught us (1991). Not that it could be qualified as entirely postmodern, either. But beyond the elements mentioned above, we also have, here, the trope of the "historic", a trope much loved by postmodern cinema, and rather ignored altogether by Modernism (turned toward dystopian futures instead of the past and the "past-iche"). And while *Russian Ark* can hardly be regarded as a traditional historical film, it certainly does carry its load of historical consciousness in terms of Robert A. Rosenstone's main thesis on the subject: that showing, proving that something is "history" somewhat valorizes it, renders it more important, more prestigious.[13] As Rosenstone points out, "the film medium simulates witnessing and add[s] an important experiential quality for the viewer" (2006, 2). Even if "historical" films (and the claim holds particularly true in Hayden White theory on the subject) are a complete fabrication and inescapably biased, "the authenticity of historical films exonerates them from the sin of inaccuracy" (Nadel, 2009, 77). We see from these considerations, that time is time and is not time in Sokurov's, that history is history without being it—a representation of history possibly accurate or possibly fabricated, self-consciously replicating the historical "process" which led to the creation of many of the paintings adorning the walls of the Hermitage: a mixture of referential fact and allegorical or symbolic elements. But let us close this digression and go back to nostalgia.

A reverie and a voyage imbued in a yearning for things past, *Russian Ark*, formally, *is* nostalgia. But it is not merely that. Although nostalgia and a sense of melancholy pervade the works of Sokurov, in this film we see a variety of elements dancing together and colliding: comedy and tragedy; the basely corporeal (Catherine the Great seeking a place to pee) and the lofty and celestial (Rembrandt, El Greco, Canova); as discussed above, past and present. There is also a great sense of trepidation about the whole experience, although one we as outsider an

fully embrace, as Geoffrey McNab notes: "One will have retained
ld sensation of being caught in the characters' exhilaration, but
s, being kept at a distance." (2002, 20) The *Ark* then turns into a
erful showcase, an aquarium, almost, which we can observe care-
but never truly penetrate. There is something slightly unnerving
this sensation of being kept at bay from the genuine events and
ons at stake, especially when we understand that we are watching
binding resin keeping the ark of civilization afloat" (Gambrell,
29). The ark as aquarium as floating object—we can clearly discern
tradiction in terms here. And this may have to do with the anti-
alistic, Messianic drive of Grand-Russian nationalism to save the
(the Hermitage collection serving here as an elegant, if forceful,
nymy) from its tendencies to over-rationalize, to drift away from
ıal life and religion, and, as might be the hint, toward totalitarian
"Leftist," "secular," "politically correct") modes of thought—only
)lace them with another dogma or authoritarianism. No wonder,
that many people were somewhat alienated by the film, even
ıd the peculiar nature of its style and form.
s distance might have something to do with the fates that befell
of these historical figures. We would almost shake in anticipa-
)f something dreadful happening, but which never does within
)undaries of the film. Rather it is hinted at, especially in the final
nce, when all the guests from the final ball (alluding to the 1913
which was to be Tsar Nikolay II's last) walk down the main stair-
)f the palace, looking grim and full of melancholy. Sokurov has
ly elaborated on this sad ending: "the characters are sad at the end
se they will all be killed." And killed by their own compatriots,
ı is worse in the Russian director's eyes. Sokurov does thus imbue
ıaracters with a form of prescience that takes them further out of
ıme of a traditional, psychological tale and makes them enter the
of art. And "it is not the role of art to judge." Sokurov goes on:
has condemned them—to a torturous death. History and God put
)ne in their place." While this place will have been the graveyard
history books, Sokurov uses a tomb of a very peculiar nature: the
ım, a capsule of space and time which is not about a Renoirian
panorama in the manner of *La Règle du jeu*, as Charles Tesson noted.
ov prefers romanticism to an aggressive research into something
can't access—their personal lives" (quoted in McNab, 2002, 20).
when he shows Catherine the Great running to the bathroom, thus
ving her with a human, universally relatable quality, Sokurov, both
ı narrator and as filmmaker, remains on another plane of existence

from his characters. He is, in a productive yet contradictory way, both in touch (as a great artist, "spirit," a famous Russian soul and figure) and out of touch (as an inhabitant of the twenty-first century, born long after the fall of Imperial Russia) with the subjects he depicts. Similarly, he is both with his friends that he pictures in the film, and away from them (he establishes the link between the dream of the *fabula* and the reality of its production; he is always more than just the character and just Alexander Sokurov, the filmmaker who never appears on camera, but who won't leave its side, even for one second). Instead of trying to enter an unreachable "naturalistic" portrait of privacy of his characters, Sokurov weaves a carefully structured stream of consciousness akin to a dream, which is also yet another one of his elegies, which ultimately eulogizes and restores.[14] Rather than confronting the Russian myth(s), the film memorializes them, the formaldehyde flavor of which is, again, redeemed by the uncanny, dreamlike formal quality of it all.

The use of Steadicam in the film is in many ways just as important as the one-take aesthetic to achieve this effect. As Deborah Young noted in *Variety*: "In lesser hands [the film] would just be an irritable gimmick, here, miraculously, it gives the film a magical visual style, recalling the way we glide through dreams and videogames" (quoted in McNab, 2002, 22). The floating, seamless, and disincarnated movement provided by this technology evokes the ghostly world of its inhabitants, but it also allows the dreamlike quality of the film to develop, for the invitation to the voyage to take us away (while never letting us in entirely). The film's remarkable achievement is rendered even more impressive by the fact that instead of calling perpetually to the viewer's attention, it makes one forget, time and again, that it is a one-take film. More importantly even, what the technical achievement of the film procures is an unprecedented feeling of coexistence of multiple times within one single space—something the structure of a relatively old building, witness of many crucial historical events, but also repository of thousands of years of human artistic production, lends itself to perfectly. *Russian Ark* becomes thus a sort of poetic evocation and analog to the museum. It is a film, which, as with all of Sokurov's films, celebrates death in the most eloquent—and here allusive—ways.[15] It is about the death of many people, but it is also about the changes Russian society underwent and the simultaneous decline of European civilization, concluding in the emotional note following the ball sequence when Sokurov says "Farewell, Europe."[16] After the party guests have departed, what remains is the ark itself, a depository of Europe's high art tradition, stranded for some reason on this land of marshes, this city that has haunted and

inspired generations of painters and writers, which threatened to fall on several occasions—and never did.

"By the time the film concludes," Anderson notes, "it is less the technical bravura that is in evidence, than the melancholic mood that permeates the nobility's final exit from the Winter Palace." This overwhelming emotional weight accompanying the film's final moments confirms *Russian Ark's* elegiac status, which in its case pertains to the passing of high Russian and European civilization. *Russian Ark* eulogizes not only the pre-Revolution Russian history that is given "life" by Sokurov's cast of thousands which fill the grand hallways and ballrooms of the Hermitage, but also the beauty and majesty of this waning civilization[17] (Figure 14.2).

Another role of *Russian Ark*, namely conservation or preservation, is epitomized in its title, but also evoked in the pervasive smell of formaldehyde mentioned by Custine, and can be interpreted in two ways. On the one hand it is an ark, a safe haven floating on the tormented seas of history, preserving the beacon of a civilization. On the other hand, it may be the much less compelling discourse of the aforementioned Russian faith: that the salvation of the West (of Western civilization

Figure 14.2 Sad fates/sad faces: history walks down the main stairwell of the Hermitage. With Natalya Goncharova and a brooding Alexander Pushkin in the foreground

at large) comes through a *Russian* ark, a messianic mission that has legitimated, ironically, a lot of the exactions under the Imperial and Soviet regimes alike, which Sokurov alternately—and somewhat inconsistently—praises or condemns. Be it as it may, it is obvious that there emerges a parallel between the nature of the museum and this ark, with their momentous legacy, destined to "sail forever."[18]

A third and fundamental function of any museum is to restore certain works of art. *Russian Ark* takes a determined moment in history and restores it like a valuable artwork. Sokurov, time and again, has stressed the importance of art (and cinema), as being a door onto the "other life."[19] Art is the other life,[20] and so the museum, repository of art, becomes a paragon space for Sokurov's conception. But also the very fact of integrating historical figures into the film makes them part of this other life, and thus equates them with art. Again *Russian Ark* is finely tuned to this notion, and this homology can be considered both in formal as well as thematic terms. The seamlessness of the camera movement is in dialogue with a work of art whose surface veneer has been restored, removing the cracks that have made some portrait into an unlikely jigsaw puzzle. Likewise the very elaborate post-production process of the film (thousands of instances of digital enhancement, color grading, and focus manipulations to create or alter the sense of depth) evokes the work of color restoration done on many works damaged by sunlight or humidity. But the most important conceit here is purely cinematic: the film articulates a gap between the cinema of yesterday (35 mm) and tomorrow (digital), showcasing both at the Cannes festival, where the film was projected both from a digital projector and from a 35 mm print transfer. As Tony Pipolo pointed out, Sokurov's project generates a nostalgia for the future of the other life of film, where the actual distinction between digital and analog will have been forgotten, and where also, perhaps, the very emotion promised by art will have changed beyond recognition.[21]

Thematically, the whole issue of restoration is where the film touches upon its most complicated and ideologically fraught aspects: restoring Imperial Russia, which was part of the political agenda of the Russian government under Yeltsin and the early Putin (a showcase and celebration of its past, minus 70 years of the Soviet regime). As *Cahiers du Cinéma*'s Charles Tesson (a proponent of the film, unlike Jean-Michel Frodon) underlined, to Sokurov the "splendor and pomp of Imperial Russian life, inextinguishable object of melancholy [forgo any] ideological scruple. The Russian soul, associated and reduced to the imperial court and the confines of the Palace of the Hermitage [...] Outside these

walls and the lifestyle it contains, there is no salvation" (2002, 48.) This is precisely because for Sokurov a civilization's salvation, its redeeming value, what will be left of it, is its art, and to him these regal figures, their lifestyle, are a work of art, while the Bolshevik figures and the years of the Soviet Union are the unnamable, unfilmable cause of a loss beyond repair. The film can only try to atone for this loss by obliterating that dark period entirely. It does so not so much by bringing back the life of the past, as by restoring its image, its spirit, and its artistic essence.

In this way, the film's "restoration agenda" comes in two major ways: the first one is "museological," classical, literal, restoring carefully the beauty and pomp of the Tsarist era much like one restores a work of art. But this metaphorical restoration goes through a literal re-creation and re-appropriation. I ask then—is the work of art still the same? is it faithful to its original embodiment? The other mode partakes in the magical—a hallucinatory mode, a daydreaming collapsing several times in one space in this miraculous ark, this magical realm where beauty and truth are preserved and prosper, a haven on the dark and troubled seas of history. In short, the film as museum and the film as a child's memory image album,[22] both carrying the sense of utopianism that is in many ways inherent in any ark or museum project. Both modes communicate with one another, thanks to the use of the Steadicam and one-take aesthetic, as I pointed out above, creating the very unique affect (and effect) of the film.

A word should be said for the remarkable performances of lead actors Dreyden and Mozgovoy. Both men are stage actors of note, and I was blessed enough to see them perform on stage on several occasions in St Petersburg. It is obvious that no "simple" screen actor could have pulled off the remarkable feat of achieving such physical intensity and perfect timing combined with apparent ease. But in many ways, the apparatus at play had the actors in familiar territory: in more than one way, the acting of *Russian Ark*, with its accent put on precision in timing, line memorization, and athletic stamina, evokes the world of the stage rather than that of cinema, with its scores of close-ups, repeated takes, and discontinued degrees of intensity. Indeed the film constantly refers to the theater through the metaphors of life as a stage and masquerade. A group of actresses wearing masks is seen recurring throughout the film, and one of the early scenes, shot in the Hermitage's theater, shows a performance of a play for and by Catherine the Great herself. This stressing of the theatrical dimension in the film is hardly a coincidence. Indeed it derives straight from Custine's observation about Russia in his book. There, as Mikhail Yampolsky reminds us, the Frenchman

noted, with plenty of irony, the constant waltz of the servants and court officials at the imperial court, and how it resembled a constant dress rehearsal, endlessly reprised with each day, and where it was never clear who played what part exactly (Yampolsky, 2006, 278). In this frame, it was the tsar who appeared as the ultimate *metteur-en-scène* of this never-ending production. Sokurov, aware of this to the point of self-consciousness, yields a moment of welcome levity in the film (right after the old Catherine runs into the distance in the snow-covered courtyard), where Custine/Dreyden, being asked by the masked actresses whether he wrote the book (which we must assume to be his own Russian recollections), points playfully at the narrator/Sokurov, saying: "Me? Not at all! It's him, he wrote it all!"[23] (Figure 14.3).

The theatrical association that the film posits with the Hermitage complicates the face-value nature of the depictions we are given to witness. Numbed by the beauty and hypnotic quality of the film, we marvel at the stream of careful historic detail and feel puzzled when asked to assess the value of it all. In *Russian Ark*, it is not so much historical factual data we bring back home, but rather the experience of peeping (yet hardly more than that) beyond the image, catching a glimpse of an unfathomable maze. We glimpse the dark ocean of history which

Figure 14.3 Breaking the fourth (non-existent) wall: theatricality and self-reflexivity for an endless "dress rehearsal" in the former winter palace of the tsars

both swallows and spits back these figures liked a wrecked ship on its shores, where we dwell before being swallowed ourselves, miserable grand figures or magnificently unnoticed. The feeling of the maze is reinforced by the sense of enclosure and loss of points of reference. But the maze is also temporal: Before our eyes, 300 years of Russian history conflated within one long take, episodes commingling in an apparent random manner. And yet, unity is achieved and we accept this new—genuinely new—historical time. In this sense, the films play both with Foucauldian heterotopia and plain *Ungleichzeitigkeit* (i.e., the idea that history is always a smoothing-out of its very a-synchronicities).[24] The switches in point of view in the film efficiently dramatize and instantiate these frictions, gaps, and lapses in both historical and psychic levels.[25] It appears, then, that Sokurov could not have used another form and "spatial poetics" than the one he deploys in the film to precisely obliterate the horrors of the Tsarist and, specifically, the Bolshevik regimes. He does the former to better celebrate the positive aspects of Tsarist Russia, while he clearly shows a form of contempt for the latter. However, Sokurov does not so much rescue events as he embalms them in shrouds of thickly enmeshed layers of facts and phantasmagoria, in spaces just as mythological and ghostly.

Sokurov evokes the eclipse of the Soviet period without showing it, to better express its darkness, but seems little concerned with the fates of those who perished under the tsars' regimes. Even more symptomatic, perhaps, is his dispensing with two of them, Alexander I and II, who are generally considered the more liberal Russian emperors. And while Sokurov evokes in passing the fire that burnt down the Hermitage in 1837, he seems at odds with the recollections of Custine, who points out the many lives of workers which were lost trying to reconstruct the palace, simply to restore it to its former glory as rapidly as possible. But what do the lives of hundreds, if not thousands, of workers mean, in the face of the greatness of the achievement ahead? The existence of the Hermitage, and moreover, its resilience through repeated adversity—most notably the famous Nazi "blockade" which cost the lives of one million residents of St Petersburg/Leningrad—matters more in itself than the petty achievements of individuals.

There is something of this rather disturbing, grand-Russian ethos in Sokurov's enterprise: his vision, as it were, of Russian culture as a crucible of art and history that is essential to the survival of a whole nation (perhaps, even, to the survival of humanity at large, if only in the sphere of the spirit), underpins the mythological representation of the Great Russia, pre-Soviet mostly, but also, and even more disturbingly

so, of the new Great Russia, that Russia of Putin and the oligarc or
of "maestro" Valery Gergiev,[26] who appears as himself conductir he
Mariinsky Theatre's[27] Orchestra in the final ballroom sequence ne
myth (an ark of culture and art) founds another myth: that of the it-
ness of a powerful Russia, and the promise of its regained grar se
status, presumably lost during the "dark" years of the Soviet re ie.
And this partakes, no doubt, of the zeitgeist of post-Soviet Russia,)e-
cially since Putin, with his unabashed cult of personality, took the ns
of the country. As Thomas Campbell points out:

> Today's Russian culture—lowbrow, middlebrow, and high w;
> political as well as artistic—is a culture of big names, big m :y,
> broad gestures and spectacular events; of massed forces anc ip-
> down discursive control. It is the culture of Putin and Pugache of
> Gergiev and Piotrovskii, a culture of generals where even a s rb
> chamber artist like Sokurov is moved, for some reason, to refl()n
> the lives of "great men" like Lenin, Hitler, and Hirohito.
> (Campbell,)5)

In view of this, there is something blood-chilling about Russian k's
tableaux vivants. But Sokurov is not a mere reactionary. It is much)re
interesting to conceive of his discourse as a constantly ambiguous te-
ment. Sokurov's filmic form again gives us clues as to the nature iis
message as a full, complex epistemological tool.

The camera movement of *Russian Ark* is floating and fluid, bu is
not without its internal tensions and hesitations. Time and ag it
pulls back, zooms forward, slides sideways. It is never an easy, ot us
trajectory, and this is not merely the reflection of the obvious diff ty
encountered by Steadicam operator Tilman Büttner (whose ph :al
achievement cannot be underestimated). This sense of spatial u ie,
of delicate balance on the verge of imbalance in the movement, coi er-
balances the apparent smoothness of the historical representati of
this ark. As Yampolsky has noted, history in the Hermitage's hal as
no possibility of movement, it is enclosed on itself. Instead of *tal ux
vivants*, what we see here (and the creepy pinched piano strings c ie
soundtrack by composer Yevtushenko are but one indicator of th ire
rather *natures mortes*, pictures of the dead, frozen in the past. An iis
frozen character might have to do with observations made by Ci ie
himself in 1839: Russia, for the French diplomat, was an a-hist :al
entity. Past, for Custine, was never inevitable in Russia, as it ild
always be revisited, indeed, re-made. And St Petersburg, of all p es,

w̄ ɔ Custine the most a-historical of places, having no roots, either
in tory (at the time it was one of the youngest cities in the world, as
it founded by Peter I in 1703), nor in the earth (having been built
ou f Peter I's megalomaniac drive on the inhospitable marshes and
qu nires of the Baltic gulf). We can thus see a homology between the
m ım and the specific history of Imperial Russia (that constant dress-
rel rsed play, never fully realized, always slightly amiss), this "world"
of tsars, are like the frozen scenes in the paintings of the museum,
isc ed in history.

pe s is why most of the film is uncanny in form, befitting Sokurov's
ali iar take on history—a curious blend of Russian reactionary nation-
m and subtle analytical and critical thinking. The forward camera
al: ment can be engulfing and neutralizing of critical thought; it is
W march forward that criticizes itself by the fact of its very being.
fo this type of forward tracking shot dominates the film as it
is vs Custine through the halls, it is important to note that the film
es] ikended by two backward camera movements. The second one is
co ıally conspicuous in the final scene, when the guests of the ball
pt down the large staircase and walk out of the frame, as the camera
ov back and films their somewhat closed and sad faces. It would be
ca ı formalistic to impart strict and simplistic meanings to given
sti ra movements and directions in the film. One must, however,
th the importance of the unique and therefore uncanny nature of
fo ıne-take venture, rendered further strange by instances of dolly
tic rd and simultaneous backward zooming, which creates distor-
tra nark anamorphic lenses and filters, themselves an evocation of
m eval anamorphoses and their implications regarding vanity (and,
ce ries later, the Lacanian gaze)[28] which he could not, for obvious
re ıs, use in this film.[29] The flow of history is thus inescapable and
ur ıny, but it can also be preserved. As Dragan Kujundzic argued, the
ch e of the one-take camera movement—in this film which celebrates
pr ıviet history and somewhat condemns, through obliteration, the
ye of the Soviet regime itself—can be read as an overt reaction against
th eat tradition of cinematic montage championed by Dziga Vertov
an . M. Eisenstein. Sokurov himself repeated several times that, by
th me he conceived of the film, he had grown weary of montage in
ge al, thus his desire to make a film that would be montage-free.

so one can see the aesthetics of the hyper-long take as connected to
se ess aesthetic imposes a dreamlike quality which numbs the

viewer's ability to question what is taking place before him. In this sense, it furthers the notion of Sokurov's apparatus as a reactionary and imperialist agenda-advancement device. But, as Yampolsky has sensed, the floating nature of the one-take aesthetic, as well as the very freedom imparted on the final result of the whole film (many of the extras were hardly trained at all), precisely excludes the notion of total control and directorial tyranny.[30] Oblique as it may be, Sokurov's comment on the nature of control and coercion is inescapably present throughout the entire film.[31] Likewise, his character-narrator may have his ideas on what Russia is or should be, but he is defined by a lack of agency. Although Sokurov the author shapes this collage of Russian history, Sokurov the narrator seems incapable of inflecting upon his environment, other than in his conversation with Custine. Time and again, he and Custine are being chased from various rooms of the Hermitage (a critique, no doubt, of arbitrariness and blind authority), and the shadowing by the spy always reminds us of this control and repression apparatus that has characterized the various Russian regimes. One can conceive of these moments in the film, of transition between the various rooms, but also of shifts in mood and perspective, as a pendant to the psychoanalytical notion of "suture" in cinema.[32] To me, in Sokurov, the notion does not apply as is. I like to refer to Sokurov's shifts in point of view (especially in *Moloch, Taurus,* and *The Sun* (2005)) as instances of "rupture." This notion carries a sense of break, of change in tone, which is especially remarkable in a film apparently so tonally uniform (and editing or cutting free) as *Russian Ark*. One could write a whole piece about this notion alone, but suffice it to say that an eminent instance of rupture in this film can be found in the moments when Custine and the narrator appear as invisible men, unnoticed by the characters (the ghosts of ghosts, so to speak), and those moments when they are clearly interacting with the characters (Sokurov's friends, the dancer Alla Ossipenko, the staff of the palace/museum chasing the characters away). Elsewhere other ruptures occur, as passages from one realm to the other without a cut in the footage, from one "historical period" to the next. The rupture manifests itself also in the uncanny moments of wonder and unease expressed both in the voice-over, aligned often with frequent stops in the camera movement, moments of stasis and potential hesitation. Ultimately, the film that was to feature no montage at all is, also, dominated by a form of rupture-induced editing, and so its historical message is similarly multilayered.

In Sokurov it is not so much a "full tableau" of Imperial Russia that is being rendered, so much as a certain image of melancholy for a grander past (which perhaps never quite *was*) irretrievably lost—enshrined with classical music, the military, and the greatness of Russian and European art of the past—that illustrates the universe the director yearns after.[33] In this sense *Russian Ark*, as Arkady Ippolitov deftly points out (2006), is ultimately much less about history than about memory. The most important force driving Sokurov in making such a film is a celebration of his own past. Not his real past, but the dreamt past of a child whose imagination was larger than the frames offered by a barren hospital room, and, beyond these recesses, the society of his time. These confines made him want to reach out for more—and what better place to do so than one of the greatest museums in the world? After all, the director admits freely that *Russian Ark*, is, above all, a "fantasy." But it is a fantasy with a purpose nonetheless, an artistic mission. Very clearly, in a context where big money and unscrupulous politicians, real estate and industrial Russian tycoons could very easily wipe the (unprofitable) past from a country traditionally so attached to celebrating it (even in some-times adulterated forms), the concern of Sokurov is to keep the ship of memory afloat on the seas of history. The romantic nature of his project, however utopian, of preserving and restoring a glorious past once smothered in the ashes of history, elevating it on a par with the great works of art of Western civilization, forces the admiration for the sheer conviction that carried it through, even though the ship has yet to dock somewhere—arcadian shores it might never reach, for much like these revived tableaux, they never were. In any case, as with all of his cinematic output, the Russian director may be facing the past and speaking to a world of dreams, but he is moving toward the future of his medium, ever lucid and fascinating. Alexander Sokurov, an overt opponent of violent breaks and revolutions and proponent of evolu-tion, knows well that it is by learning the lessons of the past that one might be able to avert the repetition of mistakes past, and, perhaps (but in Sokurov sadness and pessimism always seem to get the upper hand), build a wiser tomorrow.

Notes

1. This most telling and moving anecdote comes from Sokurov's friend and film critic Lyubov Arkus. The filmmaker himself is most discreet when it

comes to discussing his own miseries, past and present. Yet in this instance, it is not without significance. To this, one should add the fact that Sokurov's childhood was a nomadic and therefore uprooted one: his father was in the military, and the young Alexander's youth was thus one of perpetual displacement, between Poland, eastern Russia, and Asia Minor.

2. Invented in 1976 by Garrett Brown, but never used to such formidable lengths hitherto.

3. And likely final, time and light being in short supply on this winter day— one of the shortest days of the year in a northern city which gets very little sunlight in the wintertime anyway.

4. At the time of the premiere, the film was deemed mediocre by Jean-Michel Frodon (*Cahiers du Cinéma*), merely "of interest" by Gavin Smith (*Film Comment*) and Jan Lumholdt (*Filmhäftet*), but excellent by Gioca Nazaro (*Filmcritica*) and Jan Dupont (*International Herald Tribune*). The poll reprising these ratings and opinions can be found in issue 211 (July–August 2002) of *Film Comment*. Subsequently, upon its American release, the film gained wider and wider appraisal and recognition: In a later *Film Comment* poll (issue 212, September–October 2002), M. Dargis, J. Rosenbaum, R. Ebert. and J. Hoberman deemed it excellent, and *Art in America*'s Jamey Gambrell gave it an accolade, calling it a "compelling meditation on History, memory, time and art" (29). In Russia, the film has decidedly polarized critics, some praising its philosophical depth and artistic commitment, others sneering at the high kitsch it epitomizes, its questionable ideological agenda (a criticism widely reprised in France), and the vanity of its technical accomplishment. As time goes by, the film is more and more considered as a modern classic, and undoubtedly grows with every viewing, such is the richness of its fabric.

5. There is the compelling and elegant "making-of" of the film available on the US release of the film on DVD, but also various reports from the 2002 Cannes festival, where the film premiered and where, in spite of not getting any prize, its phenomenal production history was one of the big attractions of the festival. See Hoberman (2002), McNab (2002), or, in French, Tesson (2002).

6. While it also allowed it to become probably Sokurov's only film marginally famous outside of Russia and cinephilic circles.

7. As Angela Dalle Vacche suggests, this poignant image is not unlike Tarkovsky's flame carried across the pool and then dying in and out at the end of *Nostalghia* (1983).

8. The image of the ark, the boat, is already intimated in the very beginning of the film, when, still in the darkness of the black screen, we hear the sounds of a harbor, and a boat's powerful, and almost painful whistle.

9. Alexander Sokurov's views of history are complex and, in many ways, problematic. The director is generally considered a conservative, skeptical of the present and generally denigrating twentieth- century art. Several of his films deal with historical figures and posit an original film grammar, founded on the dislocation of traditional point of view, which I have interpreted as a challenge of perspective and questioning of history as unified discourse articulated around figures of authority. However, Sokurov himself is not without models and "points of reverence," while his films and the (hypothetically historical and/or political) discourse they carry must always

be considered for their subtlety and ambiguity, even when they seem to endorse an imperialist agenda. The most blatant case would be his 2007 feature, *Alexandra*, which parades under the guise of a quasi-documentary about a woman visiting her grandson, a soldier in Chechnya, while actually being a totally mythical (in Roland Barthes' terms) fabrication.

10. When Custine meets two of Sokurov's real-life friends, an actor and a doctor, he complains about their smelling of formaldehyde. Although they are, unlike Custine, contemporaries of the film's shoot, they too will lapse into death and oblivion, with art and symbolic forms the only way of redeeming them partly from it—something Sokurov is almost painfully aware of.

11. The French philosopher's influential two books on cinema, *The Movement Image* and *Time Image* (1986 and 1989) discuss the nature of cinema, elaborating on Henri Bergson's theories on time and space. Deleuze rebuffs the idea that cinema is a succession of still images, emphasizing rather the continuity of movement. In the first volume, he discusses a series of films and creates sub-categories to the movement-image, most prominently the perception-image, affection-image, and action-image. This cinema is still preoccupied mostly with movement and thus action, led by logic and rationality. But by the aftermath of World War II, its score of unspeakable horrors, and the collapse of a rational, graspable notion of the universe and its causalities, the movement-image is superseded by a new category, the time-image. This second category is illustrated, among others, by Italian Neorealism and the Modernist cinemas of the 60s (the French New Wave, etc.).

12. In the language of logic, philosophy, and theory, the term *aporia* designates a difficulty encountered in establishing the theoretical truth of a proposition, created by the presence of evidence both for and against it.

13. In his books on the subject, Rosenstone has distinguished between historical cinematic accounts in terms of mainstream, documentary, and innovative dramas. In the latter category he places Eisenstein's *October* (1927), and all those films that prove more complex, interrogative, and self-conscious. As we will see, it is highly ironic to place the cinema of Soviet montage next to Sokurov's rather clearly anti-Soviet and montage-free (or rather, "cut" free) work, but it is still the category where it most clearly belongs.

14. The film follows and completes the project of his two earlier documentaries on museums, *A Happy Life* (about painter Hubert Robert) and *Elegy of a Voyage*. Both are available in the US under the Facets video label.

15. Not that cinema, as film scholars on many sides have long argued, is not by its very nature a celebration of death: death through movement, impermanence preserved, so death through life; but none other than Sokurov has better examined the very nature of death as a narrative element (actually superseding the narrative), and the time of dying, the time of death as not only ontological (cf. Bazin, of course) but quasi-epistemological. None has written better on the subject than Mikhail Yampolsky ("Death in Sokurov," in *Sokurov*, ed. L. Arkus), but any viewer of his films will get the point, particularly in *The Second Circle* (92), *Stone* (93), or *Mother and Son* (97).

16. The sentence itself might be interpreted as a Freudian lapse, but there are no such easy "mistakes" in Sokurov. The filmmaker clearly alludes, here, to the contemporary drifting away of Russian culture from Europe, once its founding tsar's open model for the building of St Petersburg (Dutch

and Italian influences, particularly). In a context of almost erotic flirtation over gas and other sources of energy between European countries, such as Schroeder's Germany with Putin's Russia, after years of cold war and postcommunist chaos, this statement might surprise. But Sokurov, as an individual, certainly laments a certain loss of tradition and manners (borne from the idealized European models) in Russia, replaced by the priorities of market economy and "coca-colonization," where English has replaced French as the lingua franca of business and diplomacy, and the Russian soul itself is fading away.

17. Again, in Sokurov nothing is ever simple and fully straightforward—much like the winding patterns, sometimes hesitant, sometimes assertive, of his camera in the film. Nostalgia meets and collides with philosophical substance, and the ongoing dialogue between Custine and the narrator is productive in the conflicted views they propose, but also in the quasi-enigmatic, sometimes Socratic reflections by either character, followed by very clear statements a moment later. In this view, Sokurov, for all his professed Grand-Russian nationalism, can never be viewed as a plain reactionary. There is always an element of paradox, formal or thematic, which complicates the whole fabric of each discursive element in the film. This unique—and far more complex than many would have it—use of paradox (what I call *paradoxism*) is one, but not the only, important contribution of Sokurov to film and film theory, beyond the many stylistic and formal experiments, idiosyncrasies, and innovations in his cinema.

18. And, of course, in many ways Noah's ark was the first collection, the first zoo, the first museum in human history.

19. For a further discussion of the "other life" in Sokurov's own terms, see my interview with the director, but also Tony Pipolo in *Film Comment*.

20. Sokurov's notion of "the other life" should in no way be confused with the idea of "going beyond the mirror" as illustrated, for instance, in Jean Cocteau's *Le sang d'un poète*. It is in no way this literal or simple, and there is no room for surrealism in Sokurov's cinematic universe anyway.

21. In the sense that the progress of High Definition will, ultimately, offer an image quality which will supersede the precision of 35 mm, but will probably also, in spite of its attempts to imitate the latter (artificial generation of grain and flicker effects, etc.), provide an image of a different nature altogether. Even in the event that it will still be projected through the physical body of film (through the technology of imprinting audiovisual material, shot digitally, onto a "traditional" film reel), something of the nature of the photographic image will be lost, and retrieved only in film archives and museums.

22. Tesson interestingly compares *Russian Ark* to Sacha Guitry's *De Jeanne d'Arc à Philippe Pétain* (1944).

23. And indeed, Sokurov was the main author of *Russian Ark*'s script, not working this time with his usual screenwriter, Yuri Arabov. Yet this is hardly a Brechtian moment of breach of the fourth wall. The "fourth" wall in the film is both open and closed throughout the film, since it is literally embodied by the ghostly presence of the narrator/Sokurov (the distinction between the two entities is never made clear, and in this the film is close to Sokurov's

documentaries, where he often partakes in the "action" and narrates it with the same mild, yet often probing and ironic, voice) (Figure 14.3).

24. For more information on the term *heterotopia*, see Michel Foucault's *Des espaces autres* (*Of Other Spaces*, 1967) in which he discusses (appropriately to the present film and its postmodern implications) an epoch in which places and spaces function in non-hegemonic conditions, and provides a series of different heterotopias. The term *ungleichzeitigkeit* ("non-synchronicity" or "non-synchronism") was coined by Marxist thinker Ernst Bloch in his book *Erbschaft dieser Zeit* (*Bequest of this Time*, 1935) with its criticism of rising Nazism.

25. Again, the tension between Modernist and postmodern dimensions in the film, between subtle historical assessment and love of art with heavier, quasi-totalitarian aggrandizing of the imperial past and obliteration of most of twentieth-century politics and art, but also the lapses, in the characters, between moments of interaction with actors and moments of "ghostliness," when they are unseen by the historical figures. This lack of coherence reinforces the arbitrary, dreamlike feeling provoked by the film.

26. The artistic director and chief conductor of the Mariinsky Theatre.

27. Much like the Bolshoy to Moscow, the Mariinsky Theatre is the reference theatre of St Petersburg, boasting its most prestigious performances of ballet, opera, and symphonic music.

28. For a discussion of anamorphic paintings, see Jurgis Baltrusaitis' *Anamorphic Art* (1977). For Lacan's discussion of gaze in Hans Holbein's painting *The Ambassadors* (which does feature a famous anamorphic skull), see *Four fundamental concepts of psychoanalysis* (1977).

29. It would have been impossible to apply seamlessly and inconspicuously the layers of anamorphic lenses, filters, gauze, Vaseline, and other props onto the camera without disrupting the course of the film. Besides, the desired effect, often requiring elaborate tests with lighting and contrast, would almost certainly not have matched the effect desired by Sokurov.

30. In this, Yampolsky echoes André Bazin's famous paean in favor of the long take and depth of field, calling this aesthetic "the most democratic" form of filmmaking. See, for instance, his article on William Wyler's *The Best Years of Our Lives*, in *Revue du Cinéma*.

31. This being said, Sokurov, who refers to the Soviet revolution as a catastrophe, does not seem to find cruel the reconstruction of the Hermitage (which burned down in 1837), requiring over 6000 workers, many of whom died in the process only to be replaced by other workers, and which Custine criticized vividly in his recollections.

32. The term *suture* was coined by Jacques-Alain Miller, a psychoanalyst and follower of Jacques Lacan, to whose theories (and especially the mirror-stage) this notion owes a lot. "Suture" in cinema designates the moment between two takes when we preserve the unity of film, glossing over the rupture represented by the cut. One typical instance of suture is, for instance, the technique whereby, in a shot-counter-shot exchange between two characters, we see, in the foreground, a part of the body (say, the shoulder) of the character opposite the character whose face we see. This body part helps "suture" the two shots together. While the notion itself has proved very influential, it

has also polarized critics. David Bordwell, for instance, is a strong opp nt
of suture, while its greatest champion, no doubt, is Slavoy Zizek.
33. Cf. the anecdote opening the present article.

References

M. Anderson, "Russian Ark," in *Tativille* (27 March 2008), http://ta le.
blogspot.com/2007/03/russian-ark-2002-russiagermany-96.html.

J. Baltrušaitis, *Anamorphic Art*, trans. W. J. Strachan (New York: H. N. A 1s,
1977).

A. Bazin, "William Wyler ou le janséniste de la mise en scène," *La Re du
Cinéma* (February and March) (pp. 10–11).

E. Bloch, *Erbschaft dieser Zeit* (Zurich: Oprecht & Helbling, 1935).

T. Campbell, Review of *Bipedalism*, in *Kinokultura* (10 September 2005), w.
kinokultura.com/reviews/R10-05priamokhozhdenie.html.

M. A. de Custine, *Russie en 1839* (Brussels: Société typographique belge, 1٤ .

G. Deleuze, *Cinema 1: The Movement-Image*, trans. H. Tomlinson and B. Habl m
(Minneapolis, MN: University of Minnesota Press, 1986).

G. Deleuze, *Cinema 2: Time-Image* (Minneapolis, MN: University of Min ta
Press, 1989).

M. Foucault, *Of Other Spaces*(1967), http://foucault.info/documents/hetero ia/
foucault.heteroTopia.en.html. Accessed on July 13, 2010.

J. Gambrell, "The Museum as Time Machine," *Art in America* 91:7 (July), ٦ 1.

J. Hoberman, "And the Ship Sails On," *Film Comment* 212 (Septe r–
October), 54.

A. Ippolitov, "Mir-Rossia-Peterburg-Ermitazh," in *Sokurov, Chasti Rec] d.
L. Arkus (St Petersburg: Seans, 2006, pp. 283–91).

F. Jameson, "History and elegy in Sokurov," *Critical Inquiry* 33:1 (2006), 1–

F. Jameson, *Postmodernism, or, The Cultural Logic of Late Capitalism* (Durhar C:
Duke University Press, 1991).

D. Kujundzic, "After 'After': The Arkive Fever of Alexander Sokurov," *Qı rly
Review of Film and Video* 21:3 (2004), 219–239.

J. Lacan, *Four Fundamental Concepts of Psycho-Analysis*, ed. J.-A. Miller, is.
A. Sheridan (London: Hogarth Press, 1977).

J.-A. Miller, "Suture—elements of the logic of the signifier" (1966), http:/ w.
lacan.com/symptom8_articles/miller8.html. Accessed on 12 July 201(is
text was published in French in *Cahiers pour l'analyse* 1 (Winter 1966 b-
sequently its English version, translated by Jacqueline Rose, appeared in en
18 (Winter 1978).

G. McNab, "Palace in Wonderland," *Sight and Sound* 12:8 (August 2002): 2

A. Nadel, "What makes films historical?" *Film Quarterly* 62:3 (Spring)),
76–80.

T. Pipolo, "Whispering Images," *Film Comment* 212 (September–October 2),
52–61.

K. Ravetto-Biagioli, "Floating on the Borders of Europe," *Sokurov's Russi￼ rk.
Film Quarterly* 59 (2005), 18–26.

R. A. Rosenstone, *Visions of the past: The Challenge of Film to our Idea of] ry
(Cambridge, MA: Harvard University Press, 1995).

R. Rosenstone, *History on Film/Film on History* (Harlow, UK: Pearson
 :ation, 2006).
A. .rov, "Interview with Aleksandr Sokurov," conducted by Jeremi Szaniawski,
 cal Inquiry 33:1 (2006), 13–27.
J. : iiawski, Historic space in Sokurov's *Moloch, Taurus* and *The Sun. Studies in
 ian and Soviet Cinema* 1:2 (2007), 147–162, doi: 10.1386/srsc.1.2.147/1.
C. ion, "Restauration," *Cahiers du Cinéma* 569 (June 2002), 48–49.
M npolsky, "Smert v kino," in *Sokurov*, ed. L. Arkus (St Petersburg: Seans,
 ł, pp. 273–8).
M npolsky, "Lovets istorii sredi ee eksponatov," in *Sokurov: Chasti Rechi*, ed.
 ·kus, (St Petersburg: Seans, 2006, pp. 277–81).

15
Museums as Laboratories of Change: The Case for the Moving Image

François Penz

> Le cinéma est avant tout un révélateur inépuisable de passages nouveaux, d'arabesques nouvelles, d'harmonies nouvelles entre les tons et les valeurs, les lumières et les ombres, les formes et les mouvements, la volonté et ses gestes, l'esprit et ses incarnations[1]
> —Elie Faure, *Ombres Solides* (1934, 6)

Background

This chapter takes its inspiration from two research projects[2] carried out in 2007 and 2010 at the University of Cambridge, UK. Under the title "Discursive Formations—Place, Narrative and Digitality in the Museum of the Future," the first project investigated the integration of digital technologies into the physical context of the museum space using the Fitzwilliam Museum as a case study. The work was organized around three practice-based research workshops:

The first workshop[3], *Embodying the Digital World*, aimed to investigate how the physical and haptic nature of our surroundings, apprehended through our senses, can be transposed into the augmented gallery by the tangible interface.

The second workshop, *Navigating the Museum Space*, concentrated on the rationale and motivations for museums to engage with the moving image through hands-on experiments where the participants created narrative expressive space movies of parts of the Fitzwilliam Museum, with the aim to consider the role of the moving image in a museum context.

The third workshop[4], *Every Fragment Tells A Story*, built on the experience acquired in workshops one and two and, more particularly, addressed the technical and resource challenges of authoring and implementing new media into traditional museum contexts by exploring the museum as a space for narrative, ritual, and performance.

The second research project, "Museum Interfaces, Spaces, Technologies" (MIST), had similar objectives and aimed to explore how new technologies, at the intersections of material and digital culture, open the way for new forms of museum spectatorship, making our cultural heritage more interesting and engaging as well as reaching new audiences. MIST was also organized around two practice-based workshops:

Workshop 1 investigated issues of spatiality, narrativity, and interactivity in the museum context, and explored how contemporary digital research may provide new ways of understanding objects and artworks.

Workshop 2 examined how media and performativity potentially offer the museum visitor a deeper engagement—not through re-enactment, but through original transmedia augmentations of the collection.

Points of contact between cinema and the museum

> *It is disappointing ... it is better to read "Les Voix du Silence" than to go to the Museum of Modern Art ... because at least we have the paintings with us ... it is the opposite of its mission to end up in a museum ... unlike cinema.*[5]
>
> —*Godard (1965)*

While this chapter builds on the outcome of the research projects mentioned above, it concentrates essentially on the role of the moving image in museums. In the twenty-first century, museums have become extraordinary "laboratories of change"; audiovisual media have permeated the museum space: from handheld devices to large screen projections, to interactive technologies at the intersections of material and digital culture. These screen-based applications have all evolved out of the 115 years of shared audiovisual rhetoric and visual narratives between the cinema and the museum. In order to understand

the overlap, we must briefly consider the numerous points of contact between cinema and the museum in the twentieth century.

Cinema and the museum are essentially nineteenth-century institutions, both capturing memories, archiving knowledge, and displaying it in purposely built architectural spaces, the movie theater and the museum space respectively. Interestingly, both institutions have become very successful again, around the same time, after going through difficult times from the 1960s to the 1980s, for different reasons, and have reinvented themselves in the late 1980s.

In the 1950s the Louvre had an average of 600,000 visitors a year; in the 1960s it was a million, 5.6 million in 2001, and 8.5 million in 2009.[6] Similarly cinemas have enjoyed increased audiences since the advent of the multiplexes.[7] Both institutions refer to "blockbusters" for successful movies and exhibitions. In particular in the case of museums, prestigious building projects carried out by world leading architects have certainly played an important part in this revival, a trend that started with the opening in 1977 of the Centre Pompidou in Paris (Piano and Rogers architects).

However, museums and cinema pander to different audiences, and museums fail to attract young adults: the 16–24 age group[8] who, on the other hand, constitute the bulk of cinemagoers.[9] This is certainly an issue for museums in relation to attracting public funding and it has triggered the UK Museums, Libraries, and Archives Council to identify "digital activity as a very important way of engaging new audiences."[10]

Beyond considerations at the level of the institutions, the points of contact between cinema and museums were elicited with great clarity in an April 2006 issue of *Les Cahiers du Cinéma* devoted to museums. There are museums of cinema exhibiting filmmakers—Almodóvar in 2006 at the French Cinémathèque (*Les Cahiers du Cinéma*, 2006, 24), while modern art museums exhibit the work of filmmakers—Godard at the Centre Pompidou (*Les Cahiers du Cinéma*, 2006, 8), a trend in part started by Dominique Païni with the exhibition *Hitchcock et l'Art: Coïncidences Fatales* in 2001, where he successfully exhibited the film-maker's oeuvre in a modern art museum context, a theme thoroughly explored in Païni's key text *Le temps exposé: Le cinéma de la salle au musée* (Exhibiting time: from the movie theater to the museum, 2002).

In 2006 the Centre Pompidou also staged *Le Mouvement des Images* (The movement of images), curated by Philippe-Alain Michaud. It was a seminal exhibition focusing on cinema and its influence on modern and contemporary art across the twentieth century, convincingly demonstrating that cinema had long entered the museum.

Significantly *Le Mouvement des Images* exhibition was organized around four ontologies, or four ways of eliciting the presence of cinema in twentieth-century visual art: *défilement* ("unwinding"), *projection, récit* ("narrative"), and *montage*—a categorization which has proved useful for this essay. Michaud further makes the case for cinema to get out of its theatrical and narrative corseting, associated with most of the history of cinema, making the point that "we are witnessing a massive migration of images in motion from screening rooms to exhibition spaces, a migration borne along by the digital revolution and prepared by a twofold phenomenon of dematerialization of works plus a return to the theatricality of the art scene" (Michaud, 2006, 16).

But one key development highlighted by *Les Cahiers du Cinéma* (2006, 29) was the emergence of museums, such as the Musée d'Orsay and the Louvre, as co-producers of fiction films. In particular, the Musée d'Orsay celebrated its 20th anniversary in 2006 by commissioning two feature-length films, one by Hou Hsiao Hsien and one by Olivier Assayas. The original brief given to the filmmakers was that the museum had to be present either throughout the film or in just one scene, no doubt hoping that it would last longer than the running scene[11] through the Louvre in *Bande à Part* (Band of Outsiders, Godard, France, 1964).

As it turned out, in both cases—*Le Voyage du Ballon Rouge* (The Flight of the Red Balloon, Hou, France/Taiwan, 2007) and *L'Heure d'Été* (Summer Hours, Assayas, France, 2008)—the Musée d'Orsay is only present in the last scene. This experiment was followed by the Louvre co-producing *Visage* (Face, Ming-liang Tsai, France/Taiwan, 2009). The key motivation for both museums is to be seen as a "lively" institution, as coined by Serge Lemoine, the Musée d'Orsay's director: "Musée d'Orsay, musée vivant" ("Musée d'Orsay, a living museum", *Les Cahiers du Cinéma*, 2006, 29), and echoed by Henri Loyrette, director of the Louvre: "Le Louvre has always been for me a home for living artists. Although the collection stops in 1850, it is important to show the liveliness of the works [...] which can still animate, inspire, invigorate artists today" (Schwartz, 2009). Of the three films, *Visage* by Ming-liang Tsai is the most directly inspired by the museum environment: here the Louvre acquires a genuine dramatic function.

Aside from wanting to project a more vibrant image, there is a range of motivations for such large national institutions to engage with the film industry. These include a desire to retain some level of control and to be associated with quality projects, avoiding the *Da Vinci Code* (Howard, USA, 2006) syndrome—a mediocre film[12] by all accounts, in part staged in the Louvre. And beyond wanting to regain the initiative

and be associated with films of high artistic values, museums are able to take advantage of cinema's universal ability to communicate and, in particular, to reach out to those who do not go to museums, by conveying more of the museum experience through the cinema and, ultimately vice-versa, putting more of the vitality of cinema into museums through the widespread use of screens and other handheld devices. However it remains to be seen if the museum experiments with the film industry will carry on, as the next set of projects profiled in *Les Cahiers du Cinéma* in 2006 have yet to be confirmed.[13]

Hypothesis one: From museum space to screen language—The case of the Fitzwilliam Museum

> *Real museums are places where Time is transformed into Space.*
>
> —Pamuk (2009, 510)

Capturing something of the museum experience and conveying it to a modern audience is at the heart of the Musée d'Orsay and the Louvre's experimentation, and goes back to Walter Benjamin's earlier preoccupation with the "being there," confronted with the work of art: "Even the most perfect reproduction of a work of art is lacking in one element: its presence in time and space, its unique existence at the place where it happens to be" (Benjamin, 1999, 220). Benjamin's point is poignantly illustrated by Godard during a 1965 visit to the Musée d'Art Moderne de la Ville de Paris. He is talking on camera standing in front of Matisse's *La Blouse Roumaine* (1940): "it looks very simple as a painting ... purely decorative and the more we look at it, the more we discover it as a feeling ... I mean it is a young woman dreaming, this escapes us when we first look at it ... and the more we look at her the more we are interested in what's human in her ... and those eyes which are only two lines signify a look" (Godard, 1965). We couldn't be further away from Godard's flippant take on the Louvre in *Bande à Part*, and there is a genuine emotion in his voice as he expresses his feelings. But while this clip conveys Godard's sentiment admirably, it hardly achieves any sense of "being there" as far as Matisse's painting is concerned. We are merely watching somebody contemplating and commenting on a painting—and while it might instill in the audience a sense of curiosity, in this case heightened by Godard's personality, it is lacking the "here and now of the work of art."

But can cinema and the moving image render something of "a" museum experience? Can the moving image capture both the experience

of moving in space as well as the emotion of being confronted with the work of art? And in that sense, is the museum space different from other spaces? In this respect, Giuliana Bruno goes some way to elicit the power of cinema in a museum context in her analysis of a scene in Rossellini's *Viaggio in Italia* (Voyage in Italy, Italy, 1953) where the main character—played by Ingrid Bergman—is fascinated by the Roman statues of the Museo Nazionale in Naples: "Katherine gets close to its seductive offerings [...] The camera makes this sculptural-haptic not only visible but palpable and obtainable, ultimately revealing how a sculpture is spectatorially experienced in a haptic way, with movement that emoves" (Bruno, 2002, 390). Long before Bruno, Benjamin had noted the tactile quality of film: "It promoted a demand for the film, the distracting element of which is also primarily tactile" (Benjamin, 1999, 238), while also attributing similar qualities to architecture: "Buildings are appropriated in a twofold manner: by use and by perception—or rather, by touch and sight" (Benjamin, 1999, 240). The tactile and haptic argument of cinema is furthered by the phenomenological approach of Vivian Sobchack: "Thus, the film experience is a system of communication based on bodily perception as a vehicle of conscious expression. It entails the visible, audible, kinetic aspects of sensible experience to make sense visibly, audibly, haptically" (Sobchack, 1992, 9). But we need to turn to Juhani Pallasmaa to have a holistic interpretation of both space and film: "A film is viewed with the muscles and skin as much as by the eyes. Both architecture and cinema imply a kinaesthetic way of experiencing space, and images stored in our memory are embodied and haptic as much as retinal pictures" (Pallasmaa, 2001, 18). This approach has been later enriched by the work of cognitive psychologist Julian Hochberg who concluded that "perceiving the world and perceiving pictures of it may not be all that different—once you grasp how to look and what to ignore" (Peterson, 2007, 401).

This closeness in the relationship between screen space and real space implies that film can render something of "a" museum experience as suggested by Bruno. Cinema does not aspire to describe museums nor does it aim to educate spectators about artifacts but, through mise-en-scène and mise-en-cadre, it may convey a character's feeling when looking at a painting or an emotion when walking in a gallery space, not unlike Picasso's quip in response to a detractor[14]: "He's right. I can't paint a tree. But I can paint the feeling you have when you look at a tree" (Hare, 2002). It is this feeling one has when looking at a painting or walking through a gallery space, which was explored during the 2007 *Navigating the Museum Space* workshop.

This workshop built on the Digital Studio for Research in Desi
Visualisation and Communication's long experience of filming
museums, through an exercise entitled "narrative expressive space."
the time of the workshop, we had produced 25 short—around th
minutes—moving-image portraits of all the museums in Cambri
University (bar the Scott Polar Institute). A careful analysis of
moving-image database revealed a number of considerations, wh
were subsequently taken on board as part of our hypothesis.

First, the notion of "discursive formations", proposed by Mic
Foucault (2002, 34). This describes the various ways in which knowle
and discourse become manifest through institutional structu
networks of associated text, norms of language, and even phys
environments. We used the term in particular to refer to the phys
nature of museum environments both as spatial "formations"
as "discursive," that is, revealing structures of knowledge that wo
otherwise be hidden from view through spatial arrangements. But
also used it to acknowledge the potential power of the moving im
to augment and challenge these static organizations of objects reveal
new spatial and narrative structures. This is in line with Foucault's
hypothesis: "statements different in form, and dispersed in time, fc
a group if they refer to one and the same object" (Foucault, 2002,
Museum artifacts, museum spaces, museum visitors, and movies ab
museums form a group and in that sense we are dealing with a partici
discursive formation.

The second part of our framework—arising from the notion
discursive formations—was to elicit the analogy between screen sp
and real space by matching modes of museum exploration with scr
language based on the analysis of our database of museum movies.
different modes of museum explorations were identified as: educati
exploration/search, and entertainment. Those are broad catego
which correspond to the educational mission of museums, museu
as a source of information and research, as well as, increasingly,
museum as a place of wonderment.

Based on this analysis we proposed to equate the first m
(education) with continuity editing—the screen language conc
whereby filmmakers create an illusion of continuous action althou
time and space are condensed from real time and real space. In
museum environment under the continuity editing mode, there wo
be only minor ellipsis of time and space, which in effect correspc
to momentary lapses of attention while one progresses through
museum space, seeing nearly everything on display. This is a m

o loration typical of school visits, as, conveniently, the curatorial
ar ;ements allow the teaching to take place in a single space—or
se of contiguous spaces.

 second case—exploration—corresponds to the museum as a
pl of research where one would need to connect artifacts that are
on ferent floors or wings of the museum. This relates to the notion
of ontage and creative geographies as first explored by Kuleshov
(Y olsky, 1994, 45) and used in the city symphonies of the 1920s,
wl e spaces are juxtaposed on the screen across physical boundaries
wi n the same city and sometimes across several cities, as in *Man with*
th ovie *Camera* (Vertov, USSR, 1929).

 last mode of museum exploration—entertainment and
wo erment—is the province of *flânerie*, allowing for a serendipitous
ex ration of the museum space, a site of wonder and chance encounter.
It responds in screen-language terms to a mixture of montage and
co inuity editing with a touch of Kuleshov effect (Prince and Hensley,
1992, 59). As in the education mode, the flaneur may for a while follow a
museum section, then on a whim may depart for another floor or wing,
while at all times allowing the possibility to be led and teased by another
display, ready to take advantage of the Kuleshov effect, whereby the
juxtaposition of two images may produce a third enticing meaning.

This provided the framework from which to explore the Fitzwilliam
Museum with our cameras. In addition, the brief called for shooting
ar cutting, using a digital video camera and editing suite, a two- to
th minute narrative moving-image piece, expressing an aspect of
th useum space through a narrative structure. For this exercise, the
pa ipants were asked to explore continuity editing and montage in
ev ng the museum for an audience and exploring it in a coherent
na tive style, using human presence to help create that coherence.
Tl eams had to identify a suitable narrative device to be expressed
th gh cinematography, editing, lighting, soundscape, and music
(a nposer joined the group for a day and composed music for each
m e). In order to ensure that the choice of shots was making sense as
a esentation of 3-D topography and orientation on a 2-D screen, the
pa ipants were required to reconnoiter their route (using still cameras)
th gh storyboarding the journey pictorially in the traditional five acts
of Western narrative structure.

 r three days of hard work, the groups produced two moving-image
"e s":

nento *Mori* (2'30"), and *Some Words with a Mummy* (2'50"). In
M nto *Mori*, a visitor charts the whole life cycle, from birth to death,

through seven paintings. In terms of modes of exploration, this was an example of exploration/search, corresponding in screen-language terms to montage and creative geographies; yet it also combined an educational aspect, as one could imagine that a museum might create a "cradle to grave" journey of relevance to schools' curriculum. Therefore it combines elements of both continuity editing and montage—continuity editing as the cuts are motivated by the character's journey through the museum in search of relevant paintings, mixed with montage shots of floor textures in particular. At the same time, the physical space of the museum is being reconfigured through the editing process, eliciting very vividly the screen-language notion of creative geography.

The superimposition of the plan and the various cut and paste stages of the museum map are an almost perfect visualization of Jean Mitry's statement that "shots are like cells, distinct spaces the succession of which, however, reconstitutes a homogenous space, but a space unlike that from which these elements were subtracted" (Heath, 1981, 40). Indeed the final reconstituted plan, shown over the credits, presents us with the new map of the museum, a mental map corresponding to a new curatorial arrangement—the life cycle through paintings. The map/plan metaphor sees the Fitzwilliam Museum being remodeled in real time, with great chunks of the building folded away in the interstices of the screen montage, while the newly created topography emerges out of the collage of fragmented rooms and galleries. The floor plan of the museum becomes the script as well as the main character, and seven paintings come forward in this cinematic "stations of the cross," becoming in the process new landmarks of the Fitzwilliam Museum.

In *Some Words with a Mummy* (2'50"), the narrative is loosely based on a story (1845) of the same title, by Edgar Allan Poe (Beaver, 2006, 154), about the unwrapping of an Egyptian mummy "on loan from the City Museum," a satire of Egyptomania and "mummymania" in vogue at the time (Lupton, 2003, 23). In this movie the museum becomes a site for entertainment and wonderment through the narrative device of the flaneur. It allows for a leisurely walk around the museum spaces while the voice-over (adapted extracts from Poe's story) gives a different meaning to the notion of the body and space in a way that would not normally be apparent in a museum (Figure 15.1)

Essentially, *Some Words with a Mummy* sets a dialogue between the voiced narrative of Poe's story and the artifacts: "we found the flesh in excellent preservation, with no perceptible odour. The colour was

Figure 15.1 Key frames from *Some Words with a Mummy*

reddish ...," as the flaneur gently ambulates around the burial display of Nakhtefmut in the Egyptian room on the ground floor. The voice further informs us: "The eyes it seemed had been removed, and glass ones substituted, which were very beautiful and wonderfully life-like, with the exception of somewhat too determined a stare," giving a new meaning to the stares of Anthony van Dyck's paintings of Archbishop Laud and Rachel de Ruvigny—part of the British Art 16th and 17th-centuries room on the first floor.

The implication is that paintings, not unlike mummies, are a way of preserving life and the body. In other words, the moving image allows us to make connections across a "system of dispersion, between objects, types of statement, concepts, or thematic choice" (Foucault, 2002, 45), across time (several centuries separate Nakhtefmut and van Dyck) and space (in this case, across the floors of the museum). The formation of a "discursive division" pertaining to museum "objects" (statement, concepts, themes, etc.) crystallizes on the screen in a way which would otherwise remain hidden, as they do not fit the spatial narrative of the museum nor do they correspond to the curatorial stance.

In this practice-based research experiment, the movies acted as proof of concept by probing the initial hypothesis. In particular it showed that the moving-image medium challenges the museum building as sole organizational device of artifacts and demonstrates how knowledge representation can be liberated from the "ballast of materiality" (Benedikt, 1991, 41). New structures of knowledge can therefore be divulged, excavated out of the hidden layers of the combined spatial and curatorial arrangements and be cinematically revealed as a discursive formation.

Hypothesis two: The cinematic within the museum space

This mental cinema is always at work in each one of us,
and it always has been, even before the invention of the
cinema. Nor does it ever stop projecting images before our
mind's eyes.

—Calvino (2009, 83)

In hypothesis one we explored the capability of moving-image media to capture something of a museum experience. We also started to elicit an analogy between the language of the screen and real space, by providing a tentative match between museum exploration modes with film grammar. However, the exploration of the museum space as a vehicle for a cinematic experience needs careful investigation and is the focus of our second hypothesis, testing what we could call "mental cinema," after Calvino.

This notion has gained favor in cinema and architecture scholarship, most notably through the work of Giuliana Bruno: "She who wanders through a building or a site acts precisely like a film spectator absorbing and connecting visual spaces. The changing position of a body in space creates both architectural and cinematic grounds" (Bruno, 2006, 23). However, it would appear as if museums have been leading the way in this form of proto-cinema for sometime, as argued by Alison Griffiths: "The spatial organization of life groups within nineteenth-century museums of natural history can be read as a form of 'promenade cinema'" (Griffiths, 1996, 54). Indeed as early as 1896, Franz Boas suggested to Frederic Ward Putnam, in charge of the anthropological collections of the American Museum of Natural History in New York, that "In order to set off such a group to advantage it must be seen from one side only, the view must be through a kind of frame which shuts out the line where the scene ends, the visitor must be in a comparatively dark place while there must be light on the objects and on the background. The only place where such an effect can be had is in a Panorama building where plastic art and painting are made to blend into each other and where everything not germane to the subject is removed from view" (Griffiths, 1996, 64). Griffiths links the idea of the promenade cinema to the notion of "promenade theatre," a staging technique in which the action takes place in discrete areas organized around a central space. However, Griffiths stops short of making the link with the notion of *promenade architecturale*, at the heart of Le Corbusier's principles and which also has a nineteenth-century ancestry. But in order to understand the poignancy of the association and its relevance to museums,

we must take a brief detour to consider what links Choisy, Eisenstein, and Le Corbusier, with cinema and the *promenade architecturale*.

Auguste Choisy (1841–1909) was the first to attempt to retrace in its slightest details the aesthetic motivation of the apparent disorder in the placement of buildings on the Acropolis and to link it precisely to the variable point of view of a mobile spectator. Eisenstein, greatly influenced by Choisy's writings, visited the Acropolis and proclaimed: "The Greeks have left us the most perfect examples of shot design, change of shot, and shot length. The Acropolis of Athens has an equal right to be called the perfect example of one of the most ancient films." (Bois and Glenny, 1989, 117.) And so it is Eisenstein—thanks to Choisy—who for the first time established the notion of a cinematic promenade as experienced by a mobile spectator, which crucially allowed him to elaborate his montage theory.

Around the same time Le Corbusier coined the expression *la promenade architecturale*: "This second house will be rather like an architectural promenade. You enter: the architectural spectacle at once offers itself to the eye. ... Here reborn for our modern eye are historic architectural discoveries ... once again we must learn at the end of the day to appreciate what is available" (Le Corbusier, 1929, 60). Crucially, *la promenade architecturale* is didactic, as "we must learn." It echoes Franz Boas's rather stern view of what the American Museum of Natural History's spatial organization should be: "By dividing the Hall into two longitudinal halves visitors are compelled to see in the collection their natural sequence, and even if they pass through only one half of the Hall, will be more benefited than when seeing one alcove here, one there" (Griffiths, 1996, 58). The museum in the Victorian era was not conceived as a place of entertainment and "the challenge for museum administrators became how to discipline the distracted gaze of the museum-goer" (Griffiths, 1996, 58).

Spatial arrangements have been a key mechanism for channeling visitors' attention, as noted by Sue Ballard: "Many museums thereby construct a narrative which the visitor follows through from beginning to end at varying degree of speed and with differential levels of interpretation. In the directional flow museum, this is highly structured, offering a linear concept of the past which is often presented as an established, well understood story." (Ballard, 1997, 95.) And to a certain extent, one can detect a definite positivist and didactic interpretation of Italian art in the Fitzwilliam Museum, in particular in the first floor gallery—Italian Art, rooms 6 and 7.[15] As visitors move along the linear gallery their gaze reads the paintings as a series of frames or *défilement* ("unwinding"), close to the cinematic effect: "the image is no longer

thought of in a static dimension but in a dynamic dimension based in movement [...] and produce discontinuous running phenomena which call upon the cinematographic experience independently of the technical apparatus" (Michaud, 2006, 52). The *défilement* effect is particularly noticeable in the long galleries that are like filmstrips made of paintings. The film of the paintings unravels itself at the pace of the visitor's gaze. The strong axial structure implies an inescapable linear reading, and there is little relief for the eye.

However, the highly directional "floor script" of the Victorian museum space was later challenged by looser "storied layout," allowing for a more democratic interpretation of knowledge. And so, across the twentieth century, the notion of a cinematic architectural promenade would evolve from being didactic and firmly directed to becoming more like a cinematic *flânerie* as museums became places of entertainment and wonderment. New museum designs generated new modes of exploration.

The layout of the museum is much more than just a space for exhibiting art. The building fabric embodies much of its history, stories, and concerns. It is a container of narratives inscribed in the walls and the floors. It is a place of many layered narratives. And this narrative layering is richer than in most spaces. Using here the "narrative turn" (Ryan, 2004, 1) in its broadest sense, the unsuspecting eye of the museum visitor encounters a succession of narrative layering—the storied building, the curatorial narrative stance, the numerous tales and journeys contained within each artifact, the personal motivations and stories embodied in the visitors themselves. Lastly, we can add a fifth layer pertaining to all aspects of digital technologies visibly (and invisibly) present in museums—screens, projections, audioguides, handheld

Figure 15.2 The camera reveals a succession of narrative layers

devices, etc.—all narrativized media, which inform, interpret, reinforce, filter, edit, and generally (re)mediate the museum.

We could therefore postulate that the museum narrative layers constitute a discursive formation; the five layers differ in form and theme from each other, are dispersed in space and time, but do form a group belonging to the same "object museum." This narrative layers hypothesis was tested during a visit to the Musée du Quai Branly in Paris (Figure 15.2).

Hypothesis three: Narrative layers as discursive formation: The case of the Musée du Quai Branly

> *Around the 50th day they meet in a museum filled with ageless animals.*
> —*La Jetée* (The Pier, Marker, France, 1962)

In this section, I am recounting my visit to the Musée du Quai Branly[16] on Sunday, 28 February 2010, when I visited for the first time this newest of the Paris museums, devoted entirely to the arts of Africa, the Americas, Asia, and Oceania. I embarked on this visit using the so-called participant observation method, which is common in ethnographical and anthropological studies, with a view to test the "narrative layers as discursive formation" hypothesis. In line with the participant observation method, I collected thoughts and notes in a diary, took photographs, and recorded short movies. I consulted and gathered a great deal of material before and after the visit—newspaper articles, websites, and related electronic sources as well as leaflets and publicity material inside the museum. Given the approach, I am also adopting a first-person point of view, in contrast to the previous sections.

Preparation started in Cambridge, essentially by reviewing the Musée du Quai Branly website. I noted at the time that it involved taking in quite a lot of information, and by far the most informative and digestible elements were two sound podcasts—three-minute interviews with Philippe Descola, the curator of *La Fabrique des Images* (The making of images), one the exhibitions I had selected to visit.

I did book our tickets[17] online for fear of queuing—I think museums encourage that. This preparation points toward the fact that one rarely goes to a museum without careful planning; museums are places outside our daily routine, they are part of what Michel Foucault dubbed "heterotopias" (Foucault, 1984, 46). While the notion of heterotopias is not solely consigned to museums—cinemas, theaters, prisons, graveyards are all heterotopias—Foucault attributed to museums another

specificity: the notion of *heterochronia*, the fourth principle in
definition, thereby acknowledging that museums constitute a perpet
and indefinite accumulation of time in one place.

This was my first encounter with the building and it was adn
tedly disappointing, in part because I approached it from the ba
Rue de l'Université, and could not quite recognize the building fr
the photographs. The initial impression was of an industrial build
which did not obviously speak of "museum," and this was furt
compounded by the fact that the entrance was hard to locate—a far
from the majestic entrance of the Fitzwilliam Museum, typical of ma
nineteenth-century public buildings.

My anticipation in part clashed with the building's narrative; the arc
tect, Jean Nouvel, deliberately aimed at a low-key entrance, someth
I only became aware of after my visit as I consulted numerous arch
materials and interviews with the architect. Past the entrance,
access to the museum is via a gentle ramp and the arrival to the m
space, *le plateau*, is quite breathtaking, and I rapidly overcame my ini
frustration. I was struck by the spectacular displays, the lighting
particular—as if it was emanating from the objects themselves. Enter
the main space is like stepping into a cinema or a magic show wh(
instead of sitting, one experiences a form of proto-cinema in circulat
around the artifacts, as if Nouvel had taken a leaf out Franz Boas's bo
"the visitor must be in a comparatively dark place while there must
light on the objects" (Griffiths, 1996, 64).

But for Nouvel the reference is not Boas, but cinema. He has l(
claimed inspiration from the language of film: "In the continue
shot/sequence that a building is, the architect works with cuts a
edits, framings and openings [...] I like to work with a depth of fi(
reading space in terms of its thickness" (Pallasmaa, 2001, 17). T
mental cinema effect is reinforced by the way visitors move arou
the building. There are no staircases, only gentle ramps, an essen
component in Le Corbusier's design philosophy, which rapidly beca
adopted as part of the twentieth-century architectural vocabul;
There the gaze of the mobile visitor is offered carefully framed vie
in the tradition of the cinematic *promenade architecturale* evoked in
previous section.

The other spatial characteristic of note is the combination of a str(
directional flow according to the various continents—Oceania, A
Africa, and the Americas in that order—but with plenty of leeway wit
each continental zone. In other words, it combines a broad directio
floor plan reminiscent of the Victorian museum, while allowing enou

:ndipity to spice up the didactic journey through the museum space. hough the space is vast, it is laid out in such way that there is plenty egibility; I never felt that I was getting lost. As in a sculpture garden, artifacts act as landmarks.

he encounter with the artifacts is, of course, the real motivation for ning to the museum. Given that the Musée du Quai Branly (MQB) is ethnographical and anthropological museum, visitors are confronted double heterotopias since the artifacts on display are from non- stern cultures. Every artifact carries and embodies its own powerful ry—my second narrative layer—and begs a series of questions: who de it, where does it come from, who collected it in the first place, and which collection did it originally belong, as the MQB is a collection other museum collections? It constitutes a rich narrative layering which the museum provides various levels of explanations, from imple label adjacent to the object right up to full notes available ine for every exhibited artefact through the MQB website under the *ilogue des objets* section.

very museum visitor around me was embodying his/her own rative layer of stories and history, motivations, knowledge, and ectations. We were all moving at different speeds, alone or in ups, showing various levels of interest, ranging from what appeared be sheer boredom on the part of some adolescents, to much more isidered expressions of interest, from casual *flâneries* reminding me of id visual montage to careful examination, continuity-editing style. d not note any case of extreme emotions, no evidence of Stendhal idrome[18], and neither did I suffer any such episode in the line of y. However, I felt intimidated by the Abelam masks of Papua New inea. I realized that the masks, enclosed in a glass "cage," brought k to me vivid images[19] of Tintin's adventures in *Les Sept Boules de* stal (The Seven Crystal Balls, Hergé, 1948), an episode where the hropologist, Professeur Hyppolite Bergamotte, together with his leagues, suffers devastating consequences from having brought k the mummy of Rascar Capac and enclosed it behind a glass cage his personal museum. As a consequence, my childhood memories nehow prevented me from taking a photograph of the masks, despite relative safety of the glass enclosure. The spirit of Rascar Capac was ering.

he fourth narrative layer, the curatorial narrative, was strikingly lent in the exhibition of *La Fabrique des Images*, situated on one of mezzanine levels. The exhibition presents a novel interpretation anthropological artifacts by dividing the world according to four

ontologies: the "animated world" devoted to animism, the "objective world" of naturalism, the "sub-divided world" of totemism, and finally the "entangled world" of analogism. On the floor below—*le plateau*—the artifacts are organized geographically by continent, which by contrast constitutes a light-touch curatorial arrangement.

Given the scope and ambition of *La Fabrique des Images*, as a visitor I felt that I needed a higher level of interpretation and explanation than for the rest of the museum. This was provided very effectively by a simple audio device of the type present in museums for decades. In addition to audioguides, there are many screens dotted around the museum with extracts of anthropological films, as well interactive touch screens. Those constitute the fifth narrative layer. Most screens were embedded in the walls, as if emerging from the sides of a troglodyte cave. The walls surrounding the screens and the seating are covered in leather, with no sharp angles, making it a very tactile and sensual experience (see Figure 15.3).

However, I have to confess to losing patience with the interactive screens. The juxtaposition of the screens next to the striking artifacts (see Figure 15.3) was unfavorable to the screens. The scale of the images on the screen was no match compared to the real thing. A much more powerful and moving experience was to walk among a group of sculptures from the Solomon Islands, surrounded by funeral singing. The experience of the body in movement, accompanied by the sound,

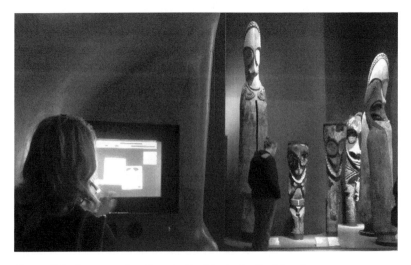

Figure 15.3 Screen and artifacts in the Musée du Quai Branly

made it one of the most memorable parts of my cinematic architectural promenade.

Lastly, I attended a dance performance in the Levi-Strauss theater situated in the bowels of the building. The dance choreography was built around the syntax of the *capoeira*—an Afro-Brazilian art form that combines elements of martial arts, music, and dance. There was no doubt that this performance augmented the museum experience, but even more interesting is that the museum augmented the performance. One enters the space of the theater after having spent several hours around exhibits, filling one's imagination with images, stories, and voices that act as a theatrical "primer."

Exiting the museum, my earlier hesitation regarding the entrance was swept aside as I had become much more in tune with the building: the visit had been transformational. Even the savannah-like garden played its part in helping me to reenter the city, by acting as a threshold. As I became reabsorbed into the bustle of Paris and its everydayness, it was a gentle way of easing myself out of the heterotopias and heterochronia of the museum.

Conclusions

During my visit to the Musée du Quai Branly, the narrative-layers approach helped me to synthesize a wide range of dispersed systems, bringing together different strands, themes, and scales which constitute the discursive formation pertaining to the museum "object."

The case study highlighted the dramatic function of the museum space in its mise-en-scène and mise-en-cadre of the artifacts. It showed that the curatorial narrative can transform the physical classification of artifacts into a system of ideas. It corroborated hypothesis two, the cinematic architectural promenade, as a valid mode of museum exploration. It confirmed the importance of the "top-down perception," where the individual visitor's cognitive perceptual processes are "based on acquired knowledge and schemas" (Branigan, 1992, 37).

But above all, my visit to the Musée du Quai Branly revealed museums as laboratories of change, as the technological/digital layer cuts across all the other narrative layers; the interactive screens are embodied in the architecture as modern artifacts, the audioguides help to convey both the curatorial narrative and the stories of the artifacts. Technological involvement is an inescapable part of the visitor's experience, in situ but also before and after the visit, as much can be gained from excavating the many resources of a museum website. My own experience made

me favor the acoustic dimension, both in the form of the audioguide and the "diegetic" sounds emanating from the artifacts. In many ways, my involvement with the technology was a rather passive experience, although admittedly the audioguide required the odd prodding here and there. Interactive screens and handheld devices require a much greater level of participation. But how can technologies make museums more engaging? Are digital technologies really the answer to reaching new audiences? Bernard Stiegler attempts to answer such questions by arguing convincingly against a culture of consumerism, which distracts the museum visitor from a deep engagement (Stiegler, 2009, 31). He advocates the return to the figure of the *amateur*, in the eighteenth-century sense, who is not a passive consumer but somebody actively engaged with the art.

Translated into twenty-first-century terms, Stiegler claims that "Novel photographic and video functions found on smart phones as well as new forms of tagging mechanisms, afford critical spaces for which new forms of editorial and software development must fundamentally transform the relationship between the cultural institutions and their audiences" (Stiegler, 2009, 31). Stiegler and his group have translated this idea by creating a new software, Lignes de Temps,[20] which allows visitors to annotate their museum experience[21] and therefore become more actively engaged.

In the same way that Lignes de Temps can augment interaction and contribute to the "takeaway" potential outside the museum itself, thus giving the museum visitor—*l'amateur*—a deeper engagement, performances within the museum can potentially offer a similar rewarding experience. I certainly felt that the *capoeira* spectacle in the Musée du Quai Branly greatly augmented my museum experience and added yet another layer to the dispersed museum system. With new generations of integrated media technologies supporting a new generation of artists and performers, there is the opportunity for original transmedia augmentations of the collections.

But finally, coming back to hypothesis one, capturing through the moving image something of the museum experience, the Benjaminian "here and now"; one could conceive of it as an exten-sion of the practice of the *amateur*, as well as of the performative. It entails capturing and editing the recorded space by means of the mov-ing image, well within the scope of the enlightened *amateur's* practice, while capturing performances within the museum,[22] with actors—as in the case of our proof-of-concept movies—or with visitors playing themselves.

Within this context the movie-making activity has a double trans-formational effect: through the process, the *amateur* movie-maker becomes an actively engaged participant, while on the screen appears the transformation of an unconsciously recorded space—or naïve space—to a consciously recorded space which becomes an expressive space. This is the crucial passage from one state to another referred to by Faure (1934): "Le cinéma est avant tout un révélateur inépuisable de passages nouveaux." (Cinema is primarily an endless revelatory medium of novel passages.) As the moving-image medium reveals new spatial and narrative structures, it challenges the traditional material structure of the museum and affords an innovative, empowering, and immaterial freedom. This constitutes the case for the moving-image medium within the museum context.

Notes

1. Cinema is primarily an endless revelatory medium of novel passages, new arabesques, innovative harmonies between tones and values, light and shade, forms and movements, motivation and gestures, spirit and its incar-nations [my translation].
2. In 2007 the Arts and Humanities Research Council (AHRC) funded a research project entitled "Discursive Formations—Place, Narrative and Digitality in the Museum of the Future," led by the Digital Studio for Research in Design, Visualisation and Communication (Department of Architecture, University of Cambridge), and which centered around the Fitzwilliam Museum, Cambridge. In 2010 the AHRC funded another project, "Museum Interfaces, Spaces, Technologies" (MIST), a collaboration between Goldsmiths (Computer Science) and the University of Cambridge (Digital Studio, Department of Architecture).
3. Led by Alan Blackwell from the Computer Lab, University of Cambridge.
4. Led by Maureen Thomas, Digital Studio, Department of Architecture University of Cambridge.
5. My translation of the original voice-over from Godard in French: "C'est décevant ... c'est mieux de lire 'Les Voix du Silence' que d'aller au musée d'art moderne ... parce qu'on a la peinture avec soi ... c'est le contraire de sa mission [de la mission de la peinture] finalement que d'être dans un musée ... contrairement au cinéma." I think that he refers here to the crea-tion of the French Cinémathèque and his support of Langlois.
6. Musée du Louvre—Direction de la Politique des Publics et de l'Education Artistique—Chiffres clés 2009: http://www.louvre.fr/media/repository/ ressources/sources/pdf/src_document_56789_v2_m56577569831270673.pdf.
7. "Cinema attendance has seen some resurgence in popularity in Great Britain after nearly 40 years of decline. Cinema admissions declined sharply from the 1.4 billion in 1951, to reach a low of 53 million in 1984. This fall was probably influenced by the advent of television, and later of video recorders. Over the next decade, however, cinema admissions rose, and were 123 million in 1998. This revival may be related to the investment and expansion

in multiplex cinemas in recent years." Office for National Statistics—Cinema admissions, 1951–1998: Social Trends: http://www.statistics.gov.uk/StatBase/xsdataset.asp?vlnk=1443&Pos=3&ColRank=2&Rank=272.

8. Table 3.1 in Attendance of Museums and Galleries 2006–2007—survey document by Museums, Libraries and Archives Council (MLA): http://research.mla.gov.uk/evidence/documents/Attendance%20of%20Museums%20and%20Galleries.pdf.

9. "Young people aged 15–24 are the most likely age group to go to the cinema. In 2002, 50 per cent of this age group reported that they went to the cinema once a month or more in Great Britain, compared with 17 per cent of those aged 35 and over." Office for National Statistics—cinema attendance by age: http://www.statistics.gov.uk/STATBASE/ssdataset.asp?vlnk=7191.

10. http://www.mla.gov.uk/what/programmes/digital/strategic_approach.

11. The scene itself only lasts 27 seconds but Godard's voice-over informs us that Sami Frey, Claude Brasseur, and Anna Karina did it in 9'43" seconds which "broke the record set by Jimmy Johnson of San Francisco."

12. While the *The Da Vinci Code* may not rank high on the artistic scale, it was a generously endowed Hollywood production and as such paid the Louvre handsomely for the privilege of using its setting, which in turn allowed the museum to coproduce *Visage* (Schwartz, 2009).

13. François Margolin from Margo Films, the coproducer of the Musée d'Orsay films, mentioned that the Jarmusch and Ruiz films are unlikely to go ahead for lack of funds on the museum side (personal e-mail communication to the author on July 11, 2010).

14. This was Picasso's unexpected reply when he was told of the insult which the Royal Academician Alfred Munnings had delivered after looking at his work for the first time. "Picasso," Munnings said, "can't paint a tree" (Hare, 2002).

15. See museum floor plan: http://www.fitzmuseum.cam.ac.uk/visit/galleryguide/.

16. See website: http://www.quaibranly.fr/.

17. I was accompanied by my wife, Fabia, who acted as a "one-person control group" in my participant observation experiment. The conversation we had at the "debriefing stage" was of great help for this study.

18. A term coined only recently (1979) by an Italian psychiatrist, Graziella Magherini, and which refers to a psychotic episode—dizziness, fainting, confusion—when an individual is exposed to art. Such episode was first described by the French writer Stendhal when he visited Florence in 1817.

19. For many people of my generation in France, Tintin and this particular episode would have been their first childhood encounter with the idea of the museum and of an anthropological collection.

20. To enrich the exhibition *Traces du Sacré* (Centre Pompidou, May7– August 11, 2008), a new multimedia system is accessible to listen to curators and figures from the world of culture and the art. Visitors can also record their own comments, using the multimedia guide or their mobile phones. Afterwards, visitors will be able to access their audio comments on the Internet, modifying, annotating, and indexing them, thanks to the software Lignes de Temps, before publishing them on a collaborative web site developed for this event (see http://web.iri.centrepompidou.fr/traces).

21. In a modest way I certainly experienced this when taking numerous photographs of the Musée du Quai Branly. It gave me another level of

engagement. Being able to take photographs was for me the equivalent
of making personal notes. It was rewarding at the time and, of course,
afterwards as I was able to study the results, observing the observed, produc-
ing new knowledge of the experience.
22. Providing, of course, that the museum allows it; but many do, such as the
Musée du Quai Branly.

References

S. Ballard, "Phenomenology, Perception and the Museum," in *Archaeological
Review from Cambridge* 14:2 (1997).

H. Beaver, *The Science Fiction of Edgar Allan Poe* (London: Penguin Classics, 2006).

M. Benedikt, *Cyberspace: First Steps*, ed. M. Benedikt (Cambridge, MA: The MIT
Press, 1991).

W. Benjamin, "The Work of Art in the Age of Mechanical Reproduction," in
Illuminations, ed. H. Arendt, trans. H. Zohn (London: Pimlico, 1999).

Y.-A. Bois and M. Glenny "Montage and Architecture Sergei M. Eisenstein,"
Assemblage 10 (1989), 110–131.

E. Branigan, *Narrative Comprehension and Film* (London: Routledge, 1992).

G. Bruno, "Visual Studies: Four Takes on Spatial Turns," *Journal of the Society of
Architectural Historians* 65:1 (2006), 23–24.

G. Bruno, *Atlas of Emotion. Journeys in Art, Architecture, and Film* (New York: Verso,
2002).

Les Cahiers du Cinéma 611 (April 2006).

I. Calvino, *Six Memos for the Next Millennium* (London: Penguin Books, 2009).

E. Faure, *Ombres solides (Essais d'esthétique concrète)* (Paris: Edgar Malfère, 1934).

M. Foucault, "Des Espaces Autres," *Architecture, Mouvement, Continuité* 5
(1984), 46–49.

M. Foucault, *The Archaeology of Knowledge*, trans. A. M. Sheridan Smith (London:
Routledge, 2002).

J.-L. Godard, *Au Musée d'Art Moderne de Paris—Cinéastes de notre temps*, http://
www.ina.fr/art-et-culture/cinema/video/I04188950/jean-luc-godard-au-musee-
d-art-moderne-de-paris.fr.html. Accessed on 31 July 2010.

A. Griffiths, "'Journeys for Those Who Can Not Travel': Promenade Cinema and
the Museum Life Group," *Wide Angle* 18:3 (1996), 53–84.

D. Hare, "Why fabulate?" *The Guardian* (February 2, 2002).

S. Heath, *Questions of Cinema* (Bloomington, IN: Indiana University Press, 1981).

Hergé [G.P. Remi], *Les Sept Boules de Cristal* (Belgium: Casterman, 1948).

Le Corbusier [C-E. Jeanneret], *Les Oeuvres Complètes Vol 1* (Zurich: Erlenback-
Zürich, 1929).

C. Lupton, "'Mummymania' for the Masses—Is Egyptology Cursed by the
Mummy's Curse?" in *Consuming Ancient Egypt*, ed. S. Macdonald and M. Rice
(London: UCL Press, 2003).

P.-A. Michaud, *Le Mouvement des Images* (Paris: Centre Pompidou, 2006).

D. Païni, *Le Temps Exposé. Le Cinéma, de la Salle au Musée* (Paris: Cahiers du
Cinéma, 2002).

J. Pallasmaa, *The Architecture of Image—Existential Space in Cinema*, trans.
M. Wynne-Ellis (Helsinki: Rakennustieto, 2001).

O. Pamuk, *The Museum of Innocence*, trans. M. Freely (New York: Al
A. Knopf, 2009).

M. A. Peterson, B. Gillam, H. A. Sedgwick, eds., *In the Mind's Eye: Ju
Hochberg on the Perception of Pictures, Films, and the World* (Oxford/New Y
Oxford University Press, 2007).

S. Prince and W. E. Hensley "The Kuleshov Effect: Recreating the Cla
Experiment," *Cinema Journal* 31:2 (Winter 1992), pp. 59–75.

M.-L. Ryan, ed., *Narrative Across Media: The Languages of Storytelling* (Linc
NE: University of Nebraska Press, 2004).

A. Schwartz, "Musées en quête de cinéastes," *La Croix* (5 November 20
http://www.la-croix.com/Musees-en-quete-de-cineastes/article/2400302/5:
Accessed on 31 July 2010.

V. Sobchack, *The Address of the Eye: A Phenomenology of Film Experience* (Prince
NJ: Princeton University Press, 1992).

B. Stiegler, "Technologies culturelles et économie de la contribution," *Cultu
Recherche* 121 (2009), 30—31.

M. Yampolsky, "Kuleshov's Experiments and the New Anthropology of
Actor," in *Inside the Film Factory: New Approaches to Russian and Soviet Cine
ed. R. Taylor and I. Christie (London: Routledge, 1994).

6

Right Here ... Right Now ... Art Gone Live!

Gavin Hogben

Where did the walls go?

If museums have no walls, it is, perhaps, because they have no need of them. But how could that be? They are full of valuable things which must be protected. Has the digital age come up with some wonder like an invisible dog fence that keeps these valuables from straying beyond the museum perimeter, or a prisoner's ankle bracelet that allows the curatorial staff to round them up if they break curfew? Or, could it be that all valuables, like up-to-the-minute dictators and movie stars, have acquired digital doubles so convincing (and so numerous) that there is no need for security? Perhaps these doubles are so much more convincing than their so-called originals, and so widely and conveniently available, that no one recently has thought to check whether the museum, or indeed the palace or the movie studio, still stands.

All these things are largely true, but they are not the reason why today's museums might easily dispense with their walls. That reason follows from a long-standing drive in all cultural practices away from objects and collections and toward performance and events. Artists have led this drive, and now the museum is only one venue among many where performances can be staged. In effect, the museums need no walls because the artists have left.

It is tempting to credit the digital era with this flight from the museum, and to associate new media with the rise of performance and arts that engage fugitive phenomena. But all these things were well under way in the pre-digital cold-war world of electromechanical devices. Robert Smithson's work of the late 1960s with snapshot cameras and Super-8 film, wasteland travels and earthworks, oscillates between installation, archive, and performance, and it anticipates many

301

of the directions that would be taken up by artists using digital tools and techniques. And, Smithson also provides the motivation. The work is coupled with a strong critique of the museum as a trap for unwary artists and a "cultural prison" for art where vacant rooms and false labels "lobotomize," or purify, the works for consumption as "visual fodder" (Smithson, 1996, 155).

Art must be set free—to roam and absorb the impure multivalent entropic processes of the outside world. Smithson imagined a world in which this free art might then repossess the museum as a site for impure processes and encounters. His own work was full of mixed impure practices that cut across categories and places, as in the *Spiral Jetty* project which existed in three manifestations—the earthwork, the movie, and the movie stills montages—three independently fugitive takes on the performance of site and "nonsite" (Smithson, 1996, 364).

Digital performance

Armed with Smithson's challenge, artists could work outside of established media and institutions, and explore the crossover of counter- and hacker cultures promoted by Stewart Brand's *Whole Earth Catalog* (1968)—later reborn as the online community *WELL*, or *Whole Earth 'Lectronic Link* (1985). The *Catalog* operated as an open network for sharing resources focused on self-discovery, and was quick to embrace those digital tools that enhanced the communicative and expressive capacities of the new electronic devices. What had been a tool of corporations and the forces of (late-Fordist) conformity would now be repossessed as a pathway to personal transcendence. Timothy Leary's call to "turn on, tune in, drop out" (1966) applied as easily to the new digital tools as it did to the psychotropics for which it was coined. The promise of digital psychotropics had become rather darker by the time (1984) that William Gibson framed cyberspace as a "collective and consensual hallucination," but the link had been made. From here on out, hacker culture would enjoy the same association with nomadic, ludic creativity that attached to the writers, gamers, and musicians of psychedelic culture (see Turner, 2006).

Free of its corporate environment, the truly personal and personable computer was born—and with it the digital age. Before this point, there were only visionaries and boxes of circuits, but, from this point forward, the digital had a cultural mission of transformation and transcendence, and a band of countercultural missionaries to take it mainstream. With the mission identified—and the "digital" brand

established—the rollout of new digital technologies could simply be focused on achieving universal access, across divides of wealth, skills, language, age, faith, and so on.

Cheap silicon, the icon and the mouse, modems and broadband, wireless and hands-free, and now tablets, wearables, pervasives are all just the technological tactics in this ongoing campaign toward transcendence. What seems a directed progress in the development of tactics is actually a scattershot, truly evolutionary process of contingent improvisatory practices—as can be seen in the burn rate and boom–bust lives of start-ups. The tactics succeed, and come to seem inevitable, only when they support a practice that advances some frontier or outpost of the grand campaign. Technologies catch on only when compelling images of their transformative potential emerge and fan out into common practice.

Like any emergent meme, this image-seeding occurs in any number of domains, familiar and otherwise: as when David Bowie said that, born a generation later, he would have jumped into the Internet instead of rock and roll; or when Brian Eno takes synthesizers and electronica into ambient sound and then multimedia environments and instant mix handhelds; or when the impassive cap-down dorm room guitar kid tagged as "funtwo" updates the more than well-known Pachelbel Canon for posting on the then mostly unknown website called *YouTube* (early 2005) and picks up more than seven million hits in eight months (over 75 million by 2010), leading to Google's purchase of *YouTube* the next year (late 2006). Sounds and images have shown the keys and screens to be expressive, so that even text—remade in a temporal, dialogical form as wikis, blogs, chats, and the like—can be seen as a venue for creativity and community. Sound-streams, image-streams, text-streams all open individuals to *flow*—the immersed-in-the-moment sense of total well-being and personal growth identified by Mihály Csíkszentmihályi.

Flow arises from situations rather than things, so that the success of image- and video-sharing sites, like *Flickr* and *YouTube*, or of online communities, like *World of Warcraft* and *Second Life*, follows from the trade in tokens of novelties and status rather than from the accumulation and display of the images and videos themselves—which are surprisingly disposable given the investments in time and money that they often embody (see Castronova, 2005).

Museum field work

While some artist practices have been associated with the search for a distinct digital aesthetic, say in the graphical expression of ASCII

characters or the structural dynamics of databases (see Vesna, 2007), others, like the institutionally disruptive operations of *net.art*, have taken up the Smithson challenge and addressed the simple complexities of living in a world supersaturated with digital devices and media channels. Disrupting the ideology of obsolescence built into the digital economy is a common tactic for *net.art*, and these works often hover between glimpses of technological futures and digital junkyards—much as our homes, schools, workplaces, parliaments—and museums—typically do (see Paul, 2003). Probing, intervening, disrupting, and leaving traces, trails, damages, this productively chaotic work has served as both catalyst and map in furnishing the digital imagination, sketching out plausible "digital" lives to know, or to skip. Tactically agnostic and playfully opportunistic, these projects operate at edges—boundaries and glitches—in the digital–nondigital (dis-) continuum. And, like Smithson's projects, their contingent, field based, mode-hopping, multivalent working method can best be understood through time and performance: serial or ongoing performances that are situated by, undertaken with, and induced from events in the field.

This blithe variability of the working methods, articulation, and/or communication of these digital-age works has consistently challenged the structured world of museum environments. And, when the museum is itself the site of such field work, its own processes emerge as a multidimensional knot of performances—administrative, acquisitive, conservatorial, interpretive, exhibitive, surveillant, choreographic, consumptive, digestive, and so on.

Museums already live in the digital age in the sense that digital devices and practices have been introduced into the performance of every one of these dimensions, but it is not so clear that the digital age lives in the museum. Most often, digital initiatives are accepted only as tools of service and not of expression. And, they are confined to redundant duplicative tasks—their exhaustively shallow Web presences, for example—that run no risk of invalidating the primacy of the collections as defined by their objects, and underwritten by their texts and guardians. In effect, the museum insists that only the object performs, but this is to deny the knotwork of performances which temporally entangle it. For fine arts museums, in particular, the digital threatens to disturb this carefully crafted fictional arrangement, either by outshining the performance of the object, or by outing the secret performances that have kept the object in its place. But, how bad could this be?

As Jean Genet exposes the complicity of needs between the maids and their mistress, and between the brothel and the revolution, the digital

could bring out into the open the Smithson-ian entropic complexities and "thicket" of tangled performances that constitute the museum. As at Pompeii or Passaic, the walls of the open museum might become just walls as walls, rather than walls as containers and metaphors of containment.

Anywhere but here

Performance work, portable in time and place, strictly non-reproducible, yet replayable and responsive to new contexts, has stretched the exhibitionary resources of museums since it is teasingly unclear whether the art work is in the act, the notational description of its procedures, the (Peirce-ian indexical) traces it leaves, or the effects it radiates.

Concern with the instantaneity and dispersal of such traces can be seen in much digital work by artists—for example, Stelarc (*Ping Body*, 1996; *Exoskeleton*, 1998), Toni Dove (*Artificial Changelings*, 1998; *Spectropia*, 1999–2002), Victoria Vesna (*Bodies, Inc.*, 1995), Michael Naimark (*Be Now Here*, 1995–7), Paul Sermon (*Telematic Dreaming*, 1992; *A Body of Water*, with Andrea Zapp, 1999)—work often described as telematic art, art conducted across the net. It is not appropriate to drop digital artists wholesale into a single portmanteau, as the work is not only as varied as any other area of arts activity, but also looks to the open horizons of digital techniques to allow a sharper focus on many pre-digital lines of enquiry. However, notwithstanding its diversity, such work does pose many common issues for museums, in terms of staging, acquisition, conservation, and dissemination. Clearly canvases and marbles have life spans, but the highly compressed life cycles of time-based arts have introduced an urgency to models for the valuation and stabilization of works, particularly those which, like digital or performance works, arise out of instruction sets—programming code, musical scores, dance notations, etc.—that may play out differently at each context and each enactment. And, just as the normative conventions of conservation have changed in the past, moving from restoration to preservation, these so-called *variable media* have driven a number of new museological commitments toward common standards for archiving and maintaining the (re)"playability" of these projects, whose boundaries are often less clear than those of traditional art works (Christiane Paul, 2003, 23–5).

In this sense, digital works may extend the challenge to museums of such "can't-fit-won't-fit" movements as land and public art, or conceptualism and minimalism. Museums, from the 1960s onwards,

reconstructed themselves as SoHo lofts to accommodate the gestural scale of Abstract Expressionism, installations, and performance work, adopted guide systems for interpretative media, founded outposts to embrace situated works, and emulated festival programming, in a bid to achieve a viable funding model for ephemeral works (see O'Doherty, 1976). However, there may be a fault line within the digital world that divides the work which museums can meaningfully engage, and that which they nullify. Digital projects whose iterations are controlled by the use of genetic algorithms, say *Genesis* (Eduardo Kac, 1999) or *ecosystm2* (John Klima, 2002), and which spawn their way across multiple data spaces, or employ peer-to-peer transmission structures, reside at no-particular-where and no-particular-time. In such cases, the museum is just one of many incidental points of their (dis)appearances. The digital may then swallow the museum rather than the other way about.

Two projects of Paul Sermon convey the ambivalence, or indifference, of much digital work to exhibition within museum environments—indeed, to exhibition as a mode of display. Both projects established live video capture, and projection, links between paired sites. In *Telematic Dreaming*, a 1992 project staged at the annual summer exhibition in Kajaani, Finland, visitors could share a double bed with the images projected from the remote site—a deceptively simple arrangement that induced highly unsettling feelings of improper intimacies and mis-embodiment.

Sermon's 1999 project, *A Body of Water*, joined the shower room of the abandoned Ewald/Schlägel und Eisen mine in Herten, with a gallery in Duisburg's Wilhelm Lehmbruck Museum. In this case, a screen of falling water carries three sources of images: the visitors to the mine and museum sites see themselves overlaid, and projected, on one face of the water, while documentary footage of the miners projects through from the other. The impact, again, is to blur boundaries of the self, but, in this case, also to invade the private histories of the mine and to repopulate the past. Here, too, the museum is only peripherally involved, a stepping-off point that could be any-place-whatsoever.

Up-Starts + Start-Ups

It is worth observing that, if the museum has taken two steps back, from author to facilitator and then to mere point of access, the artist is often self-cast as a kind of roadie and cable-wrangler in the touring of these technologically induced performances—a new kind of

facilitator—or even dis-facilitator, in the case of "hacktivists" who exploit the patterns and habits of media networks to advance social and political causes. These artist-activists build their reputations through festival, conference, and teaching networks, and do not depend on galleries and museums for their advancement. In many cases it is hard—and perhaps pointless—to distinguish their practices from cult-hobby technological experimentations, like "circuit-bending"—the repurposing of hot-wired electronic junk (such as dolls' voice boxes or answering machines) into instruments for musical composition and performance (http://www.anti-theory.com/soundart/circuitbend/cb01.html and http://www.bentfestival.org/), or "machinima"—the use of game-engine replay technologies to make live and recorded animations (http://www.machinima.com/ and http://festival.machinima.org/). Both of these widely practiced media arts have made the leap from outsider to curiosity to cool—circuit-bending and machinima now have annual festivals in New York, based, respectively, at the Tank Space for Performing and Visual Arts, and at Eyebeam Art and Technology Center (previously at the Museum of the Moving Image).

The digital economy has priced ordinary people into the game: tools to experiment are cheap, and so are the tools to share interests and build communities (see Newman, 2008). When glass and stone were dear, guilds, church, and crown controlled access; when oils and canvas were cheap, academies and museums set the rules; now cycles and storage are essentially free, and wikis, forums, blogs, and social media sites go where the energy is: clubs, festivals, and institutions follow (Anderson, 2009). Under this regime, events rule over venues, and events aggregate through social websites that jockey for niches within broad ecologies of interests. An example is the Brooklyn Art Project, which operates under the slogan "Sign up or we'll break your legs" (http://www.brooklynart project.com/).

This social arts model builds and distributes cultural capital in a way quite different from the traditional museum. Nevertheless it is a competitor for eyeballs, visits, and the younger demographic constituency that will shape the long-term future. But the museum is also challenged from another direction: a change in the culture of gallery representation for artists. A survey of London galleries from June 2009 determined that 33 out of a total of 217 venues (a count that excludes state and local authority institutions) operated as not-for-profit organizations with the defined mission of developing contemporary art by bringing together art-makers and art publics (http://www.artmonthly.co.uk/listlon.htm, surveyed 16 June 2009). Typically, these organizations combine gallery

display with artist support and public education programs. Like
social arts model of the Brooklyn Art Project, they emphasize eve
over venues, and projects over works: thus, the exhibit and educat
programs are interleaved calendar-wise and theme-wise; and exp
mentation is fostered by presenting mixed forums for work a
ideas. Galleries are commonly developed as, or alongside, experim
tal laboratories, and are associated with (subsidized) studio spa
Commissions and residencies animate the experimentation, and
many cases, the galleries support the development of individual arti
either over the long-term or through specific projects. In the survey,
of the 33 organizations described their work as including commissi
ing, collaboration, production assistance, residency support, or ca
development for artists. What is particularly notable is a nomadi
associated with project based work: 15 of the organizations develo
"off-site" work; five had no regular gallery base; and two operatec
"consultancies" to other arts, entertainment, or business venues.

Artangel and the Arts Catalyst represent the leading edge of t
gallery-less nomadism, as they bring together themes, artists, ven
publicity, funding, insurances, and more, working in a role t
resembles independent film production, or, perhaps, festival devel
ment (http://www.artangel.org.uk/ and http://www.artscatalyst.o
The literalist edge may be represented by the art-where-they-are a
art-when-they-want projects of Truck Art and *Art-o-mat* (http://w\
truckart.org and http://www.artomat.org/). Both do, respectively, j
what the name claims.

It is worth noting that these not-for-profit organizations hav
potent entrepreneurial role. They are structured to provide alter
tives to standard cultural channels: in many cases founded by arti
they are able to tap private and public funding for experimentati
and to develop effective reciprocal relationships with the mainstre
institutions. They bring to these relationships not just the cachet
experimental work itself, but also the situation of that work wit
lateral networks that extend into other fields: music, fashion, popi
fads, social and political causes, and so on. In effect, they swallow r
and allow institutions, like museums, to outsource their research wo

Art of vanishing

Nomadism multiplied by anonymity equals the guerrilla tactics
Banksy, the Bristol-area native who has made his hidden iden
famous. Like the Guerrilla Girls of New York's mid-1980s, Banksy

de graffiti that mobilizes wide media attention. While the Guerrilla
ls, delivering "A Public Service Message from the Guerrilla Girls,
science of the Art World," "hung" the city with "low art" poster
iges demanding that the dead, white, male domination of the "high
" museums be overturned (see http://www.guerrillagirls.com/posters/
ex.shtml, 1985–), Banksy stencils graffiti tags that challenge property
ners, passersby, and public servants to determine what art is, to
om it belongs, and where it should be allowed. Banksy's fame owes
east as much to his deft handling of modern media structures as to
distinctive stencil technique and recurrent motifs and themes of his
s. He is both a delinquent and a darling of the auction rooms, an
3O (Anti-Social Behaviour Order) with a gift for disarming authori-
, museums included. He received a major show at the Bristol City
seum and Art Gallery, *Banksy v Bristol Museum* (summer show, 2009).
re than 100 Banksy pieces were on display and the show drew big
ndances, but, in an intricately managed dance with intermediaries,
seum staff, and media, Banksy remained unseen and his identity
liscovered—a remarkable feat as the show wreaked a transformation
one, two, and three dimensions of the museum as a culture-scape:
tily disruptive texts, images, and installations, including animatron-
"sub-versions" of the museum's collections, and, in a deeply teasing
ve, a construction of his supposed studio complete with many of
stencils well-known from media reproductions of his street work.
e absence, or Pimpernel illusionist's vanishing act, could not be more
ispicuous: more than 300,000 people waited up to four hours to see
at they knew, and hoped, would remain unseen.

spite appearances

t *Through the Gift Shop* (2010) is Banksy's movie debut, and tells
story of the rise of street art and his place in it. This simple story
complicated by the obscurity of its sources on the one hand—lost
rks, lost locations, lost identities—and on the other, the who, what,
en of how it was made. Although the directing credits go to Banksy
iself, the movie opens by passing responsibility to Thierry Guetta,
o is introduced as the surprise star of the film and the pivotal figure
its story (Figure 16.1).
hierry is a disheveled Frenchman who lives in Los Angeles and
ls in used clothes. He has a manic—and indiscriminate—appetite
shooting video. Through an accidental connection, he becomes the
iporary accomplice and documentarian of one figure after another in

Figure 16.1 Banksy, *Exit Through the Gift Shop* (2010)

the loose network of street art scenes developing across Europe and the US. Hooked on the thrill of shooting in precarious locations, one step ahead of the police—a kind of art *parkour* urban gymnastics—Thierry eventually meets Banksy, and is drawn into the movie project. His ultra-disorganized digital video archive will be the basis of the movie and his quest to meet and shoot the most notorious and elusive tags in the business will structure the story. But this is a feint.

After endless delays, it becomes apparent that Thierry can shoot, but not cut. He finally delivers what amounts to a disc-dump, MTV-paced, fly-by collage that resembles nothing so much as the involuntary spew of a binge-shooter. Banksy steps in to take back the project and recut the movie into the story that shows the hand-off, Thierry's adventures, and the crazed disc-dump. It would seem to be headed into a nonsensi-cally recursive loop, but the story remains locked onto Thierry and his further adventures as he abandons his camera—quitting the obsessive hobby that amounts to his day job—and goes into the street-art biz for himself. He signs himself "Mr Brainwash" and, having learned from the best, rapidly succeeds in building an outsize reputation for working the streets, the press, dealers, and the public.

The movie's climax is an opening done "guerrilla" style in the adminis-trative offices of a defunct LA movie studio. It guilelessly exploits and mindlessly parodies Banksy's earlier LA gallery opening, when the press had swooned over a live painted elephant. Thierry's opening is also a spectacle. It is caught on tape by hordes of cameras that may belong

to "official" paparazzi, nightly news lifestyle segments, or reality show makers—very likely, all three, but it is hard to say which of these derivatives of the documentarist tradition is which. And, of course, the off-takes of one will likely be the candids and gotchas of the others.

Waiting for the opening, the lines wind around the block with art-goers cheerfully admitting that they know nothing about Mr Brainwash and his art, except that the lines and the wait show that it must be a big deal. Thierry's opening is a big success.

Banksy's movie frames Thierry's big event with standard documentary moves. The chaos of the preparations is covered with quick shots following along at Thierry's elbow as he rushes from crisis to crisis, shouting at assistants, preening for reporters, and confiding to the camera. The aftermath features a series of static interviews with figures from all corners of the street-art phenomenon: artists, publicists, curators, and so on—all stripes of art and media experts evaluating the Thierry effect. Banksy is one of the featured interviews, and expresses disdain for Thierry, his art, and even for a mode of art that could be so easily hijacked by hacks like Thierry. Banksy double-underlines the disdain by presenting it as mild dismay; that is, through English understatement that would sting if this French-American was not such a blithe buffoon, such a lens without an eye. Banksy lampoons this very enduring stereotype of English stereotyping—and the English fear that whatever they say, all the world hears is the accent they love. The end.

A grain of truth

Where does this leave the moviegoer? You buy a ticket and make an 80-odd-minute investment to see the famous Banksy, but barely catch a glimpse of him. You take at face value Banksy's invitation—actually delivered in voice-over by the proxy of a well-known actor—to see him with Thierry's eyes, only to find you are now effectively cast as a star-struck groupie, almost a star-stalker. Thierry is now your proxy/avatar. The two major sightings of Banksy fall when he rejects Thierry's movie, and when he dismisses Thierry's show—undercutting all that is seen and learned in the pursuit of Banksy. You leave the cinema, rebuffed by Banksy, knowing now that it was, all along, an oxymoronic desire to insist on seeing the illusion for real; and relieved that he pulled off one more vanishing trick, showing that your first faith in his illusionist skills was always, and remains, well-founded. Perhaps the investment paid off, after all. With Banksy, when you buy a pass to the magician's workshop, you do get to see that smoke is smoke and mirrors are mirrors.

Press reviewers were more keen to show that they had not been gulled. They focused on the question of whether Thierry Guetta was, as the movie showed, the accidental tourist of the street-art world who had gone native so successfully, or whether he was a fabrication, a misdirection by illusionist director Banksy that kept the movie teetering on an edge between documentary and fiction. On the surface of it, Thierry's clips have a treble-depth claim on documentary veracity. At the top level, they are vouched for by the reportage style of the camera following Thierry. Then, there is Thierry's innocent home-video eye. And finally, there is the relentless obsession that never stops shooting and cannot edit. But, in practice, each of these claims merely rests on popular conventions that are invoked by the scenes shown in the movie, and must be taken individually and severally on faith.

When we cut from Thierry's eye glued to his camera to jerky grainy clips showing street artists in action, it is easy to accept that they are shot by the omnipresent Thierry, but there is no way to be sure that they are from his camera or even shot in his presence. In short, Thierry could be an all-purpose mask for the identities of all the artist taggers, a protection against legal action and a further boost to their general mystique. This line of thought quickly leads to the suspicion that the clips may be staged as re-creations, dramatizations, exaggerations, and the like. Then comes the unsettling notion that Banksy is operating with the standard modern media mode of circular (dis)attributions and plausible denial; living in a kaleidoscopic media world, it's not that it's prudent to doubt what you see, but that the dubious is all you see.

When we see Banksy face to face, he presents himself in shadow and hooded—once again, a familiar device used to protect identities of informants, blackmailers, terrorists, and so on. And, just as with the street-art action clips, the mask may not hide anything more than another mask, an actor standing in for Banksy, or, perhaps, merely enacting or improvising the strictly impersonal narrative logic at work in the movie.

When we see Thierry present his great show, and Los Angeles shows up for the opening, it is hard to believe that the event is a sham. But, there can only be a sham in relation to the expectation that documentary conventions are in play. If, however, this is fiction, anything goes. The street-art guerrilla tactics of viral marketing, flash mobs, warehouse rave venues, and so on may be a well-fitting mask for the tactics of indy-budget movie fiction.

Is *Exit Through the Gift Shop* a work of fiction? If fiction is a work closely shaped around a detailed plan developed by writers, producers,

designers, actors, directors, and editors, then the answer is strictly "no"—the majority of its scenes consistently present an observational attitude to events motivated by factors external to the making of the movie. If fiction is a work of imagination that proceeds from a rough plan to a provisional outcome via considerable improvisation, the answer can likely be "yes"—the observational tactics may be the evolving view of a live experiment in teasing the art world through the invention of the naïf par excellence, Thierry Guetta, and his adventures. Seen this way, *Exit Through the Gift Shop* is the open—and slippery—account of a production process and not a closed—and stable—record of its intent or outcome. The diegetic time and space of the movie is, uncannily closely, overlaid with that of its production mechanics.

On the face of it, the story of Thierry's transformation from absolute unknown into the media phenomenon, Mr Brainwash, seems to be implausibly long for the perpetration of a hoax, but it conforms fairly closely with the ordinary production frame of a movie. And what are movies, if not a specialized and enjoyable type of hoax? *Exit Through the Gift Shop* presents a model for movie-making where astutely directed publicity induces events and multiple media traces—public-ish and private-ish—of which the "official" movie is just one. With *Exit Through the Gift Shop*, standard procedures are turned on their head. The publicity makes the movie, not the other way about. Even the distribution techniques—through viral channels and festival and art-house cinema circuits—are extensions of the media-to-effect mechanisms that Banksy adopts as a *saboteur-provocateur*.

The charm of Banksy's *Exit Through the Gift Shop* movie is to show how transgressive events can be conducted *in plain sight* of a media-(hypno)tized public, and yet vanish absolutely in the clamor of sightings and *déjà vu* that they precipitate. Street art is seen by all and by none. The hurt is that the same is true of terror, operating within the same digital age of DV cams and 24/7 news cycles spun around the globe by satellites and optic fibers.

Live + True

Exit Through the Gift Shop and the digital media through which it is made and propagated are instances of the triumph of *technologies of live*—hard and soft technologies that ride on the present, that make the just past and the distant past equally reclaimable as the now present. This capacity, multiplied by the encircling reach of satellites, led Marshall McLuhan, late in his writings, to rework the

"global village" as the "global theater"—a world where experience is regularized into archetypes which descend through repetition into clichés (McLuhan, 1970, 9). The specifics of such live technologies, in many cases, have military origins—as with the point-to-point radio that preceded broadcast networks, or the anti-ballistic missile warning systems that foreshadowed real-time interactive networked computing. But live technologies infiltrated the popular imagination in the presentation of such contexts as politics, sports, pageants, disasters, and "live aid" global appeals.

For live to take off, the hard technologies of mobile production trucks, lightweight cameras, laptop editing, and so forth, had to come together with what may be thought of as the soft technologies of popular cinematic and televisual literacy. Ethnographic film and war reportage, like Pathé News, brought distant and urgent events into focus, and, from the late 1950s, when sync sound became feasible with light handheld cameras, a mobile intimate—even invasive—eye shaped the worlds brought to the screen by filmmakers of the New Wave, cinéma vérité, and direct cinema movements. From the mid-1970s, the nimble glide of Steadicam work generalized the haptically expressive use of the camera as a body projected within the action—seen in such early uses as the maze scene from Stanley Kubrick's *The Shining* (1980) through to such regular TV staples as the "walk'n'talk" shots of Aaron Sorkin's *The West Wing* (1999–2006) (see Ferrara, 2001).

From eerie to scary, calm to crazy, Steadicam work is enormously flexible, but remains a narrator's tool. Home video, by comparison, is driven by the contingencies of the event, by a live "shoot-first and save-later" opportunism that comes to be read as innocent of narration, and free of persuasive intent. But, the innocence is soon lost as this construction of live is co-opted into the scripting strategies and cutting styles of early "unscripted" shows, such as MTV's *The Real World* (1992–), created by Mary-Ellis Bunim and Jonathan Murray, or the situational scripting and "found footage" exploited to inject a shocking immediacy into the horror-mystery of *The Blair Witch Project* (1999) by Daniel Myrick and Eduardo Sánchez— a reworking in updated media of the Orson Welles' *War of the Worlds* (1938) Halloween radio drama-as-newscast hoax strategy.

Now, between the shoot-and-share cell phone camera and the first-person shooter (FPS) video game, just about everybody has an eye on the screen and a finger on the trigger—just about everybody has become, in effect, a citizen-journalist or a drone-pilot assassin in waiting.

Through these technologies, live comes to be conflated with true, and to reside in an experientially potent dual awareness of the infinite

immediacy of the present and the disposability of the prior moment. The current frame is always more vivid than the last, the joy of shooting or finding new footage outshines the pleasures of reviewing old clips. Thierry, then, is a figure of the *true*, both in his persona as the consuming naïf par excellence, and in the world that his lens consumes *live*. Unlike Voltaire's Candide, whose bitter experiences, humiliations, and injuries in the world wean him of the delusionally rosy optimism of his tutor Dr Pangloss, Banksy's Thierry, stuck within the infinite present of digital video, is thoroughly transparent to experience and absolutely secure in his naïveté. His appeal, like the Hallmark image of the eternal child, is the pure travesty of all experience *as lived*. Just as Thierry, the apparent naïf, brings out the naïveté in all the folk he meets, *Exit Through the Gift Shop*, an apparent naïf of the movie world, does the same for the art critics reviewing movies, the movie critics reviewing art, the media critics reviewing media, and so on. All are caught in a performance defending their performance.

Museums have film series these days, so it is likely that *Exit Through the Gift Shop* will make an appearance within their walls. But when this happens, and notwithstanding the panel discussion that will likely be tied into the event, will the museum have become just one more cinema—with Banksy's name on the marquee?

Are the walls back?

The yellow pages and the arts/science pages are still full of museums. The arts/science and education markets continue to be buoyant platforms for investment, and museums continue to be planted as catalysts for, multipliers of, and statements on economic growth and prowess. Old and new, big and small, these structures invariably operate with and within a world of digital practices. These practices—and the devices that drive them—are all irreducibly physical, but as they commonly report and exert effects that are below and beyond the ordinary expectations of the sensorimotor reach of humans, they are said to be nonphysical, immaterial, virtual counterparts to the standard action–perception bubble (see Noë, 2004).

For museums this means an unfruitful struggle to overcome the ungrounded, yet apparently commonsensical, division of their assets and energies between object preservation and information dissemination, between displays and databases, and between street facades and Web addresses. In this digital age, all museums are committed to dual presences—so much so that the UK's Tate Gallery insists that its online

offering is a fifth destination to set alongside the four built locatic
But the reputational presence of any entity is not so easily dividec
is a changeful matrix of effects that operates across many simultane
fronts—from buildings to signs and flyers to online coupons, and fr
fashionable openings to malicious headlines. Digital practices gener;
expand and accelerate these effects, but they all have mechanisms, ;
all of these mechanisms are housed somewhere, often, in part at le
alongside the collections and their galleries. Walls have not entii
gone away.

The digital age has hidden its connective tissue in radio wa
and optic fibers, so that the mobilities and pluralities of practice
more conspicuous than the techno-economic rigidity and centra,
of the underlying processes. The surface of life in the digital age
gone"glo-cal"—global reach with local action. The old communi
tion technologies of one-to-many—radio, TV, and so forth—h
given way to new modes that operate as so-called peer netwo1
one-to-one or many-to-many. These are the technologies of
"distributed person" and the "extended mind"—images that wo
seem to come from science fiction, but are, in fact, equally at ho
in academic studies of "material agency" undertaken by economi
psychologists, and anthropologists (see Gell, 1998; Knappett ;
Malafouris, 2008). These models of agency embed human activi:
within a general account of how events transpire among circuits
things, and are found to inform cultural frameworks more commo
and more profoundly than might be imagined. Western investme
in the moral autonomy of the individual have tended to obscure
common-sense basis of these models and frameworks which acc
closely with the simple procedures by which the human brain st1
tures its relations in the world.

Man's ancestors could handle social communications, throu
physical grooming, in groups of around 40, and then, through ve1
grooming, in groups of 150 (see Dunbar, 1996; Mithen, 1996, 1
2006, 135). Now, electronic man, working with peer technolog
digital grooming through Twitter and the like, seems to be hea(
toward numbers that far exceed those of all traditional kinship grou
President Obama's mid-2010 tally of "followers" on Twitter excee(
4.47 million! "Pop-up" services and "mix" cultures are the behavic
spawn of these social technologies located in the digital microdim
sions of server space. Social capital emerges from the multiplicat
and cultivation of "weak ties"—distant relationships that bring rem
knowledge pools together (see Granovetter, 1974).

)igital devices greatly multiply the ease with which such "weak ties"
ι be developed, but they are only as effective as the "technologies"
trust and privacy that they support. As centralized one-to-many
tems yield to distributed peer networks, the tokens, actions, recip-
ations, and protocols that guarded trust and privacy are being
lated—the transition being marked by raised levels of anxiety and
ıd. For legacy institutional structures, like museums, the impact of
se changes in the environment of social capital formation, trust, and
vacy is profound. The sum of their social relations and investments
edefined—up, down, or out of existence—from the outside. The one-
nany universe in which museums enjoyed an authoritative position
given way to the one-among-many pluriverse where all the players
only as good as their last performance. In this newly plural world,
ıble organizations enjoy all the advantages.

en season

the early days of the World Wide Web, the static one-to-many model
the encyclopedia was outflanked by the dynamic many-to-many
del of *Wikipedia* and its like. How can the museum avoid this fate?
f lively art and science practices spring up in the open spaces where
es are loose, rents are cheap, peers gather, music is made, and bonds
tied—say, art in 1990s Berlin, or science in 1970s Menlo Park—the
seum must recast itself as a congenial home to such forces. But one
titution does not make a scene, and so it must actively contrib-
to the traffic of the "weak tie" peer networks that bring together
erimental interests and coalitions. It must tolerate debate, dissent,
barrassment, and risk, and do so publicly. Real stakes must be
:ed. Failure should equal closure. Success is to become a favored
nt of contact within a rising scene, and should be feared as much as
ebrated. Reinvention should be continuous.
he static introverted model of the museum as a place of privileged
owledge is often tied to, or excused by, an account of its origins
t focuses on the collections of occult curiosities housed in the
vate chamber, the *studiolo*, of the Mannerist prince, or the *cabinet* of
Baroque alchemist. Another account focuses on the collections
votive materials housed in the *treasuries* of temple sanctuaries, the
enoi, of ancient Greece (Bennett, 1995, 21–39; Duncan, 1995, 475;
dman and Pantel, 1992, 55–62, 96–7).
his account offers a dynamic extroverted model for the museum, and
: which goes far toward meeting the challenge of this digital age. The

key to this account is not to focus on the interior cell of the treasury, or, for that matter of the temple. Although the votive goods were stored in the treasury and the tutelary god's image was housed in the temple, votive deeds were performed in the open, in front of these structures, where they were public acts. The constructions of the treasury and the temple themselves were, likewise, publicly shown acts of dedication to the gods. Although the boundary of the sanctuary marked a place of special protocols and taboos, votive deeds were threaded through every aspect and place of Greek daily conduct and life. Festivals connected the sanctuary to the calendar of daily life. The quadrennial festivals combined processions, sacrifice, feasting, and competitions in sport or drama. The great Panhellenic sites, such as Delphi, had stadia and amphitheaters where the competitions could be publicly presented before the gods.

This Greek account of the museum's origins has two central features, *anatheke* and *agôn*. The first defines the fundamental votive act and translates as a thing "set-up." The second defines the quality of the act as something of excellence proven through contest. Thus, the sanctuaries and all the events that embed them within the Greek world are essentially places and occasions for the witness of great deeds, of winning performances in architectural craft, drama, horsemanship, and so forth (Cartledge, 1985, 101).

Walls are a part of the witness of the place as deeds take place before them. They do not close the sanctuary off from the world which encircles them. Rather, they concentrate the world on the special features of the place. They include, rather than exclude, and situate the events which transpire over time. The walls themselves are events situated in time—the amphitheater, for example, is no more than a circle of dirt for dance surrounded by loose benches and an actor's tent until it comes to be fixed in stone with the canonical form of the stage, or *orchēstra*, the tiered seats, or *theatron*, and the stage-house, or *skēnē*. It is through the regularity of the performance that the nomadic and transient comes to be situated and enduring (Cartledge, 1985, 122–5; Parke, 1977, 29–50).

The Great Exhibition of 1851 brings much of the ancient Greek festival experience into the context of the modern museum. The scale of the event, and the remarkable demonstration of ingenuity and organizational powers designed to honor the British state in front of other nations, would have been quite familiar to the Greeks, as would the public nature of the celebrations. But, perhaps, the most conspicuous emulation of the Greek way was in the competitive spirit driving the event. At a broad level, there was competition of empire—the French Industrial Exposition of 1844 had to be topped. But, at a level more

pertinent to the future of the museum as an institutional type, the great display halls that drew the crowds were presented in parallel with competitions for all classes of manufactures. The goal was to define a "natural history" of manufactured goods by species and to expedite the processes of natural selection for the benefit of the nation, as an economy and as a people. With the transfer of the Exhibition's contents to what would later emerge as the Victoria and Albert Museum, the principal of general public education for the national benefit remained, but the focus moved to the collections rather than the competitions (see Wesemael, 2001).

It could be that it is of the nature of the collection to be closed; that is to say, it may be added to, but always with a view to completion. Walls serve as a commitment toward that completion. And, it could be, correspondingly, that the nature of the competition is to be open—that there is always a shadow over the champion's performance as long as there may be another challenger out there. In the digital age, challengers just keep showing up. Walls, here, are just to mark the score on.

References

C. Anderson, *Free: The Future of a Radical Price* (New York: Hyperion, 2009).
T. Bennett, *The Birth of the Museum: History, Theory, Politics* (London: Routledge, 1995).
P. Cartledge, "The Greek Religious Festivals," in *Greek Religion and Society*, ed. P. E. Easterling and J. V. Muir (Cambridge: Cambridge University Press, 1985, pp. 128–54).
E. Castronova, *Synthetic Worlds: The Business and Culture of Online Games* (Chicago, IL: University of Chicago Press, 2005).
R. I. M. Dunbar, *Grooming, Gossip, and the Evolution of Language* (London/ Cambridge, MA: Faber & Faber/Harvard University Press, 1996).
C. Duncan, *Civilizing Rituals: Inside Public Art Museums* (London: Routledge, 1995).
S. Ferrara, *Steadicam: Techniques and Aesthetics* (Oxford: Focal Press, 2001).
A. Gell, *Art and Agency: An Anthropological Theory* (New York: Clarendon Press, 1998).
M. Granovetter, *Getting a Job: A Study of Contacts and Careers* (Cambridge, MA: Harvard University Press, 1974).
C. Knappett and L. Malafouris, eds, *Material Agency: Towards a Non-Anthropocentric Approach*, New York: Springer, 2008).
M. McLuhan, *From Cliché to Archetype* (New York: Viking Press, 1970).
S. J. Mithen, *The Prehistory of the Mind: A Search for the Origin of Art, Religion and Science* (London: Thames and Hudson/Orion, 1996).
S. J. Mithen, *The Singing Neanderthals: The Origins of Music, Language, Mind and Body* (Cambridge, MA: Harvard University Press, 2006).
J. Newman, *Playing with Videogames* (New York: Routledge, 2008).

A. Noë, *Action in Perception* (Cambridge, MA: MIT Press, 2004).

B. O'Doherty, *Inside the White Cube: The Ideology of the Gallery Space* (Santa Monica, CA: The Lapis Press, 1976).

H. W. Parke, *Festivals of the Athenians* (London: Thames and Hudson, 1977).

C. Paul, *Digital Art*. World of Art Series (London: Thames and Hudson, 2003).

C. Paul, ed., *New Media in the White Cube and Beyond: Curatorial Models for Digital Art* (Berkeley, CA: University of California Press, 2008).

R. Smithson, "Cultural Confinement (1972)," in *Robert Smithson: The Collected Writing*, ed. J. Flam (Berkeley, CA: University of California Press, 1996, pp. 154–156).

R. Smithson, "A Provisional Theory of Non-Sites (1968)," in *Robert Smithson: The Collected Writings*, ed. J. Flam (Berkeley, CA: University of California Press, 1996, p. 364).

F. Turner, *From Counterculture to Cyberculture: Stewart Brand, the Whole Earth Network, and the Rise of Digital Utopianism* (Chicago, IL: Chicago University Press, 2006).

V. Vesna, ed., *Database Aesthetics: Art in the Age of Information Overflow* (Minneapolis, MN: University of Minnesota Press, 2007).

P. V. Wesemael, *Architecture of Instruction and Delight* (Rotterdam: 010 Uitgeverij, 2001).

L. B. Zaidman and P. S. Pantel, *Religion in the Ancient Greek City*, trans. P. Cartledge (Cambridge: Cambridge University Press, 1992).

Index

Page numbers followed by 'n' indicate notes.

F
face, 159–77
 autism and (*see* autism)
 facial reticence, 162–6
 human, 160
 of mother, 159, 160, 166–7
 other objects and, 166–9
Face (Visage), 281
"faciality," 8
Farocki, Harun, 111
fascism, 180, 181–2, 185–6, 188,
 193n33
Fascist demographic policy, *Cocktail*
 and, 180
Faure, Elie, 71–2, 124, 235
Faux, Anne-Marie, 200
Feeding the Baby, 59
felix culpa, 126
Felleman, Susan, 4, 7, 8, 249
Fieschi, Jean-André, 209
Figure in a Landscape, 223
film and cinema, 150–1
 audiences, 280, 297n7, 298n9
 Bazin in (*see* Bazin, André)
 Benjamin in (*see* Benjamin, Walter)
 central conflict theory of, 149, 150,
 155n8
 on culture, 117
 early (*see* early cinema)
 ellipsis in, 120
 fascism and (*see* fascism)
 image, painting and, 148–54
 Malraux in, 115–20 (*see also*
 Malraux, André)
 materiality of, 154n3
 movement in (*see* movement in
 cinema)
 museum and (*see* museum and
 cinema)
 for Neorealism, 142
 nostalgic quality of, 153
 painting and, 144, 200–20
 photography and, 51, 124, 126
 "scientific" conception, 82
 "seventh art" of, 74
 soundtrack in, 146, 150
 style in, 120, 130–2
 "suture" in, 270, 275n32
 tactile and haptic argument of, 283

Film as Film, 245, 252n7
filmmakers
 painters and, 200–40
Fire Dance, 66
Fireworks, 233–5
Fitzwilliam Museum, 278, 282–7
Flaubert, 207, 208, 209
Flickr, 303
*Flight of the Red Balloon (Le Voyage du
 Ballon Rouge)*, 2, 281
Flying Out of This World, 247
Flynn, Catherine, 176n20
Focillon, Henri, 124
Forrest Gump, 147
Fortini/Cani, 202
The Fortune Teller, 39
Foucault, Michel, 133, 284, 291
 discursive formations, 284
 heterotopia and, 267, 275n24,
 291
The 400 Blows, 133
*Fragment of a Crucifixion (After Francis
 Bacon)*, 232
framing, 170
 ellipsis and, 128
 style in, 130
French Cancan and *Elena et les
 Hommes/Paris Does Strange Things*,
 209
French Cinémathèque, 280
French Industrial Exposition of 1844,
 318–19
Frères, Pathé, 58
Freud, Lucien, 229
Fried, Michael, 5, 57
"frightening," 200
Frizot, Michel, 108
Fuller, Loie, 58, 59, 60, 61–3, 65, 66,
 67, 72, 75n10
Fuller, Peter, 228

G
Gaigne, Pascal, 145
Gambrell, Jamey, 259
Gan, Aleksei, 82, 83, 84
Gance, Abel, 135, 224
García, Antonio López, 141
Gardner, Helen, 44
Gasquet, Henri, 204

Gasquet, Joachim, 203, 204, 205, 206, 207, 208, 209, 211, 212, 213, 214, 217
Gaston Gallimard, 116
Gazzetta del Popolo, 191n9
Geffroy, Gustave, 205–6
Gegen-Musik/Counter-Music, 111
Genesis, 306
Genet, Jean, 304
genre painting, 39, 41, 42, 47, 53.
 see also The Card Players
George, Boy, 227
Gergiev, Valery, 268, 275n26
Germany, Year Zero, 154n2
Gérôme, Jean-Léon, 44–5, 46
"the gesture as a sign of sound matter" *(matière sonore)*, 70
Gibson, William, 302
Gide, André, 116, 117
Gilliam, Terry, 245
Godard, Jean-Luc, 4, 108, 115, 132, 133, 134, 135, 147, 155n8, 155n13, 200, 202
Gogh, Van, 136, 137
Golan, Romy, 187, 189
Gordon, Douglas, 245
Gough, Maria, 81, 88
Goya, 122
Gradiva, 249, 250
Gran, Enrique, 144
Grant, Duncan, 246, 253n16
Great Exhibition of 1851, 318
The Great Ice Cream Robbery (1971), 247
Greco, El, 121, 122, 133, 134, 135, 136
Greenaway, Peter, 4, 245, 247, 252n9
Greenberg, Clement, 5, 57
Griffin, Roger, 181
Griffith, D. W., 127, 215, 243, 244
Griffiths, Alison, 288
Guernica, 138n14
Guerrilla Girls, 308–9
Guetta, Thierry, 10, 309, 312, 313
Guido, Laurent, 67
Gunning, Tom, 59, 68

H
Hainge, Greg, 230
"The Hand of the Artist," 30

Hanks, Tom, 147
"happy fault," 126
hard technologies, 313, 314
Harrison, Martin, 223
Hayward Gallery, 245, 248
Herbin, Virginie, 202, 217
Hermitage Museum, 1, 10, 248
Hess, Barbara, 35
heterochronia, 292
heterotopia, 267, 275n24, 291
Hirst, Damien, 245, 252n10
Histoire du Cinéma, 4, 135
History of Cinema, 244
Hitchcock et l'Art: Coïncidences Fatales, 280
Hochberg, Julian, 283
Hogben, Gavin, 10
Hölderlin, Friedrich, 201, 210
Hou Hsiao-Hsien, 2, 281
House of Cards, 40
The House of the Hanged Man, 47
Huillet, Danièle, 6, 8, 149, 200–20, 248
humanism, style after, 130–2
Hunter, Sam, 221
The Hypothesis of the Stolen Painting, 155n8

I
iconoclasm, 35
Il Selvaggio (The Wild One), 8, 178, 179, 180, 181, 182, 185, 191n9
image d'Épinal, 43, 52
image(s). *see also* digital image/ digitization
 face and, 159
 of films, painting and, 148–54
 language and, 172–3
 movement and, 5–9
image-sharing sites, 303
"imaginary conversations," 204
"imaginary museum," 3
Imperial War Museum, 242
Impressionism, 62, 207, 214
inanimate things, 166–9
In Camera: Francis Bacon: Photography, Film and the Practice of Painting, 223
Incorporating Images, 5

336 *Index*